Drinking Lightning

Art, Creativity, and Transformation

Drinking Lightning

Art, Creativity, and Transformation

PHILIP RUBINOV-JACOBSON

Foreword by Ken Wilber

Preface by Ernst Fuchs

SHAMBHALA
Boston
2000

Shambhala Publications, Inc.
Horticultural Hall
300 Massachusetts Avenue
Boston, Massachusetts 02115
www.shambhala.com

9 8 7 6 5 4 3 2 1

First Shambhala Edition

Design: Craig Peterson
Colour separations: Sang Choy, Singapore
Printed in Singapore by Kyodo Printing Co.

⊗ This edition is printed on acid-free paper that meets the
American National Standards Institute Z39.48 Standard.

Distributed in the United States by Random House, Inc.,
and in Canada by Random House of Canada Ltd

COVER ART: Detail of *Faith, Attending Night*, 1980 by Philip Rubinov-Jacobson,
egg tempera and oil on panel, 52" x 51" in.

Library of Congress Cataloging-in-Publication Data

Rubinov-Jacobson, Philip.
 Drinking lightning: art, creativity, and transformation / by Philip Rubinov-Jacobson.
 p. cm.
 ISBN 1–57062–746–0 (cloth)
 1. Rubinov-Jacobson, Philip. 2. Artists—United States—Biography. 3. Spirituality in art.
 4. Creation (Literary, artistic, etc.) I. Title.

N6537 .R775 A2 2000
709'.2—dc21
[B]
 00–037157

This first book is dedicated to my mother,
Rose Cohen Jacobson

and to the memory of a great poet-warrior,
my father, Israel Jacobson

and

to Sandra Lee Reamer in recognition of our love
and many years together

and

to the creative spirit that resides in everyone.

"By this fierce ardor ... some men at times caught into the spirit, above the senses; and these words are spoken to them and images and similitudes shown to them, teaching them some truth of which they and other men have need, or else things that are to come. These are called revelations or visions ... Sometimes a man may also be drawn above himself and above the spirit ... into an Incomprehensible Good, which he shall never be able either to utter or to explain in the way in which he heard and saw; for in this simple act and this simple vision, to see and hear are one."

"... At times God grants to such men a sudden spiritual glimpse,

like the lightning in the sky ..."

from
The City Without Walls
Jan van Ruysbroeck (1293–1381)

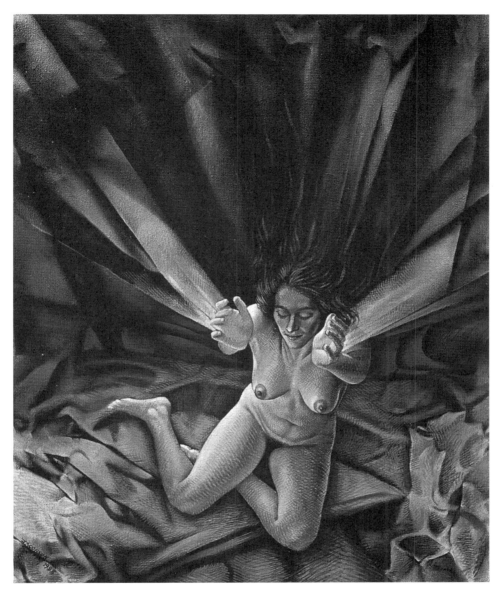

FIG. 1 Philip Rubinov-Jacobson, *Into Light #1*, 1988, egg tempera and oil on canvas, 30 x 24 in.

FOREWORD

Art. Its definitions are legion, its meanings multiple, its importance often debated. But amid the many contradictory definitions of art, one has always stood the test of time, from the *Upanishads* in the East to Michelangelo in the West: art is the perception and depiction of the sublime, the transcendent, the beautiful, the spiritual. Art is a window to God, an opening to the goddess, a portal through which you and I, with the help of the artist, may discover depths and heights of our soul undreamed of by the vulgar world. Art is the eye of spirit, through which the sublime can reach down to us, and we up to it, and be transfigured and transformed in the process. Art, at its best, is the representation of your very own soul, a reminder of who and what you truly are and therefore can become.

Philip Rubinov-Jacobson is a true artist, one in whom the sublime is at work. But, as Phil explains in this book, the spiritual impulse — the artistic impulse — is at work in every act of creativity. Art can be a way to awaken that creative and spiritual process and hone it to a fine degree. That is what Phil has done in his own life, and it is what he shows the reader how to do in the following pages.

This is a wonderful book, ripe with the wisdom of an artist in whom the creative fire is alive, touched by the gods and goddesses of a realm that the conventional mind too often fails to see, enraptured by the vision of a beauty too painful to pronounce. Art, as the eye of spirit, is the royal road to your own soul, and this book is nothing less than a road map for that extraordinary adventure.

Ken Wilber

CONTENTS

PART TWO: **PUSHING FLESH TO HEAVEN**

PREFACE

What choice is there if you are a chosen one, born to be a visionary painter on an esoteric path?

Among infinite chances to meet or not meet a person, is it by chance that we meet one bearing a special message — step by step, forming a spiritual world of visual contemplation, of theological and philosophical Reasoning?

Phil and I met years ago just at the beginning of his path — at the entrance to the reality of the imagination.

It was at Castle Wartholz where I gave lectures on the techniques of the Old Masters and, ever since, he has followed his way through the wilderness of contemporary art. His talents have revealed the message he has been chosen to give to his students first and to all who have set out to explore an esoteric interpretation of the universe. Now that a presentation of his work is published, I gratefully accept the opportunity to wish this book every success.

Ernst Fuchs

The essential ground of this book was written by me and first published in 1989 as *The Sacred Path of Art* by the Faculty of Arts and Humanities at the University of Denver. The book contained both my personal experiences and perspective on art as a transpersonal device and spiritual practice. With the publication of *Drinking Lightning*, more than ten years of experience and knowledge is added to the refinement of my first endeavor.

Although this is a book addressing art and creativity, in essence it is about transformation in our lives. In this context, art refers to any aesthetic medium or physical demand that goes beyond mere mechanical exercise and allows us to give outward expression to our inner feelings and states of consciousness, or to experience non-ordinary states of consciousness through an extraordinary appreciation. In the text I often use the term "creative worker" interchangeably with the words "artist" and "mystic" and in describing any endeavor in which creative energy is employed. So whether a painter, computer programmer, single parent, poet, businessperson, musician, or plumber, we all share the potential for inspiration, creative power, and spiritual transformation.

Thus this book is for everyone. Wherever we may be standing on the path, looking at someone ahead or behind us, we are merely looking at ourselves from where we once stood or where we will one day be, from where we are now at every point in our fullness. We are one person looking through the eyes of many. One of my former teachers, Swami Muktananda Paramahansa, often told the story of how gold can be beaten or formed into any shape — a goblet, a goddess, or even a ring. Are they all different objects or are they all simply "gold"? In this book I share parts of my own journey, as well as the journeys of many others, in search of our "inner gold" — that shining, deathless, golden essence which resides in us all.

Herein I will convey a few experiences that may seem extraordinary and hard to believe. It is difficult to write about my personal experiences and spiritual journey. I have struggled with how to do that without sounding boastful and narcissistic, wild and inaccessible. There are things in this book that I do not like to put into words and usually don't, not even to my closest friends. But I have done just that, in order to relate certain events and share what I believe may be important for all of us. This isn't a religious book, and I'm not addressing the salvation of your soul, although I want to take up the spiritual aspects of creative power. I'm more interested in discussing precisely what happens, and the role your mind plays, when art or creativity takes on such forces as to utterly change you and your outlook to such an extent that you can never be the same again.

My own quest began early. Among my boyhood heroes and "sheroes" were Moses, Alice in Wonderland, Michelangelo, Joan of Arc, Samson, Jesus, Houdini, Saint Bernadette, the heroes and heroines of Greek myth, Superman, Einstein, Sugar Ray Robinson, Mahatma Gandhi, and later, others of great spiritual genius: Krishna, Mohammed, and Buddha. My secret "inner school" was so out of sync with the external life of "education" that, at a very early age, I developed an adverse reaction of monumental proportions to a

rigid public school system. Later, while an adolescent, I challenged my Jewish upbringing and other dogmas propagated by religious fundamentalists. I struggled with the idea that any one religion could lay sole claim to spiritual reality when generations of sincere people were born into such a diversity of religious and cultural environments. Now how could the answer be true for only one of the many? Surely the answer, or rather the journey, had to be much deeper than the dogmatic, superficial exclusivity of one group over another.

As a young boy I had an ability to "see" and comprehend certain forces beyond the realm of ordinary experience which mixed with an almost uncomfortable sensitivity of "feeling" the inside of other living things. At the time, I did not know this was unusual but thought it a common occurrence that everyone shared. Books in the library of the old Orthodox Jewish temple on Leopold Street in Rochester, New York, revealed texts containing actual illustrations of other realms of existence populated with extraordinary spirits and supernatural beings. These illustrations affirmed some of the things I was seeing. With this affirmation, a window flew open in my mind as wide as the sky itself. Using painting as a transpersonal device, I became more and more inspired as I continued to align myself with a spiritual source.

I searched through history to find mystics and artists who saw similar things and expressed it in their work. Later I discovered other contemporary Visionary artists, and my search for a family formed in spirit, the mystic artists, in part included my journey to Europe where the realm of art and mysticism merged under the mentorship and lineage of the extraordinary artist Ernst Fuchs.

My immersion into the studio arts and art history was complemented by further studies and direct experience in other fields such as education, psychology, philosophy, comparative religion and metaphysics, history, and sociology. I absorbed the works of Freud, Jung, Maslow, Ouspensky, Steiner, Gurdjieff, Krishnamurti, Ramakrishna, and many others. As my heart filled I needed to serve and quench the metamind. Theosophical literature, almost all of it, was revealed to me by a remarkable man: the cultural anthropologist-alchemist, poet, and craftsman, Dr Wilson Wheatcroft, a mentor and friend who introduced me to his guru, Swami Muktananda.

I share selected events from my life that include journeys to a castle in Austria, the sun-baked land of India, the streets of New York City, a Walden-like existence in a cabin deep in the woods of Massachusetts, and a crisis in health depicting how the creative inner power, together with benevolent forces, assisted me in overcoming a prognosis of paralysis from a recent accident. My journey did not bring me to a final destination but rather to an expanding "inner Creative Mansion" with increasing access to the various rooms inside.

This book is not written to dissuade others from following any particular religion established by God's succession of chosen messengers. We each must find our own way. We may, at times, feel the need for a teacher, an outer guide, but in the end we must know for ourselves which way to turn, which thing to choose, which action to take. I have tried to live by the gentle and sweet guiding impulses of a creative power that, also at times, may cast one into a temporary spiritual fire that is all-consuming, even turbulent, but allowing

for an opportunity to emerge with a fresh vision and tremendous secrets of the human spirit. This spiritual source has always been available to assist everyone on their way, by taking the Creative Royal Road. It is my sincere hope that I may offer some piece of the puzzle — an affirmation, perhaps — to all those who can resonate with the words and images in this book, recounting the way back to what is commonly held, and has always been, sacred.

Creativity is a source in all of us, enabling us to cultivate life in a way that invites transformation, peel away layers of illusion, and therefore bring us ever closer to our true nature. Perhaps the most important gift is creative self-empowerment. Through it we discover our resilience and our ability to endure, regenerate, and transform anything — even the ugliest, the most terrifying, or the most painful situation — into a creation, an opportunity to experience love, beauty, or truth, and share that with others through our own unique expression.

Philip Rubinov-Jacobson
BOULDER, COLORADO

Acknowledgments

I am especially indebted to Ken Wilber for his support, friendship, inspiration, and encouragement. Ken has been a loving and ethical beacon of guiding light. His infallible ear, persistent companionship, humor, genius, and "regular guyness" are all precious to me and helped make this book come alive.

My deepest thanks to my mother, Rose Jacobson, for her unwavering faith, saintly support, unconditional love, and gentle teachings. A salute to the memory of my father, Israel, whose fearlessness bestowed courage, a taste for adventure, a love for philosophy, poetry, warriorship, and tradition. I wish to express my deep gratitude to all the "Joes"; my brothers Alan and David and sister Jess, my *puckahs*, too, Uncle Abe, Aunt Norma, and Tante Leah, all of you who are my tribe and have always been there for me. Marta Leone-Nienstedt's love and confidence in me and Matthew Raisz's belief and patronage have played a special role in my growth as an artist and human being. They live in my heart of hearts and have always been and always will be "family." To my "forever friend" and sister heart, my "Muck," Mary Jane Fenex, for her fire and softness, her love and soothing wisdom. Many thanks to Joanna McKenzie who helped nurse me back to health while I wrote the guts of this book. I am grateful to Antoinette Lopes for her help and refreshing curiosity, to Dr Gordie Dverin and Cathy Modrall for their special caring.

I am deeply indebted to Alan Sparks for his consummate editorial help and belief in this book and in me. His sensitivity, honesty, support, companionship, and wonderful clarity of mind are a treasure, and his friendship … the most valuable of all. To Alex Grey for his compassion and camaraderie, unique brand of wit and wisdom, his images and gentle encouragement. Many blessings to my visionary neighbors Robert Venosa and Martina Hoffmann — they have been so very sweet to me, and Robert helped make this publication possible. Thank you. I am also thankful to all the wonderful artists and writers who have contributed their brilliant and beautiful work to this book — many blessings.

Homage to Chogyam Trungpa Rinpoche, who called me from deep inside a dream to serve a dream. In that dream I was asked to plaster and fill in the holes of an ancient cave, which he said was "Naropa." The dream plastered itself into the everyday working world by gathering together a family forged in creative spirit, who shared and served a vision — the bliss and contractions of birthing a new School of Continuing Education at Naropa University in Boulder, Colorado. I am grateful to those beautiful and dedicated individuals who assisted me in that awesome task. I am proud of all of them. And in memory of Lex Hixon who helped to seed that school, may that school — and all schools — measure their vision, truth, and value by his blessed heart. To Steve Glazer, Frank MacEowen, and Charlotte Rotterdam for their diligence, dedication, intelligence, creativity, humor, and company on this challenging and fruitful journeyless-journey, but most importantly for their continuing friendship.

Professor Takashi Takahara is greatly honored and appreciated for his friendship, wisdom, compassion, and patronage. A special thanks to a dear mentor and friend, Mayor

Peter Jay Chipmann, "Chip," for his wisdom, strength, support, and understanding. His kindness and immense generosity are lifesaving. Salutations to all of my mentors but particularly Samuel Cohen, grandfather and master artist, who carefully watched my first marks make "their own" way. Thanks to Jan Wheatcroft, Dr Wilson Wheatcroft, and DeEs Schwertberger for their unique magic; Wilson and DeEs for their mentoring, but most of all for their timeless brotherhood and transcendent love. To Ernst Fuchs in gratitude for the ancient-future knowledge and friendship he continues to share with me through a rare relationship that is always evolving. He has my deepest love and respect. To Swami Muktananda for all his grace and for clapping his hands loudly while I was sleeping. Salutations to friend and teacher, Thakar Singh, who softened my heart and continues to do so, even though fifteen years have now passed since we met.

And finally, of course, to Sandra Lee Reamer, who was my link to this world and others, who always gave to me the freedom to experience life in my own unique, sometimes outrageous manner, through love, art, uncontrollable laughter, joy, pain, ecstasy, and tears, while teaching me about loving unconditionally and creatively. Without her support and love over many years, I simply wouldn't be here, and this book and many other works would not exist. Her beauty, artistic genius, gentleness, patience, wisdom, acceptance, and loving company have been blessings beyond measure. I will miss her and remember her victorious kiss like an eternity inside me, her absence outside … like a transparent lighthouse where love watches over me … a wandering lightning forever at sea.

PART ONE:

THE SEARCH

Chapter 1

A Lineage of Sacred Vision: The Legacy of the Invisible Tribe

Let the beauty we love be what we do.
— Rumi[1]

THE MYSTICAL MYSTERY TOUR

I'm walking up to a castle. The emerald trees are swaying in the warm winds that swim down from the Alps. In a few moments I will meet Ernst Fuchs, the founding member of the Vienna School of Fantastic Realism and perhaps the greatest living Visionary artist. This will change my life forever, and I will tell you why.

Fuchs represents an entire path of sacred art — from the beginning of time — a lineage that carries the power to transform a human being. This Secret Masonic Lodge of Visionaries, if you will, crossing time, cultures, and beliefs, was transmuted to me. Regardless of the reluctance of many art historians to recognize this tradition, the legacy of this Invisible Tribe of Artists lives on. An unbroken understanding and intuitive knowledge has been passed on that allows the eye to see what it has not seen before. Even in the midst of scientific materialism squashing the art of man, this lineage has fanned the coals of spirit, never allowing us to fall entirely into a spiritual amnesia. The living history of this mystic lineage in art not only shows you what you are but transforms you into what you can become.

I was nineteen years old that Christmas of 1972, and after six months of waiting I finally received a letter back from Master Fuchs. He was holding an art seminar the following summer at Castle Wartholz in Reichenau, a little village nestled at the foot of the Austrian Alps. With financial help from my friend Matthew, I was able to cross the ocean. I will never forget that first morning of the seminar as I waited respectfully at Castle Wartholz for the great artist. The windy-cool song of the birds comforted my fiery heart, and the scenery was inspiring. There I sat on the steps of the castle in the romantic, fairy-tale countryside. I was the first student to have arrived and would be the only American that year. Ernst, mystic and master of all the studio arts, was fashionably late. As I waited for the great artist to arrive, my eyes inhaled the scenery. The mountains were a beautiful distraction, easing my anxiety and nervousness over meeting the King of Fantastic Realism. I imagined that the Alps camouflaged my youthful, awkward combination of nervous energy, raw sensitivity, and (as reported to me by others) a fierce gaze I was not yet comfortable in owning. My eyes followed the valley, the mountains on each side, mentally drawing a golden chain through the ages of humanity until the shapes of strange beings rose up in the trees. The foreheads of the "tree people," bejeweled on either side of the passage, stretched out like a continuous avenue from one end of time to the other.

Self-amused and leaving behind yet another secret and imaginary excursion to Visionland, I returned to the present moment as Franz Bayer, one of Austria's great printmakers, approached. He too had come to study with Fuchs. He did not speak English and I did not speak German, but we greeted each other. I entered through the doors of Castle Wartholz and proceeded to the main hall that would serve as my first studio space. I decided to start painting while waiting for the great artist to arrive and believed I would impress the master with what I thought was my shining and youthful brilliance. I set up my easel, my palette, my panel, and began in my usual chaotic manner. With that mad glint in my eye, my long hair flaming from my head, oil colors all over my hands, face, and farmer jeans, I began the ecstatic painting ritual I had been accustomed to.

Ernst Fuchs walked through the castle doors and was met by Bayer, who had also begun to paint. Bayer and I were the only students who had arrived. Fuchs looked at Bayer's painting and enthusiastically remarked that Bayer was Lucas Cranach in a former life and expressed his happiness to reconnect with him again. Then Fuchs walked toward my space. He wore a beautiful powder-blue suit and tie and one of his signature Prussian hats he had designed himself. He still paints in similar attire, which I find remarkable. The features of his biblical face carried a paternal wisdom, and his eyes were like deep, black coals where the mysteries burned. The knowledge and history of art were living flames in those eyes. His tall and noble figure filled the room with an awesome, creative force, and his presence was commanding.

Fuchs stood behind me, looking at the painting I had started, observing my manner of working. With my heart in my throat, I said, "I am so honored to meet you. My name is Philip." With great intent in every gesture and tone in his voice he turned to me and said, "Ah, look at you! What a mess! If you begin with chaos, you will paint chaos. Go on, get out of here, and don't come back unless you really want to learn to paint!" I couldn't have felt worse. I left in tears. It was as though my whole world had been crushed. I thought, "What shall I do, where shall I go, and how long will my thirty-five dollars last?"

Walking toward the Alps with my head down, after many hours I reached a peak where I sat upon a rock. I rethought my entire concept of art — the value it had for me, the course my life as an artist would have to take, and the sacrifices I would have to make. I slept there for the night.

Upon returning to the castle the next morning, nearly forty students from all over the world had now gathered around Fuchs's easel. Making my way through the crowd, I approached Professor Fuchs and said, "I have thought about it and I am ready to learn." Fuchs rolled his eyes in Jewish fashion and with a silent *oi vey* toward heaven he gently said, "Good." I quickly realized that although he rarely gave such harsh and dramatic lessons to the other students, he somehow knew that my nature required it. In one brief meeting, Fuchs had stirred me to confirm my life's commitment to art. I had discovered the roots of my aesthetic, where I sat on the tree of vision, and where I knew I must climb next.

POPPY AND DANCIN' WITH GOLIATH

I had begun my journey as an artist many years before and began drawing seriously when only a little boy. One of my grandfathers was a rabbi; the other, a master artist. My mother's father, Samuel Cohen, like Ernst Fuchs, had mastered all the studio arts, but particularly engraving and sculpture. He was gentle and charismatic. Unlike my other grandfather who equally impressed me and constantly prayed to and spoke of God, did feats of magic for children, and displayed an unbelievable physical strength, my maternal grandfather was an atheist, playful, and a Marxist. Samuel, or "Poppy," as his grandchildren called him, gave me drawing lessons and introduced me to the Old Masters, particularly Michelangelo. By the time I was ten years old, I would be considered by some to be an expert on Michelangelo's work and life, and he emerged as my boyhood hero.

I was a very quiet and sensitive boy, almost painfully so. To speak was an extremely important act for me, and to express verbally what I was feeling inside often seemed to be a monumental action or simply unnecessary. Adults commented on how much my eyes spoke to them, how green and beautiful they were. Whatever I felt always seemed much more sacred, or secret, than the world should know. The world seemed too harsh to hold my soft feelings. I loved the quiet and peaceful immersion that I felt when drawing. Every line was alive with a life of its own, and yet each line was intimately connected to my own life, an extension of my self, a way for me to talk to the world. Poppy seemed to know everything I was thinking and feeling, whether I spoke or not. He would tell me, "You're the best in the country! Why, even I couldn't draw like that at your age — the best in the country, I tell you, the best!" Poppy's words were wise, a great comfort and source of confidence. He was content, so at peace with himself and life. His appreciation for beauty and zest for life spilled over into his flower garden, his cooking, his art, and conversations with anyone he encountered. Poppy lived very simply. He and his wife Emma were crazy about each other to the very end. Poppy was so full of love, joy, and magic that even when he gave his grandchildren simple things like paper clips, colored rubber bands, or balloons, we thought they were precious jewels, secret treasures from a wondrous kingdom beyond this world. Whatever he touched became saturated with a scintillating energy and wonder.

My parents permitted me to draw and paint on anything and everything. My little hand, crayon firmly gripped, covered whatever my eyes grasped, nothing left unmarked. I particularly favored window shades, walls, even lampshades. After a short time, every window in our home was stripped bare. The shades, unrolled, became my first canvases. I didn't realize that this liberty I took with the window trappings was a great privilege granted by a mother and father who didn't have much of an income. After going through all the window shades in our own home, I would comb the streets of my neighborhood looking through the curbside garbage cans for discarded rolled-up shades. As a ten-year-old boy, I could feel and almost hear something calling me from the garbage cans, the shiny, silver-gray containers lining the streets like medieval knights presenting scrolls — noble

and creative commissions, my next artistic experiment. My painting projects extended to the basement and attic walls, and I experimented with household products. Detergents, dyes, coffees, cleaners, shoe polish, hair sprays, were all utilized as I unknowingly imitated the manufacturing of medieval, Renaissance, and alchemical paints, fixatives, and mediums for my artistic expression and investigations. A few years ago I asked my mother why she let me tear down the window shades. Why didn't she just buy me some drawing paper? My mother paused and with that characteristic, quiet smile on her face, she replied, "I don't know. It didn't matter. We wanted to encourage you, not interfere with your inspirations or injure your growth as an artist."

My father was a source of encouragement and confidence. A strength leaped from his body to mine, like an electrical charge arching between two metals, providing a spiritual food that was packed with power. Most of the work my father did was of a self-employed nature, and he took me on his jobs as an interstate truck driver, garbage collector, grocery store owner, property manager and handyman, parking lot owner and attendant. Whatever kind of work my father did his spirit was always the same: noble. Added to these earthy experiences was his legacy as a poet-philosopher, prize-fighter, legendary war hero (one of the most decorated Jewish soldiers of World War II), cantor, and devout son of a rabbi. He had immigrated here with his father from the village of Little Naryevka in Belarus (White Russia, now the eastern border of Poland) when he was just a boy.

In 1966, at the age of thirteen, I underwent the Orthodox Jewish ritual into manhood, my father standing beside me at my bar mitzvah. A few weeks later he died of cancer. He was forty-two. The "authority" issue I had developed in response to the public school system now became magnified by my grief, feelings of abandonment, and my need to protect myself. My boyhood severed, cut short, the public school system was at a loss as to what to do with a "gifted problem child," a phrase that the system used for many years to define me. At this time, the only authority I had responded to in life was my father, a lion tamer of sorts. He was gone and I felt vulnerable, exposed. That same year I was placed in an experimental program at the University of Rochester. This innovative program was developed to give an opportunity to unusual students from underprivileged families. Two students each were chosen from a selected number of high schools in the state of New York, students who exhibited a severe rebelliousness and dissatisfaction within the school system yet demonstrated an unusually high intelligence and creativity. Of the sixty thirteen-year-old kids in the program, most were black, since most families that are financially underprivileged are not white, not in America, and certainly not in 1966. I was one of seven white kids chosen for the experiment. Upon completion of the four-year residential program, we would be offered full scholarships to prestigious universities for further studies in our chosen fields.

Some never made it through the program, but for most of the others it was a lifesaver. As an example, one of the students, Leonard, was a fierce and highly intelligent young man. He was very angry inside and mysteriously quiet on the outside. No one had offered him what he really needed, and Leonard didn't know how, or what, to ask for. This program

was the only thing that might help. At thirteen, I honestly had never seen a kid box in the ring or on the street better than I, or who was faster, stronger, or more agile than I, but Leonard was. He wasn't exceptionally large or muscular, was rather skinny, and probably was nowhere near as strong as I. One day I saw him sparring with a much bigger black kid in the dorm hallway. Leonard was so fast, your eyes could barely keep up with the motion of his fists. I thought that this boy could be a world champion if he ever went for it. But help arrived too late: Leonard was imprisoned for murder before his third year in the program, his sixteenth birthday.

In contrast, another student in this experimental program became one of the top defense attorneys in Manhattan. Yet others blossomed into great musicians, artists, scientists, entrepreneurs, and athletes. This was an assemblage of very tough and talented kids, survivors. The experience in that program, to this day, colors my view and dedication to educational missions and curriculum development on all fronts, but particularly for youth-at-risk. For me, this program is what made the difference between creative empowerment and self-destruction. With my father gone and my older brother away at school, there wasn't a male role model to help me through that dangerous passage, and without this program I may easily have joined Leonard in his fate. My anger and pain would not have been redirected and would have gone unattended, unexpressed, and unchanneled, as in the case of a lost champion like Leonard and the lost life of his victim.

Fortunately the program connected me to Peter Vogelaar, a man who would become my counselor. Peter became my mentor and was also an exceptional artist, a very sensitive and strong man physically, intellectually, and emotionally. He was a great friend and helped fill some of the holes, rites, and rituals in my transition to manhood and maturity as an artist. Pete would do funny and interesting things like place a large rock on the floor of his dorm room, not far from the doorway entrance. He did this just to observe who would trip over the rock and who would immediately notice the misplaced object. In fact, that was how we met: "Hey, Pete, my name is Phil Jacobson. I'm in your group. What's that rock doin' on the floor?" But most of all, Peter taught me a great deal about creative empowerment, forgiveness, and compassion.

One day, in the first month of the program, I walked out of the dorm to make my way to the library. The University of Rochester is in a beautiful setting along the banks of the Genessee River. As I walked across the courtyard outside Lovejoy Hall, our residence, six of the black kids in the program started messing around with me. I recognized four of them right away. Two of them were from Franklin High and another two from Madison High. I had seen them on the wrestling teams at competitions I was in. In 1966 these two high schools were the most violent in Rochester and, due to racial tensions, were the first schools to require police officers in the hallways.

All six of them started yelling at me and then urging one of their own to fight me. He was their biggest and best. "Come on, Rufus, hit him, box the cracker's ears in!" shouted one of the boys circling around me. Another snapped, "Hit the motherfucker, kick his ass!" Their champion raised his fists and advanced toward me. I raised mine in defense and

looked at them all and said, "Okay, look, I'll fight every one of you, but one at a time. Come on, goddamn it — let's do it!" My eyes focused in on my adversary. I planned my moves just moments ahead, visualizing cause and effect.

Inside the human boxing ring, Rufus and I gazed at each other, both of us uncomfortable and scared. I could see in Rufus's eyes that he hadn't learned to move his fear into a creative courage and energy, and in that moment, I knew he would lose. We both felt set up, like black and white pieces on a game board, and began moving around each other, each of us trying to figure out the other's technique, to psych each other out. My father, as the professional prize-fighter he once was, had trained me a little; as a result, I was pretty skilled as a boxer. I had also trained in wrestling and judo and had been in a few scraps before. This kid was almost a foot taller than I. At thirteen years old I was barely five feet tall.

The match began, and the shouting from the human ring around us bounced off the courtyard walls: "Kill him, beat the shit out of him!" Rufus started swinging his long, lanky arms at me. His reach seemed almost twice as long as mine. His fists were quick, coming close but missing my bobbing head and body. I saw an opening and took it. I hit him once, very hard, my whole body behind a single, solid punch to his face. Dazed, his legs weakened, he went down and stayed down. He looked up at me, his lip bloody and quivering. He was embarrassed, shocked, and too frightened to get up and continue. I felt sorry for him.

The other boys looked down at their fallen champion, their Goliath whom they had chosen for the mini-race war they had started. Their blank faces soon turned to anger as Rufus refused to get up, and the five of them attacked me. I immediately went to the ground and curled up into a little ball, tucking my whole body in, exposing only my backside and ribs. They pounded my back with their fists and elbows, kicked me in the ribs, spat on me. I silently took the blows, my head curled in underneath my arms. After a little while, they stopped. They started to walk away, and when I looked up to see their expressions, something was different. I put my head back down in case they turned around, even though I could feel that they weren't going to attack again, that somehow they all felt as defeated as their Goliath who had been struck down.

After a few moments I lifted my head up again, and they were gone. My body ached, my bones felt sore, especially my ribs. I walked slowly back to my room, holding my side. I just wanted to go home, leave the program. I was sad, and I thought to myself, "My daddy's dead, my daddy's gone. If he were here he'd kill them all, the bastards. Nobody's here to protect me, everyone's trying to hurt me. I'm all alone." My big brother, Alan, would sometimes visit me at the university on weekends. He'd drive up on his motorcycle wearing his black leather jacket and sunglasses. He would dismount from his Harley wearing a wide grin. He was tough as nails, sharp as a tack, and as handsome as a Hollywood hero. But Alan wasn't around to help me that day and soon would be away at college, and I would be the "man" of the family.

Back in my room I got out my funky suitcase and started pulling my clothes out of my

drawers and folding them. My head down, no longer able to hold back the tears, I began pairing up my socks when Peter, my counselor, opened the door and said, "So you're leaving, huh, Phil? Can't blame you. You know, you could stay and they could go. You have the power now to kick them out of the program. All six of them. They are all in the director's office waiting for your decision. Some of the other students saw the whole thing from their windows. The boys involved all admitted to what happened. Shall we go down there, together, to the office?"

I tried to wipe the tears off my cheeks so Pete wouldn't see them. I thought to myself, "Why did they want to hurt me? I never did anything to them." I remained silent, continuing to pack my clothes, and Peter said, "You know, Phil, I think your courage did something to those boys. I think you changed them. You did something they never expected, saying you'd fight each one of them. It was a creative and courageous act." Peter always made me feel like I had my own power, that my creative abilities affected everything, that being creative in a situation and using unexpected ways to deal with things can sometimes alter what is going on in a positive way. Peter showed me that I didn't have to be a victim in any situation if I tapped into my creativity. His statements, as usual, made me curious. I kept packing, but much more slowly, as I was running out of clothes to fold and I secretly wanted to hear what else he had to say. "Phil," Peter added, "what you did was very brave, and I know that these guys are not *black* to you, that you see differently from them, that they are just 'other kids.' I also know you are hurt and confused right now, but that you understand how good this program is for you and for them."

I finally spoke: "Pete, would you still see me if I left the program? Could we still draw and paint, go fishin' and stuff, drive around in your T-bird?" "Of course," Peter said. "Tell you what — I'm going to go join the boys and Director Shannon in his office. You decide what you want to do: to stay, to go, or have them go and you stay. It's your decision now. You created that space, little big man. I'm okay with anything you decide. We'll wait for ten minutes or so. Catch you later."

I sat on the edge of my bed and wiped the tears from my eyes. I looked at all the drawings PeeWee and I had done and taped up onto our dorm room walls. I loved PeeWee. He was my roommate, my best friend. He was a very talented, young black artist. He was a big kid for his age (thus, his nickname) but was not part of the clique that had attacked me. He would have stuck up for me, even though I was white. But PeeWee was away for several days at a tennis tournament, another of his talents. Actually, I always felt closer to the black kids than the whites. We seemed to understand each other better. Yet these particular black kids, these boys in the program who jumped me when I took their Goliath down, were not fair in fighting. They weren't warriors with a code of honor, the way my father was, the way he taught me to be.

Sitting there, thinking of Pete's words, I began to feel that I shouldn't leave. I knew that being here at this university was so much better than high school. I thought, "I love it here. Why should I leave because of them? I'm staying, goddamn it!" I marched out of my room, down the corridor and stairway to the director's office, slapping a victory beat on the

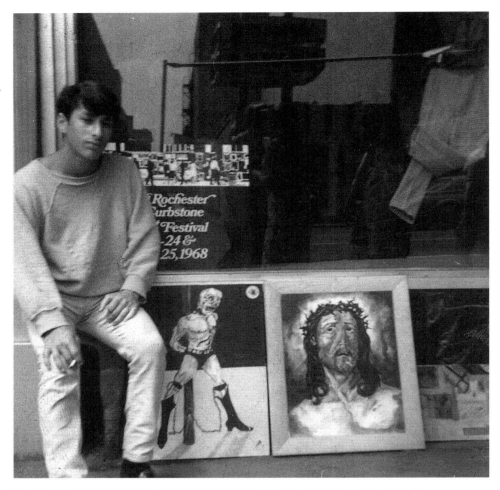

Fig. 2 *Summer 1968, Rochester, New York.* This is the first time my friend PeeWee and I — both from underprivileged families — tried to sell our work at a downtown art festival. The painting on the left — *Chains*, 1968, acrylic and ink on canvas board, 20 x 16 in. — is created from working with the unconscious. My work also became increasingly religious and, although raised in an Orthodox Jewish family, I began to express feelings and images inspired by other wisdom traditions, particularly Christianity, as evidenced in the portrait on the right — *Crucifixion*, 1968, India ink on canvas board, 24 x 18 in. It is painted with ink, and I used my own blood for the thorny crown. PeeWee and I did not sell anything that day, and we went home disappointed, but we continued to paint. Photograph: Jessica Ann Jacobson

hallway walls. The director and Peter were sitting in chairs. Rufus and the five boys who jumped me were standing in a line. Mr. Shannon said, "Philip, it's up to you. Every one of these young men will be expelled from the program on your word. I want all of our students to feel safe here. I also understand that you may just want to leave the program yourself. What do you say?"

I stared at each of the boys who had hurt me. I looked deeply into their eyes, looking right through them, each one of them. They were all frightened and looked vulnerable,

which surprised me. I continued to look at them and thought about it a little while longer, then responded, "I think we should all stay." The black kids smiled at me with genuine gratitude and respect. Peter winked at me. The director nodded his head, his cigar bobbing up and down, signaling approval. The meeting was over. Then the "real" meeting took place.

As I walked back into the courtyard to be alone for a few minutes, I saw the six black kids and their leader, Oscar, who was absent from the event and had had no part in it. As they walked up to me, I thought they were going to jump me again or tell me how they would get me later. But instead they all started patting me on the back, and Oscar (who later became the high-powered Manhattan lawyer) said, "You're all right, Phil, you got some balls on you, boy. Ain't no one gonna hurt your ass again, that means nobody!" Another said, "Yeah, you cool, you didn't kick us out, and not 'cause you weren't afraid, either. You're our man now, we're gonna watch over you, little brother man." Then Rufus came up to me. The blood on his cut lip was dried up now, but his ego was still a little bruised. He extended his hand and said, "Sorry, my man, you one gutsy mothahfuckah — for a little man, you bad. You got a hell-of-a right punch, too. You're okay, we brothers now!" Their stance had gone from attacking me to a promise of protecting me. I saw, in a very elementary way, that they had been hurt and raised to believe that all white people would always hurt them. I understood that I was the first white person who not only didn't try to hurt them, but after being hurt by them still accepted them, even forgave them. Somehow this changed them, opened them to acceptance and transformation. The choice I had been given to expel them, had gone from exiling them, to accepting them, to forgiving them.

These young black men and I became very close friends. On weekends I went home with them, back to their ghetto neighborhoods, stayed with their families, shared their meals, and met their parents and siblings. They did the same thing with me at my home. We were exposed to one another's ethnic backgrounds and cultures, one another's talents and skills, our secret hurts, hopes, losses, and most of all, our dreams. We saw one another's determination to free ourselves from the limiting conditions that life had placed around us, those things that could help or hinder our dreams. I understood these young men, loved them, and they loved me. We became brothers. I had learned something about the transformative power of forgiveness and had gained so much from one creative act.

The deepening of forgiveness is a venture into the inner world of loving-kindness and creativity. It is an expansion of the awareness that you are literally hurting yourself when you injure another, because there is no "other." To hurt another is to hurt yourself; it is like being angry at our own foot if it fails to walk right. Forgiveness softens the way and assures continued progress by letting go of painful resentments. Forgiveness is the creative integration and resolution of conflict between individuals as well as between polarized aspects within ourselves.

When we leave relationships unresolved, unfulfilled, incomplete, that leads to a life only partially lived. We are not only half alive in our unresolved relationships, we are half

dead. Although it is easier for me now to articulate what was happening inside me back then in Director Shannon's office, as a boy I simply felt that I should forgive so that things could continue, be fulfilled, so that we could complete the program.

We have all held onto unresolved issues at one time or another — feelings of being betrayed by friends or by the world — and we have found it difficult to simply let them go. We resist and hold on tightly to the unresolved people who live inside us, the unfinished events, and it seems to take immeasurable effort to soften the tightness inside and regain a natural openness. That day in the courtyard I learned that it is only forgiveness that unloosens the knots of painful resentment tied up inside us. I saw that by being inwardly and outwardly creative, we can transform a situation, we can arrive at a fresh way to see ourselves, others, and the world at large. It would become part of my practice, the essence of my art, and a continuing challenge.

I quit the program in the final year. My mother was very upset and tried everything she could to convince me of the benefit in staying there. But in my fierce adolescent-hippie rebellion, I blew off the scholarships and then had to return to my high school. That year race riots broke out all across America. One morning, as I entered the huge lunchroom at East High, I was stunned. Black kids were on one side of the room, flinging chairs at the white kids. As chairs banged against bodies and walls, the black kids moved across the room and began beating up the white students. I adjusted to the scene, determined to get something to eat. I was hungry, and that was that. I started walking across the massive room toward the service counter, now abandoned by the staff. I walked through the sea of violence as a path was cleared for me by the black kids, even as the chairs flew over my head. The youth in the black community knew who I was. News of the incident at the University of Rochester some years earlier had spread through the street culture, as street stories do, no doubt by Oscar, who influenced the black gangs at both East and Madison High Schools. The word was that I was never to be harmed. I was their brother. Nor would I ever harm them or anyone else because of skin color. On top of all that, my older brother and I already had a reputation on the street. I was the leader of one of the toughest gangs at the school. As the white and black gangs in high schools and in various cities in America went at it, fighting and even killing each other, my order to my gang was to stay out of it. I remained untouched, and so did my gang. Discovering and exercising forgiveness earlier in my life was still affecting me and protecting me years later. Forgiveness is a creative act, for it is the ground for rebirth, positive revolution, and transformation.

During this volatile time, my artwork began to change. The religious and realistic artwork I had been doing had evolved into a surrealistic and mystical imagery around the age of fourteen (see Fig. 2). I had not even heard of the word *Surrealism*, nor the name of Carl Jung, yet images repeatedly floated up from the depths of my unconscious and found their way to the canvas. Some of this imagery blended the violence of my outer world with the turbulent upheaval of my unconscious. I soon became aware that my art was a kind of hidden visual language. Independently, I began to see that art could be used as a psychological device to unveil awareness and the symbols arising from within.

TRACKING THE INVISIBLE TRIBE

Although I had left the experimental program at the university, I was still offered scholarships to various institutions of art, but after examining them I felt they were lacking something. My intuition told me that an academic setting was not the best way for a young artist to learn about art. I had discovered that art schools and art departments, at least in the early 1970s, did not offer a means to obtain my particular goal. They taught you or, rather, told you *what* to paint instead of *how* to paint. I knew I wanted to obtain the knowledge of the Old Masters in painting and already knew what I wanted to paint but could not find any formal school or university in the United States that offered a program to meet my needs. It also seemed to me that the realm of contemporary art had been circumscribed and subverted until it served only a blind self-interest, motivated more by a materialist philosophy than a spiritual one.

My gut feelings told me that I should learn more about human nature, the nature of a master artist, and the nature of myself. I concluded that the only way to learn the secrets of the Old Masters was by studying restoration and conservation techniques at the Metropolitan Museum of Art in New York. In 1971, I was accepted by the museum for the eight- to twelve-year training program in conservation. But when the time came to go, I decided not to, realizing that I wanted to study the Old Masters only in order to apply that sophisticated technical knowledge to creating my own original work as an artist. Eight to twelve years in conservation was too long. Still, I believed that the visions and feelings I wanted to share required a refined and meticulous technique of painting. I wanted to experience and learn about the world by studying with a visionary master of art — but who, and where was a master to be found?

In 1972, the world was still a strange and chaotic place that bore little resemblance to what I had learned through self-study or in the classroom. It was a world characterized by war, civil riots, sexual ecstasy, tribal love, seething unrest, and an electronic culture gone mad. It was also an environment colored by the strange enchantment of mind-altering drugs, by occult murmurings, by sciences and literatures never touched upon in the classroom. Another year passed and I continued to teach myself the art of painting. Although many people praised my work, I remained frustrated, impatient, stumbling onto knowledge through self-study, producing dozens of journals and notebooks.

My frustration was counterbalanced by an immense freedom in experiencing life. I had been very independent, particularly after taking on my father's role to some extent after he died. I had also taken a common-law "wife" after my father's death. That is, when Marta Lee Leone and I first looked at each other, although we were both only thirteen years old, we were in love. Marta, my girlfriend, my boyhood-to-manhood love, and best friend, spent more time at my house than at her own home. We were so in love, our parents were more inspired than upset by our union. For nearly ten years, Marta would share her love, incisive perception of human behavior, and secrets of Nature with me through her own affinity with the natural world. Her father also died when she was still

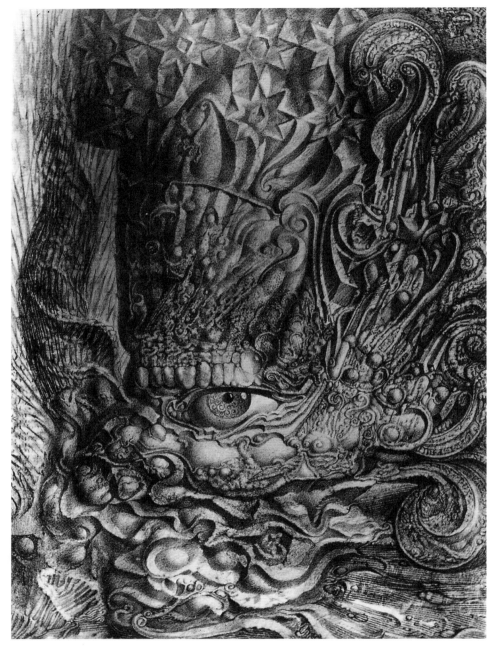

F<small>IG</small>. 3 Ernst Fuchs, *Cherub Like a Rhinoceros*, 1962, pencil, approx. 12 x 10 in. Private collection

in her adolescence, and this mutual tragedy brought us even closer together, and we comforted each other. Above all, Marta opened me up to accepting my gentle, childlike qualities as well as my power. She was beautiful in all ways and accompanied me on my trip to Austria, sharing adventures and providing me with encouragement. Her assurance

that there was great potential in me, as an artist and even in my youth, added greatly to my confidence.

First seeing the work of Ernst Fuchs in 1972 is one of the most indelible memories I have, yet I do not believe I can *really* describe what happened to me in the moment that I first saw his art. Flipping through the pages of the magazine that showcased his etchings had a hypnotic effect on me. I immediately felt connected to the work and the man. It was as though some long-forgotten memory had erupted from a darkened room inside me and burst into the light of day. The overwhelming feeling of being drawn to his work, to him, and to his knowledge was more than magnetic — it was unquestionably essential. I had to meet him, connect with him, study with him. It was something that became an intense longing, a mission that had to be fulfilled immediately. The whole force of my life poured itself into this mission!

The "Fantastic Realists," the group of artists to which Fuchs belonged and which he organized, began receiving international acclaim, as well as controversy, in the early 1960s. The controversy began over whether or not Fantastic Realism was merely a resuscitated Surrealism, and it continued with their touring exhibition to America in 1966. Ernst Fuchs was one of the few living artists possessing the knowledge of the Old Masters, the knowledge I thirsted for. This knowledge had nearly died out with the Industrial Revolution, the artistic light of the guilds dimming as the wheels of industry ran over what was left of the master-apprenticeship tradition. Yet here was Fuchs in possession of this knowledge and, as well, he was using this knowledge of painting to express the human spirit and the journey of the mystic.

So, in the late spring of 1973, my friend Matthew Raisz gave me $160 for the round-trip ticket that enabled me to go to Austria. My older brother Alan had introduced me to Fuchs's work via the magazine *Avant-Garde*, Issue 9, November 1969. Alan was a wonderful teacher. He was brilliant, passionate, and was a great resource and comfort to me in my adolescence. When he handed me that magazine, neither of us knew that he was handing me my future, the beginning of a fantastic journey.

On arrival at the seminar in Austria, I totally surrendered to Fuchs's knowledge and guidance. I was able to do this without giving up or losing my discernment, my self. Fuchs had a remarkable ability to awaken artistic knowledge and creative energy throughout all the layers of one's being. This did not appear to be a conscious effort on his part, but it was inspired by his presence and was especially pronounced while he was working at the easel or telling stories. At one particular seminar he taught, among other things, the Old Masters' "mixed technique of egg-tempera and oil-resin painting."[2] This was the technical method employed by the old Flemish and German painters, such as Hubert and Jan van Eyck and Albrecht Dürer.

During the seminar I stayed at a pension-farm named Flackl, which for many generations belonged to a family by that name. The first artist I would meet there was an Austrian named Wolfgang Manner. Wolfgang was a commercial artist, a mountaineer, and an assistant to Fuchs during the seminars. We became very close friends. More than ten

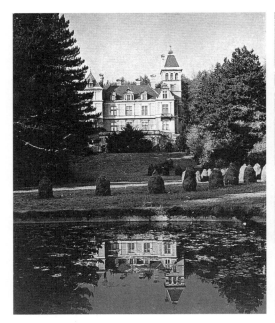

Left: FIG. 4 *Reichenau, Austria, 1973*. A view of Castle Wartholz. Wolfgang Widmoser and I painted in the high tower. Fuchs painted in the room adjacent to us. *Right:* FIG. 5 *Prein, Austria, 1973*. I bought a funky, old coat and hat to keep me warm as the Austrian winter approached.

years my senior, he was like an older brother and a mentor to me. Later, we went on a number of trips together, including the US and England. He was married to Gerti Flackl who helped her brother Freddie run the family business. A sweet and loving woman, Gerti mothered and looked after me. In time, all the artists would congregate at Flackl in the evening hours to eat, drink, and hear fabulous stories and gems of knowledge from Fuchs.

Through my immersion in Visionary art, I began to see history no longer as a meaningless façade of facts and artifacts but as a living alchemical formula, a symbolic calculus, a mystery play enacted by the collective human psyche on a planetary stage, and a contributing influence on the present. At the same time, divisions between mind and body, intellect and creativity — divisions I had always accepted as rigid and absolute — suddenly seemed flimsy, fluctuating, and arbitrary. There was nothing to stop me from going beyond them. I was compelled to transcend, to move with the urge to love infinitely, without bounds, beyond this flesh but in this very body. I was determined to fulfill these urges through the creative action of art.

… Only a person who participates in spiritual life has an impulse for a creative activity transcending the merely natural. Otherwise, where would the impulse come from? In all ages the human souls in which the artistic element flourished have had a definite relation to the spiritual world. It was out of a spirit-attuned state that the artistic urge proceeded. And this relation to the spiritual world will be, forever, the prerequisite for genuine creativity.
— Rudolf Steiner[3]

My basic artistic problem at this time was achieving a marriage between the psychic impulse and the technical skills required in the art of painting, which eventually came to me through self-study and apprenticeship to Fuchs. Combining *psyche* with *techne* enables the painter to communicate the underlying mystery of our world and our individual personalities. For me, the transformative experience is never only a one-time total completion; it is always a beginning and ending and a new cycle of birth, life, death, and rebirth on an increasingly new and more evolved threshold.

Examining the differences in the artwork I produced in 1972 compared to 1973, the year I began studying under Fuchs, is mind boggling. It is as though hundreds of years in the practice of painting had transpired in the first few weeks I spent at Castle Wartholz (see Fig. 4). The incredible thing about it is that Fuchs had barely uttered ten words to me in that first month. There seems to have been some process of artistic osmosis taking place or a reawakening of forgotten knowledge. However, the teachings did not always come with ease or lack of embarrassment. Being full of fire and energy, a problem at the time was with my lack of patience and discipline. In the first few weeks of my studies, I couldn't sit still, or stand and paint, for very long before I needed to be physical and play: run, throw Frisbees, climb mountains, wrestle, chase the female artists and so on. Recognizing this, Fuchs responded to my need for help. I approached him and explained my dilemma, and he said, "Go get your drawing pad, some charcoal, and pencils and return right away." Without question I ran and got my materials as quickly as I could, leaping up the castle stairway to the tower where I painted. I flew back down the stairway, my eyes just catching and hooking onto the fantastic works of art along the walls. I was so excited, and I thought, "Yeow, *yeow!* I'm going to get special attention!" So, having returned to my teacher, I was ready and must have looked like an eager husky puppy. "Okay, all set, Master," I said. "Good," Fuchs said. He spoke in a hurried, inspired, and exuberant tone: "Very good. Now, take your materials and quickly go. Run to the woods and keep running! As you run I want you to do nature studies. While you are running, draw as many trees as you can and bring the results back to me." Then, smiling with that biblical and fatherly grin, he said, "Go, run, run, run!"

So I ran. Wiry, young, strong, and fast, I was out the castle doors! Running, my feet barely touching the ground, around the back of the castle, down the stone stairway, across the field to the woods. Then among the trees, still running and preparing my sketchbook. Running and opening the pages of my sketchbook, shuffling my pencil to my fingers. Running and looking at the trees passing by, trying to draw as I ran. Then I stopped. My mind went blank for a moment, followed by a wave of shame. "How dumb," I thought to myself, "I'm so stupid." Embarrassed for a moment, I then exploded with laughter. Falling to the ground, I laughed so hard I had to hold my belly. I did not walk back to the castle. On this particular day, with the help of Ernst Fuchs, I had realized and acquired a new admirable quality and space within me. I had found a source of discipline and patience, by running away from my "center" as fast as I could.

I slowly made my way up the hill to Gasthof Flackl, where I had a shot of "the

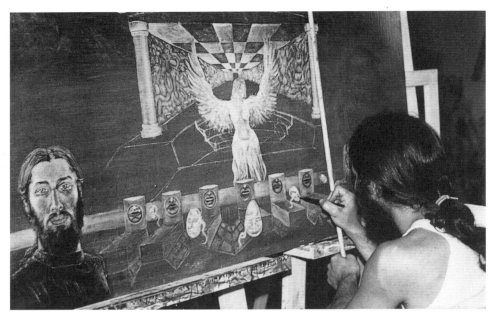

FIG. 6 *Castle Wartholz, 1973*. I tried my hand at a larger painting. I was working on the underpainting for *Sheet from a Dream* (see Fig. 23), which initially was rendered in a monochromatic, egg-tempera white on a dark red, resin oil–covered ground.

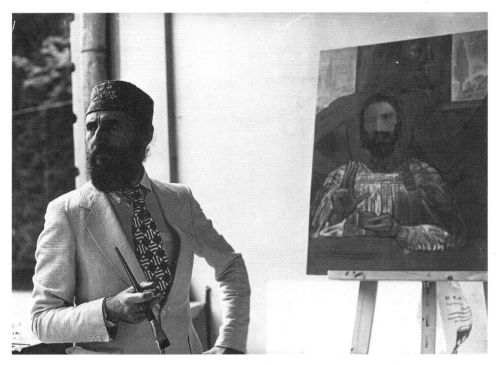

FIG. 7 *Ernst Fuchs painting outside Castle Wartholz, 1974*. The photograph was taken by Herbert Ossberger, artist and former student of Ernst Fuchs.

cherries" (homemade mountain schnapps) with Freddie, the owner of the historic pension. I kicked back and thought about the day as it sank into a living painting by Frederick Church, a sunset imported from the Hudson River Valley of my home state. The sky, spreading like a luminous blanket over the peaks of the Austrian Alps, soothed my untamed heart and encouraged me to recognize the abilities increasing in my steady hand.

In the past there have been many painters whose eyes were focused on the outside world, while others strived to externalize inner visions; on rare occasions there have been artists who were visited by higher orders of reality — a phenomenon still rejected by scientists, as it cannot be witnessed in physical or sensorial terms.

These earnest ones may be informed of my conviction that art is the highest task and the proper metaphysical activity of this life …
— Friedrich Nietzsche[4]

Unfortunately most art critics are influenced by the eye of science more than the eye of spirit. This general attitude has, in the business of art, affected the life of the *artist as mystic* in a dramatic way, maybe even making artists' lives miserable but never stopping them. Art historians have linked the Vienna School of Fantastic Realism to the Surrealists, although there are differences so profound as to have given birth to an international family of painters more spiritually grounded yet forged in spirit, creating subgenerations of Visionary and mystical artists. Historically, in relating the Surrealists to the Fantastics, we do find an obvious link as mother and child. In the early 1980s, the curator, Michael Bell, referred to Fantastic Realist painters as working in a Veristic Surrealism.[5] The Vienna School of Fantastic Realism, although having a number of artists on the fringe, is truly embodied in Arik Brauer, Ernst Fuchs, Rudolf Hausner, Wolfgang Hutter, and Anton Lehmden. They dared to restore poetry to painting, revealing art and concealing the medium. This began in the lean years following World War II, when Austrian art had almost ceased to exist, save for a few elderly practitioners of Post-Impressionism and a certain teacher, Albert Paris Gutersloh. The oldest of the five students of Gutersloh, Rudolf Hausner was the first to be initiated. At the age of thirty-three, Hausner returned to Vienna with the courage to swim upstream. Most of his contemporaries were beginning to imitate the latest abstract vogues, but Hausner kept faithful to his inner promptings, mining through a world of personal vision.

All five of the Fantastic Realists used what the critics referred to as "antiquated" techniques. In contrast, I refer to this as the secret knowledge of the Old Masters. The Fantastic Realists were not escapists. They did not pretend that they were living in the fifteenth or sixteenth century. They were not an Austrian version of the Nazarene (the German Romanticists in Rome) nor the Pre-Raphaelites' brotherhood, who simply, and romantically, ran away from the Industrial Revolution and all it implied. Quite the contrary, these five experienced the terror of the Nazi period in different degrees, and the melancholy beneath the glittering façade of the post-war Austrian republic can be felt in

their artistic endeavors. In the early stages of the group's work, a nightmarish quality pervaded a landscape full of tanks, death, planes, apocalyptic visions, and cosmic prophecies with a tragic content. Yet, of the five, it is the work of Fuchs and Brauer that moved through the horrors of World War II and the dark night of the soul, transforming into the most astonishing paintings of beauty, light, revelation, and "upliftment." The work of these two expanded into a starry mansion that included angels, nymphs, and magicians because they have existed in the human experience and mind throughout the ages. They used allegorical themes from the Old as well as the New Testament and from the Kabala, because religion, in the broadest sense of the term, was a major inspiration for them.

Except for Hausner, Fuchs and his colleagues were still teenagers when the Third Reich collapsed. Brauer, a Jew, had not escaped subjection to slave labor. Ernst Fuchs was deported to a transit camp for children of mixed racial origin until his parents agreed to a formal divorce saving their son from the extermination camp. Later his father had to flee from Europe. Brauer, Fuchs, Hausner, and Lehmden met after the war at the Vienna Academy of Fine Arts, where they were students of Gutersloh, a man of Kokoshka's generation. Later, Hutter would join the others.

Like Gustave Moreau, Gutersloh also encouraged his students to develop their own individuality instead of imitating their master. Gutersloh instilled in his pupils an appreciation for craftsmanship, knowledge of the Old Masters, and an ability to render the minutest detail. Those familiar with Gutersloh's combination of matter-of-fact realism and imaginative whimsicality may detect his influence in the works of Brauer, Fuchs, Lehmden, and Hutter. Gutersloh is not well known in the United States, although there is a hypnotic portrait of him by Egon Schiele in the Minneapolis Institute of Art.

He who by reanimating the Old
can gain knowledge of the New
is fit to be a teacher.
— Confucius[6]

However, the credit for restoring the knowledge of the Old Masters of painting must go to Ernst Fuchs. In 1946, Fuchs was already researching and experimenting in the resuscitation of techniques employed by the old icon painters and the Dutch schools of the Renaissance and earlier. In fact, on a recent visit to Fuchs's studio in Monaco with a few of my students, Ernst responded to my inquiries on the subject and stated that Gutersloh was very good at alla prima painting but taught him nothing on the mische (mixed) technique. Ernst related that his intensive self-study was confirmed and enhanced by encounters with two painters he had met. The first painter, an Italian named Pietro Anagone, was working in a mixed-technique when Fuchs met him in Paris in 1950–51. The second artist was a Lithuanian Jew named Max Bussie whom he visited in 1957. Fuchs met Bussie in Israel while traveling.

The two encounters with these painters were very brief but served to confirm the

investigations and research Fuchs had begun years earlier. Fuchs's initial research was inspired by the accounts reported in Max Döerner's book on the methods and materials of the Old Masters. There is no question that it is Ernst Fuchs to whom artists are indebted for the revival, the virtual resurrection, and dissemination of the knowledge and techniques of the Old Masters. On this recent visit in Monaco, Fuchs also took out a magnificent sword (used as a prop for a recent painting) and took a few steps as a warrior-king. Turning round, he called me over. I knelt on one knee. He raised the sword, tapped me on each shoulder, and dubbed me "Sir Levi-Strauss." I was charged with creating, directing, leading, and preserving the knowledge of the Old Masters and Visionary lineage through creating a museum and academy. But, back to a brief history of Fantastic Realism and the Old Masters.

On their world tour in 1966, the five Viennese artists of Fantastic Realism were greeted with enthusiasm in some quarters and heavily rejected in others. I will discuss resistant attitudes toward the artist as shaman, mystic, visionary, and prophet from a number of angles throughout this book.[7]

The masters to whom the five Fantastic Realists are most indebted have been dead for centuries: the great practitioners of Flemish, German, and Venetian painting, who are more richly represented in Vienna's Kunsthistorisches Museum than in any other institution in Central Europe. They include Jan and Hubert van Eyck, Dürer, Brueghel the Elder, Bosch, Grunewald, Leonardo, Titian, and certain Baroque painters. Having so much in common, the five young Austrians decided to organize a formal group. Galvanized by the fervor, fire, and pioneering energy of Fuchs, their path began to blaze. They comprised the first wave of artistic spirit to rise from the dried blood of World War II. Each of them would spawn notable artists in the decades to follow. Beginning with Gutersloh and his students in the late 1940s, the lineage of informally organized mystic Visionary artists has been expanding and, with a few exceptions, continues to be ignored by the contemporary art scene, thus my coining of the term *the Invisible Tribe*. Strangely, even the most renowned contemporary artists and critics are often ignorant or in denial of such a lineage of knowledge and mysticism in art. Contemporary art history books rarely, if ever, mention the Vienna School of Fantastic Realism and many of the other great Austrian artists, such as Friederich Hundertwasser.

This was exemplified to me when the internationally renowned artist, Francesco Clemente, came to the university where I worked in the summer of 1994 to take part in honoring his friend, Allen Ginsberg. Emily Hunter, a former board member, had envisioned and organized the now historic tribute to Allen, the great poet and political activist. As the dean (1991–97) and founder of the new School of Continuing Education at Naropa University, it was one of my responsibilities to oversee the entire general operation of the summer session, and it was in that role that I first met Ginsberg. I have always felt fortunate to have known Allen. He was a generous, kind man, a tireless worker, a genius-poet who imbued his performances and readings with an energetic balance of humor and poignancy. During the tribute to Allen I had the opportunity to spend some time with him and Clemente.

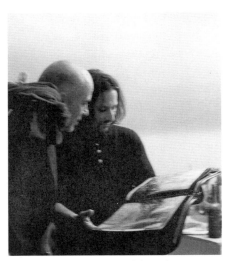

On one of the afternoons of the conference, I accompanied Ginsberg and Clemente to Denver, where they were to give a public talk at the Denver Art Museum. Emily had rented a white stretch limousine to shuttle us from Boulder to Denver. My wife Sandra attended, and I had invited Cydney Payton, director of the Boulder Museum of Contemporary Art, to join us. On the way, the extravagant and spacious interior of the limo provided a surreal backdrop for the ensuing metaphysical conversation between Clemente and me. I began to talk about art and theosophy. Surprisingly, Allen was not aware of the theosophists, but Francesco was and he became excited as we discussed mysticism, Madame Blavatsky, illustrations of "thought forms" documented by Leadbeater and Besant, and other information I had to share from a variety of rare books, supplied by the amazing Dr Wilson Wheatcroft. I loved Francesco immediately. As the conversation continued, I mentioned my studies with Ernst Fuchs, our lineage of mystic artists, the handing down of knowledge from the Old Masters through Gutersloh and Fuchs, our Tree of Vision. Clemente became disengaged and dismissed my artistic heritage and knowledge, not accepting anything I had to say in this regard. In addition, Francesco emphatically stated that art cannot really be taught and that all knowledge of the Old Masters was lost without hope of recovery.

I invited Francesco to come to my campus studio the next day. Francesco arrived with Allen Ginsberg, Gelek Rinpoche, and an entourage following the three of them around campus. It was a tight fit in the formerly unused, tiny attic space I had converted to a makeshift studio on campus. Showing Francesco my work, I explained one of the painting techniques of the Old Masters that Fuchs had taught me. Francesco was intrigued with a recent painting I had done of my co-worker and dear friend, Mary Jane, shortly after she had been in a car accident (she is just fine now). The painting, *Mary Jane*, 1994 (see Plate 1), was a very raw, intensely psychological piece, executed in the mixed technique of egg tempera and oil resin that Fuchs had taught me. Francesco, an amazingly sensitive artist, quietly absorbed all this. A little embarrassed by his hard statement and position on the previous day but with a slightly curious smile, he was intrigued by what I had shown him. I gained from his response, comments, and encouragement, and I believe Francesco Clemente had gained as well. He discovered that the knowledge of the Old Masters was alive and well. He saw that there are contemporary artists out there using this knowledge and that they are connected to each other through a mystic lineage, a family formed in spirit.

Why has this been a secret? How had the transpersonal artists become an Invisible Tribe? Perhaps, to some extent, it is because the artists themselves have not written about

Fig. 8 Jim Harter, *Regeneration*, 1998, collage, 8 x 11 in.

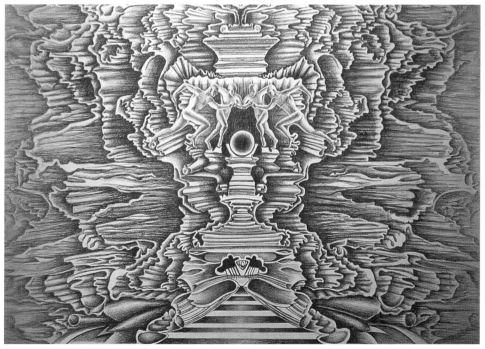

Fig. 9 Olga Spiegel, *Running*, 1977, lithograph, 22 x 28 in.

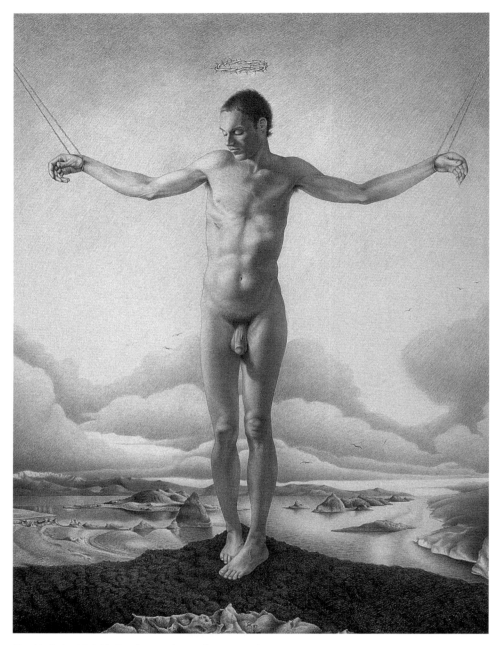

FIG. 10 Carlos Madrid, *Crucifixion*, 1996, graphite on Strathmore paper, 54 x 36 in.

their experience. After all, most contemporary visual artists hesitate when asked to write about their art. The tradition of verbal shyness inherent in their craft creates a difficult bridge to cross — the medium of the image on one side and that of the word on the other. Indeed, if Ken Wilber, the Einstein of consciousness research, whom I will refer to several

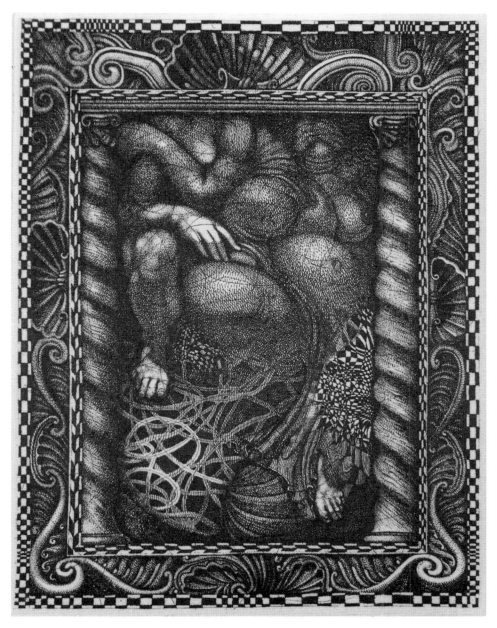

FIG. 11 Daniel Friedemann, *Fountain of Venus*, 1977, etching, approx. 20 x 13 in.

times, had not encouraged me to finish this book, I probably would have joined the silent ranks of my peers. Ken has become a dear and trusted friend, and the essence of some of our conversations has weaved its way into this book.

The genealogy and history of the "artist as visionary" is beginning to be addressed but by relatively few art historians and usually from outside the mainstream and academic

world: Michel Random of Paris in his two volumes of *Le Art Visionnaire*; Michael Bell in California; Ramon Kubicek of Vancouver in his book *Art as Healing*; the collage artist and writer, Jim Harter (Fig. 8); Christian De Boeck in South Africa, who has cataloged hundreds of creative mystics; and others in western Europe, Australia, and Japan.

In any event, the spawning of these transpersonal artists has been mysterious, suggesting a positive spiritual conspiracy of subcultural light being disseminated and orchestrated from some higher order of reality. This activity, although occurring in the arts for centuries, has recently taken on a significant boost. A spiritualized force and momentum was initiated through the auspices of Ernst Fuchs and later propagated by some of his own students. The characters involved should not be confused with the California movement of Visionary Art as endorsed by the commercial publisher, Pomegranate Publications, or the early owners of Illuminarium Gallery in Mill Valley and its later owners in Florida, or Gallery Imago in San Francisco. Although the tendency toward New Age commercialism in Visionary art does seem stronger in that part of the country, California has produced some outstanding mystical and surreal artists, and some of them have been inspired by our lineage. Gage Taylor, Valerie Vickland, Cliff McReynolds, Gilbert Williams, and the brilliant California artist, Clay Anderson, had never even met Fuchs directly, although most are aware of Fuchs's work. A group of artists, with whom Sandra and I associated from 1986 to 1988 while living in Flagstaff, called themselves the Arizona Visionary Alternative. We showed our work together in several exhibitions held in Phoenix. They had a number of members, such as Carl Helbing and Sybil Erden, who were strong painters.

Over the years, while teaching seminars, creative mystics are discovered, returning like wayward spirits of the Invisible Tribe, like lost children returning home to the Visionary Lodge. Often they arrive already in an inspired state with advanced technical accomplishments, an original vision, and come to gain the secrets of the Old Masters and to reconnect to their lineage. Two examples of this can be seen in the artists Cynthia Ré Robbins (Fig. 31 and Plate 33) and A. Andrew Gonzalez (Fig. 43 and Plate 32). Cynthia first studied the painting techniques of the Old Masters with Robert Venosa and then with me at Naropa University in 1994. She came to Castle Kuenburg in Austria just this past summer of 1999 to work with me once again. Gonzalez also attended this seminar for the first time. They, along with all the other attendees, also came to meet Michael Fuchs, Brigid Marlin, and of course, DeEs Schwertberger, Wolfgang Manner and Ernst Fuchs. They are just a few of the many emerging artists in this tradition.

Alex Grey, a New York artist with a powerful vision, has always been a brother of the "fantastic" lineage. Although quite aware of Fuchs and many of the Fantastic Realists, he had met Fuchs only a few years ago, when they exhibited together in a group show of Fantastic Art held in Venice, Italy. Alex has been more directly influenced by the Russian artist, Pavel Tchelitchev. Alex has grown to become a strong voice in the choir of mystic painters. The contemporary mystic lineage springs from all five of the Fantastic artists, but herein I will address only the branches of Fuchs's tree, and even then it is but a sketch. All the artists whom I cannot mention here will have to forgive me, as there are so many, and

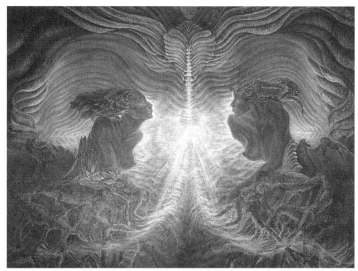

◀ FIG. 12 Sandra Reamer,
Reflections, 1980,
egg tempera and oil
on panel, 48 x 58 in.

▼ FIG. 13 Mati Klarwein,
You're Next, 1979,
egg tempera and oil,
63 x 63 in. Private
collection, Paris

FIG. 14 Michael Fuchs, *Self-Portrait*, 1976, egg tempera and oil on canvas, 25 x 19 in. Private collection

this is not a historical survey per se. (For a more detailed rendering, see the website for Christian De Boeck from South Africa.) To name just a few of some of the notable former students of Ernst Fuchs, now artists in their own rights: his former wife Eva and sons Johannes Elis, Daniel Friedemann, and Michael Fuchs, DeEs Schwertberger, Mati Klarwein, Robert Venosa, Isaac Abrams, Linda Gardner, Wolfgang Manner, Suzanne

Steinbacher, Clayton Campbell, Hanna Kay, Sandra Reamer, Brigid Marlin, Olga Spiegel, Wolfgang Widmoser, Herbert Ossberger, and me.

Fuchs's second son, Daniel, whom I just mentioned, is an extraordinary character. As an artist, he has studied numerous techniques and media and mastered all of them, and I have a great admiration for such versatility in both style and technique. Daniel studied with his father but did not stop there and went on to study painting in Munich with Professor Marc Zimmerman and in Vienna with the esteemed artist, Wolfgang Hutter. Under his belt, tucked away, ever ready to be grasped by his able hand, are techniques of painting that run from the Renaissance to the Baroque. He has studied the old ways, from etching to mosaic methods in the tradition of Italy's school of Spilimbergo; from *al fresco* murals to sculpting Carrara marble, the stone favored by Michelangelo himself.

FIG. 14A Wolfgang Manner, *The Calendar*, 1974, egg, tempura and oil on panel, approx. 36 x 24 in.

Daniel's vision defines a dream realm where bizarre elements are juxtaposed in a metaphoric language. There is truth in the strangeness, and upon closer examination the classical Greek figures, the baroque quality of his brush application, and Judeo-Christian themes all blend together to reveal the Great Mystery rubbing up against human desires, aspirations, strength, and frailty.

Numerous others from all over the world have benefited from either brief or more extended study and encounters with the master's master, artist Ernst Fuchs. Among them are H.R. Geiger from Switzerland (as well as being an artist, Geiger created the alien creature for the *Alien* series of films), Franz Bayer, Gottfried Helnwein, Helga Herger of Austria, the precocious Marin Kasimir of Germany, Carlos Madrid of Peru, Takahashi of Japan, Dr Ilan Kutz, Jacov Gildor, Hanan Milner, Sylvi Sani, and many other Israelis, artists from Russia (Fuchs recently had a major museum exhibition there), and others from Europe.

Although Fuchs found it increasingly difficult to find the time to teach, and the seminars at the Castle Wartholz ended (1972–74), he has taken on a few students since that time. The artist Sandra Reamer lived and studied at Fuchs's museum and home at the Wagner Villa from 1984 to 1985. The American, Joseph Frederick Askew, has been assisting

and studying with Fuchs for years and resides near Fuchs's villas in Castillon-la-Bataille near Monte Carlo on the French Riviera. Joseph and I have discussed starting an extension of the school and seminar I have been running in Payerbach-Reichenau. Others flock to meet Ernst Fuchs at his villa-museum in Vienna, and I am always hearing reports on the transformative experiences that occur even from their brief encounters.

TAXI TALES AND TEACHINGS

I have dramatic memories of my time studying with Fuchs at the castle in the Austrian countryside and in the old city of Vienna. Events such as a clash with underworld figures and the black market alternated with animated conversations among artists and intellectuals. Romances and characters on the edge of life at Café Havelka mingled dream-like with the reawakening of unconscious knowledge. Latent powers of the artist as mystic were rumbling to the surface within me.

Fuchs has had several wives and at least sixteen children. His son Michael, a year older than I, is an accomplished painter and draftsman. During my studies with his father, Michael and I quickly became good friends and brothers in art. Despite the apparent chasm between his traditional Catholicism and my eclectic and mystical views, there is an unconditional love and acceptance between us. This undefinable bond is the glue that, in spirit, over more than two and a half decades, has kept us together in mutual support and recognition. Our actual contact has been interrupted by long periods of time, and an ocean of distance between us has never seemed to hinder our bond.

On my first night in Vienna, after moving from Castle Wartholz in the countryside, I was with Michael and his friend Rocky, an American musician who played at the local bars, and Michael's girlfriend, Susie Steinbacher, a student of Rudolph Hausner. We had been out dancing at a local bar, where we had met up with two artists, Alex and Lee. They had just come from Salvador Dali's estate in Spain, where they had made jewelry in joint projects with the great Surrealist master. They were now assisting Fuchs in a sculpture project and lived upstairs from me in Fuchs's studio in Vienna. They were the most beautiful and handsome men I had ever seen.

After an intense evening of dancing, Michael, Susie, Rocky, and I caught a taxi home. Michael became angry as the cab driver sped recklessly through the dark and narrow streets of Vienna. He shouted at the driver to stop the car immediately. The taxi driver finally came to a screeching halt after bantering with Michael. Michael again shouted at the driver and in a state of rage flung the car door open, grabbed his girlfriend's hand, and, strangely, ran off. Rocky and I, abandoned and bewildered, were left in the back seat. Michael was already doing well financially as a talented young portrait painter, but Rocky and I were just two young, hippie Americans, broke and enthusiastic. We looked at each other and said simultaneously, "Do you have any money?" We both shook our heads, no. The driver turned to us, yelling in German, pointing at the meter. We said we were sorry and tried to explain that we didn't speak German and had no money, but to no avail. The driver got on

the radio, and we got out of the car and ran! Rocky was a big man, six foot three and husky, a good man to have with you in a threatening situation. As already mentioned, in my teenage years I was a gang leader (although gangs in the mid-to-late sixties were dramatically different from those of today, with confrontations involving words and fists, not the bizarre, cowardly, and sick phenomena of gang banging, assault rifles, and drive-by shootings). What followed was a very dramatic and important piece of my education. During our "orientation" of Vienna at the bar, Michael had explained to Rocky and me that the taxi services in Vienna were a front for the black market, drugs, loan-sharking, and prostitution rings in the underground.

At this point, Rocky and I walked, aimlessly, down the empty, dark, and unfriendly streets. We turned a corner and a dozen taxicabs screeched to a halt right in front of us. The same occurred behind us. The first wave of about seven men walked toward us. I said to myself, "Shit, we're dead. Maybe we can take five of them." Although I had met Rocky only that night, in that moment I knew this guy had been in some scary situations before, too. There is that unmistakable look that daring men share, young or old, in dangerous moments — a locking and union of the ancient warrior's preparedness — and it is recognizable in their eyes. In the silent strength of our connection, and with no way out, we waited, back to back. Soon we were surrounded and attacked.

Harsh German words filled the air, and we were dubbed the *Größe* and the *Kleine* (the "big" man and the "little" man). We defended ourselves very well. I was attacked by two large men. I lifted one man clear off the ground, over my head, and threw him against a nearby stone wall, turned, and knocked the other one out cold. I looked over to check my comrade-in-arms, and two men were unconscious at his feet, while he was boxing with a third. Rocky had a knockout punch, and he never missed his mark. His large fists seemed to rain down from the sky, pounding like Thor's hammer on his adversaries' heads. At that moment, it looked like John Wayne had fallen out of a movie fight scene, dropped LSD, and kept on swinging. Rocky was a gutsy musician who sang folk songs in a deep, resonant voice that melded the likes of Dylan, Taylor, and Feliciano. I looked more like a little, Rasputin-faced, Bowery boy at the time. We had almost deflected the full attack when I looked down the street and again heard screeching tires. "Rocky, run!" I screamed, as I saw more taxicabs and a gang of men approaching us. Some had tire irons in their hands. Rocky was so engaged in his real-life John Wayne movie that he didn't seem to hear me. I yelled at him again, "Let's get the hell out of here, there are too many!" With the mob almost upon us now, I turned and ran. As I made my way around the corner, I heard a series of loud and deep screams. It was Rocky's voice: "Help! Help me!" and then a long, drawn-out, and fading "H e l p." I stopped, hesitated, and thought, "Goddamn it, I can't help him now. He must be dead — killed — and I'll be next."

It was about 2 a.m. I resumed running aimlessly, not knowing where the hell I was. The streets were empty, dark, and unfamiliar. I was frightened while running, scared and thinking it out, imagining my capture and then being at the bottom of some river with my feet in cement. I could hear cars racing behind me, brakes screeching, and many

footsteps running after me. I turned down the very next street, and there before me was a sixteen-foot wall, a dead end. There were some cars parked toward the end of the alley, near the wall. With seconds left I hid my body behind one of the cars. I heard footsteps, heels against the wet skin of the pavement making a slapping sound. Gazing underneath the vehicle I could see the legs and feet of about six men walking toward me. My heart was in my throat. My adolescent mind conjured up the legendary ghost of my prize-fighter, war-hero father as I wondered what he would do. "I cannot run by them, and I won't lie down and let them drag me away to die. I'll try to scare them!" I thought, knowing they had seen me lifting their comrade over my head and flinging him through the air. I saw the amazed looks on their faces at the sight of a short, wiry kid doing that. They were on the other side of the car now. My presence still undetected, I sprang to the hood of the car that was hiding my body, banking on the element of surprise. I screamed out my best Bruce Lee imitation, struck a martial arts stance, and prepared to pounce like a lion. They were startled, but I noticed that their eyes were not threatening. They stared up at me, slowly moving closer. My tense muscles relaxed, and I lowered my arms as I saw sympathy in their eyes.

I was scared but ready to fight. The enemy looked almost gentle. Two of the men motioned for me to come with them while they kept repeating, "Kollege, kollege, kommen mit." They looked almost sad. "Collaygee," I thought, "What the hell does that mean? Ah, *colleague*, friend, pal. Shit, Rocky's dead, and now they are going to kill me, too! Or maybe he's hurt bad and they are being sensitive and want me to help. What do I do?" I came down from the hood of the car. Now they had a hold of me, with several more men behind and in front of me. I thought this was my own funeral procession and said to myself, "Should I run, try to make a break for it or do a quick judo move, and sprint? No, one of them, at least one, probably has a gun and could shoot me before I get ten feet." They were marching me back to the original fight scene. I expected to see Rocky on the ground or stuffed into the trunk of a taxi. As we approached the scene I saw a crowd of a dozen men, taxi drivers, and two policemen in uniforms that reminded me of Nazis. My first perceptions of Austrian men in their early fifties and older was heavily colored by my Jewish upbringing, World War II documentaries, and the war stories told by my father. Photo exhibitions, books, and various scenes from Woody Allen movies also affected my response to German accents at the moment.

I saw Rocky hunched over in the back of a lime-colored Volkswagen beetle police car. He was okay. The two policemen grabbed me by both arms. I thought to myself, "You've got to be kidding — I could outrun all of you and this little green beetle. But why should I run? What did we do that was so wrong, that our lives were threatened?" While I stood next to the policemen, two of the cab drivers kicked me in the legs. The policemen intentionally turned away, ignoring the assaults. I snapped at the police, "Hey, don't you see what these assholes are doing?" They turned their faces toward me for a moment with an indifferent and indignant expression. I yelled at the kickers and raised my fists: "Back off!" They smirked at me and stopped.

Finally, the police put me into the car with Rocky and drove us down to the station. They put us into a room and interrogated us. We told them our story, and when I added that I was Ernst Fuchs's student, their eyes suddenly opened wide. Time seemed to stand still for a while as all the authorities in the room gazed at me and then at each other. I gave them Fuchs's phone number. They called the revered artist, and at the end of the conversation Rocky and I were immediately released. That was my first night in Vienna. Professor Fuchs wasn't pleased, but I did detect that he secretly delighted in my wild nature and the mischief I seemed to get into from time to time.

Through this drama I learned something that was especially potent to a young American artist. In witnessing the response of the police to Fuchs's name alone, I had seen firsthand that an artist can command great respect, be admired, and have tremendous influence. This was an immense revelation for me. In fact, I was shocked. Policemen exhibiting an awe and royal respect for an artist? A single artist so influential that his name alone redirects the actions of a police department? In America, most artists are considered bums, crazy, or bohemians. But here in Austria, Fuchs was considered a king. I had learned something that no textbook would ever offer. I had learned for the first time that what I was studying was noble and that I, too, would become ennobled from that study. I saw that as an artist I had great worth and value, regardless of the attitudes in America. This learning would serve me in all my days to follow.

STREET CORNERS AND CASTLES

After the summer seminar in the Alps ended, I stayed for a while with Fuchs's son Michael in Vienna. Meeting at a jazz club, Michael asked his father whether I might be able to move into his studio to paint and continue my studies. Somewhat reluctantly, the great artist agreed. Ernst Fuchs is a wonderfully generous man and I was never treated badly, but he was not always so playful and friendly to me, either. Why should he have been? I'm still amazed he took me in at all, being the wild young man I was, but he did and provided me with shelter and a place to paint at his studio on Marokkanergasse. I had to give his cook two dollars and fifty cents each day for food, and I was also responsible for getting my own art materials and anything else I required. I would sell small, one-color posters of my paintings and original etchings at local flea markets and village festivals like the one in the small Austrian village of Prein and occasionally arm wrestle in the bars for money. I would do well in both ventures.

The weeks in Fuchs's studio passed by like something out of a movie produced by both Fellini and Zefferelli. One morning at breakfast, Fuchs introduced me to the King of Liechtenstein. Fuchs was painting his portrait. I shook the King's hand and spilled milk all over my shirt. Feeling like a doofus, I left the King and walked into the studio. I beheld a statuesque Amazon of a woman, completely nude, having just finished a modeling session with the master. Her skin was so white, like smooth porcelain, her hair like spun gold. She grinned at me as she slowly slipped her panties on and puckered her big, red lips. She

locked her eyes on mine as she bent over and picked up her bra. I wanted her. She had a mischievous grin that a mature woman sometimes gives to a young man she enjoys playing with, teasing. Cracking a smile back, I regretfully crept out of the room before my teacher spotted me. Just another day in Fuchs's studio. This was a time of enchantment, of study, with Fuchs and his magical assistant at the time, DeEs Schwertberger. DeEs is one of the greatest Transformative artists we have. Over the years he has become my closest artist-brother, and I love him dearly. His work touches and inspires my mind as Sandra's touches my heart. Whether we are painting together or having a fantastic dialogue, mutually building architectural ideas of organic buildings that respond to human emotion or just laughing over new insights, being ironic or silly, our minds and spirits have a rare resonating relationship that is beautiful, loving, creatively powerful, and playful.

My education continued in Vienna, and it was encompassing. I spent a good deal of time by myself at the famed Café Havelka, an artsy hangout for the local intelligentsia. Paintings hanging on the walls were done by the original Fantastic artists before they had become famous. Fuchs, Brauer, Hausner, and the rest had bartered a painting for a tab of coffee and food, and now the collection was worth millions. I would walk back to Fuchs's studio very late at night. Across the street from the café, Franz Kafka once recorded his strange musings. The writer's spirit was somehow still present in the shadows of the mysterious streets.

On one particular night, I passed by a prostitute with jet-black hair and piercing blue eyes. She wore a bright red dress, just barely covering her *tushee*. Her long, shapely legs invited my eyes. I looked at her hard but beautiful face, imagining her vocation and her personal story, wondering how she arrived at this moment on the corner. Her eyes met mine, teasing me and soliciting my invisibly empty wallet. I looked back at her. Her erotic shadow stretched high and long over the Jugenstil architecture. Her giant silhouette was so eerily staged against the repressed atmosphere of the times and place. Tired and curious, I continued on my way, resigned to call it a night.

From 1972 to 1974, many students came to study under Fuchs at Castle Wartholz. I think it is important to note that there were profound differences between the academic art student and our contemporary, experimental version of the guild. The differences in learning between universities and our creative community of artists were profound. We were all young, working, struggling artists studying with the knowledgeable, successful, and matured artist — the creative worker as master. The very style, motive, and visionary qualities of our art underlined our spiritual path. Our concerns were not an A or B letter grade but the pure skill, content, and philosophy of our work and the integration of these elements. The entire history of art was made alive to us through the master. Understanding the business of art, creating a powerful hand in organizing and disseminating our vision, discussing art that was thousands of years old or an exhibition just seen in a contemporary gallery were among our daily topics. Ours was the constant examination of the past, present, and future roles of the artist. Our motivation was a desire to receive the skills and awakening needed to express an inner vision, a growing intuition, and what we as

individuals held sacred. Our concerns equally included how each one of us was feeling, surviving, and selling our work. Witnessing how the master played the game in the art world while growing deeper into the truth of his own work was inspiring. We all shared our aspirations, visions, joys, and fears, and — most of all — each of us in the private domain of our hearts quietly fanned the coals of our faith.

Art for art's sake is an empty phrase. Art for the sake of the true, art for the sake of the good and the beautiful, that is the faith I am searching for.
— George Sand[8]

Being for the most part self-taught, my shelves full of copious notebooks, my studio replete with creative experiments, and knowledge being what I really wanted, I began to understand clearly, despite my fierce independence, that knowledge is very, very difficult to acquire alone. If you attempt to climb the highest mountain with no training, fight the fiercest battle with no skills, create a monumental sculpture in marble twenty feet tall — if you want to do brain surgery and you've had only an anatomy course in college, the likelihood of injuring yourself and doing damage to others is very high. In every field, you can learn things on your own, but at certain junctures, a mentor is essential. The highest level of accomplishment often requires some time spent within the environment of a mentor.

In the arts, I have always avoided teachers who peddled a style, doctrine, dogma, or somehow attempted to have me abide by a set of commandments. A true teaching will respect every single person and instill appreciation for the diversity of all life. I have found this to be true in art and in spiritual matters as well. Ultimately, a great teacher doesn't give ideas or concepts as the true teaching; the teacher doesn't even need many words to teach, because his or her very presence is the transmission of everything extraordinary that the student needs to absorb. This heart-to-heart transmission is the living relationship between a teacher and a student.

Therefore the sage goes about doing nothing, teaching
no-talking.
The ten thousand things rise and fall without cease,
Creating, yet not possessing,
Working, yet not taking credit.
Work is done, then forgotten.
Therefore it lasts forever.
— Lao Tzu[9]

The experience of learning art in Austria was of an entirely different nature from its university counterpart in the United States. I was learning from an artist whose sustenance comes only from what he creates. His whole waking life is permeated by his

engagement with the creative process. Unlike the experience provided at most schools, where one's head is separated from one's body, our experience was holistic, engaging all of life, all of our being. The art studio, the philosophical discussions, the streets, my sexuality, my highest vision — all merged together in a unified experience. I dove right into the heart of my artistic heritage and had come to understand something. I saw that although we may reawaken forgotten knowledge, if indeed we have already done the work, something is transmuted through a lineage that is unlikely to be attained and imbibed in any other way. Even though we may attain the same heights of accomplishment through great discipline and self-study or through sheer, unexplained genius, this intangible thing I speak of is a spark derived from spirit that ignites our own flames. It is what enables an artist to finally hold his or her head up in the company of a master, because he or she has become that also, through alignment and attunement of spirit. It happens through some mysterious transference in which one is nourished by an artistic spiritual food that is offered on visible and invisible levels. This is true of the tradition of which I speak, for it is a lineage. I was living the teachings, fully alive and entering the center of life and my very essence.

I advanced consciously to the highest simplicity of expression … The inner command was obeyed still more frequently; to allow oneself to fall into one's own essence.
— Julius Bissier[10]

My teacher had resurrected, transformed, and nourished a style of painting that rose like a phoenix from the ashes of World War II and Surrealism. When Fuchs, Brauer, Lehmden, Hutter, and Hausner some twenty years earlier came together in their formative days, they did not subscribe to the older Surrealists' rejection of established religion. Fuchs, apparently, disdained much of Salvador Dali's early antics to secure publicity and attention in any shape or form. Later, Dali became a hero of genius to Fuchs, and they continued to meet over the years. These meetings, as described beneath a photo of the two of them in the book *Ernst Fuchs*, by Ernst Fuchs (Abrams Publications, 1977), says a great deal about their relationship: "In conversation with Dali at the Hotel Maurice. As always, it is about theology and physics. Surrealism as a metaphysics. A new art of metaphysical painting. His intellect illuminates obscure corners, brings me new perspectives on space I had just come to think I knew. He, for his part, reads Holy Scripture through me, and his new pictures become pervaded with it."

In the 1960s, Fuchs spoke for the Fantastic Realists when he reminded us that the Bible mentions an artist — Bezalel, creator of the Tabernacle (which held the tablets of The Law, Given by God to Moses) — and describes him as one imbued with "the spirit of God, in Wisdom, in understanding and in knowledge, and in all manner of craftsmanship." Unlike Dali and the Surrealists, whose work was indeed a profound contribution on the level of mind and in the field of psychology, this new generation of artists (Fantastic Realists) not only revealed the mindscape but added a spiritual dimension

and understanding to their work. It was simply less cerebral and calculated, more devoted to the spirit in art.

Before I came to know Fuchs's work, I was preparing to make my way to Salvador Dali's abode, knock on his door, and beg him to teach me. At the age of sixteen I discovered Dali's art in books and writings, and these became my "university" for a time. I was enthralled with Dali's technical ability and hallucinogenic world. I idolized him, was fascinated by his madness, mistaking it for pure spiritual attainment. I even believed that his folly and clowning was the appropriate demeanor of the artist. This was a mistake in perception that led me to powerful hallucinations which fragmented instead of unified. Dali would visit in my dream school and escort me through unbelievable worlds and hallucinatory realms filled with monumental buildings, cityscapes, and architecture that defied physical laws. A typical mindscape in my adolescent dream world included flying creatures, giant swans with iridescent skins carrying suns in their beaks, which illuminated an inhabited sky. In the dream sky, numerous moons that had respiratory systems of their own waxed and waned with the rhythm of their silvery lunar breath, their size changing from that of a baseball to that of a planet. I was on my own in this magic theater, similarly described by Herman Hesse in his story *Steppenwolf*. In fact, the sets for the film version of Hesse's story by Ingmar Bergman were done by another Fantastic Realist painter of enormous talent and vision: the former student, roommate, contemporary, and friend of Ernst Fuchs, Mati Klarwein.

In discovering Fuchs, I had also come closer to understanding a higher purpose for the artist and for myself. Dali's technical abilities were awesome, yet at a certain level of artistic mastery one artist is simply "different" from another. Technical ability among artists at this level is no longer a distinguishable concern, and we turn our attention to the image, the essence of the creation itself, the magic of its message or expression. In my view, Salvador Dali remained in the realm of the psychological (although, later in his life, Dali devoted his time to more spiritual endeavors in his art, producing extraordinary, large-scaled masterpieces of Christian mysticism), and I was searching for the spiritual, the artist as shaman. Fuchs was a mystic with the wisdom of the Judeo-Christian traditions in his heart. In the early 1970s, Fuchs was, in my opinion, leagues beyond any living artist; the knowledge of the Old Masters who preceded him resided within him.

While the fame of the Fantastic Realists grew in the early 1960s, I was still a young boy in the United States. Along with other young artists, girls and boys in other countries, we were busy at work, drawing and sketching, developing the garden that Fuchs and other mentors would later tend when we arrived at the castle. My mother, Rose, often recounts the story of how, when I was four years old and throughout my childhood, I would earnestly inform her that "I will live and paint in a castle when I'm older, and I'll buy you one, too."

Nearly every student who had come to study with Fuchs had brought with them what my friend at Naropa University, Stanton Dosset, had referred to as "that mad glint in their eyes." They had that creative fire burning within them. But it was also

true that some had problems accepting and receiving knowledge from the teacher, as they were very busy, on some inner level, competing with Fuchs. I have also observed, in other cases, that those who do not have issues with a teacher during studies may later dismiss the teacher psychically, harshly. It is a shame that many students can find their own way, their individuation, only by mentally and emotionally killing off their teacher, competing for power or recognition. Personally, I have had this unfortunate experience only with one individual. It is an awful tragedy that is very sad for both parties, and it's unnecessary. It is, therefore, very important to understand the invisible laws governing the transmission of knowledge. There should not be a competition. Competition arises from insecurity and selfishness, and it limits the flow of knowledge. If there is competition on the side of the teacher, then true mastery is not present. If it is on the side of the student, then learning is already limited by fear, disrespect, or opportunism.

In my experience as a student, I discovered that I had to find within myself that dimension of knowledge that is embodied in the teacher. I could allow the teacher to nourish me and strengthen that dimension within me. I came to understand that Ernst Fuchs and I were intimately interrelated and a part of one fabric. For the serious student of a sacred art, a real teacher is the greatest treasure to be found, a treasure to value, care for, cultivate, and respect. Great students will never be limited by any teacher and will always benefit from their company. Great teachers will always respond with generosity to the open hearts and eyes of their students. I shall always be grateful to my teacher, Ernst Fuchs.

In 1974, the art seminars culminated with an exhibition on the main floor of the castle. On other floors, in various rooms used as studios, the attendees of the exhibition could walk around and see us working at our easels, painting. The castle, the Alps, the master, the students at their easels, the surrounding exhibition, and the daily tourists and visitors provided a stimulating, encouraging, and inspiring environment. During that year, just barely out of my adolescence, I would either be at my easel painting, gazing out the castle window and dreaming of adventure, romance, and combat, or behind some door kissing a fellow female student or a girl from the village. According to the town mayor, Mr. Cerney, some of us were "destroying the atmosphere of the castle" by painting late into the night. DeEs and his lover, the Israeli artist Hanna Kay, my German friend Wolfgang Widmoser, and I painted with the moon.

That final year, Widmoser and I were invited to stay in the castle due to insurance requirements for the exhibition. On occasion, we would fill our nights by entertaining the local Austrian girls and fellow female students by inviting them to "our castle" for special, late evening celebrations. Wolfgang would play guitar, and we would both sing songs that I had just written (amazing that my voice didn't scare everyone away). Wolfgang and I designed special capes which fellow student Cicely Gilman made for us. We wore them as castle keepers posing as princes. Wolfgang's cape was a chic leopard pattern, and mine was black satin with a deep burgundy inside and an attached hood. Our capes and playful

imaginations transformed us into royal artists of Castle Wartholz strutting all about town. We also wore them on our visits to Vienna and Munich.

As I have mentioned, in the spring and summer of 1974, in my final year of study with Fuchs, all the students stayed in a dorm at Gasthof Flackl, except Wolfgang and me. The two of us resided in the castle, just as I had declared I would to my mother when I was just a little *pisher*. As a result of my embarrassing and humbling forest drawing lesson, I could sit and paint for hours. Widmoser, Hanna Kay, Schwertberger, and I would paint until the wee hours of the night — ten, twelve, sixteen hours a day — breaking only for meals and the evening gathering of the artists with Fuchs at Gasthof Flackl.

As usual, Mayor Cerney would make the rounds every so often. One night, while circling the castle and relying heavily on his cane due to an old World War II injury, he reminded us again how our activity, painting at night, was "destroying the atmosphere of this historic castle!" In truth, the mayor of Reichenau, who looked a bit like the actor Peter Lorre, was also concerned about the occasional private parties Wolfgang and I were having. Or maybe he caught us once or twice peeing off the fourth-floor balcony and window ledge of the castle under starry skies. Later that evening, Mayor Cerney complained to Fuchs and to the Flackls, so Wolfgang and I adopted a behavior modification program, and things got back to normal and we managed to stay on in the castle.

The next day an old flatbed farm truck pulled up to the castle. Schwertberger and I went to see what was going on. In the back of the truck, lying face up, was Fuchs's large painting, the *Judgment of Paris*. We were mesmerized. DeEs said that he had watched Fuchs paint this one, starting with one, little square panel and slowly adding square upon square. Without a preconceived layout the painting grew into a perfect masterpiece of exquisite symmetry. We were so inspired that we ran back into the castle and painted till sunset.

Sometimes Fuchs would tell us stories from his own life experiences. He would also teach by telling stories of other artists' lives, covering everything from aesthetics and personal accounts to business relationships, such as the one between Salvador Dali and his most important art collector, A. Reynolds Morse, who also founded the Salvador Dali Museum in America. Fuchs would offer insights and interpretations of our dreams and share his own. The master would unveil the game and business of the art world to us, gently breaking our innocent and naive hearts. But, at the same time, he would arm us with the spiritual and worldly wisdom needed to engage the world and the business of art. We would ask philosophical questions about life, religion, and art. We would share the realizations we were experiencing. Fuchs would also sketch after dinner, and many of us would join in that activity. I would just watch Ernst sketch and draw. His draftsmanship was absolutely astounding and was as big as his vision. His lines and markings reminded one of the Renaissance master, Albrecht Dürer. When the media compared Fuchs's work to Dürer's ("the German Leonardo") and commented that it seemed Dürer had come back in the likes of Fuchs, my teacher's response was, "He is alive and I am he." In this incredibly charged atmosphere, his teachings became real, alive, and solid.

After all these teachings, I was still the wild child who had just been seen hanging by one hand from an amusement ride at a local festival, spinning twenty feet off the ground. Spinning in the warm air, I looked down at Fuchs walking by with Eva, his wife. It was a beautiful evening, the air still as the stars began to arrive, poking their illuminated faces through the pinholes of a velvety, night-time cloak. Fuchs looked up and shook his head as I was swinging by, dangling from the bottom of a miniature metal airplane, one of the rides at the village festival. Holding fast to the orbiting object, my other hand free and reaching for the sky, time slowed down and I thought with my heart, "I could catch the stars with this very hand. I want to be up there with them. At least I could be with them for a little while, as long as I hang onto this little plane." And for a few moments, it was just the stars and me …

Of Meridians, and Parallels,
Man hath weav'd out a net, and this net throwne
Upon the Heavens, and now they are his owne.
— John Donne[11]

Professor Fuchs was not surprised when he saw his wild American student swinging by, dangling from the airplane ride, not any more than when I was scaling the castle walls in Reichenau. I walked (climbed) the walls of the castle, three stories up, on the outside ledges of the noble building, waving at him through the window as he painted at his easel.

In Vienna, Fuchs was so busy! His studio buzzed with dignitaries, collectors, publishers, artists, theologians, scientists, gallery directors, media people, and commissions, and the teachings became few and far between. I felt like a burden at times, as though I were in the way. On occasion, Fuchs would be short with me or totally ignore me altogether. Then, all of a sudden, on some late evening he would sit with me at the easel. He would look intently at my painting before he verbally cut through it. He would find its wound on every level and then prescribe the remedy. He would wield an exceptional scalpel at first, then finish with a gentle assurance and just a hint of encouragement. This was a very different form of art education.

I overheard only one specific compliment about me from Fuchs during my time of study, and indirectly at that, but that was all I needed. (I am astounded by my American students' neediness and the level of pampering they demand.) During the castle seminars, Fuchs was sitting with a group of students at Gasthof Flackl and was speaking about Schwertberger's and my progress. He had just finished remarking about how DeEs's paintings were so beautiful due to his use of the middle colors. As I walked into the room, Fuchs was making a fist and shaking it in front of his heart. Looking into the eyes of the new young students before him, encouraging them without noticing my entrance (or perhaps being quite aware, I don't really know), he exclaimed with charismatic force, "The Phil is a very strong painter, very strong!" That was it, the one and only compliment. But it meant everything to me. It would be twenty-three years before the master would praise

my artwork again. In the late autumn of 1996, still a dean at the college, I was in Vienna to organize an art seminar for the following summer. A staff member traveled with me to help with the coordination. We met with Fuchs and hung out with him for several days, and he took a look at my portfolio. Looking at the variety of my work (which can appear as though a number of different artists had been very busy), the great artist told me that a singular style is not a necessary goal to achieve; he encouraged my looser and more passionate works over the ones that were meticulously rendered. His comments supporting my more expressionistic art took me by surprise, given his own ultra-meticulous style, and I found his words very encouraging and supportive. For me, having one style, as opposed to many, has always felt unnatural.

Since the castle also served as a contemporary museum for all of our works, Fuchs wrote the following introduction to the exhibition catalog:

Within the third summer seminar we shall exhibit a selection of works for the first time which have originated in close connection with my teaching at Reichenau. It should not be presumed that these are simply student works, nor supposed that they are results dependent only on my teaching. Nearly all the artists who accepted our invitation to form a working circle at Reichenau had acted like sleepwalkers following a dream. They all have brought something with them which could not have been suddenly produced by any lesson: It is the affiliation to an inclination by talent, to a family formed in mind aiming to reconquer the lost domain of "to know how." All had brought this necessary qualification with them and therefore my statement is demonstrated that one cannot speak of student works. It is my conviction that in art one cannot speak of teacher and student, and since the relation which still existed at the beginning of our century of master and apprentice has now died out, we can only find an entirely new and experimental mode of cooperation. In art, especially in the fine arts, the word is not a good mediator of knowledge and thus visible examples are necessary to illustrate what words can only say in a clumsy manner. Consequently, the results of our working circle have been produced by "looking over your neighbor's shoulder" as well as by my teaching. My share, above all, has been in demonstrating my knowledge of methods and technique and handicraft available for the creation of paintings. I have tried to show the visible and controllable bricks in the building of a picture.

Amidst all those who have come to Reichenau to "do some studying" there stood my easel, and everybody was able to watch how the knowledge of the technique of painting was expressed in my own work. All were able to view the manner in which I daily have sought to find means of expression. This is probably the secret of our mutual eagerness: In our study group we were able to discover that what can be learned is an important help and especially so for beginners, but that its value is significant only when used as a medium in a spiritual search for an adequate expression of our experience.

— Ernst Fuchs
Castle Wartholz,
Reichenau, Austria, 1974[12]

In a letter home to my fifteen-year-old sister, I reflected and related my experience. In the paternal role I had taken on since our father's death, I also responded to her letter and concern regarding the counterculture she was left in when I departed.

June 25, 1973

Dear Jessica,

As I sit back in my chair and gaze at the Alps, my mind wanders back through the years to when I was just a little boy of four, looking at a book at Poppy's (grandfather's) house. The book was of Michelangelo and stirred such an awesome curiosity in me that, from that moment on, I knew what I wanted.

It was a simple wish: I knew that I wanted to study under a master artist. But later, I found that to have such a wish in the twentieth century was utterly ridiculous. And so through all my adolescent years I was so socially happy, blatantly happy, outwardly happy, but truly I cried in the deep corridors of my heart, for never did a minute go by that I did not ponder my secret dream.

And now the dream has been fulfilled but only gives birth to new dreams even more impossible!

Yet this is the joy of it all, the great challenge: to see the apple of life and sink your teeth into it, as deep as you can, tasting every drop of the precious juice.

Perhaps you have become aware of my friends back home, a little, anyway. You see, some of them lack a direction. Their spirits dangle by a thread and bob to and fro on no particular path, and so, to try to attain partial inner peace, they drug themselves up and obliterate awareness of their very actions.

In other words, they feel better when they are fucked up, because then they do not have to contemplate what they will do with their lives.

Drugs show some things until they are totally abused. I have had what I needed in taking them. Now I look at Life, in which we have the terror, joy, and the most imperial honor to live.

Give everyone my love,

Philip

OF MERIDIANS AND PARALLELS

As young artists of the Visionary Lodge, we used the creative power to face both the outer and inner worlds, the joy and the terror, in order to see. We would not be satisfied to conform to the world. We wanted to penetrate the mystery of the world, of life, to use our art and skills to immerse ourselves into the spirit of all things and express, create, and share our findings as cartographers of consciousness.

The phenomenal world is merely a means for the artist — just as colors are for the painter, and sounds for the musician — a means for the understanding of the noumenal world and for the expression of that understanding. At the present stage of our development we possess nothing so powerful, as an instrument of knowledge of the world of causes, as art. The mystery of life dwells in the fact that the noumenon, i.e., the hidden meaning and the hidden function of a thing, is reflected in its phenomenon … The phenomenon is the image of the noumenon … Only that fine apparatus which

is called the soul of an artist *can understand and feel the reflection of the noumenon in the phenomenon ... The artist must be a clairvoyant: he must see that which others do not see; he must be a magician: must possess the power to make others see that which they do not themselves see, but which he does see.*

— P. D. Ouspensky [13]

Some decades earlier, in sectors of the art world, contemporaries of the Fantastic Realists gave little contribution in liberating inner states of experience and vision. Sexuality, repressed through the puritanism of abstract art and in the fifties and sixties brought back in a crude manner by Pop art, was also a major formative factor in the contrary art of the five Fantastic Realists.

These "fantastic five" were the nonconformists of their time, yet their symbolism was never obvious. Their pictures dealt with their obsessions but transmuted them aesthetically. They did not simplify; they refused to popularize their themes as, for instance, so many of the theosophical artists did, thereby discrediting symbolism. Their works met the public halfway — as do those of Redon, early De Chirico, and young Chagall, even the innocent sophisticate, Henri Rousseau. Their work was sufficiently clear, attracting the spectator who may feel like entering a new land while remaining obscure enough to hold the viewer's attention over a length of time, inspiring him or her to solve the puzzles, get to the core. The transpersonal artist's intent is born from a more integrated source deeper than mind, deeper than the psychological. It is more intimate and refined than the Surrealists' ambition to intentionally disarm and destruct awareness in spectators, jolting them into some alien landscape that has a certain fascination yet rarely holds the promise of love, wisdom, intimacy, or other human longings toward positive, transpersonal experiences. Where the Surrealists usually break down mind, the transpersonal artists build.

Of the five original Fantastics, it is Brauer and Fuchs who have added strength and aesthetically bridged the ancient mysteries and contemporary knowledge with the Old and New Testaments, providing essential links in the transcendental chain of western mysticism. After long ages of religious materialism and spiritual stagnation, the legacy of ancient lines drawn between the pagans and early Christians has become all but erased. The Greeks of old, who had once crowded the agora of Athens, with its altar to the Unknown God, are no more, and their descendants firmly believe that they have found the "unknown" in the Jewish Jehovah. The divine ecstasies of the early Christians have left their visions in the ether, making room for "progress" and a more businesslike Jesus, with crucifixes made of plastic.

Long centuries have trodden on the graves of ancient adepts, almost entirely obliterating all sense of spiritual ecstasy from the hearts of humankind, and have taken the lightning from our eyes. This is what the Invisible Tribe provides: a restoration and recall from spiritual amnesia of what we attained long ago and to what we might yet become; it restores lightning to the eyes. Each creative mystic serves as a bridge, large or small, singular or multileveled, each unique and collective in nature.

To achieve a powerful vision, we must realize, through pure education, that we must

be in constant revolt — inwardly, deeply, psychologically in constant revolt. This revolt is not to be confused with adolescent rebellion or states of irritation. As Krishnamurti stated, it is only those who are in constant revolt who discover what is true, not the ones who conform, following some tradition. (Unless, through that tradition, one does not lose discernment and constantly questions the way that is being prescribed and what is true in each moment for him or her personally). It is only when you are inquiring, constantly observing, and learning that you find truth, God, or love. You cannot become deeply aware unless you move through your fears. So, in my view, true education is the moving through and eradication of fear, inwardly and outwardly. Creative courage washes away the fear that limits human thought, human relationship, and love and is cultivated through the arts.

Like Fuchs and his four compatriots, his students (and particularly those from America) would learn that the public would not be overly sympathetic to an art that does not *appear* to ask enough questions or make social statements (for example, a trend in the art world toward social commentary). Transpersonal artists are more concerned with expressing a direct or intuitive experience grounded in a perennial philosophy, and the feelings and awareness that arise from that involvement are likely to become a target of criticism. The perennial and mystical in art has little choice but to soar in a sweeping arc over the teeming mass of artistic "movements" and "isms" and theories regarding fleeting issues of the

Fig. 15 *Rochester, New York, 1974.* A photograph of Marta Lee Leone and me, not long before we parted.

moment, sacrificing small questions of material concern for the far-ranging ideas, vision, and emotions that embrace all humanity.

However, many professional artists in every field never ask themselves whether the arts bear any meaningful relationship to broad questions of human values. Many of the contemporary visionaries themselves have become lost in *techne,* concentrating on technical prowess, forsaking *psyche* and the promises it can fulfill. But for those artists on the creative path of psyche, of inspiration, the public must be willing to risk supporting an art in which the boundaries between the outside world and inner world are effaced in an enigmatic richness.

BACK TO THE NEW WORLD

Fuchs's compliment in 1974 signaled that I had learned a great deal from him and that soon it would be time for me to return to the United States. As Fuchs put it later that year, "Yes, it's time for you to go back to America and wash dishes." My teacher laughed but was also serious. I was a little hurt by his comment, but later I would understand that he was not being mean to me or was happy to get rid of me; he was simply commenting on the lack of support for artists in America, particularly young transpersonal artists. In little time, his dish washing prophecy would come true. I also missed Marta terribly and couldn't wait to see her. Back in Rochester, New York, Marta had already set up house for us.

Our time apart had allowed Marta and me to grow in ways that a couple cannot when they spend each day together. We had missed each other so much, and our love continued to flower that year. But the time came when Marta had to leave and find her own way, too. She felt both overwhelmed and inspired by me and needed to grow on her own, away from me and my sphere of influence (a continuing saga as my life unfolds). In the late winter of 1975, I woke up one morning as she was leaning over me; she was very emotional. She was dressed in her long, beige cashmere coat and her matching knitted scarf and hat. She gave me a kiss. I looked out the snowy, crystal-covered window, hearing the motor of her old, green Chevy running. As the sun melted the snowflakes on the window, I watched her melt away from my life. A small U-Haul trailer was attached to her getaway car. She kissed me good-bye again, now with tears in her eyes while the sleep was still in mine. Stirring from sleep, I began to ask her what was going on. Her voice shaky, she said, "I can't talk about it now; if I do, you will convince me to stay, and I must go," and then — she was gone. I stared out the window and watched the back of her little trailer bounce onto North Goodman Street. I was stunned, in a state of disbelief, my heart broken.

Marta had been half my world for nearly ten years. I spent the following year in oblivion, drunk and self-medicated on barbiturates. Today, twenty-six years later, Marta and I are friends, and I will always be thankful for her love, companionship, and her teachings. She lives back in her home state of North Carolina, weaves incredible tapestries, makes stunning quilts, swings a wicked green thumb in the garden, has done great work in social services, is married, and has two wonderful boys. We will all be challenged by loss, change,

and transition in our lives — that is the nature of life itself: impermanence and the evolving spirit of things.

Back then, my friends witnessed my pain and plight over Marta, my poverty and struggle as an artist. My friend Matthew Raisz lent his generous hand, and I went to live in his family's empty cabin on Poncapog Pond in Massachusetts. This bare, essential, tiny rustic cabin had no electricity or running water. The cabin's entire living area was about nine by twelve feet, had a wood stove, a small table, and two army cots. The porch served as my art studio and overlooked the tranquil pond. I was penniless but had no debts. Life was simple and great.

I have no money, no resources, no hopes. I am the happiest man alive.
— Henry Miller[14]

There, in a cabin in the woods, I would paint and heal. I rarely saw a human being that whole year, except for Matthew's occasional visits to drop off supplies and get an evening's escape and rest from bustling Boston. At night, by the light of an old oil lamp, Matthew and I would read, talk philosophy, put the lamp out, and go to sleep. I had breakfast with the same squirrel each day; she scratched at my door in the morning, begging, and we ate together. I called her "Gimmey." Occasionally, the deer would also come to say hello. I spent my time canoeing on the pond, reading, contemplating, and, until sunset, I painted. I worked on paintings that were done using some makeshift eyeglasses I constructed from prisms. Some fine work was done on this Walden-like retreat, and I describe the style of paintings I did then as "prismatism." I enjoyed the solitary experience. I was at peace again.

Almost a year passed and winter approached. The cabin was not suited for winter living, so my dear friend, the artist and fine craftsman Alfredo DeLucia, offered the next roof over my head. Alfredo had gone to art school in Rhode Island and after graduation called Providence home. Strangely, just as Fuchs had prophesied, my first job in Providence was at a soup kitchen, *washing dishes.* Between 1974 and 1978, I lived in seven different cities working as a dishwasher, janitor, garbage man, construction worker, sparring partner in the boxing ring, soda pop deliverer, maintenance man, truck loader, and so on. But no matter what I did, I painted every day. By 1977, with a studio full of unsalable, mystical pictures, I had hit rock bottom. I accepted an invitation from a remarkably beautiful and dynamic "cat-woman" (she had *those* eyes) named Lorraine to move to her Long Island home. When we met our eyes merged liked magnets. Our relationship was passionate, intense, turbulent, and star-crossed, even though I really loved her. Toward the end of our relationship, and unrelated to it, I survived a near-death experience due to a perforated stomach ulcer. Having cheated death, I went back to my hometown, lived at my sister's, healed, and finally found a place where I could be myself for a while at a local art school.

In 1978, AllofUs Art Workshop, Inc. in Rochester, New York, was the only place where the real, dedicated artists were to be found in this cultural but conservative city. At this

workshop, for the first time, I taught painting on a classroom level. I taught the basics of the old masterly knowledge I had learned from Fuchs and combined it with my experiences in meditation and contemplative studies. Before each class, my students and I would meditate together. The transpersonal was encouraged in their work as well as philosophical discussion. Except for some early childhood lessons from my grandfather and my experience with Fuchs, I had never formally studied art anywhere. I had never gone to art school, and never accepted the scholarships offered to me through the program at the University of Rochester. So I took full advantage of the opportunity to study with the other artist-teachers at this workshop.

At AllofUs, I studied clay sculpture in the basement where art schools always keep the "mud people," the ceramicists. Making my way up to the top floor, my studies included jewelry, stained glass, printmaking, and photography. I also kept a close watch on the director, quietly studying arts administration. It was at this energetic and funky workshop that I met the profound, beautiful, and radiant artist Sandra Lee Reamer. It was springtime, and she had run up the stairway of the old brick art building, which once served as a jail and police station, to sign up for a workshop I would be teaching the next fall session. Her energy was simultaneously sensual and effervescent. She was an athlete, an accomplished martial artist, a black belt in Kodakan judo, and a brilliant painter. Sandra sang like an angel and played guitar. She was simply stunning. In the moment I saw her my heart opened like a vast ocean, and I immediately knew that this angel of art would one day be my wife. Sandra was a vision of beauty, the muse embodied, with the gentlest of hearts, a heart so gentle that just taking flesh, just being physical, was almost too harsh a frame.

After four years of pain and loss over Marta, then Lorraine, I was in love again! Yet after attaining a level of artistic mastery of my own, I had become increasingly more driven toward *self-mastery* — that is, to directly experience, and connect to my own true nature, to God. I had become very observant of others and myself, but that was not enough. At this point in my life, art was not enough.

He who knows others is wise.
He who knows himself
is enlightened.
— Lao Tzu[15]

Chasing the angelic Sandra and following the romantic road would have to wait. I was not offering any courses until the fall, months away. In my pocket was a ticket to Bombay, and I left on a plane just forty-eight hours later, like a boy on the back of an elephant following the star of India.

FIG. 16 Philip Rubinov-Jacobson, *Portrait of Swami Muktananda*, 1979, egg tempera and oil on panel with 22-carat gold paint, 36 x 32 in. Collection of the Siddha Yoga Dham of South Fallsberg, New York

Chapter 2

Inside India — An Oasis of the Living Fire

All the arts we practice are apprenticeship. The big art is our life.
— M. C. Richard[1]

ALL THAT EASTERN STUFF

I sat in a crowd of about one hundred people facing him from about twenty feet away. This was a relatively small gathering compared to the hordes that would gather around this teacher in years to come. It was 1975, and I was in the Catskill Mountains of upstate New York. After reading a number of his books and discussing them with my mentor and friend, Dr Wilson Wheatcroft, I went to meet Swami Muktananda Paramahansa at his ashram in South Fallsberg. My friend Randy Walker and I made the trip down from Rochester in his mother's powder-blue Volkswagen bug. The two of us, all hippied out, artistically and intellectually open minded on one level but spiritually reserved and skeptical on another, were doing our first bona fide guru investigation.

For many years, even as an adolescent, I was aware of an internal witness state, a watcher within me that never slept. I had been painting from this state, expressing my experience through various artistic endeavors. This witness state revealed itself in my artwork beginning at the age of fifteen when this all-seeing eye appeared. This "heavenly eye" usually appeared in the upper left-hand side of images I created. The presence of this witness image in my paintings went on for years. I had also been painting my dreams and investigating them for quite some time. But I wanted to connect even stronger to that witness state.

The swami was talking, giving a lecture on all that eastern stuff. In my own arrogant but necessary litmus test for gurus, I said to him in the silence of my mind, "If you really are a master of meditation, the self, and the eight limbs of yoga, turn toward me and point at me right now!" To my surprise the swami ceased talking, pulled his characteristic sunglasses down his nose, unfolded his lotus posture (his legs touching the floor before his cerulean blue-cushioned throne), looked straight at me, extended his arm, and pointed his finger directly at my face. He held his finger pointed at me for several moments, then gracefully resumed his lecture, returning to his former lotus posture.

I, on the other hand, underwent a very unusual experience. I felt a subtle wiggling at the base of my spine as I sat in an awkward lotus position which I found very uncomfortable (and still do). It felt as though the live tail of a snake had been implanted at the base of my spine. The strange sensation felt pleasing and stimulating. My eyelids closed naturally. This energy from the point of the swami's finger literally felt like a warm stream of electric oil that flowed out of him and into me. That wiggling at the base of my

spine started to snake up my back toward my head, where the subtle force expanded, becoming a mandala in my mind's eye. The mandala of kaleidoscopic and crystalline colors metamorphosed from vibrant patterns into a many-armed female form appearing in a starry, night-time place. As she danced, universes were created, spinning off her whirling arms and long, exquisitely curved fingers. Her dance slowed down as she seemed to wrap the universe around her, like a celestial shawl. This was followed by a total quieting of my mind.

I fell into the deepest peace, a sightless, soundless void. All my life I had experienced an unrelenting imagination with a life of its own. In fact, the visionary and mental activity within me was so intense that I sometimes considered it harassment. It never stopped. As a result of this intense mental activity, since late adolescence it had been difficult for me to sleep more than four or five hours a night, and that was a very light sleep, often disturbed by awakenings. For the first time in my life, when *I wasn't painting*, my mind was still, quiet, and at total peace. I was not thinking, yet I was fully aware and conscious. I felt rejuvenated. This quieting of my mind was more profound than any of the unrelenting visions that rolled like thunder through my mind.

THE SPIRITUAL FIRES

The mission of Swamiji's life was to awaken the divine consciousness of the aspirants by means of *shaktipat diksha*, thereby furthering their spiritual development. *Shaktipat* is a subtle spiritual process by which the guru transmits his divine power into the aspirant either by touch, look, or thought. This awakening of *shakti*, the *kundalini*, divine energy, or what we may call the spiritual fires in the aspirant, unfolds transpersonal experiences and awareness. The grace of the guru transforms the aspirant; his or her attitude undergoes a change. Spontaneous feelings of peace, bliss, and attacks of painful awareness occur. Eventually one begins to experience the divine within ordinary reality and not merely as a figment of abstract imagination. As in Fuchs's presence before, where ancient knowledge of art unearthed itself within me, so in the presence of the guru would spiritual attunement unfold and surface in the creative fires. Mind dust, impurities in the shape of thought forms, negative impressions that had become almost solid through actions, would bake away to nothingness.

The metaphor of sparks, flames, and the actual raising of the spiritual fires (*kundalini*) has been with us seemingly forever. That we are born of fire and stardust, in truth, shows more agreement than difference among science, our creeds, the wisdom traditions, and all the speculations of modern physics. The Christian who says, "God is a Living Fire" and speaks of the Pentecostal "Tongues of Fire" and the Jew who speaks of the Burning Bush of Moses and the Pillar of Fire are evolved fire worshipers, an extended experience of our predecessors.

Rosicrucianism, Kabalism, and other traditions set about describing the divine fire within us and the Deity as "the Lord thy God is a consuming fire." The Kabala delves into

Fɪɢ. 17 Alex Grey, *Sacred Mirrors: Psychic Energy System*, 1980, (detail), acrylic on linen, 84 x 46 in.

the divine fires in man with great enthusiasm, stating that "He maketh the wind his messengers, flaming fire His servants," and that the spirit permeates every atom in the cosmos. Almost all of our sacred traditions and paths refer to the divine power as a purification by fire and initiation, as a deity or force pervading all space and things, the

spirit of light. This reference to the "living fire" describes the bestowal of gifts that magnify all the human resources and senses.

As in the Kabalistic works, so *the fire* is also spoken of in all of the Hindu books. In the Hindu tradition, the serpent power of *kundalini* is at the center of practice and is beautifully reflected in the arts and between the dance and coupling of Siva and Shakti. In the Kabalistic works, the Zohar refers to the "white hidden fire residing in the *Resha trivah* (white head)" — or crown chakra. In theosophical phraseology it is a serpent power (coiled energy) that expresses itself in three spirits, the Atma–Buddha–Manas. In most traditions the awakening of the spiritual fires is accomplished through the sacred relationship between the teacher and the student.

In the traditions of Tibetan Buddhism, *awakening* may take the form of numerous *empowerments*. Each empowerment may be given by a teacher who is specialized in one or many different *transmissions*. In the Hindu–Siddha tradition, the singular empowerment of *shaktipat* is an unceasing, organic process that continues to raise the inner fires, nurtured by the aspirant's cultivation of meditation and devotional practices, the spiritual discipline or work given by one's teacher, and, above all, direct experience of God through an evolving identification with the Absolute. The effect of Shaktipat may run through numerous lifetimes.

Swami Muktananda did not blatantly perform any miracles, nor did he encourage others to take interest in them. He gradually transformed any desires for *siddhis* or "spiritual powers" into real spiritual urges and devotion and daily practice. The greatest miracle that Swamiji (or "Baba," as he was affectionately called by his devotees, meaning "father" or "saint") performed was the invisible transformation of an ordinary life of frustration and confusion in an aspirant into a life of spiritual fulfillment. Speaking for myself, this was true.

In 1978, after I had studied for several years with Swami Muktananda during his tour and teachings in the United States, he returned to India. I traveled to India to be with him at his ashram and then, for a period, to wander as a *sadhu* on my own, naked to the world. Muktananda was a *Paramahansa*, one who is an ascetic and has reached such a level of self-knowledge and self-control that no ordinary conventions bind him, no ordinary emotions disturb him.[2] Muktananda had been the disciple of the great *avadhoot*, Bhagawan Nityananda, a renunciant who had risen above all duality.

I traveled far from the lush and sparkling green landscape of upstate New York to the arid summer of India. Walking the last mile, coming upon the small village of Ganeshpuri, the world seems to be baked in a pale ocher as far as I can see, to the hills thin beyond the morning mist. During the monsoon season, everything will blossom and melt into a rich, emerald green. But now the dying green of the leaves, the earth, the clumps of rock, the wiry rice of the fields, the bony dogs, even the thinly chirping birds are pale ocher-brown, almost a golden yellow. Two naked boys pass by, a third in shorts too big for him and tied with an old, dingy rope that scarcely substitutes for a belt. Their shining black-brown skins are smudged into the same, all-pervading color.

The ashram stands in the distance, a bright, white block of light beckoning me. A red flag flicks slowly in the wavering breeze. I walk the few remaining steps away from this

monochromatic, sun-drenched landscape. There comes a tinkling of bells, a sound too soft for gaiety — but peaceful, enhancing the stillness — as the ashram cattle walk in a line, their soft eyes easy with the world. One cow, more curious than the others, stops to examine me, and we exchange some love. I turn for a last look at the hills in the distance as the dust dances off the dirt road. I advance toward the gate, and above my head is an arching blue placard with big, white letters that read "Sri Gurudev Ashram — Thou Art That, That Thou Art, So'ham, See God in Each Other." I was immediately reminded of Moses and the Burning Bush, when he left his life as a shepherd to become the Law Giver and take up the staff as a prophet. The liberator of the Jewish people in Egypt, Moses did not know how to describe God to the masses that awaited his word; he did not know what "name" to give to "That" which has no name, is infinite and eternal. What was God's name? Who shall he say has sent him? And God said, "Tell them *I Am* has sent you." In the Five Books of Moses it is written that God said unto Moses, "*I will be that I will be*," and He said, "Thus shalt thou say unto the children of Israel: '*I will be* hath sent me unto you.'" In other translations: "Tell them *I Am* has sent you." The sign above the ashram gate and the story of Moses are also strangely identical to *So'ham–Ham'sa–Japa*, a meditation technique, which translates as *I am That — That I am*.³

The gate of the ashram leads into the main courtyard. The ashram is situated on seventy acres. There are a number of buildings, meditation halls, bungalows, sculpture gardens for contemplative practice, a cave where the Siddha masters Nityananda and Muktananda meditated for decades, small paddy fields, and more gardens. Goats, cows, an elephant, an albino king cobra, pygmy ponies, and other wonderful animal beings graze on the grounds.

What events in my life had led me to this place? Why was I here? I recalled the year 1969 when I had first experimented with LSD. I did not come to that event any more lightly or haphazardly than the gates of Baba's ashram. I remembered how my older brother Alan had introduced me to "acid," and, in his mystical manner, said in a soft, serious, and beautiful tone, "It has to do with God." Standing before the ashram gates, I recalled that first acid trip, which was spent partly alone. When I took acid it was like some large hand had reached over and ripped my exterior off. You don't think of having an exterior and an interior, but it was as though there wasn't any shell any more. Everything touched me and I touched everything. I had total perception in every direction as far as I wanted to extend. Everything was in extreme, vivid colors, extreme, beautiful colors. I had no sense of limitations. My mind and force of life could superimpose their mental constructions onto the outer world. I could make any shapes and attach any sounds to those shapes, all flowing in every direction. I could see forever. I could hear the thoughts and feel the feelings of everything as though they were my own, especially with my eyes closed.

Opening my eyes and looking around, it became extremely obvious that many things I had believed about reality were false. I could see through time and witness past events transpiring in the now in whatever location I fixed my eyes on. I could see potential futures. I realized that beyond the effect of the drug itself, something had been removed. Later I would discover that many people who had experimented with hallucinogenics had

had similar experiences, such as those recorded in Aldous Huxley's *Doors of Perception*, the clinical work of Stanislav Grof, and in the spiritual quests of Richard Alpert (also known as Ram Das). At the center of such an experience as this, you see everything as forms of light. What you thought were solid walls, hamburgers, or trees are just different forms of light. You see this quivering and moving, and you see it rising and falling. You can literally see mountains or flowers or trees wake up when the sun rises in the morning. You can smell and hear and feel them. You can feel the living vibrations from everything.

I recall taking a solitary walk up to the Cobb's Hill reservoir, where one could overlook the city of Rochester. The sky bled with the rising sun, dripping hot gold. It met the surface of the reservoir like a molten metal in a cosmic kiss, an erotic encounter exploding on the cobalt blue-skinned face of the waters. From the hilltop I could look down on the streets below and see everything that was happening. I could feel people scurrying around and around. As the city awoke and the scurrying began, I could see the pollution rise into the air. When a bird flew by, I could feel myself flying by — I was that bird. And I could see the absolute, total futility of humankind doing things, engaged in actions as mere forms of distraction, constantly moving, like a dog chasing its own tail. It seemed as though everyone was running away, in order to avoid coming face to face within themselves. It quickly became clear to me that all of that made sense; the only thing of value was in knowing what was really happening, what really mattered. All that scurrying around was a tremendous waste of effort, and most of it was extremely harmful and negative. I found it mind-boggling that an individual can go through life without asking even one question regarding his or her own existence, without simply standing in awe, moved by the incredible forces of creation around them, and in them.

The most beautiful and most profound emotion we can experience is the sensation of the mystical. It is the sower of all true science. He to whom this emotion is a stranger, who can no longer wonder and stand rapt in awe, is as good as dead. To know what is impenetrable to us really exists, manifesting itself as the highest wisdom and the most radiant beauty which our dull faculties can comprehend only in the most primitive form — this knowledge, this feeling is at the center of true religiousness.
— Albert Einstein[4]

Although it has been more than twenty-six years since I have taken any psychedelic drugs and thirty-one years since my first acid trip, it is not something one forgets. Yet, for the past two decades, my visionary life has been very potent, expanding naturally. Although drugs, plants, and other organic substances can induce various experiences and altered states, I will reiterate throughout this book that the creative worker who becomes dependent on such things actually limits his or her vision in the long run. Diligence, discipline, and practice are what introduce us to a greater life and vision, by and through our own nature, without crutches and dependencies. No drug is greater than the mind it feeds, the mind already in a state of fullness, spirit already transcendent.

So, here I was, at the door of the ashram. I had come to stop the mind chatter, to learn to see more, experience myself more, to love more, and to understand. All this, I expected, would occur through a relationship with the guru and in living the daily routine of the ashram life, a very special ancient tradition and an intense contemplative discipline. Like some years earlier when I opened to the knowledge of a master artist in a castle, so it was now to the Siddha in an ashram. Learning without losing my discernment, my own power. I was resigned to being fully open to absorb everything while testing all of it.

Monks and scholars should
accept my word not out of respect,
but upon analyzing it as a
goldsmith analyzes gold, through
cutting, melting, scraping and
rubbing it.
— Buddha[5]

Many ashrams have a spiritual specialty, an approach, or philosophy that the resident guru considers most important or in which he or she is particularly adept. At Ganeshpuri, this was the process of direct transmission and initiation. What followed this initiation was the practice of meditation, mantra japa, and one's *sadhana*. This initiation, *shaktipat*,[6] is a transmission of *shakti*, or the awakening of the "living fire" (*kundalini*) I previously mentioned.

One day, on a hot afternoon in the courtyard, I asked Swamiji, "Baba, is there any difference between the artist and the non-creative worker in regard to the awakening and experience of this inner power, *kundalini?*" Muktananda replied,

Artists can, and the greatest of them do, "awaken" their kundalini *(divine energy) through the prolonged practice of painting, through concentration, which is a form of meditation. However, Umesh ...*[7]

Baba added,

... the artist awakening this power is in a dangerous position if unguided by the master or if without connection to the inner guru. Unguided, the "awakening" of the kundalini *in the artist and others can lead to madness, and worse.*

I thought of artists who had suffered madness and manic depression, and I contemplated my own artistic temperament. The swami continued,

The artist must always be responsible for what he brings into the world; he must always paint the highest. As well as acting as receivers of energy, the chakras also transmit energy, as do works of art.

I thought to myself, "Is he saying that works of art are really generated by the chakras (energy junction points in the subtle body) themselves? Does that mean an artist who is stationed at a certain level of consciousness or attainment and 'chakra opening' produces a corresponding style or vibration of art? Could one say that the myriad schools and styles of art could be aligned to the chakra system as the actual source or, perhaps, indirect source of their inspiration — the invisible force behind the visible expression?"

I began to think that beyond any particular systemic comparison is the common notion that humans possess creative and inventive intelligence. In other words, artistic activity has been developed and brought forth from latency to potency in connection with the substance of the human body through which the human soul is gaining experience, which, of course, includes all its layers of being from the causal on down to the gross. Humans are aesthetically motivated and inspired to create forms, produce color and sounds, and juggle various elements in harmonious relation, and all of this type of creativity is an expression and result of aeons of conflict and resolution, suffering and joy, sight and insight. Creative expression is the power to think and feel self-consciously and to relate cause and effect. Creative action can be a prophetic process on the way to something undreamed of today. Art, in its greatest service, aids humans in asking and answering the perennial questions of life: Who am I? Where am I going? What is Life about?

The last and most important branch of non-verbal education is training in the art of spiritual insight ... To know the ultimate Not-Self, which transcends the other not-selves and the ego, but which is yet closer than breathing, nearer than hands and feet — this is the consummation of human life, the end and ultimate purpose of individual existence.
— Aldous Huxley[8]

Many of the great sages tell us that there is a spiritual evolution that coincides with the visible, that the human soul emerges by passing through preliminary "rounds" of various kingdoms (metal, vegetable, fish, bird, animal, and finally human), that an individualized soul is finally attained in the human kingdom, and that the other kingdoms share a kind of "group soul." Such thinking may be alarming, even shocking, to many pet owners and animal lovers out there, and I cannot blame you. (I used to refer to my last pet, my cat, as "my daughter with a lot of hair.") In any perspective, in the tradition of the Buddhists, we should be equally kind to all sentient beings.[9]

Returning to my conversation with Muktananda, I caught the oceanic gaze of my teacher's compassionate and earthy umber eyes. Muktananda turned to his right and said, "Tejo, can you tell Umesh more?" asking his most revered Indian disciple to elaborate. Swami Tejomayananda was an austere and intensely focused man with a depth of soul that touched the ancient corners of your heart. He was actually one of those yogis you heard amazing stories about. Tejo, in his past, had practiced strange occult methods and yogic techniques such as swallowing an extremely long line of cotton cloth dipped into vegetable oil and running it through his body as a "cleansing" process. This involved a rag being

available at both ends, the mouth and anus, slowly, over many days; the rag is pulled through the body, cleaning the intestinal region, colon, etc. Tejo would laugh when relating this segment from his history, saying only a "real yogi" could do that. Tejo turned to me, and as he spoke a lightness of being arose, austerity giving way to the happiness of his wisdom. He responded to his guru's request and elaborated on the response to my questions:

Umesh, an artist or any person, for that matter, who is strongly polarized in his astral body and working through an uncontrolled but highly developed chakra solar plexus can create havoc one way or another in the environment where he functions. In the same way, a person who works creatively through the throat or the heart chakras radiates peace and harmony in such a way that others are uplifted and quietly inspired by his presence.

I immediately thought of the still but inspirational power in the presence of Fuchs. I also thought about artists and their impact on their surrounding environment. Although artists can be catalysts for positive change, inspiration, innovation, and transformation, they can also bring into the world its polar opposite: chaos and pain. The artist, when interacting with his or her environment in an unconscious manner, unleashes forces that can create or destroy. The forces moving through a creative worker can be formidable. If life's raging rivers are to drive turbines, they must neither be completely damned nor allowed to run free. Similarly, the springs of creativity and human emotion must be channeled and harnessed if they are to release positive energy as opposed to havoc. For the artist to flow with his or her creative process, juggling many polarized forces may be necessary.

Swami Tejo smiled, then continued after a short pause:

By fulfilling the law through purification of the lower self and adding to this the practice of meditation and service to others, the centers (chakras) are slowly and automatically unfolded and, if fortunate, guided by the noble care of the Siddha (spiritual master). Your question about artists: well, by setting out deliberately to force the opening of the chakras, and to intensify their effect — whether by artistic action, chanting, or other so-called spiritual exercises designed to raise the inner fires — the aspirant or seeker in his ignorance may unleash energies that will literally burn the astral and physical tissues of the body, especially those of the nervous system and brain, thus leading to physical and emotional instability, or insanity, even death.

Tejo paused, observed the curiosity in my eyes, and went on:

In this way, the seeds of prolonged troubles may be sown in future incarnations. Do you know of any artists with these maladies?

Then I also considered the lives of many creative workers and how their usage of art healed the ravages of psychological conflict and poorly understood neurobiology, for themselves, and for all of us. I considered how their efforts to create order out of chaos must lead any

thoughtful observer to gain fresh respect for the synthetic capacity of the creative spirit. Certainly the lives of many mystics, visionaries, and artists involve having a sensitive spirit that is impressionable and vulnerable yet brave and willful enough to enter subterranean corridors of the subconscious. The visionary artist is no more comfortable in such dark, secret places than anyone else. However, he does not shrink from darkness or from light, and artistically records his experience for the rest of us, too busy, too fearful, or too distracted to venture with him on his lone journey. The courage to pass through non-ordinary states of consciousness to achieve spiritual union, wholeness, and peace is an artistic bridge built by the creative-mystic for us all to cross over and to "see" a reflection of the mystery.

I had been at Baba's ashram for several months. Dramatic events were actually very rare, and the day-to-day practice of meditation and *sadhana* were what constituted the majority of my experience. The strong discipline and daily schedule of rituals, meditation, work, study, and celebration grounded one's experience. This discipline was necessary, as the scene around an accomplished spiritual teacher can, at times, be a real zoo. The teacher and the atmosphere itself bring out the neuroses in everyone. The environment promotes, even encourages, the raw issues of the student to rise to the surface.

I kept to myself, concentrating on my *sadhana*, my spiritual discipline, and work, remaining indifferent to the social structure, hierarchy, and status positioning in the environment around the guru — the "spiritual pecking order." Yet hidden issues in the aspirant also arise within this social context where teachings lie just beneath the surface. In my own experience, the first few weeks at the ashram were a kind of spiritual honeymoon. Soon this ashram life and practice began to reach in more deeply, cutting through my self-deception. Along with the gatherings of all the ashramites in the courtyard at sunrise and sunset to meditate and chant, receive teachings, and just to contemplate, I also began to become painfully aware of some of the less savory aspects of my nature, attitudes, and belief systems.

I wanted, I needed, to find a place within me that I could go to for peace, to retreat to a place of harmony within, to rest from the turbulent forces of the creative power, my artistic temperament, and the world outside. As I sat before this unusual man, I continued to listen intently with wide-open eyes. Swami Tejo smiled at me, his piercing eyes were not threatening, and he finished by adding:

Umesh, the energy of your presence is composed of dense subatomic particles. There is reason for this. You are strongly grounded in this world and others; it is for you to see more, beyond the realm of imagination, without losing your balance. You are so strongly grounded in this world in order to scale the heights of other realms and to share that experience with us. This is a blessing of the Siddhas.

THE SOUND BODY OF GOD

I had been practicing mantra and *japa* daily, hourly, for about three years, and at a certain point I could hear the mantra, a holy syllable or sound, actually — the Sound Body of God

emanating from things. During this period of my life I poured myself into devotional practices and Hindu rituals, as I had done previously in Judaism, and even Christianity. For a short time, I became one with the mantra's meaning, its sound, its being. Like a vehicle, it carried me to higher levels of consciousness. This feeling of uniting and merging began to expand within me. I recorded the following in my journal:

May 27, 1978 *Ganeshpuri, India*

… Remember that the journey is a broad highway in which we all move; it is at the same time an inner journey. For we are all traveling through ourselves and by means of ourselves. We do not travel in outward extensions, even infinite extensions, but rather into the depths of our own consciousness, ever discovering greater dimensions of being and truth, ever tasting more nectar of love. As we travel inwardly we will grow outwardly. It is difficult for me to now separate the within and the without in the process of this journey. We must build the spiral by which we climb, as the spider spins from within itself, the web which then becomes its field of action. Everything comes into being on the field of our actions.

The use of mantra and *japa* permeated my practice. I loved these sounds so much — "music" was too thick a word for their loveliness. But even prior to this sojourn to India, holy sound had been an experience for me in the Jewish temples and for my wife, Sandra, in the Catholic church. Sandra, an extremely sensitive woman, has had similar mystical experiences all her life. For years, we shared this practice together, later studying the yoga of light and sound with Master Thakar Singh in 1985.

One episode we shared involved a direct co-experience of divine sound. While traveling through Italy in 1980, Sandra and I stopped in Pisa to see the leaning tower. Across from the tower is a chapel connected to the cathedral. We walked over and entered. A tour group was inside with about twenty people, and the guide asked everyone to be quiet. As Sandra and I stood outside the group, the guide suggested to them that they would hear something wonderful. The guide rang a bell, and the group quietly listened to its ringing, but we heard something else. The guide's voice seemed to grow softer and muffled. Sandra and I immediately fixed our gaze on each other as this unusual event began to unfold, mentally saying to each other, "Are you catching this?" We looked in the same direction, upward, to the ceiling of the chapel as the most beautiful music began, like choirs of angels, one level after another, many levels. We both looked upward and listened at the same time.

Love does not consist in gazing at each other,
but in looking outward together in the same direction.
— Antoine de Saint-Exupéry[10]

I had this identical experience once before, a few years earlier, hearing the very same music, but at the Siddha Yoga Center in Rochester, New York. At that time, however, I

Left: FIG. 18 Sandra Reamer, *Celestial Arch*, 1986, egg tempera and oil on panel, 14 x 9 in.
Right: FIG. 19 Philip Rubinov-Jacobson, *Migration of the Brotherhood*, 1985, egg tempera, oil, pencil, and oven cleaner on illustration board, 32 x 26 in. Collection of Bruce Reamer, New York

not only heard these choirs of voices but also saw them. After singing an ancient Hindu chant for about an hour with an intense focus on identification with that mantra and a heart full of devotion and happiness, I began to hear subtle sounds floating over the chant in the room. The other people in the room, about twenty men and women, were continuing the same chant, the women singing one part, and then the men another, alternately. But I was hearing something else on top of the chant, floating and moving over it. It was like a thinner, more etheric sound-river, levitated and moving in a serpentine motion above a mantra ocean. This ocean of sound was deeper and thicker in texture, more human, the river above more angelic. The heavier chanting in the room faded from my ears, and the celestial voices became clearer. I opened my eyes to see what I was hearing. The voices were owned by etheric shapes. The room dissolved before my very eyes as I looked upward. I could see nine choirs of angel-like figures, each choir forming a successive ring of lighted beings that converged and got smaller as forms and voices moved away from my eyes and ears. The choirs were circular, misty, and white rings with luminous bodies suspended in a cerulean blue space. These angelic ringlets began orbiting at different rates of motion in a circle of fiery sparks, shimmering points of light that spiraled upward.

I watched and listened to the beauty as tears moved slowly over my cheeks. So here we were in Italy, Sandra and I, in this small chapel, listening and looking at each other, then toward the ceiling, sharing this same state of wonder. The guide continued to talk to the tour group as Sandra and I quietly shared this exquisitely beautiful "secret" experience.

Then a woman from the tour group turned and noticed the look on our faces and that our heads were turned upward, our mouths wide open. She approached us and so very gently, with childlike excitement in her English accent, asked in a soft whisper, "Do you hear it, too?" We nodded our heads and whispered, "Yes." I was rather surprised. I did not expect a mystic wrapped in this proper English package, but here she was, the three of us now in awe, sharing the moment, looking upward. This angelic music was unearthly,

FIG. 20 *Sandra and me, 1979*, at my mother Rose's Fort Hill Terrace apartment in Rochester, New York.

so beautiful it made us cry, as when I heard it years before at the yoga center in Rochester.

At the ashram in India, music and sound took on an added significance in my life. I began to hear an inner voice, a "still, small voice," containing significant guidance, teachings, or poetic and spiritual musings. Sound is vibration. Music is the shape and sound of the invisible. Mantra is the shape and sound body of God. The syllables of the mantra hold forces of polarized energy that harmonized my being with the divine nature of things. The mantra becomes a vehicle that introduces the singer to higher levels of consciousness. The very forces of nature can and will be attuned to the vibrations of the mantra singer and vice versa. The mantra holds forces, and its effectiveness depends on the purity, knowledge, and devotion of the seeker. In fact, the mantra can have meaning and conscious force only to the initiated, to those who have undergone a definite and particular type of experience revealing its essential nature.

India was a time of solitary contemplation and spiritual work for me. I had only just met Sandra before my journey and she was not yet part of my life, although I knew in my heart she would be soon. So all things in the world occurring to me were filtered only through me, without the desire or need to be sensitive to a partner of any sort. When one is in a relationship, one tends to experience many things in the context of being a couple. I find this is true, at least for me.

Some months had passed, and one day I went for a walk in the ashram gardens. I saw my friend Sheela sitting in contemplation near a larger-than-life-sized statue of Hari Das, an Indian saint. There was an attraction between us, and she stood up when she saw me coming. I started to express my feelings for her, and as I approached, I half-consciously waved my hand in a dynamic circle in front of my heart. I did not expect anything to happen or to follow this *mudra*, or gesture, yet the leaves on the ground gathered by my feet directly below my churning hand and began to swirl. A little, leafy, tornado-like wind circled around me. The leaves then danced around the two of us. Sheela responded like a woman who had just heard a poem written especially for her. Startled, she called my name in excitement, "Oh, Umesh!" Gasping, she covered her mouth and blushed. I found her

FIG. 21 Robert Venosa, *Seraphim*, 1975, oil on canvas, approx. 28 x 22 in.

response to be sweet and amusing, and the event snapped me back from a month-long state of silence and God intoxication in which I had had very little sense of identity.

This incident drew me back from a near-mindless state in which I was extremely sensitive and vulnerable. I became increasingly aware of capacities and powers not yet stable or under my control, and so I prayed to be released of them. These things frightened me a little as they were not an act of my will. I experienced flashes of insight and knowledge that seemed unaccountable and of no immediate value. At times I contacted vibrations and

phenomena of other realms but remained unaware of how the process had occurred, or why, and what it meant, if anything. In many cases I was unable to renew or even recall the experiences. Time became flimsy and irrelevant; only the moment existed. I had no regrets or attachments to the past and no dreams for the future, nor did I have any desires for anything. Eventually, I did not even need to "know who I was" any more. Yet I was not grounded or centered in self-realization either. Perhaps I was somewhere inbetween, I do not know. Without much sense of identity, I was still very much at peace, very alive. My identity seemed to have taken refuge in all that my eyes took in. This is hard to describe with words, but inside, I felt hollow, a good hollow, and whatever I saw outside moved into this inside-hollowness, but there was no sense of being filled by that. That is, this emptiness inside was without "wanting" and gave me a feeling of being satisfied. Whatever I saw either joined my inner experience or already was there.

Sheela went back to her room, somewhat flabbergasted, flattered, and amused, all at the same time. I remained in the ashram gardens. Looking up toward the rooftops to enjoy the setting sun, I witnessed something quite amazing. An array of beautiful entities, *devas* spirits of some kind, were descending from high in the sky and pouring themselves, as though through a funnel, into the rooftops of the ashram buildings. An energy, which I could feel, was being emitted from these living forms, and I was very excited to see this. They were not physical things, not human, but had a force of life and were amazing and beautiful. I had no idea what this phenomenon actually was or what these things were. I felt really little, like a child in a state of wonder. It was very strange and mysterious. Some of these entities looked like giant, crystallized paramecium- and amoeba-like forms. They had their own light. The event passed and I retired for the evening.

Years later, I would notice a similarity between these forms and some of the images that my sweet friend, the angelic craftsman and brilliant painter Robert Venosa, creates (another former student of Ernst Fuchs). Venosa's painting *Seraphim*, 1975 (Fig. 21), resembles what I saw on that day in India. While traveling in California during the summer of 1970, Venosa had the first of two profound, defining visions that were to compel him to begin his life as a Visionary painter. In this, his first calling, he saw the image of Christ integrated as part of an atomic pattern. Heeding some sort of transcendent message, he cut his trip short, returned to New York, and, attempting his first painting, struggled to transpose the vision onto canvas. The result was *Atomus Spiritus Christi*. It was during one of his meditative states that Venosa experienced his second transcendent vision that inspired a number of paintings, *Seraphim* being among them. As he relates it, "It happened in a nanosecond. A brilliant, jewel-encrusted, overwhelmingly beautiful, angelic-looking being flashed in my mind's eye, shocking me out of my meditation and compelling me to attempt a rendering of this astonishing vision. Certainly that was far beyond my abilities then, as well as now, and I have been chasing that vision ever since." Robert Venosa's mission to capture the angelic vision he was granted has produced some exquisite and breathtaking paintings over the last three decades; the paintings are beautifully displayed in his recent book *Illuminatus*.

In the text of his book, Robert also reminds us that the visions of otherworldly beings are by no means a new or unique experience. He cites how Aldous Huxley, in one of his letters to Dr Humphrey Osmond, talks of seeing crystal- and jewel-bedecked creatures during one of his experiences with mescaline. Robert describes how Ernst Fuchs devoted much of his early work to the depiction of angelic creatures and celestial architecture that he envisioned during dreams. An example of that can be found in the 1963 piece *Cherub Seemingly Resting on Blue Wings* by Ernst Fuchs (see Plate 12).

During this particular period in India, my sexual energy became immense and stuck in my lower body. It did not move or dissipate. I had an erection almost all the time, and the spiritual center at the base of my spine, the abode of the coiled *kundalini*, baked in the hot, sensually divine currents of the goddess. I felt I was on the verge of an orgasm most of the day, particularly around sunset and sunrise. The heat in my body was intense. My sexual desire seemed to take on cosmic proportions, and my dreams were peppered with erotic encounters involving Olympian goddesses and gigantic beauties, often rising out of an ocean of mysterious, dark waters. In time, with the powerful influence of my spiritual mentor, meditation practice, dream teachings, and creative visualization, I gained command. The dense material vibrations, thought-forms, and desires of my lower nature were burned in a creative fire that moved upward within me. My body could barely hold these forces inside.

This took place over a period of six months, and by the end of that time, the sexual-creative-*kundalini* fire had ascended inside me. During this period and upon my return to America, I was celibate as a natural result of this spiritual practice and the movement of my inward creative forces upward. Muktananda described this to me as the seminal fluids rising within. This celibacy was not an act of my will, some renunciation, or weird repression, aversion, or denial of sex. In fact, my sexual drive had always been extremely vital and healthy. But something had changed. With this celibacy, there was no sexual frustration, no desire. I saw all women as the goddess, and sexual desire did not arise in me while in their company.

Upon my return to the United States, I reconnected with Sandra, a different kind of goddess. After nine months into our relationship, we made love. But something very unusual occurred. When making love, I would have orgasms on the inner levels. That is, for a period of time, I did not experience physical ejaculations. I would experience an inner release (an "in-jaculation"), an orgasm that occurred inwardly and moved upward from my loins to the crown of my head. It was like an orgasm that blissfully backfired inside me, and my whole body melted inwardly, into my spirit from the outside in. In time, physical ejaculation returned, but on occasion — after twenty years — I will still experience in-jaculation. This is the creative power, the *kundalini* force, the reproductive, life-giving lightning within us. This *chi*, bioplasma, *prana*, energy in the inner life has been intensely significant for me as a creative worker.

Living at the ashram amid the strange, indescribable forces, the guru, and this ancient, spiritual lifestyle refined and inspired my journey and the way I would move through the

world. I realized then that this was a time of unequaled spiritual progress for me, not because of swirling leaves, visions, or celestial sounds, but because of the silent realizations, the silent teachings, the silent assimilation, the daily practice, and the painful spiritualization of the ego, the shedding of false identification and illusions. It is a process that continues and constantly moves forward, transcending but including what came before. Much of this work was accomplished by *inaction* as opposed to *action*.

Active searching is prejudicial, not only to love, but also to the intelligence, whose laws are the same as those of love. We just have to wait for the solution of a geometrical problem or the meaning of a Latin or Greek sentence to come into our mind. Still more must we wait for any new scientific truth or for a beautiful line of poetry. Seeking leads us astray. This is the case of every form of what is truly good … his waiting for goodness and truth is, however, something more intense than any searching.
— Simone Weil[11]

Muktananda enhanced my ability to see that which was liable to distort my vision. He also revealed to me, through subtle, creative, and dramatic events, the absolute beauty, love, and noble consciousness that we are. The loss of my frozen identity was the most significant event that happened to me at the ashram, and it was one of the major transformative experiences in my life. The event that triggered this experience of individuation occurred as a complete surprise. Although self-awareness was slowly unfolding through the puzzles I painted and solved, spending time with a human being who has devoted his or her life to a deep, spiritual practice can remarkably increase the practitioner's progress.

THE EARTH IS A DIARY OF OUR SPIRIT

Each yogi and yogini (female yogi) had a daily assigned duty. My duty, my *sadhana*, or spiritual discipline, was to create art for the ashram. In my occasional grandiose manner, I thought of myself as the court painter to Muktananda. I was given a studio on the rooftop of the women's quarters where I was the only man working alongside some twenty women. Every day, the women worked on creating decorations for the ashram festivities while I painted and created fine-art portraits and figures of the various saints of India. For this sacred art I used watercolor and gouache.

Every other day, the swamis would bring my latest paintings to Baba. Word would be sent back to my rooftop studio: "So'ham," Baba says, "Yes, He is That, the paintings you are doing are truly divine. You are truly a divine painter in God's creation." The first time I heard this, I thought to myself, "Wow, Philip. You thought you were a brilliant artist, but now an enlightened being thinks you are 'divine' — just like the 'divine Michelangelo.' What verification!" This process of indirect feedback would continue. As during my time with Professor Fuchs, never hearing any *direct* response or acknowledgement of my work or progress, so it was with Muktananda, although I would see the great saint daily. I was even assigned a special seat in the courtyard directly in front of him. But I was falling into

that which I wanted to avoid, the spiritual pecking order I previously mentioned. More important were the "secret sessions" I had with him. Every morning around 4 a.m., Baba would come to the courtyard and meditate. This went on for my entire three-month stay at the ashram. Apparently no one else knew this, or no one cared. Or was it possible that he was in more than one place at one time? (Such stories are plentiful among Indians regarding their saints and accounts of bilocation.) So I would sit there with him, just him and me together, sitting, meditating. I would try to tune into the wavelength this master meditator was on. But what I picked up, what I felt, was an infinite nothing. This nothingness was so immense that it encompassed everything. There was nothing in Muktananda's mind to push against, nothing personal that rose up to relate to. When the tendrils of my mind and sensitivities reached out to him to hold something, to see something, my efforts would dissolve. It was an eerie experience yet centering, peaceful, and expansive. I began to relate to this frequency of consciousness in my teacher. I learned also to *feel* this infinite nothingness that is also everything. During these special times with Baba in the courtyard, I was in the most peaceful states I had ever experienced. I was so happy, so at peace with myself, that a single tear would sometimes fall like a pearl to my feet, staring up at me like a jeweled eye from the fine, terracotta silt, twinkling amid the sleepy Indian tiles covering the ground.

As time passed, I produced many portraits on the rooftop, portraits of Muktananda and his teacher Nityananda and other great saints of the Siddha and other lineages. These finished works of art would continue to make their way back to Muktananda, and word would continue to come back to me from the Raj Yogi: "So'ham, I Am That, cheers for Umesh, he truly sees!" I conjured up a vision of myself as "God's artist." To have an enlightened being as my own personal art critic and to receive only ultra-excellent, divine reviews is an extraordinary experience for an artist. My ego had grown so large it even had its own weather system orbiting my inflated head. I paraded around the ashram as an extremely important yogi and was met with the expected adulation and usual ashramic VIP treatment. I had fallen even deeper into the social trap of the ashram, the divine corporate ladder of spiritual status, the very thing I was determined to avoid. Little did I know that this was a set-up. So it came to pass that I was called to the courtyard for *darshan*, the experience of being in the presence of a saint, receiving their blessing. "Baba wants to see you personally about your latest paintings," said Swami Gopalananda. My head swelled. The weather station posted on top of my inflated cranium signaled a thousand sunrises in the east, lightning and thunder in the west. Finally, I, the great one, had been summoned! I prepared myself to graciously receive my teacher's adulations and applause. I was anxious to be acknowledged for the artistic-spiritual heights of my attainments and service. Like most of the Transformative, New Age, or *Thangka* painters and stupa sculptors — the spiritual creative workers — I knew, on some level, all wanted to be acknowledged and worshiped for their enlightened artistic genius, devotional service, and all the sacrifices made in service to a "divine art".

In my six years as a dean at a contemplative college, I negotiated easily several thousand

contracts with guest artists, scholars, and spiritual teachers, and this activity was a real eye-opener. Although some of our spiritual teachers today live what they profess to others, and they are shining examples of light and inspiration, the prevalent condition and psychic disease I call *spiritus-egotis inflamatus* can be found at most holistic institutions, spiritual centers, and alternative colleges. (This does not mean the condition doesn't exist in mainstream education; it does, merely in different forms.)

I waved good-bye to all the ladies on the rooftop. I had become their darling Umesh, and it was a wonderful relationship. They showered me with their feminine energies, wisdom, and love. They all encouraged me as I made my way to the *darshan* line taking place in the courtyard. A river of people flowed toward Muktananda as he sat on his beautiful burgundy-cushioned throne. The air filled with incense, and the light of India's sun bounced off the white and ocher marble walls of the ashram. Using a bundled wand of long peacock feathers, Baba gently blessed the slow-moving train of people, receiving and giving offerings to each individual who bowed before him. On some occasions, an individual approaching Baba would serve as a spark for him to tell a story, give a teaching, or even sing. When this was about to happen, a stillness would come over the attentive crowd of several hundred people. On this day, I was to be that spark.

I approached the guru, bowed, then arose. Two swamis stood beside me in brilliant orange robes, the color of Baba's order, their shiny, shaved heads glistening in the sun. Muktananda held two paintings in his lap that I had just finished. Both were portraits of him. First he pointed at me — my stomach, to be exact — and asked if I had done this painting. "Yes, Baba," I said, smiling and waiting for the applause and a big, fat spiritual medal. Meanwhile, a knot began to form in the middle of my belly where he had pointed at me (right on the spot where I had had emergency surgery for a perforated ulcer that nearly killed me only nine months earlier). I ignored the sensation, still waiting for my long overdue praise. Again, he pointed at me with one finger, while with his other hand he held up the painting I had done, showing it to the several hundred people in the courtyard. I thought this was great, because this painting was probably the best one I had done here at the ashram, and now everyone could see just how great I really was.

Suddenly, everything seemed to slow down. Everything began to get fuzzy, except for Muktananda's presence, which seemed sharper than anything else in view. Continuing to move the painting left to right for all of the crowd to see, his finger still pointing at my stomach, he exclaimed in a loud voice, "Umesh! Why have you painted me as a sick man? You should never paint me that way!" Apparently, I had worked from a photo of Muktananda that was taken several years earlier when he was ill. Now this knot in my stomach, where Baba had pointed, had grown bigger and tighter, and I felt as though everything I was, was tied up in this knot. Embarrassed and frightened, I looked up very intently at my teacher but said nothing, remaining open and vulnerable. The two swamis at my side were now firmly holding my arms, being supportive and seemingly responding to Baba's silent command to draw closer to me; or perhaps they had seen this look of mine before on the faces of other yogis or yoginis standing before Baba.

Muktananda's finger, still fixed on my belly, created the sensation in me that some line of magnetic force and connection was manifesting itself between his finger and this point on my stomach. I could literally feel, almost see, this force, like an invisible silver cord. He began to speak after what seemed like a torturously long time of silence, leaving me to really feel the embarrassment of the moment. Everyone watching, hundreds of eyes became fixed on me, the guru still pointing at my belly. My mind flashed back once again to that excruciating and painful near-death experience on Long Island, when that ulcer perforated, blowing a hole the size of a half dollar in my stomach. Hearing laughter from the crowd, I stood there in my shame. Baba slowly raised his hand, the knot twisting tighter and tighter in my belly. The knot seemed to be holding everything I was made of, condensed, concentrated in a single spot in my gut. Then, as he removed his finger from the fixed point on my belly, the knot in my stomach was simply gone! Released! I felt as though centuries of toxins in my body and mind, physical uptightness, mental rigidity, spiritual arthritis, and guck were set free. There was a profound feeling of being liberated from a self-made prison. Babaji's eyes fixed on mine, he pointed straight up to the sky and said, "Umesh, do not ever paint me as I was!" He paused, then continued, "Always paint me … as I Am!" Again, he paused for a few moments, then firmly stated, "Always paint the highest!" At that moment I was released from my body and found myself standing beside Muktananda, but in my astral or subtle body, fully conscious and present. I witnessed the two swamis tending to my physical body, laying it down gently on the sun-baked tiles of the courtyard floor.

Muktananda looked over at me as I stood in my subtle body. The crowd was unaware of my presence and our communication. Baba, very animated and using *mudras*, or spiritual gestures, said aloud, with a strong but gentle voice, "Remember, always paint the highest, as *I Am* … now!" On that final word, "now," he raised his hand again, flattening his palm toward the sky, and I was swallowed into an ascension. This movement was very full, and it contained tremendous love, knowledge, and upliftment. I had the sensation and experience of flying upward at a tremendous speed. I was following and witnessing Muktananda's state of expanding consciousness, rising, yet also present below us as he continued to relate to the people in the courtyard. His consciousness was ever rising and expanding in every direction, upward, outward, and yet grounded below. All I could do was follow and witness this noble state of grace. The whispering message was so exquisite, and my mind echoed, "How glorious we are, how beautiful we are, how noble we all are, how divine and lovely." Soon, I could follow no longer, as his consciousness continued to expand in every direction and dimension at a blinding speed. At the same time, he continued lecturing to the people below, and while contemplating how remarkable that was, I drifted back. I could feel the palms of my hands against the courtyard floor, the tiles talking and telling me I was in my body again. I could see two vague figures in orange, like warm flames, one on either side of me. Sound seemed distant, voices very far away. I felt very heavy, very weighted down, and fell into a deep darkness and sleep.

The next morning, the same two swamis who had escorted me in the *darshan* line awakened me with a cup of tea. I awoke with a sense of being part of everything in my view and of things I could not touch or see. Yet I had no sense of who I was any more. I certainly was no longer Phil, the Great Artist. Nor could I assign to Phil any other labels previously available. Even Phil simply assigned as the identity of a man no longer fit. I barely could remember or relate to the name Phil, or Umesh, for that matter. I was not, at that point, grounded in some new elevated sense of cosmic identity, either. Quite the contrary, I was in a semi-uncomfortable state, a kind of limbo, very raw and sensitive. I felt as though I did not have a sheath covering my spirit, nor skin protecting my body. Still, I was not afraid. I felt safe. There was a knowing and an intermittent feeling of peace, happiness, and a warmth inside. There was a growing sensation and identification with whatever my eyes looked upon, as though my identity felt related to whatever environment I was in.

If I wasn't "Phil, the Great Artist" any more, who the hell was I? This loss of identity was scary, but I had been through many strange, frightening, and challenging events in my life that apparently had prepared me for this moment now. I had faith in a process larger than myself and which was beyond my ability, or need, to control it.

In retrospect, I think of the *masts*, the God-intoxicated yogis that Meher Baba worked with, fed, and washed. Perhaps I was not far away from the state that those blissed-out yogis were in. Yet I was not that "gone." I was very happy but not blissed out in a divine delirium. I was present, aware of my surroundings (on several levels) and was largely on my own. Sometimes within the Grand Drama we may experience the Petite Drama; a spiritual episode (or a kind of mystical emergency) that enables us to know a concealed truth, like a seed within a shell. This is a gift given for the purpose of expanding awareness. Many seekers incorrectly believe that if you are more evolved, you will not have any drama or difficult circumstances. Obstacles or challenges that are physical, intellectual, emotional, or spiritual in nature equally provide a ground for learning. If you have a body, there is a very good chance that there is something that needs to be learned, and that things will happen that will bring about that learning. I don't think there is an end to evolution of consciousness. I believe that as the soul or consciousness expands, so do the challenges set before that soul and even created by that soul. The greater the soul, the greater the challenge. Challenge does not have to equate to suffering. Gandhi's obstacle was the power of the British Empire; his challenge, nothing less than the independence of his country of ninety million people.

Journal entry: July 1978 *Ganeshpuri, India*

When one starts to comprehend just a little of the Divine Plan, one realizes nothing comes by chance but that truly all things work together for good, and so pain and trouble and sorrow cannot come unless they are needed, unless they have their part to play in the development that is to be.

Through this out-of-body experience with Swami Muktananda I had at least confirmed that none of us is merely and only a body. I came to know emphatically that we are not

just the instrument we refer to as the mind (brain), nor are we anything that fills in the blank of the statement, "I am —." We all innately know this when we say to others, "*My* arm, *my* hand, *my* body, *my* mind, *my* ego, or *my* spirit." What are we referring to as my or mine? What is the larger thing that these items belong to and are owned by? In my experience, it is the state of the witness, a kind of neutral nothingness where the watcher resides. This watcher is the one who never sleeps, who dwells within us, sees and knows all; it is the part of us that watches our dreams and informs us of its contents, that watches our actions in our waking hours from a place fully awake, that watches our thoughts and witnesses our feelings. The watcher is the inner witness state.

In Jewish scholarship, the Kabalists, like the Buddhists, describe the innermost being as a "no-self," or as nothingness. The Kabalists use the same argument: anything attached to the word "my" cannot be the true "me." The Kabalists carry the argument further, referring to our verbalization and use of the term "my soul," implying that even the soul is not the real "me." We can no more label the soul than we can explain God. The soul, like God, cannot be theorized or understood. It can only be lived. Nevertheless, we discuss these higher things because, one, it is perhaps the only thing worthy of discussion, and, two, we need to appease the intellectual convulsions of the mind.

This being the case, what is the real me? In the Kabala, there is significance found in the Hebrew word for "I," *ani*. It is significant because if the letters of *ani* are rearranged, they spell the word *ayn*, which denotes nothingness. This implies that the real "me" is the nothingness within me. The real "me" is the intangible will that impels me to do whatever "I" decide to do. In this sense, will is higher than thought. It is the "I" (the will) that tells the mind to think. The source of my will is on a level beyond thought. It is therefore impossible for me to imagine the source of my will, and there is no category in my conscious mind into which it can be placed. When I try to imagine the source of my will, the real "me," all I can depict is nothingness.

Ani

Ayn

Although we can identify things with the self — body, mind, and soul — at the same time neither the body, nor mind, nor soul *is* the self. The self is not nothingness because of its lack of existence. Rather it is nothingness because of the lack of category in the mind in which to place it. In Kabalistic teachings, the highest spiritual levels can be understood only in terms of nothingness. To say that *will* and *mind* are coequal with God (and therefore the self) is impossible. For that matter, any word existing in the human language denoting something created by God, cannot *be* God. Since everything conceivable — including any category of thought that the mind can imagine — was created by God, there is nothing conceivable that can be identified *as* God. God cannot be explained, and *that* reality can only be remembered, realized, and lived. When I try to think about God, all that my mind can depict is nothing. As Rabbi Shneur

Zalman of Lyady (1745–1813), one of the great Jewish mystics, said, "Just as a hand cannot grasp thought, so the mind cannot grasp God."

Therefore, the *goal* is to realize reality and attain the "I am God" state in human form. Entering into the witness state promotes an experience of God. And, of course, this is not to say that we cannot speak of God, as we can speak of either "attributes of action," stating what God *does*, or "negative attributes," saying what God *is not*. Descriptions are an aid as to what God does, but not what *God is*. Although we cannot speak easily *about* God, it is very easy to speak *to* God, indeed, even speak *from* God. We find that place of still conversation in the space of the witness. Ken Wilber exquisitely describes this *I Am* state from his direct experience, from the *witness* state:

Thus, as I rest in this simple, ever-present Witness, I am face to face with spirit. I am with God today, and always, in this simple, ever-present witnessing state. Eckhart said that "God is closer to me than I am to myself," because both God and I are one in the ever-present Witness, which is the nature of intrinsic Spirit itself, which is exactly what I am in the state of my I AMness. When I am not an object, I am God. (And every I in the entire Kosmos' can say that truthfully.)

I am not entering this state of the ever-present Witness, which is Spirit itself. I cannot enter this state, precisely because it is ever-present. I cannot start Witnessing; I can only notice that this simple Witnessing is already occurring. This state never has a beginning in time precisely because it is indeed ever-present. You can neither run from nor toward it; you are it, always. This is exactly why Buddhas have never entered this state, and sentient beings have never left it.[12]

This witness state that became familiar to me through painting and the investigations of my dream life now went to a much deeper level. If all other practice failed, I knew I had attained this simple yet profound awareness. It felt good. It was as though I had exhaled all the rough edges of my life. The fight was over, even if there were to be more hardships and challenges to face. I spent the next month at the ashram taking walks in the beautiful gardens and just *being*. During this period I did not have ambitions of any kind. Most of the time I remained in a state of "not-thinking." I conversed mainly with the plants and animals of the ashram, avoiding people. People disturbed me during this time. I loved them deeply, but as I said, I did not possess a stable sheath of separation. Nor did I have a mechanism that could provide an appropriate boundary from their pain, their need to control, their fears, or their longing for peace. This would upset me and would sometimes bring me to tears. I became very uncomfortable, feeling oversensitive, empathic, and disturbed by others. People appeared too harsh for me to deal with, so I tended to avoid contact with everyone except Sheela, and V.J., the elephant-in-residence at the ashram.

That same month Sheela informed me that a God-intoxicated, "crazy" swami lived on the premises and that Baba looked after him. I wanted to meet him. He lived alone, far off on the grounds of the ashram. In India, where the visible and the invisible merge into each other, a range of behavior is permitted which far exceeds the boundaries of what we in the West would call madness. As a result, the schizoid and the paranoid often

have a place within society where they can operate and usefully connect with their fellow citizens. This is not to say that they always occupy the passive position of the "holy fool," as in the genuine case of the God-intoxicated swami I would visit; rather, the ideas that Indian society as a whole has about the cosmos can accommodate a vast number of personal demons, assumptions of omnipotence, invisibility, astral travel, methods of communication with the gods, obsessions, eccentricities, distortions of perception, and hysteria.

Since everything is but an
apparition, perfect in being what it
is, having nothing to do with good
or bad, acceptance or rejection,
one may well burst out in laughter.
— Long Chen Pa[13]

Sheela led me to the "crazy" swami. Later, I would visit him alone. Sheela, having accompanied me on the first visit, would never return. She found the enormous swami to be too weird, and he wasn't her guru; he simply frightened her. When I did visit this *mast*, I rarely spoke to him.[14] He was a huge Indian man, and his body was robed in the brilliant orange of Muktananda's order. He looked like a Hindu tent with a huge, bald, talking head. He reminded me a little of Curly from the Three Stooges, but bigger. He always sat in the same place; he never seemed to move, day after day. His eyes were glazed over with the intoxication and bliss of God. He looked nuts. His vibration was a little scary due to the ungrounded nature of his state of being. This seemed magnified by the strange energy of his veiled attainment and sheer physical size.

In his broken English he would always say the same thing to me while tapping on his massive chest, "Jesus, three time." Then he would point toward the sky and close his eyes, nodding his head yes, up and down, up and down. His eyes would open again; he'd be a little surprised that I was still there, as though hours had gone by, and then he would tap his chest again, "Nityananda, five time. Krishna, five time." Then I interjected, "Swamiji, what about Baba Muktananda?" The big swami broke into tears and with both hands on his heart, he began to sway, looking like a huge, orange sailboat bobbing on the sea. In tears, full of devotion, he began to chant, "Muktananda Mahan, Jaya Sadha Guru Bhagawan," and I would quietly step away. We in the West give our mad no opportunity to compromise with their delusions. Instead, we put them behind walls as if to drive them further into their personalized universe. The Indian remains in society and finds his delusions accepted, part of a common mythology. "I am Napoleon!" condemns us to four walls, barred windows, and shock therapy or a regimen of psychotropics, anticonvulsants, mood stabilizers, Prozac, or lithium. For an Indian, "I am Ramakrishna!" would be a serious claim, to be examined carefully and accepted or rejected on its merits and own terms.

My capacity for visual memory is really very good. I once walked into a hallway of an apartment building where my friend Matthew's grandmother lived. I had not been there for many years. In the hallway, where the elevators were, sat a small lamp on a wooden table. The lamp had been moved to the left side of the table from the right. I immediately noticed this shift from its previous position of many years earlier when I quickly entered the same elevator. I also noticed that the pattern on the lampshade was now turned around, the larger roses now on the right side of it. Yet I do not have a day-to-day recollection of this period at the ashram, other than feeling a tremendous peace and having the ability to really see the truth in situations. It is interesting to note how our internal experience regarding response to external stimuli or phenomena can alter our sense of time and therefore of sequential memory, or linear time-based recall. My experience of time in India became so fluid that segmented recall faded away. However, I do recall fondly playing with Baba's pet elephant, the enormous beast that I mentioned, named V.J. At night I would have dreams of him. His giant head, transparent as a crystal, revealed the inner head of a bearded human, a yogi. I would talk with the elephant, and the inner yogi would answer.

During the day the elephant and I played catch with the small bundles of hay I would always find near him. At night, V.J. and I spoke in the Dream Time. Later I heard Baba say that V.J. was once a great yogi who had screwed up, misused his power somehow, so regressed in his evolution and was now trapped in this huge body, just like in my dream. Baba gave him a good deal of attention and much love. As time passed, a sense of identity began to return to me. My personality began to resurface. Yet I was changed, retaining something of the old, integrated with the new. Although my spirit was still wild, the rough edges were softening, or, in fact, I was returning to my original, gentle nature, my childlike qualities becoming more prominent.

I left the ashram and for a time wandered alone, naked, around India. Later I joined a group of Indians whose philosophy appeared to be similar to that of the Jains.[15] This particular band of *sadhus* were not contemporary or traditional Jains by any means; they were radically different in lifestyle, and, perhaps, some of them were Naga-sadhus. They were not shrewd business people, as found in contemporary Jain communities. Their only business involved radical forms of simple living. They did not wear white, they didn't wear anything. The white robes of these ascetics were worn inwardly, as their spirits were so clean, so pure. They did not cover their mouths with the classic mouth guard or cloth to prevent injuring even the smallest of insects. Yet their respect for all forms of life was as strong as the Jains'. Nor did they sweep before they walked so as not to harm anything in their paths, but their footsteps were consciously gentle upon the earth. They were austere yogis, *sadhus* who renounced everything and lived by whatever the world offered in the moment, including their very sustenance and shelter. As I said, perhaps some of them actually were Naga-sadhus. Although these ascetics are often in isolated monasteries and often practice extreme forms of chastity, the sadhus I traveled with "worked" with the divine creative energies in a way that was not repressive. They may have been from some Shaivite sect in which great attention was paid to sexual

energy. We could not converse due to my lack of understanding Hindi and their "silence" and non-English tongue; yet I learned much. On some level, not fully conscious to me, I was both initiated and taught Tantric secrets that would unfold within me, naturally, over the next twenty years.

It was a rare opportunity, a sacred offering that I have never spoken much about, not to my friend Wilson, not even to my own wife. One's attunement, trust, and faith is fostered by walking stark naked through cities and woods with only a walking stick and bowl, not knowing where the next meal will come from or how your body will be sheltered from the elements. Of course, walking naked in India, anywhere at all, is looked upon as an activity of a holy man. The Indians (Hindus) feel blessed just to have the opportunity to offer you food and shelter (and you feel blessed receiving it). Here in America, or just about anywhere in the West, one would be locked up as a lunatic or pervert for walking around naked in public.

After a while, wandering naked, exposed to the world and to everything that is happening, the need to know what will happen next vaporizes along with the Great Dream. One becomes still even while moving, hearing the voice of every living thing and being instructed by their song. One learns to rest in uncertainty, to fully trust God as the power and love inside, one's self, as one's very essence.

And this, our life, exempt from
public haunt, finds tongues in
trees, books in the running brooks,
sermons in stones, and good in
everything.
— William Shakespeare [16]

During this time, as I walked naked upon the earth, I looked up at the stars and saw that the sky was the diary of the sun and moon. As my bare feet met the earth with each step, I reflected on how the earth is also a diary of our footsteps; each direction we take, each action we make, each thing we create and bring into being which was not here before leaves traces of our presence, marking our path. The earth is alive and feels our life move over its skin. The earth is a living diary of our spirit.

Time passed and I began to consider clothing myself with the world again, to ground what meager but significant experience I had gained, to be a sharer. Looking back I can see that one genuine way of achieving inner peace was letting go of personal ambitions of any kind. I began to reconsider Krishnamurti's work and that maybe he was right: that ambition will tend to breed some state of anxiety. But something was dramatically different. I personally experience ambition today — indeed, many would label me a workaholic or as having an inexhaustible energy — but now my ambitions, my energy, manifest themselves as a *service* tied to something much bigger than me or my art. It is tied to love.

As an artist, the common issues and objectives found in the business of the art world were never very important to me. My time in India confirmed that a higher art gets to the heart of what it means to be human. Through art we recreate ourselves and can move toward what we may become. Through art we are able to do something we never could do before. Through art we re-perceive the world and our relationship to it. Through this we extend our capacity to create, to love, to be a part of the generative process of life. There is within each one of us a deep hunger for this.

I had become accomplished in a number of artistic skills. Although not necessarily wrong, for me various needs for fame, recognition, and fortune were no longer central. As a human being, what I felt was lacking before was now filled, or maybe I was okay with the emptiness of certain things. I had nothing to prove to anyone any more. As an artist, as a person, there is great pain in the need to prove something or to need approval from others, giving away your power.

In the years that followed I would continue as an artist and to be deeply involved in the self-study of comparative religions, perennial philosophy, the arts and sciences. Above all, I continued to be open and to ask questions. I sought out and enjoyed the initiations and learnings of a number of spiritual teachers from a variety of traditions. Before leaving India I already knew I could no longer continue just as an artist doing my art; I needed to become accomplished in every aspect and service of the arts, administration, and education. I wanted to educate others, create experiences that gathered many artists, scholars, and spiritual teachers together with students. I wanted to create or be involved in the design of a contemplative school in the philosophies, wisdom traditions, and fine arts. I dreamed of creating a museum for spiritual or transpersonal art. I wanted to bring together the old with the young, create intentional communities of cooperation and cohabitation. My experience in India was over, but it was in my blood. I decided to go back to the United States to serve in some way, to do some good work. Living life as an act of devotional service is very fulfilling, and if adapted by all forms of business would probably change the world overnight. I did not expect to change the world, but by changing attitudes, we can do some good and change things within our own sphere of influence. Things change in direct proportion to our sphere of influence. We all have a sphere of influence. We all have responsibility in proportion to that spherical impression on, and in, life. There is so much to do in this world. Everything requires great care. It was time to work again, but now with a deeper heart, a deeper reverence for life.

The good painter is wise
God is in his heart
He puts divinity into things
He converses with his own heart.
— José Argüelles[17]

Fig. 22 Ernst Fuchs, *Salome*, 1987, pencil and india ink, 17 x 23 in. Private collection

Chapter 3

Peeling Dreams — New York Awakenings

A DIFFERENT KIND OF LANGUAGE

As an adolescent, the essential function of painting for me was to investigate my own story, the collective mind, and human consciousness. The work I produced as a teenager often originated from the unconscious and contained godlike figures as well as the grotesque. Even prior to my discovery of Jung's work, I began to realize that these gods, goddesses, monsters, and mythic figures emerging in my paintings were in fact representatives of the whole psyche — the larger, more comprehensive identity that supplies the spiritual strength and balance that the personal ego lacks. Ancient history and rituals have provided us with a wealth of material about myths and rites of initiation. Using painting to excavate and unlock the meaning of ancient symbols and icons in the psyche enables understanding of the individual ego, the collective unconscious, and full consciousness. This artistic approach promotes awareness of our own strengths and weaknesses in a manner that will equip us for the arduous tasks which life presents to us. Consequently, my adolescent artwork dug deep into the dark night of the dream world and the soul. I recorded and analyzed my dreams with an obsessive, almost religious, scientific eye. From the ages of fourteen to twenty-four, my symbolic paintings reflected a dive into the depths of the unconscious mind, which revealed its secret language to me.

The use of symbols by artists, mystics, and alchemists to both investigate and represent spiritual knowledge and experience is an ancient practice and process, a language as old as the psyche and accessible to each one of us. Thus Recejac actually defines mysticism as "the tendency to approach the Absolute, morally, by means of symbols." So, too, R. L. Nettleship: "The True Mysticism is the belief that everything, in being what it is, is symbolic of something more." The dream unfolds a symbol, the symbol disrobes the dream. In mystical symbolism the symbol retains its own form, content, and nature, but at the same time becomes the window through which spiritual truth is discerned. Through the use of symbolism, the artist bridges the divine and earthly dimensions. The basis of symbolism is analogy. In trying to express something that is beyond words, the mystics seek an analogy within their common experience that conveys an element of their mystical vision. The analogy is not intellectually contrived; it is experienced as an immediately perceived actuality. God *is* to humankind what the sun is to the earth. God *is* to the soul what water is to the swimmer. Platonic philosophy supports this, since in Platonism the objects of the material world are, in fact, related as dim shadows to their exemplars in the spiritual world. The great philosopher, Plotinus, also advocates this perspective.

There are many symbols used to represent the pilgrimage or journey. Some have

become faded metaphors, as in the Pythagorean symbol *Y* (representing the parting of the ways), and the *via contemplative* and all the other forms of the Way. (The Way was an early name for Christianity.) We should remember that these were once vivid symbols. The Way, the pilgrimage, the journey, is also symbolically manifested in the *Quest for the Grail*, or in Farid al-Din Attar's *The Parliament of the Birds*, and numerous other metaphoric accounts.

Another group of symbols portrays the journey of the soul. A frequently used symbol of this type is warfare, the finest example of which is the warfare of Arjuna in the *Mahabarata*. So, too, in Zoroastrianism, the world is a battleground between the forces of light and the forces of darkness. The *militia Christi* is the Christian equivalent of this. Sometimes the soul is seen as a city under siege, such as in the wide usage of the *New* Jerusalem.

Evelyn Underhill has called many symbols "transmutational." The symbols closely related to alchemy: the philosopher's stone and the *elixir vitae* are identified with the creative power behind the universe or the savior-mediator, depending on the religious framework employed. Thus Fludd writes, "That is the true alchemy ... which can multiply in me that rectangular stone, which is the cornerstone of my life and soul." Another obvious and frequent symbol of rebirth into a new life is Dante's *vita nuova*. It is important to realize that many of the symbols that refer to the ultimate and appear in the highest visions of the mystics are, in fact, conditioned by the religion on which they have grown up. Just recently, in a conversation with Ernst Fuchs on this subject, he stated that all visions, all mystical experiences, whether Buddhist, Native American, Hindu, Jewish, or otherwise, are really originating from the Light of Christ. But Fuchs is a western mystic, and although his symbolism encompasses a Judeo-Christian, mythological–erotic mysticism, it is ultimately centered in Christ. I believe that each mystic's vision is colored by the framework of his or her path, and that each path is a legitimate way up the mountain to Godhead. I do not believe that the mountain is Christ's mountain, but that one of the paths is Christian.

There are symbols that express the actual experience of divine union or immersion. We can return to the idea of God as a *fire*, consuming or transforming the soul. It is an experience of pain as impurities are burned away, but also of warmth and union. Rumi depicts the soul as iron heated in the fire until it takes on the color of the fire and can say, "I am the fire." Another symbol of the absorbing power of God is the ocean or river. In eastern mysticism the soul is often seen as a drop of water on the ocean of deity. The tree is a symbol from nature which is commonly used to express the relationship between God and the soul. In Hindu mythology, Radha is the beloved of Krishna, and each believer is a leaf on the vine that is Radha. In Jewish texts, The Tree of Life and The Tree of Knowledge are symbols packed with symbolic information.

If, at the very least, mainstream education offered art alongside French or German, perhaps then it would begin to understand the importance of art as another language, a language of the spirit. One of the primary educational functions of art is to objectify

feeling so that we can contemplate and understand it, to plant seeds of awareness. It is the formulation of so-called inner experiences, inner life, that is impossible to achieve by discursive thought and therefore comes to us in a visual language, a symbology. If the sign points to something directly and takes its meaning from the object of direction, the symbol represents something beyond its own image. Whereas it is impossible to limit the symbol to mere meaning and definition, it is possible to provide, or indicate, a point of departure for a voyage of exploration, a two-way journey, or quest of spirit of inner depth and outer height, the immanent and the transcendent. Symbolic usage in itself can lead to immediate and direct apprehension.

The true symbol cannot be created artificially or invented for some purely personal interpretation or whim: it goes beyond the individual to the universal and is innate in the life of the spirit. It is the external, or lower, expression of a higher truth which is symbolized and is a means of communicating realities which might otherwise be too complex for adequate expression. Thus the symbol can never be a mere form, as is the sign, nor can it be understood except in the context of its religious, cultural, or metaphysical background, the soil from which it grew. The symbol is a key to a realm greater than itself and greater than any individual who employs it.

Exclusiveness is a primitive and immature characteristic; the symbol is inclusive and expansive, and there may be many and diverse applications of the same symbol. Traditional symbolism assumes that the celestial is primordial and that the terrestrial is but a reflection or image of it; the higher contains the meaning of the lower. The celestial is not only primordial but eternal and confers on the symbol that undying power which has remained effective over the ages and continues so, to the extent that it evokes the sense of the sacred and leads to a power beyond itself. The unconscious offers integration if looked upon and understood.

It is the function of symbols to point beyond themselves, relating the present to the absolute. Thus mystical symbols can be interpreted on a variety of different levels; they reveal aspects of the world that are not immediately discernible and express patterns of ultimate reality that cannot be conveyed in any other way. At the same time they relate the ultimate to the immediate; that is to say, they are existential, they throw light on present life.

Symbolism is basic to the human mind. To ignore it is to suffer a serious deficiency; it is fundamental to thinking. The symbol is to art as humanity is to God. It is a language of the spirit, and its meaning has been pressed on the eyes with divine lips. Art objectifies the sentience and desire, self-consciousness and world-consciousness, emotions and moods that are generally regarded as irrational because words cannot always give us clear ideas of them. I believe the inner life of feeling is not irrational; its logical forms are merely very different from the structures of discourse. Art is able to express its natural forms and provide symbols to express its meaning, feeling, or spirit. Feeling is an aspect of reality that emerges gradually within nature and finds expression within the arts. The widespread neglect of art in education is therefore a neglect in the education of feeling. Most people are so imbued with the idea that feeling is a formless, total, organic

excitement in human beings as in animals, that the idea of educating feeling, developing its scope and quality, seems odd to them, if not absurd. I think it is really at the very heart of personal education.

THE DREAM SCHOOL

As a boy I went to symbol sessions in my dream school. For example, I was angry with Picasso, until he appeared in a dream. I felt he had abandoned himself. In my youth, my aesthetic bias approved of art that was produced only in forms of a classical realism. This is not so uncommon for any young artist determined to master technical skills and a traditional knowledge. The non-objective, abstract, or distilled forms of the classical ideal were, at that time, blasphemous to me. So, it seemed that Picasso had sold out, turned away from his mastery and classical knowledge, his refined and highly tuned skills. Yet there was always a secret part of me that admired his audacity, rejoiced in his liberation, versatility, and multimedia productivity. I was nineteen years old on the eve of his death when we met in a dream. Within the dream I sat on a bench as he painted. His large, four-foot paintbrush was shaped like a giant question mark, the curved translucent shaft supplying spontaneous changes of liquid color to the tip of the brush according to the movement and moment of his moods and artistic direction. He kept looking at me and pointed his great, question mark paintbrush and said, "See, my son, do you see the answer?"

In this dream I witnessed the flow of life that rushed up like a great river from within Picasso and realized how liberated his expression was as it traveled through his brush, free on its journey to the outer world. In symbolism, art can ask questions, not only make statements. The answer *was* the question, and the very symbol of the question was found in the shape of the paintbrush itself. My problem with some of the Visionary or contemporary spiritual art being done today is that although this work is often the result of highly skilled hands, the imagery suffers from being a *declaration* of a mystery rather than the *creation* of one. In other words, when a painting waves a flag at you and preaches a sermon that blurts out an explained mystery, it can rob that mystery of its inherent promise of enigmatic wonder, beauty, or truth. True mystery in painting beckons like a lighthouse in the dark of night, asking us to look over here, to experience a magic that unfolds in the space between the painting and the viewer.

I think Sandra's *Soul Descent*, 1995 (Plate 9), and DeEs's *No End*, 1964 (Plate 16), both achieve that from very different approaches. There were no blocks between Picasso and the art revealed through him. Blocks in Picasso were on other levels affecting his humanity, his treatment of others, his spiritual attunement or lack thereof. Although I understood my own particular blocks, it would take time before knowledge and movement would begin to break through and bear fruit, as I was learning a foreign language — the visual words of dreams.

I, among many others, have learned dream information from the unconscious realm,

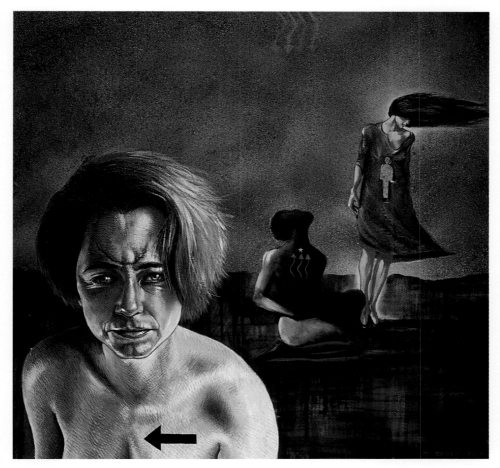

PLATE 1 Philip Rubinov-Jacobson, *Mary Jane*, 1994, egg tempera and oil on canvas, 36 x 36 in.

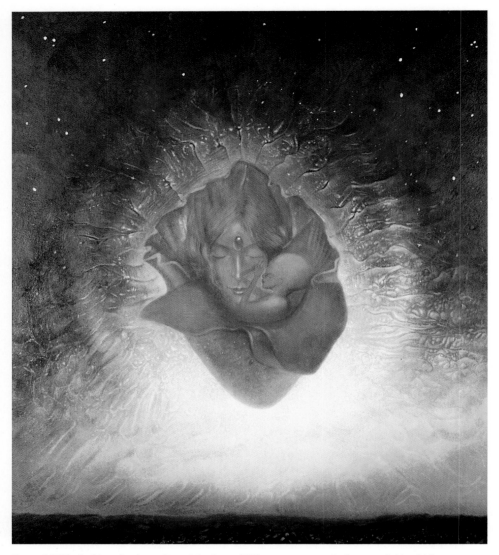

PLATE 2 Philip Rubinov-Jacobson, *Beyond the Sunset*, 1979, egg tempera and oil on panel, 32 x 24 in.
Collection of Matthew and Rose Raisz, Massachusetts

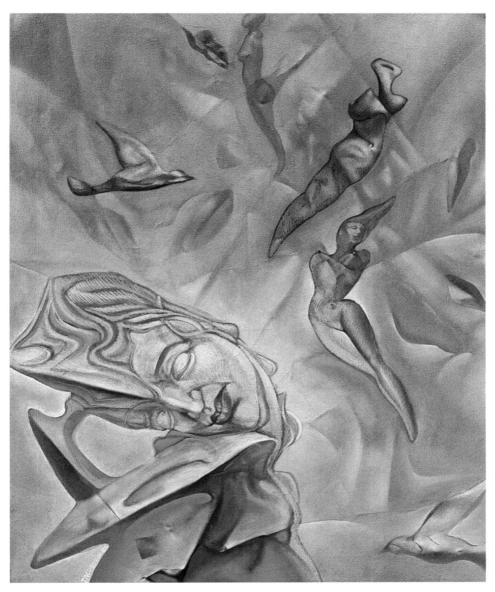

PLATE 3 Philip Rubinov-Jacobson, *Mindscape*, 1988, oil on canvas, 30 x 24 in.

PLATE 4 Philip Rubinov-Jacobson, *Electric River*, 1987, oil on canvas, 30 x 24 in.

PLATE 5 Philip Rubinov-Jacobson, *Faith, Attending Night*, 1981, egg tempera and oil on panel, 52 x 51 in. Collection of Ken Wilber, Colorado

PLATE 6 Philip Rubinov-Jacobson, *Aaron's Heart*, 1986, oil, egg tempera, and pastel on paper, 6 x 4 in. Collection of Peter Jay Chipmann, Arizona

PLATE 7 Sandra Reamer, *Celestial Rose*, 1984, egg tempera and oil on paper, 34 x 24 in.

PLATE 8 Sandra Reamer,
Chakrandala, 1985,
egg tempera and oil
on panel, 11 x 8 in.
Collection of Dr Wilson
Wheatcroft, Arizona

PLATE 9 Sandra Reamer,
Soul Descent, 1995,
egg tempera and oil
on canvas, 72 x 60 in.

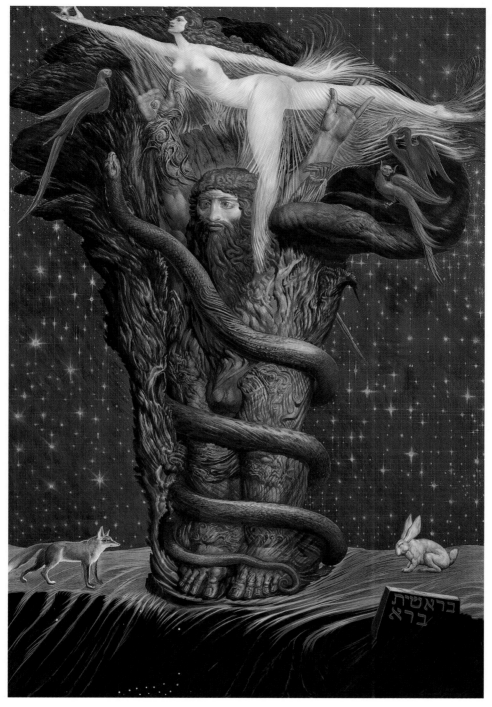

PLATE 10 Ernst Fuchs, *Adam Mysticus*, 1977–82, egg tempera and oil on linen, approx. 59 x 39 in.
The Ernst Fuchs Private Museum, Vienna

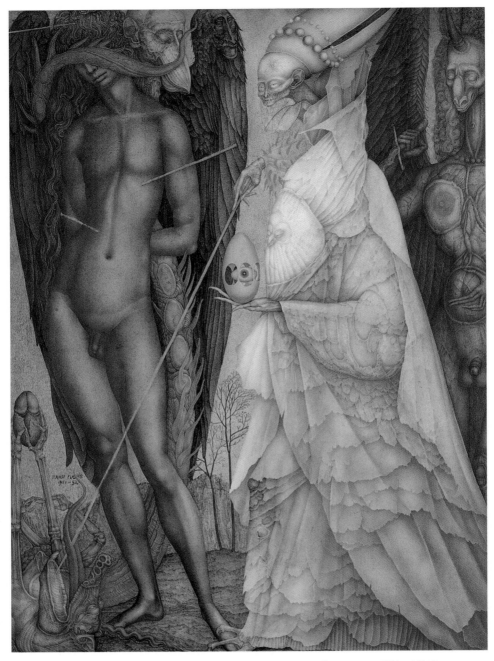

PLATE 11 Ernst Fuchs, *Battle of the Metamorphosed Gods*, 1951–58, watercolor on paper, 23½ x 15½ in. The Ernst Fuchs Private Museum, Vienna

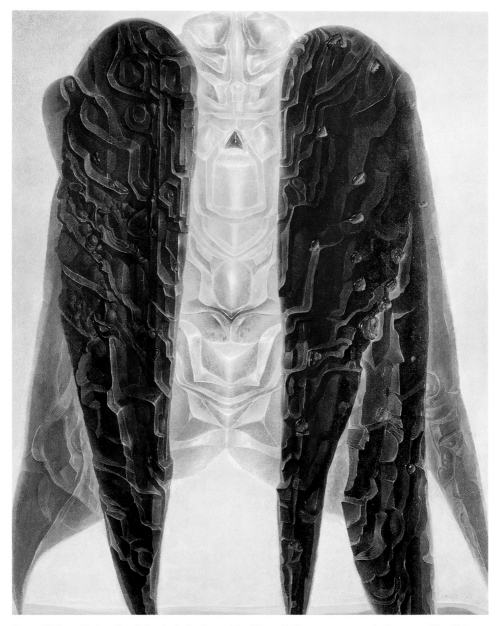

PLATE 12 Ernst Fuchs, *Cherub Seemingly Resting on Blue Wings*, 1963, egg tempera and oil, approx. 25 x 19 in. Collection of Infeld, Vienna

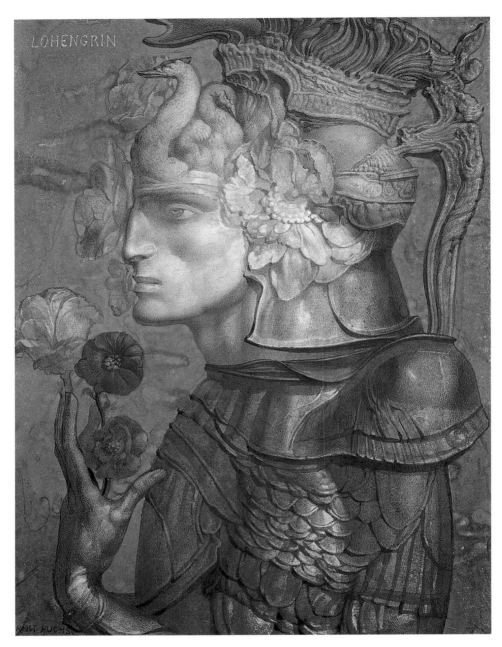

PLATE 13 Ernst Fuchs, *Lohengrin*, 1977, watercolor on paper, 30 x 22 in.
The Ernst Fuchs Private Museum, Vienna

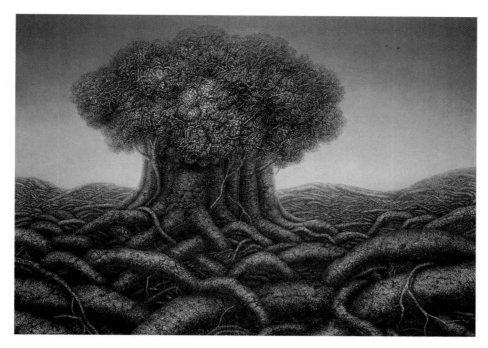

▲ PLATE 14 Hanna Kay, *Old Roots*, 1976, oil on canvas, 27½ x 35½ in.
▼ PLATE 15 Hanna Kay, *Up Rooted*, 1978, oil on canvas, 70 x 98 in.

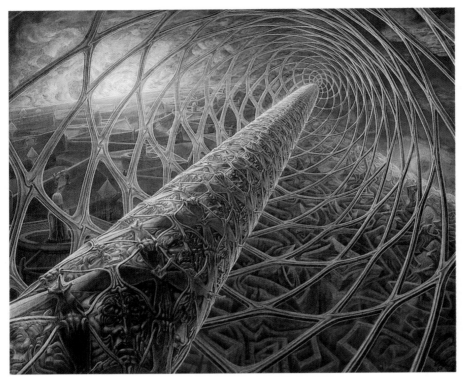

▲ PLATE 16 DeEs Schwertberger, *No End*, 1964, egg tempera and oil on board, approx. 39 x 43 in.

▼ PLATE 17 DeEs Schwertberger, *Mind*, 1974, oil on board, 24 x 32 in.

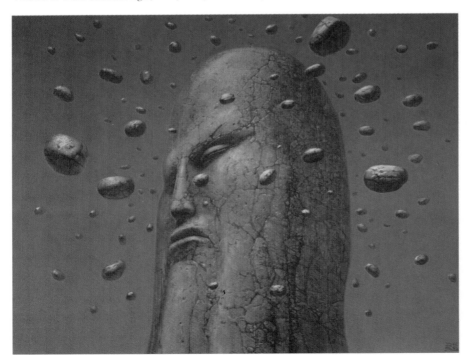

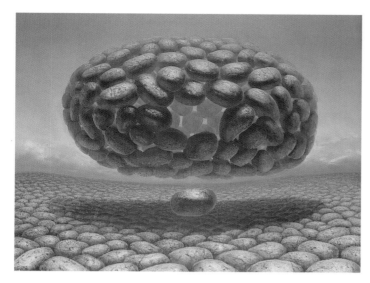

PLATE 18
DeEs Schwertberger,
Home, 1972, oil on board,
37 x 43 in.

PLATE 19 Olga Spiegel, *Creature Comforts*, 1996, oil on canvas, 44 x 44 in.

PLATE 20 Alex Grey, *Kissing*, 1983, oil on linen, 66 x 44 in.

including technical teachings on the philosophy of beauty and reflections on self and identity. My dream school included visits from various artists, philosophers, teachers, and religious figures: Freud, Jesus, Einstein, Moses, Aaron, Voltaire, Dali, Buddha, wizards, monsters, demons, angels and goddesses, Wicca, warriors, and so on. These nocturnal excursions were full of wonder, and my personal magic within the dream state grew exponentially. In time, I became totally fearless in the realms of the unconscious, with unlimited powers to go anywhere, do anything, and choreograph the content of the dream itself. For example, while in the dream, if attacked by a demon or any negative entity, I could take its nose, remold it like clay, turn it upside down, and make it smell its own evil. Then I could fly away, freely, up into the sky, downward, swooping toward the tree tops, creating destinations at will. Or I could choose to integrate a demon (shadow figure) by asking it for a gift, and in this manner, I could include the shadow by unveiling the fear or negative aspect it may represent.

For several years I followed a white-bearded and white-robed elder through the corridors of my dreams. The old one was always just out of my reach and range of vision, and I could not identify him. Finally I caught up with him and discovered that the elusive and luminous figure was Leonardo da Vinci. After catching up to him, in the hours of my sleep, he taught me a great deal about painting. Each morning I would awake with another bit of information to put into practice in life or painting. When I was eighteen, I started a painting of Saint Sebastian, and it was technically a struggle. One evening, frustrated with the rendering of the eyes in the oil painting, I gave up and went to bed. That night, Leonardo appeared in my dream. We walked together across a massive scaffold structure. On the other side of the scaffold was a gigantic living eye, one hundred feet in diameter. As we walked on the scaffold up toward the lid of this gargantuan, moist eye, the elderly but energetic Leonardo, clad in his flowing and glowing white robes, explained the anatomical structure and artistic approaches to painting the eye. It was wonderful, and I considered it an actual meeting. Certainly, the teaching was actual. I awoke with a real knowledge of constructing the eye. When painting the very next day, my session at the easel was a successful one.

Looking back over the years and recalling various responses to the dream works I created, I see that many people were struck with my technical achievements. Others have been touched by the beauty, disturbed by ugliness, frightened, mystified, or captured by the wonder, and there have been those who have just turned away, disinterested. On rare occasions, some individual's whole life was somehow changed by the encounter. As the artist, I have been, in turn, equally affected by the responses to my work. One incident occurred when I was just finishing the painting *Sheet from a Dream*, 1973–74 (Fig. 23). I was twenty years old and had just returned from my first year in Austria with Fuchs. A young woman who had heard about my work wanted to meet me and see some originals. She was also a painter and described her work as "being into bubbles," referring to the imagery in her own paintings. I invited her to my studio. This rather nice young woman responded to the invitation and knocked on our door. I was living with two fellow hippies

Fig. 23 Philip Rubinov-Jacobson, *Sheet from a Dream*, 1973–74, egg tempera and oil on board, 42 x 54 in.

I dreamt of a great battle between two aspects of myself. One body had the face I see in the mirror, the other was a "faceless self." With an equal power, we battled for hours and hours to the death for the right to make claim to the soul. In the end, the faceless self lost, and then I found myself at the entrance to a great temple. An enchanted winged goddess stood at the entrance as an emerald serpent slithered about her. She held some kind of healing rod in one hand (caduceus), and a blue-faced living jewel hovered above her other hand. She blessed me and encouraged me to circle the temple by levitation before entering. First I had to get by the crimson Cossack, sperm-headed guardians who protected emotions screaming through coffins with glass portholes. It was apparent in the dream that a crowned ape signaled that humanity passes through stages of evolution by some catch-up, cellular consciousness in hyperdevelopment through the bodies we now occupy. This also seemed apparent in the progression of my own artwork. (I later discovered historical styles I had transcended and included in my progress.) The green lion symbol (a healing courage) appears again and again. The giant Aquarian elder provided guidance in the dream and filled me with an ancient knowledge from giant books and "thought water." I entered the great temple hallway. The walls were alive, and they undulated with inlaid, moist jewels that beat like living hearts. At the end of the hallway, my "faced self" also died. I left my body and felt myself being judged, healed, and strengthened by great beings from a blue realm who then returned me to the entrance of the great temple. I awoke inspired, fearless, and rip-roaring ready to paint and explore even deeper realms.

named Stumpy and Clam. Well, the woman walked straight up to this very intense, surreal, and archetypal painting my brother Alan had generously helped me ship back from Austria so that I could finish it.

She gaped at the image, her mouth and eyes wide open, silent, completely focused. She seemed to be in some hypnotic trance. This red-headed young woman then ran, asking directions to the bathroom as she scurried through the apartment, covering her mouth with her right hand. When she returned in a rather emotional state, I asked her what had happened. She told me that she had vomited, and she had difficulty explaining what was going on with her but expressed that her throwing up was not a negative reaction. That is, she did not find the painting so revolting or disgusting that it made her hurl. Rather, it touched and resonated with such a deep chord in her own unconscious that the contents of her own soul (and tummy) were moved. She said, "This painting has changed my life," excused herself, and while still in tears, quickly ran out the door. I never saw her again. The whole encounter occurred over a period of about fifteen minutes. As the creator of the image, I was astonished. I had no idea that my art could have such a powerful effect, even though I, too, had been deeply moved to tears, laughter, awe, and even nausea by the work of other artists.

We have many references to the guidance of dreams and visions in most all of the world wisdom traditions and in most all of our cultures. The Old Testament prophecy of Joel states, "And it shall come to pass after this, that I will pour my spirit upon all flesh; and your sons and your daughters shall prophesy, your old men shall dream dreams, your young men shall see visions" (Joel 2:28). The prophet Muhammad, the founder of Islam, spoke of inward signs and guidance at the beginning of his mission as "true visions" that came in his sleep. Likewise, the "sleeping prophet," Edgar Cayce, provided a great deal of assistance to humanity in both medical cases and in prophecy.

Painting is a powerful key to unlock the door to dreams and their meaning. The rich and fruitful imagery of dreams is captured in time and can be frozen on canvas or paper. It offers a more permanent record than half-remembered, verbal reminiscences, and being physically distanced from the dreamer when it is on canvas, it will often produce a note that will vibrate sympathetically with the inner being of its creator. Often the true meaning of a dream is not at first obvious, and a painting allows the hidden message to be deciphered gradually. The dream can then become a kind of clear vision and an increasingly meaningful way of receiving guidance for anyone.

I rarely paint dreams these days, and then only those dreams that may hold a message on a personal and collective level and are beyond my immediate understanding. I will still receive invaluable counsel from dreams, which would likely happen for anyone who has been involved in a similar endeavor with consistency and discipline. On such occasions I am shown the reality of my own state, sometimes that of others, and even future events just before they occur or are still decades away. In fact, I have been blessed with so much convincing personal experience of inner guidance, counseling, warnings, education, and training manifesting in dreams that I have come to take the

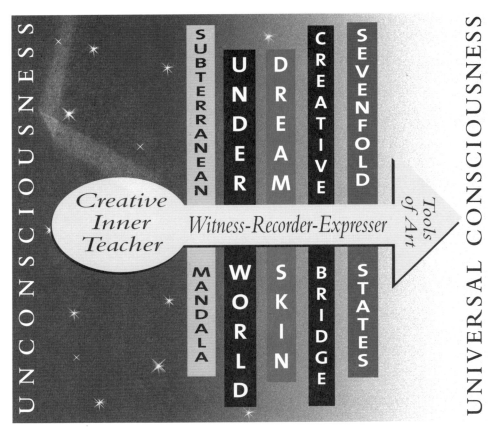

UNCONSCIOUSNESS · UNIVERSAL CONSCIOUSNESS

SUBTERRANEAN · UNDER · DREAM · CREATIVE · SEVENFOLD

Creative Inner Teacher

Witness-Recorder-Expresser

Tools of Art

MANDALA · WORLD · SKIN · BRIDGE · STATES

FIG. 24 Philip Rubinov-Jacobson, *Chart A*, 1996

Following the urges and forces of the creative inner nature, the artist passes through membranes of consciousness. Using the tools and media available, the artist's paintings, writings, performances, etc., become a mirror reflecting the signs and symbols of spirit. Spirit directs artistic practice in transcending our limited and frozen identities toward a more expansive experience of our self and infinite nature. The artwork produced reflects a language, a communication, and an expression of the soul. The mind is a microcosm of the universal process. Stars, supernovas, planets, moons, and cosmic material are constantly being created, sustained, and destroyed; so it is with the mind, always bringing new thought forms and images into being, constantly creating, sustaining, and destroying them — mirroring all creation.

phenomenon as absolutely normal and expected. Painting enhances the development of lucid dreaming and can even be used actively in waking states as a kind of trans-dreaming on paper or canvas or to complete an interrupted dream. The act of painting can be a subtle dialogue set up between the artist and the unfolding symbolic drama arising from the inner layers of being that pierces through membranes of consciousness (see *Chart A*, Fig. 24) and surfaces into the light of awareness. Painting the energetic

symbols arising from the formidable dark forces in the recesses of the unconscious eventually clears the way for lighter works to also emerge.

After a ground of experience is gained from this dream school, emotions merge with the voice of the intuitive; together they indicate important messages. Study and exploration of dream material is greatly enhanced by opening up to your intuitive systems. Many people who have nightmares and depressing dreams can be helped by developing and using intuitive faculties to approach what is terrifying in a dream and considering it an opportunity to examine what may be fearful in real life. The better the interaction between the intuitive and the conscious, the less important dreams, emotions, and the messages from them become. When the intuitive system is bottled up, it is forced to find expression in the language of dreams dwelling in the quiescence of sleep. People who are very intuitive, who accept and rely on the guidance intuition provides, do not have so many disturbing or significant dreams as those who suppress the intuitive voice. These people are dreaming with open eyes toward a more fully awakened state.

Even after graduating from the dream school, one occasionally returns to the continuing education found in that realm, until consciousness has truly become One, and the question may still persist: What is the image and stuff of a dream? Popular conception has defined dreams as fuzzy, misty, half-formed, and wavering — no doubt because of the quickness with which they fade from memory and their elusiveness when we try to describe them. But in actual experience a dream may be, and usually is, acutely vivid. When painters set about exploring this other world, they choose to do it in forms of exceptional clarity, sharper than reality, so that the fantasy and unreality of the Visionary forms are intensified.

William Blake, the eighteenth-century English painter and poet, wrote:

A spirit and a vision are not, as the modern philosophers suppose, a cloudy vapor or a nothing; they are organized and minutely articulated beyond all that the mortal and perishable nature can produce. He who does not imagine in stronger and better liniments and in stronger and better light than his perishing and mortal eye can see, does not imagine at all.[1]

AWAKENINGS: RUDE AND RADIANT

Sandra had studied the painting techniques of the Old Masters with me, but in 1979, just out of high school, she moved to New York City to study fine arts at Parson's School of Design. At my suggestion, she contacted the great Transformative artist, DeEs Schwertberger, who had moved from Vienna to Greenwich Village not long after the seminars with Ernst Fuchs. DeEs's Studio Planet Earth at 32 Greene Street in SoHo magnetized many Visionary artists, writers, musicians, philosophers, scientists, and spiritual seekers in New York City from the mid-1970s to the mid-1980s. Sandra asked DeEs for private instruction in painting, and he generously agreed to teach her for free. A year later,

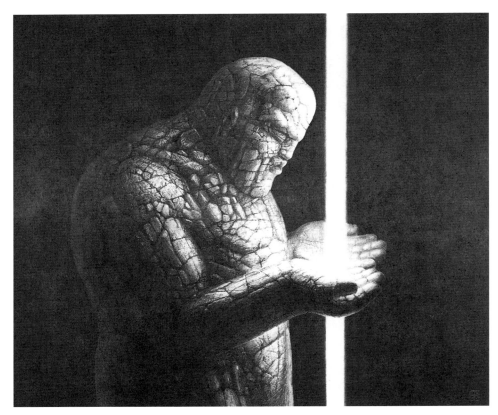

FIG. 25 DeEs Schwertberger, *Access*, 1978, oil on canvas, approx. 41 x 45 in. Artwork courtesy of Morpheus International, <www.morpheusint.com>

I moved to the city. I wasn't about to let this artist–angel fly away from me forever. Sandra had quit Parson's School of Design to study with DeEs. We moved into the basement section of DeEs's huge loft space. It was the first time Sandra and I would live together. It was so exciting being with Sandra in the capital of the art world! DeEs had kindly and single-handedly cleared the basement space that had not been used by a human being for decades. This was no easy task and equal to one of the twelve labors of Hercules, even for this small but unusually powerful bulldozer of a man. DeEs describes the two of us as having come from the same "short and wide tribe."

Assisting DeEs, we set up shop and began to teach seminars on the Old Masters' knowledge of painting in the newly renovated studio-school and residence in the basement. We taught this knowledge to students to enable them to manifest their inner vision and what they held as sacred. As mentioned, several former students of Fuchs have adopted a non-dual contemplative practice in life and in art, holding the spiritual promise at the heart of the Invisible Tribe, to expand beyond itself. There in the heart of SoHo, the combination of Old Masters' knowledge in the art of painting along with the nurturing of inner vision was a unique offering to the metropolitan area.

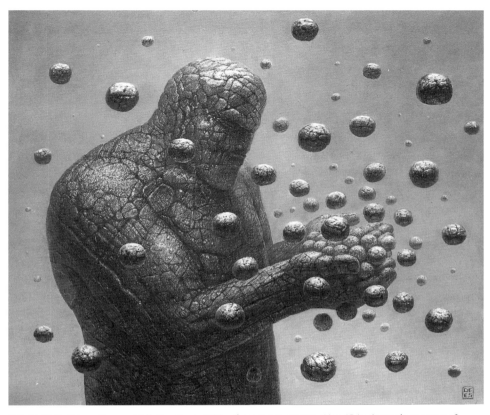

FIG. 26 DeEs Schwertberger, *Collective Power*, 1978, oil on canvas, approx. 41 x 45 in. Artwork courtesy of Morpheus International, <www.morpheusint.com>

DeEs grew very close to Sandra and me, and we renewed our relationships with some of the other former students of Fuchs who resided in New York City at the time. We also made new connections with other artists in the area. DeEs's ex-wife, Hanna Kay, a talented Israeli painter who had also studied with Fuchs (and DeEs himself), lived upstairs. DeEs had a new girlfriend, Sidney, who was an actress and pianist. She was a very talented, intelligent, and unusual woman. She practiced piano and singing and eventually tapped into her skills as an actress, securing work on stage. Mati Klarwein, the magnificent painter and peer of Fuchs, whom I have mentioned, would stop by on occasion to critique my work. Ingo Swann (see Plates 38 and 39), the artist, writer, composer, scientifically poked and probed, Stanford-tested psychic (originator-teacher of "remote viewing"), was also a frequent guest, ally, and supporter.

Ingo and I would go on outings together. He would teach me his method of "how to visit an art museum." This would involve wine, headphones, and one Walkman for mutual use. This was a plugged-in approach for two. Our first outing was to the Metropolitan Museum of Art, where we started off with a glass of wine at the café-restaurant. Then we proceeded to our first chosen wing, the paintings of the Pre-Raphaelites. Ingo plugged us

FIG. 27 *SoHo, New York City, 1980.* The "New York Visionaries." DeEs's girlfriend Sidney took a publicity shot of the group in the back alley of DeEs's studio at 32 Greene Street. In the front is Olga Spiegel. Behind Olga, from the left, are Isaac Abrams, Linda Gardner, Sandra Reamer, me, and DeEs, wearing his characteristic spectacles. Absent from the photo: Hanna Kay and Mati Klarwein

both into the Walkman, which would serve as our mutual source of music. Ingo would choose certain tapes for certain wings of the museum. For this wing he played cosmic music composed and performed by Tomito. We floated through the corridor of paintings as though on wings of wine and starry sounds. Finishing one wing of the museum, we would then return to the café for another glass of wine, then on to our next chosen wing of art, mutually plugged into a new piece of music to accompany our visual journey. God, this was fun! I highly recommend the Ingo Museum Method, at least once.

Other former students of Fuchs were also in the neighborhood: Olga Spiegel, Isaac Abrams, and Linda Gardner, along with Visionary siblings like Carlos Madrid (who later traveled to Vienna to study with Fuchs), Eve de Molin, and others. An aristocratic beauty and patron of the visionaries, Gigi Hopple, and Joseph, her brilliant husband and inventor of instruments used in microsurgery, also provided support. The well-known musician, Laraaji, contributed his celestial tones at the art openings and parties and later played during our ceremony when Sandra and I were married in 1981.

These marvelous days and nights were also a struggle, and at times we went hungry. I had to fashion a weapon out of an old broomstick with razor blades attached at one end to ward off the rats that infiltrated our basement studio-apartment. In the middle of the night I had to be ready with my rat spear to assume my chivalrous role as a rodent warrior. Though we did not have money or much to eat, we did have an abundance of

FIG. 28 *Central Park, New York City, November 1985*. On a return visit to New York, I hung out with my old artist friends, Carlos Madrid (middle) and Ingo Swann.

inspiration and laughter. There were times when we had to live on inspiration alone, on only our spirit for survival. Sandra, who had grown up in a rather comfortable environment, surprised me. She often seemed more acclimated than I in taking all the bumps, pains, chances, and risks that go with the struggles besetting an artist. She seemed to deal with all of our hardships with a calm acceptance, where I resorted to my fighting spirit and anger to get through everything. Being a creative worker, struggling financially, is a Promethean task that does not suit the timid. During this time, it was Sandra who took the waitress jobs and minimum-wage work to keep us going. She even had to wear a ridiculous uniform and little hat, but she was the cutest Visionary burger-server in town.

When the seminars with Fuchs at Castle Wartholz were over in 1974, the students had dispersed all over the world, returning to their respective countries, to small groups, cliques, or cloistered existences. I wanted to organize some of these artists, carry on the mystic movement in art, make the work and the artists established and accepted. I certainly was not the only artist in this extended group who was organizing exhibitions, events, publications, or lectures. In 1980, in New York City, I made a portfolio representing some of the first generation of Fuchs's students. There had been some continuation of group energy by other former students of Fuchs. The Austrians, Herbert Ossberger and Wolfgang Manner, and the painter Brigid Marlin (Plate 30) and her friend, the sculptress Diana Phillips had all organized a few shows. Likewise, Olga,

Isaac, and Linda had organized some art events but nothing that really stirred the critics or the media. From 1974 to 1978, I participated in exhibitions in the United States, Germany, Austria, and England. DeEs, Linda Gardner, Mati Klarwein, and a few of the other New York artists had some ties and connections to galleries there; still, there had not yet been a major group show of Fantastic art in America at a prominent gallery or museum since the original Fantastic Realists themselves debuted in 1966. I wanted to help change that. I am not an art historian, per se, and the following account reflects my personal experience, feelings, and perspective on things. Others, of course, may have theirs.

Although I did not have experience in the high-powered business world of art, I did have behind me some homespun exhibitions in upstate New York, an aptitude for organizational leadership, and lots of wise-ass chutzpah. What would work for me the most was confidence in this group of artists, our art, and an unwavering belief in the spiritual service we were offering. So I hit the streets of New York trying to make connections for a group of intensely individualized artists. My intention was to unify these artists of differing needs and egos, hooking us all up to a major exhibition on Madison Avenue. The associated artists met at DeEs's studio. I gathered their slides, photos, and résumés, and created a group portfolio which represented DeEs Schwertberger, Hanna Kay, Mati Klarwein, Isaac Abrams, Olga Spiegel, Linda Gardner, Sandra, and me. I asked Sidney, DeEs's girlfriend and future wife, to take publicity shots in the back alley of the Greene Street studio. Most of the artists were in their thirties and forties then, Klarwein was in his mid-forties at the time, Sandra was the youngest in the group at twenty, and I was twenty-seven years old.

The older artists were cynical and looked at me as though I was very young and naive to think I could secure a group show on Madison Avenue — some even laughed at me. Olga was encouraging. She is a very sweet, talented soul, and we have kept in touch over the years. But these artists had been living in the Big Apple and trying very hard to get a major exhibition for many years. Like me, Linda Gardner had also contacted Fuchs in 1972 and, along with Isaac Abrams, attended the 1972 summer seminar with Fuchs in Austria. DeEs, an Austrian himself, had studied with Fuchs in his native country in the 1960s and, with Mati and Brigid Marlin, was one of Fuchs's first students.

Regarding the coordination of exhibitions, they all said that they "had tried everything," but with little or no success. They were all very discouraged. I asked them all for names of galleries, and Graham Gallery was highly recommended as among the first places to try. Philip Graham had visited DeEs's studio before and Linda also knew him personally.

I went to the Graham Gallery alone. I was not discouraged, and in a short time I convinced the gallery director to come around with me to several of the artists' studios. Shortly after that, an exhibition date for the group was secured at the Graham Gallery, a very old and elite gallery on Madison Avenue. The exhibition was scheduled for May 18 through June 25, 1982, more than a year away. The gallery asked us to give our group

a name. This was difficult, as we were not really Fantastic artists in the pure sense. We had evolved into something else while maintaining the roots of our aesthetic. DeEs suggested "Transformative artists," a term used by the author and artist, José Argüelles. Others wanted to use the term "Visionary artists," which has, over time, become identified with the commercial art of New Age imagery, UFOs, unicorns, gardens of crystals, etc. In the end, against my better judgment, the exhibition and group would be called the "New York Visionaries."

Shortly after the good news, Gigi bought my painting entitled *Moon Child*, enabling Sandra and me to travel to Europe that summer. My secret intention was to propose marriage to Sandra in Paris, on the Eiffel Tower. I also wanted to visit Ernst Fuchs in Vienna and introduce Sandra to him and to other artists I had come to know on that side of the ocean. But when we arrived at the Eiffel Tower, it was closed for repairs.

Sandra and I walked outside the city along the canal. We came upon a park bench and rested at a beautiful and tranquil spot. It was late afternoon, sunny, and time seemed to slow down to a warm rhythm. Sandra laid her head upon my lap and looked up at me through her big sienna eyes that held the essence of some mythic tribe of deer women. The bluish whites of her eyes were like powdered angel wings mixed on a mother-of-pearl palette. Stroking her fine hair, sinking into the lunar pools of her sweet vision, falling into each other's eyes, I proposed, "Would you marry me?" And with the slightest Mona Lisa smile, she said, oh, so gently and softly, "Yes."

I love the handful of the earth you are.
Because of its meadows, vast as a planet,
I have no other star. You are my replica
of the multiplying universe.
Your wide eyes are the only light I know
from extinguished constellations;
your skin throbs like the streak
of a meteor through rain.

Your hips were that much of the moon for me;
your deep mouth and its delights, that much sun;
your heart, fiery with its long red rays,

was that much ardent light, like honey in the shade.
So I pass across your burning form, kissing
you — compact and planetary, my dove, my globe.
— Pablo Neruda[2]

The next morning we left France and made our way to Austria. When Sandra and I arrived in Vienna, Fuchs was home at his extraordinary villa and welcomed us with great

heart and excitement. I had brought him a special present, the large volume by Manly P. Hall titled *The Secret Teachings of All Ages.* He was very pleased. After our visit we left for Italy, and while traveling I recorded the following in my journal:

Milan, Italy *August 18, 1980*

Sitting in a park in Milan. Recalling my meeting with Ernst Fuchs at the villa in Vienna. Sandra, Fuchs's son Michael, and I sat with him amid the gold, glitter, and magnificence of the master's home. Fuchs was working on a recording for an album release. He had acted as singer and songwriter for this first album. I presented him with two books I had brought as a gift, The Secret Teachings of All Ages *by M. P. Hall and* Reflections of the Self *by Muktananda. Fuchs remarked how when he first began to sing in the late 1950s he had sought out this book,* The Secret Teachings, *in California. Now he said to me, "This is an omen, a completion of a cycle." Sitting next to each other, he slapped me on the knee as a thank you with applause-like happiness and said, "It is most unusual that you bring me this book now that I've started singing once again."*

The entry continues:

Before our visit and meeting with Fuchs in Vienna, we had reconnected in Reichenau at Pension Flackl. It was so good to see each other after seven years had passed. He drove up the hill in his gold and black Rolls Royce. His original mystical and erotic images veneered in wood were on the inside of his modern aristocratic carriage. Sandra and I were seated outside at a table overlooking the Alps of Reichenau's valley. The great artist got out of his car, took a few steps, and said very gently and softly, "Ah, da Phil is here." We walked toward each other, and he embraced me and in almost a whisper imparted, "Oh, my son, I thought you would never come back."

Later I initiated a conversation with Ernst that compared the Christian principle of the Trinity and the Holy Ghost with my experience, in part, of Shaktipat *with Swami Muktananda in India. As I look back at it all, I see myself serving as a psychic instrument or emissary for the Spiritual Art Center in the future that I will one day organize and manifest. I believe Fuchs will visit there, at least once, and meet Wilson as well. It was a great meeting of minds.*

While Sandra and I visited with Ernst in Reichenau and at his villa in Vienna, he shared his experience of living in California in the early 1950s where he lived very poorly, painting in someone's backyard. Neighbors, housewives, would look over their laundry lines and watch him as he worked in borrowed space on such remarkable paintings as *The Angel of Death Above the Entrance to Purgatory is Transfixed by the Angel of Light*, c. 1953–56, and *Psalm 69*, c.1949–60, and amazing watercolors such as *The Wedding of the Unicorn*, c.1952–60, and the *Battle of the Metamorphosed Gods*, 1951–58 (see Plate 11). The neighborhood women would yell over the clothespins hanging on the lines, "Ernst, you make such nice pictures, but what do you do for a living?" Fuchs moved around the United States, from New York to California, and despite the hardships, his work suffered no interruption. Of this time Fuchs said, "It was rather that my paintings, always with and

around me, were my real home." America's art scene was not ready for Fuchs. The young master took great solace in singing and the study of theosophy. Perhaps *The Secret Teachings* was a secret soothing to his soul which I had returned to him.

Ernst Fuchs was one of only two people I had known who had become intimately acquainted with theosophical literature; my friend, Dr Wilson Wheatcroft, was the other. I had found theosophy to be an excellent source for understanding various principles in ontology. In particular, the clairvoyant renderings found in such books as *Thought Forms* and *Kingdom of the Gods* affirmed many of my personal experiences and visions. Theosophy was central to my self-studies from 1975 to 1979, during which time I absorbed almost everything this school of metaphysics offered.[3]

My artwork of this period reflects the influences and inspirations that had evolved from both theosophy and direct experiences with Swami Muktananda. I spoke to Fuchs and briefly shared my experience in India with the Siddha, Muktananda, trying to fill in the years between our meetings, sharing how mysterious my time in India was. Fuchs's interest in this part of the conversation was only half-baked, as he was in the middle of being pressured by one of his sons to get involved in Scientology. Fuchs did not trust gurus and saw this activity as "culty," and he did not lean toward the eastern non-dual philosophies. Fuchs is truly a solitary mystic and must find his own way. Sometimes I see him as a master of master artists, one who has conquered not only the lost domains and the secret prime of styles but all the realms of the higher arts. Each of us engages a certain path, taking a turn when necessary, but only we can know when to do that for ourselves. In the waiting and playing, we are in samsara.

Even the *terribilita* of the great Michelangelo softened toward his death, as the deep within him was called toward the deeper. In 1554, ten years before the artist's death, he wrote a sonnet to his great admirer and biographer, Vasari:

The course of my long life has reached at last,
 In fragile bark o'er a tempestuous sea,
 The common harbor, where must rendered be
 Account of all actions of the past.
The impassioned phantasy, that vague and vast,
 Made art an idol and a king to me,
 Was an illusion, and but vanity
 Were the desires that lured me and harassed.
The dreams of love, that were so sweet of yore,
 What are they now, when two deaths may be mine, —
 One sure, and one forecasting its alarms?
Painting and sculpture satisfy no more
 The soul now turning to the Love Divine,
 That oped, to embrace us, on the cross its arm.[4]

Our European trip was at an end, and Sandra and I returned to New York and found that DeEs was away on business. Sidney, speaking for DeEs and herself, explained that it was time for us to move out (we had lived there for more than a year), and so we did. Sandra and I assumed we had worn out our welcome, and the heat bill in winter for our studio basement apartment had cost DeEs a small fortune. He had been very kind to help us out for a year. During that brutal New York winter, Sandra and I tried to save on heat by sleeping with our clothes on. We had made contributions through our food stamps, the money from Sandra's part-time job, the "New York Visionaries" exhibition on Madison Avenue that I had been instrumental in organizing, and my teaching of the seminar students. It was the best we could do, and it was a hard time for all the artists we knew and especially for the Invisible Tribe we belonged to. Of this Visionary family branch in the United States, only Mati Klarwein and Ingo Swann were doing well at this time. But Sandra and I had not forgotten the big break! The Madison Avenue show at the Graham Gallery was coming up soon. Perhaps this would change things.

Sandra and I packed our bags, I laid down my rat spear, and we quietly left the Big Apple, hitchhiking upstate, back to our hometown of Rochester. Just fifty miles outside of New York City, we spent the night in our sleeping bags on the side of the road. Early the next morning we were picked up by a truck driver named Jack. Now Jack was "married" to his rig, and his stories kept our interest for the next four hundred miles. When Jack got stopped for speeding by the state troopers, he got out, opened up the back of his truck, gave the troopers a few boxes of frozen salmon and onion rings, and went on his merry way. Jack was an interesting, gritty, and tough character, yet a kindness emanated from his dazzling, crystal-blue eyes.

Back in Rochester, with the encouragement of our friends Wilson and Jan Wheatcroft, we opened up the first contemplative art school in the state, perhaps even in the country. It was 1981 and we called it the "Art Institute of the New Age." At our school we continued to teach the knowledge of the Old Masters in painting as taught by Fuchs, but we also added a combination of other courses in meditation, contemplative and metaphysical studies, an art gallery, and a café to showcase local musicians. Sandra and I also hired twenty-two teachers, adding other studio classes, traditional and martial arts, philosophy and yoga. In addition, I served as an advanced teacher during this period for the Rochester Siddha Yoga Center under the auspices of Swami Muktananda.

Sandra and I were excited about the upcoming exhibition in New York. The Graham Gallery management would be spending a considerable amount of money on advertising. Sandra and I were both proud to be such young artists making it all the way to Madison Avenue. Our careers felt secure again, and we believed that we would be supported, recognized, and on our way. Money and security had become a central issue, and at times we went hungry. Had I lost the detached state and sense of peace achieved in India? Where did this need for recognition come from? What really made me happy was the fact that I had contributed to our fellow artists. It made me feel good to support a movement in art that was a spiritual service with an intention to expand awareness through providing

a transformative-aesthetic experience for others. I was proud of the group's spiritual integrity and mission.

A few months before the show, I decided to call the Graham Gallery in Manhattan to check on the arrangements for the transportation of our paintings and any last-minute needs for publicity, catalog production, and invitations that Sandra and I needed to contribute. The exhibition coordinator, a very "professional" and attractive woman, answered my call, informing me that: it has been decided you are no longer part of the show because you aren't New York artists any more, since you relocated to *Rochester*, New York. When I inquired how that decision was made, she would not give me a straight answer. Sandra and I felt deeply hurt, betrayed, and angry. Apparently, in the seven months or so that had passed since my initial role and since leaving New York City, other artists had gotten involved with the gallery management and left Sandra and me out of the process. Sandra's and my being excluded from the exhibition was not a question of our paintings standing up to the rest of the artists' works. Many would say that our work was stronger than some of the others. We were quickly informed by some of the former students who had studied with DeEs and me, as well as other close friends in our circle, that the decision was made by two of the artists in the group, and the others went along with it. We were told that the group merely wanted to be able to place two more paintings each or larger works on the walls of the gallery, and the group added another artist (Isaac's wife) in our place. I do not know if any of that is true, or how Sandra and I were eliminated, but we were. The rude thing was that more than a year had passed since we left New York and the show was secured, yet Sandra and I were never included in any discussion in all that time. We simply discovered in the eleventh hour that we were eliminated.

As a young painter I had assumed that all artists involved in creating spiritual works of art also practiced a spiritual path and code of ethics — not a good assumption, and obviously not always true. The so-called Visionary exhibition and movement I had contributed to putting together had backfired on me, and this became a hard lesson for me in unconditional love and service. I never really received any genuine acknowledgement or gesture of gratitude from any member of this group of artists for having been instrumental in securing this exhibition. On the contrary, I was once berated by one of the artists for even suggesting that it was I, after all, who had made it happen, regardless of who knew whom, or who did what. All of my involvement was forgotten, literally swept under the rug. There was neither an apology nor an explanation ever given to Sandra and me for having been bumped out of the show.

At a certain stage of development, artists will cling to the vision that has been revealed to them, and those artists will attach their personal egos to that vision. Not unlike each religion claiming a "copyright" on God, each artist will claim his or her patent on the vision revealed to them, or the tradition they are serving, to the exclusion of other visions, other artists, other truths. A generous and philosophical outlook unfolds automatically as one's vision expands beyond preoccupation with that favorite idol of immaturity, the

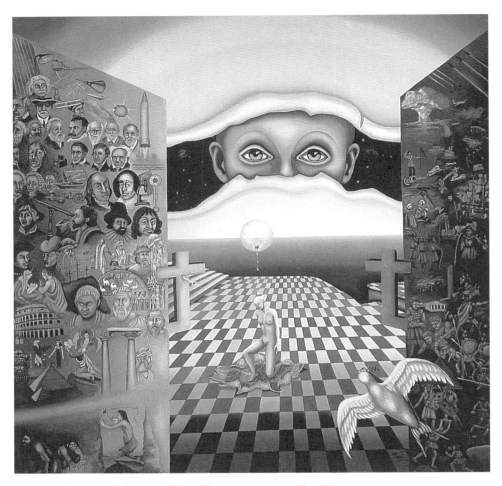

FIG. 29 Mariu Suarez, *Evolution*, c. 1980, acrylic on canvas, approx. 48 x 48 in.

strutting and self-proclaiming ego. The wise person's understanding of others derives not from a callous judgment of them but from a sense of their shared humanity with his or her own. This insight is born of deep kindness, compassion, and good humor. Wisdom arises naturally from a calm acceptance of life's vicissitudes. I aspire to such qualities, yet after this experience, I pulled back from contributing any more of my organizational skills to the Visionary art movement for many years.

Other Transformative artists attempted to reorganize into another group to continue the effort in New York. A stunning Colombian artist named Mariu Suarez (see Fig. 29) got involved and, with her positive determination but strong opinions, butted heads with the multitalented Ingo Swann, who equally held to his views. The elegant Carmela Tal Baron and sophisticated Jim Harter also tried to keep the momentum going. Mariu's, Carmela's and Jim's writings have been very articulate and inclusive on the subject of Visionary art, and, of course, Ingo is the author of *Cosmic Art* and a number of other books. For nearly two decades Carmela has given presentations and lectures that have

included many of the artists mentioned here. Mariu's husband established and financed Tomorrow's Masters, an art agency representing the works of his wife, Schwertberger, Klarwein, Orozco, Kay, Abrams, Spiegel, Sandra, and me. Mariu had a few sales from the promotions, but the rest of us did not, although her intentions were good.

Mariu also enlisted the curatorial consultant and expert on Veristic Surrealism, Michael Bell, to advise the group. Bell was a curator who, as the story has been related to me, was pushed out of the San Francisco Museum of Modern Art for heroically endorsing and documenting Visionary artists and Veristic Surrealism. Bell secured a number of our artworks from us, on slides, for the permanent slide library at the museum, and he has given presentations and lectures on Visionary-Transformative artists at universities across the country. His service to the movement and awareness of Transformative art is well documented and honored.

In the Big Apple, the politics flared. The new group, which usually met at Ingo Swann's, included Jim Harter, Carlos Madrid, Olga Spiegel on occasion, Carmela Tal Baron, Mariu Suarez, and others. They solicited other artists such as Alex Grey, who was not really interested at that point with the new group, or "groups," in general. DeEs Schwertberger, Mati Klarwein, Hanna Kay, Sandra, and I fell back. Ingo, not only an accomplished painter and author but a knowledgeable art historian as well, did not see eye to eye with Bell either, and leadership issues soon dismantled all efforts. Gigi continued her support, but to no avail. She would call me and ask for my help, expressing her frustration with the group's disharmony. However, not living in the city any longer, feeling bitter and betrayed over my efforts with the original group and the Graham Gallery exhibition, I did not want to be involved at that point. Yet the artists who were involved had gained a great experience in just connecting to one another, and over the years, both individually and through intermittent contact, their creativity would bear fruit to the world.

Sandra and I observed from a distance, receiving letters and group minutes from various conflicting factions in this latest incarnation of New York Visionary artists. As I said, over the years many of the individuals who were part of this group continued to be highly active, continuing with their individual ideals, projects, and creations. Ingo Swann, Olga, Isaac, Jim Harter, and Carmela Tal Baron have all kept the fires burning. Carmela has kept a positive attitude and energy. Where most of these artists have kept to traditional methods and materials, Carmela, as well as Isaac Abrams, has produced work as an interdisciplinary artist. Most of Carmela's recent focus has been on the theme of light. I was very impressed with her light-box piece titled *The Seven Veils*, 1989 (see Plate 22), in which music inspires a three-dimensional art that mimics layers of matter being emanated from a divine illumination. I remember Carmela as a charismatic woman, very determined, intense, and focused. But it seems that the dynamic qualities that each of these artists individually possessed may have prevented a group energy from occurring.

Then, something very wonderful occurred regarding the exhibition I had helped to create. In essence, it succeeded beyond my expectations, as *Arts Magazine* reviewed the

exhibition at the Graham Gallery. This was great, as fifteen years had passed since the American media and critics had acknowledged the "artist as mystic" during the Austrian invasion of the Fantastic Realists in 1966. *Arts Magazine*'s critic, Stephen P. Breslow, raised the questions once again in the art world:

Forgotten for at least a decade and scorned by the bulk of the American art establishment throughout their careers, a group of artists variously labeled psychedelic, visionary, or transformative, is now emerging in a newer and stronger formation than ever before.

... they trace their immediate genesis as a group back to the Austrian painter, Ernst Fuchs. Most of them met in the early Seventies while studying at Fuchs' school of "fantastic realism" in Vienna.

Breslow continues:

More than fantasists, they dream up forms, particularly entire environments through which these forms (animate, inanimate, or purely painterly) move fluidly and naturally with an inherent credibility. More than most fantasists, science fiction illustrators, or Pre-Raphaelites and the like, these visionaries postulate another reality with a poignant, enduring tenacity. Whether they meditate, pray, take psychedelics, travel through astral bodies, or have direct visions of God, they paint their visions as if they existed in fact continuously, irrepressibly, in front of their eyes.[5]

In my opinion, the artists were given a fair review. Abrams was described as a "psychedelic" artist and given a warm reception. Schwertberger was the most positively reinforced of the group, and his "stone-like victim'" was likened to the mythical Sisyphus. Breslow praised DeEs's paintings as a profound recognition of universal matter corroborated by existential philosophy, LSD, and Zen Buddhism. Ultimately, Breslow defines Schwertberger's vision as more Blakean than existential, relating it to the more traditional iconography of visionary Christian art. Hanna Kay received a brief comment on her unearthly, hauntingly provocative trees that levitate above the surface of the earth. Spiegel's work was related to science fiction and architectural civilizations of super-technological wizardry. Gardner and Hertzer (the wife of Isaac Abrams, and whose work was added to the show after Sandra and I relocated to Rochester) were not so well praised by the critic — quite the contrary. Mati Klarwein, the most financially successful and widely known artist in the exhibition, was described as being more of a Surrealist than one who draws on the processes of a Visionary — and in this, I strongly disagree. Mati was, and is, truly one of the greatest transpersonal Visionary artists in the world, and his work has ranged from realism to Surrealism to what I can only describe as mystical precisionism. Mati has not been afraid to experiment in his work, and his imagery combs the most complex realms from which, on occasion, he escapes to a sea of Zen-like simplicity. His amazing paintings have been eye-openers — provocative, sensual and erotic, intellectual, spiritual and irreverent, mysterious, sublime, humorous — and have always been an inspiration to me and many, many others.

In general, the artists were fortunate to have had Breslow review the show as opposed to many other art critics less educated, sensitive, and well rounded. Critics have rarely understood the process, experience, and expression of a Visionary artist. For that matter, even artists themselves can be unfamiliar, confused, or even disbelieving when it comes to the creative process, transcendental aesthetics, and experience. For example, while working at Naropa, I heard Allen Ginsberg lecture on numerous occasions, and his poetry readings were always memorable events, his words and energy coming together in a great celebration, a wonderful childlike joy. Allen was an incredible human being and tireless servant of a number of causes. But when Allen spoke on William Blake's cosmology, I would begin to feel he was insinuating that Blake was not a "visionary" who saw into other realms or experienced visitations and visions. Ginsberg described Blake as having invented an artistic spiritual system of cosmology that archetypally mapped the consciousness of man. Within this framework, Allen provided provocative insights — for example, that Blake's character "Urizen" is a phonetic personification of "your-reason." Blake's mythology of consciousness in other characters like Los, Enitharmon, and Luvah appears in his poetry from the Prophetic Books and do contribute to a devised cosmology, but invention does not eliminate "visitation" or a true vision of Spirit. Whether or not Allen Ginsberg recognized Blake as a visionary mystic or image-engineer, I am not alone in my opinion that Blake also had visions, tapped into other states of reality, and perhaps, other realities tapped into and visited him.

IT IS NOT WHAT THE VISION IS, IT'S WHAT THE VISION DOES

Blake was born a sacred visionary-warrior. At the age of four he told his parents that he had seen God's face at the window, an incident frequently related to indicate his visionary nature but one common enough in children at that age. At the age of seven his vision of the prophet Ezekiel in the fields surrounded by angels in trees was more exceptional. The wings of the angels were "bespangling the boughs like stars." Even if this description, as quoted much later by his wife, has the benefit of hindsight, it is quite in the spirit of Blake's art, temperament, spiritual attainment, and powers. From his wife, too, we have the description of Blake's death, certainly as jubilant a passing as has ever been recorded. He was seventy years old and confined to bed where he worked on a set of drawings illustrating Dante. On the day of his death, he called to his wife and told her, "Kate, you have been a good wife; I will draw your portrait." He proceeded to do so for an hour as she sat by the window, and then, according to her account, "He began to sing Hallelujahs and songs of joy and triumph, loudly and with ecstatic energy. His bursts of gladness made the walls resound," and then he died. This was a man who had suffered poverty and scorn and had been forced to live on the thinly disguised charity of friends.

In the eyes of many, Blake, like so many Visionary artists of extreme individuality, must either be accepted without question or completely rejected. He is either mad, manic-depressive, or a rare artist privy to exalted states of experience and perhaps

visitations. The field of psychology has matured enough, in certain sectors, to acknowledge that such an extreme evaluation is a harmful one, as it could propagate misconception and ignorance. Even madness itself does not have to be a condition considered permanent, an uninterrupted state of insanity. When madness does occur in the mystic, it is usually for a brief period, and when in the artist, it is only a short visit from the muse or a passing, divine creative fever. Blake's paintings and engravings are ecstatic and thrilling visions or, as some critics would say, conscientious, obviously labored illustrations based on forms cribbed from Raphael and Michelangelo. "Fable or allegory is a totally distinct and inferior kind of poetry," wrote Blake. "Vision or Imagination is a representation of what actually exists real and unchangeably." That for him there existed no boundary between tangible fact and what the "normal" person would see as visionary fabrication brings Blake close to lunacy by definition. He might, indeed, have ended as a confined lunatic if his wife had not combined unquestioning faith in his appointed role as a spiritual messenger with a capacity to hold her husband's body and soul together.

It can be said that the heated debate around what constitutes madness in the artist has circled around the life of William Blake more than any other artist in history. The debate: Was he or was he not mad, was he or was he not a mystic, a visionary, or indisputably insane, depressed, or in the dark night, manic or in states of ecstasy and illumination? Much of the hoopla and concern begins to stem from the premise that *mad* is *bad*, a solid and fixed state without periods of rational and lucid thought. This premise precludes that great art cannot come from madness and that great artists cannot be mad. Yet the stigma of artists being eccentric and crazy is still very much alive and ingrained in western culture. Diagnosing Blake as anything at all does not detract from his extraordinary work or make him any less an artist. Seeing Blake as a person who suffered from an occasional illness, manic depression, exalted states, and periods of despondency only commits him to a general predisposition shared with many artists, writers, and composers.

The "mad genius" versus "healthy artist" debate continues for a variety of reasons. The confusion over what is actually meant by "madness" and the lack of understanding around the nature of manic-depressive illness (one of the forms of madness) are closely bound together. In addition, the tendency to accept a link between psychopathology and genius and the regarding of bizarre and eccentric behavior in the artist as normal has become ingrained in the cultural fabric. Are artists and society itself experiencing a self-fulfilling prophecy that creative workers ought to act the part of the "tormented genius?" We have already explored whether melancholy, oddness, or manic-depression is a special form of illness found in artists due to the strains and anxieties their lives attract, or imposed on them by the culture through exiling the use of their talents. Further confusion results from attempting to unequivocally categorize thought, behavior, and emotion as sane or insane, which defies common sense and the knowledge that states of consciousness include infinite varieties and gradations, as does physical health. Many mystics and artists who temporarily abandon reason may hallucinate, have visions, hear voices or music, smell

divine aromas, exhibit strange behaviors, and act irrationally for limited periods only. All these "symptoms" can occur to the mystic or the practitioner of one of the many different yogas and contemplative practices that inspire illumination.

Currently, we could say that to think that creativity and mental health are unrelated contradicts two widely held beliefs. Two banners are being carried in the psychology community: one banner represents creative activity as a sign of mental health; the other, as a sign of illness. The flags on both sides have been waved by Freud, Jung, Maslow, Wilber, Rollo May, L. S. Kubie, F. F. Flach, A. Koestler, M. Dallas, E. L. Gaier, and many others. Approximately every five years or so, the field of psychology releases a new revelation on the distinction between genius and madness, creativity and the theoretically associated pathology of the artist. Was Blake a lunatic, or was he receiving a visionary imprint from some higher order of reality?

The tortured poet or ecstatic artist attracts our attention, and erroneously we believe that mental torment or states of extreme passion or mania is necessary, or at least is proof of illness. In my opinion, current investigation in this area is articulated particularly well by Dr Kay Redfield Jamison, who also adds very intriguing and essential questions. Dr Redfield Jamison, in her studies of pathology and artistic temperament, wisely suggests the following:

Finally, there must be serious concern about any attempt to reduce what is beautiful and original to a clinical syndrome, genetic flaw, or predictable temperament. It is frightening, and ultimately terribly boring, to think of anyone — certainly not only writers, artists, and musicians — in such a limited way. The fear that medicine and science will take away from the ineffability of it all, or detract from the mind's labyrinthian complexity, is as old as man's attempts to chart the movement of the stars.

Dr Redfield Jamison continues:

What remains troubling is whether we have diminished the most extraordinary among us — our writers, artists, and composers — by discussing them in terms of psychopathology or illness of mood. Do we in our rush to diagnose, to heal, and perhaps even to alter their genes — compromise the respect we should feel for their differentness, independence, strength of mind, and individuality? Do we diminish artists if we conclude that they are far more likely than most people to suffer from recurrent attacks of mania and depression, experience volatility of temperament, lean toward the melancholic, and end their lives through suicide? I don't think so.

… No one knows for certain where any of our knowledge — scientific or artistic — will take us, but that has always been so. Uncertainty, romantic imagination, and mystery tend to weave their way throughout both the scientific and artistic fields of thought and experience.

… The great imaginative artists have always sailed "in the wind's eye" and brought back with them words or sounds or images to "counterbalance human woes." That they themselves were subject to more than their fair share of these woes deserves our appreciation, understanding, and very careful thought.[6]

I believe that we can, in certain cases, associate creativity with certain mental disorders, since various defense mechanisms initiated by the ego when the mind "dis-integrates" will utilize highly inventive processes to restore or maintain balance. This is because creativity, in essence, always makes things whole. I think the mistake in many psychological theories is the belief that creativity of a visionary nature is a result of dis-integration, when it is actually a result of *integration*, or re-integration. Creativity builds, it does not destroy. The state of madness itself cannot always be legitimately defined as a state of dis-integration, and creativity cannot always be legitimately associated with madness. Yet psychology informs us that creativity and psychosis can become, on occasion, commingled.

Some of my students have asked me if mania, depression, or mental instability is the price a woman or man must pay for being an exceptionally creative artist. They perceived art as having driven the likes of Sylvia Plath, Vincent van Gogh, Mark Rothko, Virginia Woolf, and so many others into madness. Many psychologists would say that great poetry does not cause suicide, but great art like van Gogh's last paintings and Sylvia Plath's last poems perhaps can fend off insanity — for a while. I do not think art is dangerous (except to dictators and totalitarian governments); it is the circumstances that bring it forth that can, at times, be risky, even perilous. It is also the failure to express the passions with refined vehicles of expression that may be fatal. In my view, and in light of transpersonal and contemplative innovations in psychology, mainstream and conventional efforts in that field seem somewhat narrow, limiting and more than reluctant in assigning the creative process a more elevated role over psychopathology.

It should also be understood that any culture that does not consciously integrate the gifts that an artist offers then sentences that artist to the status of "outsider," whereupon artists relentlessly and often futilely attempt to integrate their gifts from the *outside in.* Certainly, such a set-up can induce illness; superhuman tenacity, bitterness, or compassion; or a complex combination of other paradoxical traits. In addition, this cultural set-up of the artist, and particularly the transpersonal artist, is enough to drive anyone mad. Perhaps the real truth here is not that the artist has an abnormally high level of pathology, but that the cultural collective mindset itself is sick, and the artist as "outsider-healer" is being inversely addressed as the "patient" who doesn't fit into the collective psycho-virus. This is a kind of *King of Hearts* syndrome (as in the film): We can argue that the artist is really the healer trying to bring curative and transpersonal elixirs to a world gone mad, from people suffering from repression, ignorance, prejudices, and cultural illusions, to a psyche imprisoned in a delusion of materialism and an unquestioned philosophy of scientism encasing their spirit. The artist disrobes the psyche, liberating its beautiful, naked spirit.

Artists are channels for cultural feelings and creators of images that the culture is hungry for and doesn't even know it.
— Vickie Noble[7]

Creativity can be a sign of meta-mental health in an individual. Certainly another mistake of mainstream psychology's research on creativity occurs when it links the creative force only to the life of the ego, ignoring or dispelling spirit. To look only at creativity as an adaptive operation by the office of ego central, by which the ego resolves conflict and legitimizes fantasy, is to sell creativity short. Creativity requires much more than conflict, and especially in the case of visionary phenomena. Isn't spirit of a divine source, as opposed to ego? Is the ego more solid, more visible than spirit? My problem with conventional psychology is that the spirit or soul of a human being is not acknowledged (we simply do not have one; we have an ego). Furthermore, the problem facing psychologists in the study of creativity is that if they haven't experienced creativity themselves, then they are limited in the ability to research it, because it is, in origin, a subjective phenomenon in which "productivity" is but one element of a process of invention, and therefore in psychological revaluation as well.

This does not mean that these researchers must reject or abandon knowledge or experience that they have already gained. What it does mean is that, as creativity itself permits us to do, they must understand the workings of creative spirit. They must recognize in the context of *research itself* that they should *adopt a creative mind* to *study the creative mind*. Therefore, they would need to adopt, or at least acknowledge, characteristics that can tolerate ambiguities with less anxiety, be better able to integrate thinking processes that seem diametrically opposed on the surface, rely as much on intuition as on intellectual analysis, and actually learn about new discoveries relevant to the work and do so without fear. This is no easy task. Realizing that what they are sure of now may be proved untrue tomorrow and that every answer is but a parent to a host of new questions, is the very essence of creativity. The more that researchers can understand about the practice of the art and science of creative thinking for themselves, the more they will understand it in the artists, thinkers, scientists, and creative workers they are investigating. When studying the creative, even though employing scientific method, one cannot limit that investigation by excluding the phenomenon of intuition, for intuition is the ground on which creativity stands the tallest; it is the threshold to spirit. Unfortunately, materialist-scientists do not incorporate the faculty of intuition into their work or daily life and into creative endeavors.

Blake is a perfect case study in metacreativity. If he was not insane, then where and what was his source, and how did his visions come to him? We will revisit the life of Blake in the next chapter to lend some credence to a personal story I will share and to touch on the question a little more: Was Blake a lunatic, or was he seeing into realms that the masses do not? How does an artist reach such heights of vision? It is here that the idea of warriorship enters the creative domain. It takes courage to fully enter the present moment with one's heartfelt response, then turn this attention inward upon the unique landscape of one's soul, then turn again, outward, in expression. This level of creative action involves experiencing life without comfortable belief systems and psychological defenses. Warriors, contrary to what one might think, have the courage to open their hearts and

be *more* vulnerable to life, not less, and thereby they offer a valuable service to others. Freud pointed out that the artist uses this vulnerability equally with, if not more than, the power of fantasy. He wrote that the artist can remove what is too personal from his work which might repel responders and make it possible for the masses to share in the enjoyment and release of deeper feelings. Freud reminds us that the artist possesses a mysterious power of shaping a material into a faithful image of one's fantasy. In addition, the artist can offer the pleasure of unleashing unconscious forces and providing others with a cathartic release from emotional imprisonment. This important service and vulnerable openness of the artist, and lack of repression, allows other people to derive a consolation, alleviation, revelation, and inspiration from sources of pleasure that were previously inaccessible as public domain. This is central to creative activity.

In many ways my experiences in New York peeled open my dreams, awakening me to a greater purpose. Personal dreams were crushed in order to serve a higher vision, a larger purpose. I learned that real vision cannot be understood in isolation from the idea of purpose. Working so hard and believing so strongly in the New York group of Visionary artists that I had given my organizational energy to, and feeling so betrayed, split my heart open. Through this disappointment, I had come closer to understanding my larger purpose, my reason for being alive. No one could argue with me that human beings have purpose. We all have a purpose in life. I had learned discretion in serving vision and working for purpose. Most everyone knows what it's like when work flows fluidly, when one feels in tune with a task and works with a kind of feverish bliss that also seems easy. You can recognize your personal vision in the workplace because of this "ease in making"; it is the goal pulling you forward that makes work fulfilling.

Vision is different from purpose. Purpose is abstract. Vision is concrete. It can be said that nothing happens until there is vision. But it is also true that a vision with no underlying sense of purpose, no calling, is just another idea — all thunder, no en-lightning. Vision is setting a new objective, a smaller thing. Purpose involves a goal, a larger thing. After the vision has (or has not) been achieved, it is your sense of purpose that draws you further, that compels you to set a new vision. This is an ongoing practice, a discipline and creative process that continually focuses on what one truly wants, on one's purpose. Vision is multifaceted and stretches from personal needs in a material world to the service opportunities in helping others. Vision contributes to the state of knowledge, uplifting the spirit, and when coupled with purpose, can perhaps change the world.

It takes great courage to hold and stand for one's vision and purpose. In these times, society tends to direct our attention toward the material aspects and yet nurtures guilt over our material dreams. Personal desires can be reinforced by society when they are aligned with mass marketing and advertising; for example, looking fit and trim is a national obsession. But there is little or no emphasis from society on our desires to serve. In truth, many are made to feel naive or foolish by their desire to make a contribution. It is clear that it takes courage to go forth with visions that are not honored by the social norm.

When Sandra and I were left out of the exhibition in New York, I felt I had failed. Later I saw that it is not what the vision is, it's what the vision does that is most significant. Mastery of the creative process transforms the way one views phenomena, revealing the gaps between vision and current reality. Simply put, New York awakenings had peeled my dreams, revealing underlying visions and an essence and a larger purpose that was clearer, and of greater import, than the visions themselves.

A vision without a task is but a dream,
a task without a vision is drudgery,
a vision and a task
is the hope of the world.
— From a church in Sussex, England, c. 1730[8]

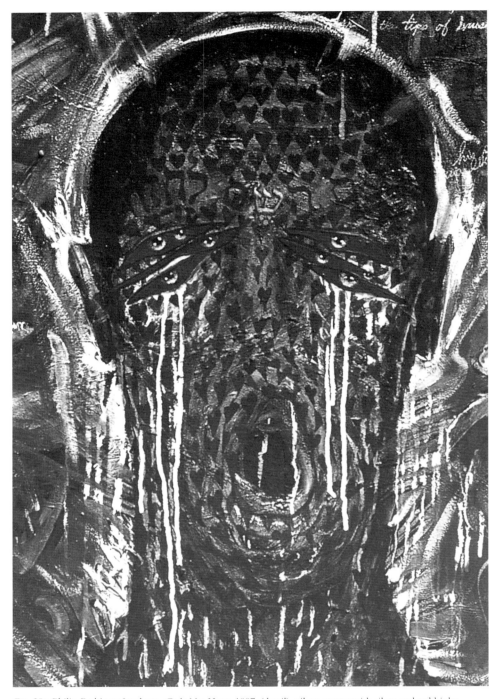

Fig. 29A Philip Rubinov-Jacobson, *Gods Not Home*, 1997, (detail), oil on canvas with silver and gold inks, 36 x 36 in.

Chapter 4

Broken Neck — Big Angels

SIRENS AND SILENCE — A SPIRITUAL EMERGENCY

In the spring of 1996, while on my way to Russia to teach seminars on creative empowerment and meditation, I checked my baggage at the airport. On my way through the gate, I wondered if the metal plate inside my neck, holding my spine together, would beep when I passed through security. Entertaining myself, I thought, "Well, you've become a Visionary artist whose head is bolted onto his shoulders." Settling into my seat on the plane, I recalled the events that had led me to the Boulder Community Hospital emergency room just eight months earlier.

September 1995: I awoke to discover my left leg paralyzed and my kidneys shut down. I had been experiencing strange symptoms for months that would come and go: pain, numbness, and fatigue, probably due to whiplash that had occurred in a recent automobile accident. As the months passed by, these symptoms intensified. Doctors tested me for arthritis, muscular dystrophy, and a number of other things but never thought to X-ray my spine. Even at my suggestion of a pinched spinal cord the doctors laughed and said, "If that were so, you wouldn't be able to walk or move your arms!" Yet in those eight months that I was walking around very strangely, I was indeed suffering from a ruptured disk in my neck and a pinched spinal cord that worsened by the day as the shattered bone matter pushed increasingly against it. As the surgeon in the emergency room later put it, it was "the worst herniated disk that this hospital has ever seen, with the spinal cord pinched to a thread," and he himself performed more than two hundred and fifty operations of this kind a year.

That September morning, as usual, I had awakened alone. Sandra was several thousand miles away, beginning her third year of postgraduate work at Pratt Institute in Brooklyn. My left leg was paralyzed, and I had an overwhelming urge to urinate but couldn't. The urge would not subside, and the ability to accomplish the task would not engage. Limping to the phone, dragging my left leg, I called one of the doctors who had seen me previously, and he said that I should go to the hospital emergency room immediately and request a CAT scan. Apparently, his inclination was to think I had a brain tumor of some kind, so I called my sister Jessica and she left work to take me to the hospital. As time passed, the paralysis spread, and there was numbness in some areas of my body and pain in other spots. A neurologist examined me and ordered that an MRI be performed immediately, as he believed that I had a tumor on my spine, not in my brain. Jess took me over to the building that conducted radiology tests. With the left side of my body almost totally paralyzed, I hobbled to the wheelchair offered to me. I was anxious but still unaware of the severity of my condition. I was wheeled to radiology and then placed into a metallic cylinder, a

tubular camera that would photograph my interior structure. It was uncomfortable, and I was told not to move at all for the next hour during the MRI. When they rolled me out of the machine, the nurse and radiologist came over to assist me off the gurney. I could not sit up. I could not move. I had become totally immobilized. They were unprepared, and not realizing the extent and progression of my paralysis when they tried to lift me off the table, I fell to the floor. How much more damage could have been done? The radiologist ordered the wheelchair and an ambulance team to be brought in while the nurse propped me, on the floor, up against one of the legs of the MRI machine. At this point, I was only a head atop a mass of inanimate flesh. I was, without question, paralyzed from my chin down with a minimal amount of sensation and movement mysteriously remaining in my right forearm and hand. This was devastating, my worst nightmare come true.

I had brushed with death a number of times in motorcycle and car accidents, drug overdoses, and street violence involving deliberate threats on my life. I had overcome poverty, artistic rejection in all shapes and sizes, and the loss of many loved ones. Through all this I did not have the aid of therapists or a wealthy family, although later in life I was blessed for about fifteen years with the support of a wife who loved me unconditionally. I had survived journeys to dangerous realms and places that existed in both the mind and in the world — I had faced monsters, both real and imagined. I had been given the opportunity through extraordinary challenges to become fearless and more loving. As a result, I had become a warrior. That did not mean a destroyer, killer, or rapist, the shadow side of the word, but the kind of warrior that Carlos Castaneda described in *Tales of Power.* "The basic difference between an ordinary man and warrior," explains the Yaqui shaman Don Juan, "is that a warrior takes everything as a challenge while the ordinary man takes everything either as a blessing or a curse."

The warrior meets life head on. But … *paralyzed*! In my view, paralysis was a fate worse than death, my greatest fear, my fiery spirit encased in a frozen body. (Thus my admiration for the physicist Stephen Hawking, and indeed, anyone challenged with physical disabilities.) I could not explore the thought. It deeply frightened me, and the notion just fell into the "it will never happen anyway" category.

I sat there on the floor after the mishap on the gurney. For a few moments I was left there alone in the high-tech, sterile radiology room. The ambulance arrived, and I felt I was scooped up off the floor like some large piece of dust. I felt I was losing my dignity as a human being. Other members of the team prepared the ambulance to receive me as I sat and thought of my present and my future. I felt helpless, and I was frightened as I contemplated my end as an artist and as a man. My only solace was the sympathy in my sister's eyes. I was whisked back by ambulance to the emergency room just across the street to await the arrival of the neurosurgeon. In a way, I began to find the situation a bit ridiculous, even funny, as the ambulance shuffled me from one building to another, a mere one hundred yards away.

Lying on a hospital cot in a curtained-off emergency room, I waited. Jessica was on the phone notifying Sandra and other family members, checking in with me occasionally to

let me know that she was there and that Sandra would be in from New York the next day. But, I thought, that may be too late. I wanted to look into my wife's eyes one more time *before* the operation, before paralysis could become permanent as suggested by the surgeon. But I was in Boulder and she was in New York, and the airlines could not bring her until the following day. I asked my sister to call my friend and co-worker, Steve Glazer, a Buddhist practitioner and a sweet angel of a man with a shiny mind. At my request, she asked him to pray for me, which he generously did all night long.

A nurse came in and inserted a catheter into my penis, and while this was awkward, it was also a little painful, and I realized that I still had some sensation left. My brother David, a prominent staff member on the administration of the University Medical Center in Tucson, was ready to have me transferred to his hospital by emergency medical transport where I would receive the best of care. When the neurosurgeon arrived, he spoke with David on the phone and assured him that there was no time to lose. Every moment of delay would decrease my chances of recovery and increase my chances of permanent paralysis. He told David that it was better that I remained where I was. Prior to the operation the surgeon asked me to sign a paper that released him of any resulting negative conditions of the operation. The list seemed endless, including loss of mobility in my arms and legs, loss of sexual function, kidney function, and so on. I signed the paper with fading strength and tolerated the pain in my right hand. I said, half-jokingly, "Why don't you just list me as a surviving talking head only, instead of all the failed parts of a whole?" When he asked if I had any questions, I told him I wanted the complete truth of my chances of recovery. The doctor, turning his eyes away from me, reluctantly said that I had a fifty-fifty chance of walking again after a long period of physical therapy. I could tell he wasn't being completely honest or confident in that statement. Later I discovered that the surgeon had told my brother David, before the operation, to start looking into services for a quadriplegic. He told David that I was not expected to move again, and if I did, then it might be three months to a year before I could begin even moving my toes.

The hundreds of paintings I had done flickered within me like an animated movie. I imagined paintings with lives of their own, living on the tiny surfaces of white, round canvas cells in my bloodstream, imprisoned, forever circulating inside me, with no way out. All the potential paintings and art I had yet to do in the future was dying in me, drowning in the crimson river of paralysis. The children my beautiful wife and I had not yet co-created, the places we had not yet been to, the friends we had yet to make, the people we would meet, our spiritual journey together, our adventures, my work in the world as an artist, educator, and administrator — all the potentials wrapped up in each moment of our lives that I had taken for granted were now only a wisp of a possibility.

It had been seven hours since I had checked into the hospital, and I had been fully paralyzed for as long, partially paralyzed for several days, and in pain for many months. It was now almost midnight. I cried inside but would not let myself release the tears. Crying would not serve any purpose now as a release or anything else. I needed to stay active,

aware, alert, and bold. But I became listless, and my spirit was fading rapidly ... Then in the stillness of my body, in the quietude of my heart, I heard these whispering words, "You are needed to serve more, there is much work to be done, you are needed, spirit and body, spirit and body." The words were like an answer to a plea that arose from within me. It was not a desperate cry for me to walk again, a cry to some Daddy/Mommy–God in the fluffy clouds of the sky: "Dear God, I'll be good and promise to do so and so, if you only do this or that ..." It was a request and a response, all in one, all within itself. In part, it came as a result of working a long time with creativity, experiencing inspirations, and following a kind of intuitive guidance, a deep listening ...

You need not leave your room. Remain sitting at your table and listen. You need not even listen, simply wait. You need not even wait, just learn to become quiet, and still, and solitary. The world will freely offer itself to you to be unmasked. It has no choice; it will roll in ecstasy at your feet.
— Franz Kafka[1]

Where is the power and creativity in paralysis? Where was the passage hidden within the obstacle, to go through, to overcome, that I had always found in the past, always moved through in a crisis? Where was the teaching in the situation? Conditions of which we are unaware hold us prisoners. States of being which are still untouched and we cannot see isolate us from a larger life. In the stillness of my body, I envisioned all of us in the outside world walking around within a prison cell, our legs poking out through the bottom of our cages. Once we see the cage we are in, it no longer has the same hold on us and we are free. Through this experience I found an essential force that the creative process and the arts bestow. I discovered an essence that all creative-contemplative practice offers, and I wanted to share it. Yet this incident of personal crisis unearthed my fears and challenged the beliefs that I had lived.

So I lay there fully paralyzed now, not even my right hand responding to the slightest command. Obviously, the surgeon was not committing to the resurrection of my body (not to dismiss his brilliance, for he was a fine surgeon). I could not count on him alone to "save me." My spinal cord had been pinched to a thread. Would it return to its normal shape and condition, and would the multitude of nerves return undamaged?

Finally I was wheeled out of the emergency room and down the hallway toward the operating room. I experienced a deep sadness, helplessness, and fear. I looked over at my sister, who was still making intermittent phone calls. She arose and I caught the look of sympathy in her deep, black eyes while being rolled past her. Later she would describe my face as having the most devastating and hopeless expression that she had ever seen.

Farther down the hallway I experienced an unusual phenomenon. While I was lying on the gurney, I could feel the presence of two visitors. I felt a very light and gentle touch on my right and left shoulder — not physical, but a definite pressure was there. Turning to my right I saw a very tall figure. Looking up from the gurney, he seemed to be eight feet tall. But being a little *schpucka* myself, everything always seems bigger in my view. I

was not drugged at this point. This being was not physical, but I could clearly see him.[2] The other figure, on my left, was smaller but still seemed about seven feet tall. Their presence generated a wonderful feeling in me; I felt soothed and calm. I felt centered again, looked after, supported. A central teaching for me in this dramatic event was to contemplate the word "support": to ask for it, expect it, and receive it. The larger of the two figures spoke; that is, I could clearly hear him in my mind say, "You will be all right." I believed this utterly and completely, and from that point on, *I knew* I would be okay. I knew that my inner request, inner prayer, was answered and that I would, without question, *walk* the next day.

I was wheeled into the operating room. Staring upward from the stainless-steel bed, my eyes caught the television monitors, instruments, tubes, and apparatus of the surgeon's studio. I could still see the angel-like visitors standing by me, and I turned toward them, absorbing them with my eyes. Although my spiritual practice had leaned toward the East in my adult years, this visitation was clearly from the western side of God's face. I accepted the angel-like presence without question. I had experienced angelic presences in my life several times before, feeling them near me, hearing voices, tones, and music as I did in Pisa, Italy, but I rarely "saw" them, aside from the vision at the Rochester Siddha Yoga Center. This visitation at the hospital was absolutely clear and crystalline. (By the way, these visitors did not have wings.) The surgical team did not share in my vision nor did I convey my experience to them, as they may have decided to switch their agenda to a lobotomy or electroshock therapy. I carefully turned my head slightly toward the people scurrying about in the operating room and called the two women and three men on the surgical team to come nearer to me. The room filled with a scintillating energy. The atmosphere in the room seemed to sparkle, as if the atoms themselves were sprinkled with a superfine silver dust. The sparkling *shakti* energy floated happily in the air like a billion micro-stars.

The surgical team drew closer, and I said, "I am asking that you all be artists, now, and do your best, because I must continue to create paintings and so much else. I am counting on you." One of the team members said, "But we are not artists." I replied, "Oh, yes you are. It is not that an artist is a special kind of person, but that each person is a special kind of artist. This is what I mean when I tell you that you must do your best and be artists." Warm smiles came over all their faces, and they all made eye contact with me. The feeling in the room suddenly shifted, and a beautiful, loving energy and connection was felt by all of us. I felt a oneness I would never have anticipated in the operating room of a hospital. While this loving warmth grew pervasive, I accepted that the mysterious visitors were unquestionably real but unexplainable. My eyes closed and I drifted into a deep, silent, and comforting darkness.

In retrospect, this whole experience conjures up William Blake for me again. Some would say my experience with the visitors in the operating room was merely a result of shock, hallucination, or an unstable mind, such as Blake's. Blake is a spirit I have always felt kindred to, not because of his feeble or unstable mind (which is an absurd notion to me),

FIG. 30 Philip Rubinov-Jacobson, *The Visitors*, 1995, graphite and colored pencil on paper, 14 x 11 in. Boulder Community Hospital, Boulder, Colorado

but because of his powerful vision and connection to other orders of reality. Indeed, many members of the Secret Lodge of Visionary Artists — the poets, painters, and philosophers — have felt the same kinship with Blake and may even envision him sitting at the head of a great table.

THE CHAIRMAN OF THE LODGE

Was Blake a lunatic or privy to seeing more than meets the eye of flesh? We can answer from the two eyes of the psychiatrist and from the third eye of the mystic. The beauty of a rose is protected by its thorns. Perhaps our psychologists, when making observations about the association between art and psychosis, see only the thorns. The less thorny and more rosy psychologists might add that visions experienced by artists are actually a restoration toward a balanced state of mind. This balanced state of mind is achieved by totally bypassing dependency on a laborious and painful march from psychotic defenses to immature defenses to neurotic defenses to mature defenses, allowing psychosis to blend with mature aesthetic sublimation. We can appreciate the acknowledgement from the mainstream science of the psyche that creativity can, in certain cases, be lifesaving. However, the transpersonalists recognize that creativity does not only rescue, it has the power to utterly transform human beings so that they are never the same again — so that they see more, feel more, know more, and experience everything from that point on in an entirely new and more open manner. In addition, perhaps transpersonal psychologists would agree with me that the power of creative expression not only can sublimate psychosis, it can enable people to live longer, live more fully, love and be more fully loved, and cause those who love them less pain. Blake had an elevated love inspired by an uplifting and pervasive vision.

Looking through the third eye of the mystic, we can return to William Blake as a subject in investigating the question of vision versus lunacy. William Blake was one of England's geniuses and surely among its most neglected. Much of his original artwork went unsold and his most ambitious literary work unpublished. He spent his whole life in London and had many talented and influential friends, yet he managed to alienate even the most loyal until he was pushed further and further out of the professional activity of his time. Nearly all of the commissions he got would fall to pieces or be taken away and given to a competitor due to his alienating behavior. He was married to the same woman for forty-five years, Catherine Boucher from Battersea, "Kate." Blake celebrated the visionary power of children, but the Blakes had no children themselves. Kate cooked, cleaned, made their clothes, got up in the middle of the night to keep William company when he was working, and helped hand-color his prints. At times, the couple lived in a single, small room that served as a bedroom, kitchen, and alchemical space for William to miraculously create his synthesis of art and text, word and image, that he called Illuminated Books. By the time he reached middle age, his trousers were shredded and filthy from the inks and waxes he employed in his work. But he kept busy writing and illustrating, creating radiant images of sexual and spiritual energy. In a way, as Ginsberg and others have noted, Blake was writing his very own version of the Bible. Visitors would come to the Blakes' tiny abode to see the great and strange man. After they drank their tea and left, they would say, "Poor Blake, still poor and dirty."

Although a part of Blake yearned to be a prophet for the masses, another part knew

that only a happy few would ever understand him. "What is Grand is necessarily obscure to Weak men," Blake once wrote in an edgy letter to the Reverend John Trusler — a clergyman and author of the eighteenth-century best-seller *The Way to Be Rich and Respectable* — who had ordered some watercolors from him and then withdrew the commission after a time. Blake thoroughly alienated what friends remained and managed to continue his work on the menial subsidy of those who possessed the greatest patience. He was an eighteenth-century radical in spiritual and sexual as well as political views. He hated monarchs and all formal religions, calling the State and the Church "the Beast and the Whore"; he espoused free love and proclaimed, via Paracelsus, Böhme, and Swedenborg, a particularly personal definition of Christ. Blake once said, "Christ … is the only God … and so am I and so are you."

As a mystic, firmly opposed to rationalism, Blake was no fan of scientific advances. Industrial turning of wheels and pistons would pound pain in Blake's ears. But the idea of electricity seemed to befriend him: it sparked and flashed across his spiritualized imagination, and his words and images would galvanize responders. Blakean images would be made of light, smoke, and shadow, grottoes lined with semiprecious spectral beings who appear and then vanish like the visions that appeared to him his whole life. As a transpersonal artist and member of this Visionary Lodge, I raise up Blake in order to negotiate the present and measure what might come next. Blake was a lifelong student of esoteric systems: the Gnostics and the Kabala, the Arthurian legends and the texts of Freemasonry. He would read everything he could lay his ink-stained hands on, including the ways of the Druids. As I have mentioned, from early childhood Blake had seen visions. William talked to his brother Robert almost as much after Robert's death as before it. It was the posthumous Robert who guided William with technical suggestions about the innovative relief-etching process the brothers had developed in the late 1700s and used in William's Illuminated Books (in much the same way that Leonardo, visiting me in the dream state, had taught me to paint eyes).

These visitations in spirit would increase in certain locations. While living on South Molton Street in London, his wife would say, "I have very little of Mr. Blake's company; he is always in Paradise." People who still came over to spend time with the Blakes would be startled by the casual way William would talk about meeting the Prophet Isaiah or the ghost of a flea; others weren't flustered at all, since they saw visions themselves. Blake also got out of his tiny room to join his radically spiritual ideas within the circles of the Swedenborgians, Neoplatonists, and the Christian redemptionists, who also dabbled in mesmerism, magnetic healing, sexual magic, alchemy, and other aspects of the occult. He became exposed to things that would still be considered sexually radical today, such as polygamy. There is also a story regarding an invitation to William by a certain Mary Wollstonecraft to join in on a ménage à trois, although we have no evidence that William was less than faithful to Mrs. Blake. There is documentation that one visitor found the Blakes stark naked in their backyard reciting *Paradise Lost*. Blake's erotic drawings included hermaphroditism, homosexuality, and children engaged in voyeurism. The wild man in

Blake is also demonstrated in other stories, such as William's single-handedly freeing Thomas Paine from hanging at the end of a rope and assisting his escape to France.

Long before Carl Jung, Blake was interested in spiritual androgyny, and his God was one who spoke through people, female or male. He did not reject the physical world or consider bodies sinful. Blake was indeed a visionary, but his mysticism was solidly planted in his physicality. He was a rather sturdy, powerful, broad-shouldered man, on the shortish side. His eyes were large and bright all his life. He walked twenty miles a day and was a prolific worker. All of the Visionary painters, mystics, and philosophers I know share a quasi-mystical reverence for this spiritual genius. I admire the stout, stubborn dignity of Blake, the lower middle-class Cockney that could carry on a heavy conversation with Spirit in the light of day. Some still say Blake was mad; of course, it was the visions that did it and the hermetic, shifting imagery of his later verse. It is true that Blake would be given to nervousness, fears, and fits of rage, but that does not make his work incomprehensible or mad. He has also been described by people who knew him as the most satisfied, happy, and joyful human being whom they had ever encountered. Blake was no more insane than Saint Francis, Saint Teresa of Avila, Joan of Arc, or other mystics who have experienced visions, visitations, or stigmatas and have been sainted by the Church or some unofficially qualified body as such.

It is interesting to note that a good deal of Blake's poetic work begins with a visitation from a bard, a muse, or some sort of prophetic wisdom figure. Is a visitation so hard to accept? The occurrence runs through nearly every culture and time. The Welsh and Scottish, the East Indians and North Americans all treasure the visitation and vision as central to their spiritual practices. Blake believed absolutely that his work was inspired. He sent Catherine out with their last pennies to buy a pencil for him to sketch her portrait before he died. Earlier on I described his passing but left out one thing: One of the young men inspired by Blake was also in the room and closed his dead mentor's eyes, in order "to keep the vision in."

So in pondering Blake, I felt that I was in good company regarding the angel-like visitation I had had in the hospital. After the operation, I was taken to my room. My sister sat beside me as I awakened. One of the nurses assisting with the operation came to visit and, in an excited state, she said, "Philip, at the very end of the operation, just as we removed the anesthetic, you sat right up on the operating table! You waved your arms and hands in the air and shouted, 'Look! I can move my arms! I can paint! Goddamn it, I can paint!'" The nurse continued, "Then you lay back down and fell right to sleep. It was wonderfully strange and amazing because not only does it take hours for the anesthesia to wear off, but sitting up and waving your arms was not expected at all. In fact, we had little hope that you would ever move again, and then only your toes at first, and not at least for three months to a year." She gave me a consoling look and held my hand. I smiled at her and felt very content, knowing that my healing, my *full recovery*, would begin that evening.

Before falling back to sleep, I thought how healing is like painting with light. The canvas in healing is the body, and vision becomes an inner paintbrush, a movement of colored sight,

or "in-sight." Paint becomes streams of light. I saw everything as a baked light, a printout of Divine Mind. Love heals; the vibration of light is love. I focused on my injury with thoughts and feelings of love. When I escaped the mind's entrapment of pity, I could turn my mind toward genuine thoughts of love, emanating from myself to myself. It poured from my hands and inner eye like shimmering streams of painted rivers to the injured parts of my body. It was a kind of bio-etheric painting, all things being born of light.

That afternoon at the hospital, after the operation, I declared to my caretakers and visitors, "I will walk when Sandra arrives this evening!" The nurses were alarmed and said, "Now, Philip, do not expect so much. We do not want you to be disappointed." I wanted a walker brought in so that I could get out of bed and demonstrate to Sandra that I could walk. The nurses wanted to shoot me up with Thorazine, to knock me out. They looked at me as though I were crazy, in a state of denial that was becoming serious, and that I wasn't accepting my prognosis of paralysis and immobility from my waist down. They called in social workers, counselors, and doctors to get me to accept my condition: that I wouldn't walk again. I threw them all out of my room.

Even my own mother discouraged thoughts of full recuperation, of ever walking again, lovingly trying to protect me from disappointment, but my response was agitation. I was irritated with anyone who was not as convinced as I was that I would walk immediately. Lying in this state, the only thing that soothed and calmed me down was Whadsworth, a little stuffed bear that my eight-year-old niece, Jade, had placed by my bed. The little bear sat up and stared at me all the time. My sweet Jade had placed him close to me, saying, "You won't feel alone now." Whadsworth seemed alive to me. His compassion and company made me feel better. This was very generous of Jade, since normally Whadsworth would be as difficult to separate from her as it would be to pry clouds from the sky.

I floated between states of human willfulness, healing, and warmth. I could not and would not allow anyone's disbelief in my full and instantaneous recovery to enter my mind and heart for even a moment. There are times when we can become unique in our intensity, will, and ability to direct our focus. Focusing on a desired result with complete, unwavering attention and awareness, and not on the process or the means used to achieve that result, is unfailing. This is like the martial artist who sees his raised hand as already having passed through the block of concrete before he makes a motion.

Many caring and supportive friends came to see me in the first few hours after I woke from my operation. The president from Naropa and his assistant were among my first visitors. The president, who brought a most beautiful flower arrangement that he had created himself and sat at the foot of my bed, inquired about the prospects for my recovery of motion and physical sensation. I replied, "Well, I have my arms and hands back, but from my waist down I am paralyzed." I pointed to my left foot and continued, "I am told it will be three months to a year before I move my big toe, if ever, and …" But before I finished my sentence, the big toe on my left foot moved. We were all startled! I had been awake only five hours since the operation. It was eerie and marvelous. The event seemed to rattle the president a little, giving him the heebie-jeebies. Around midnight Sandra finally

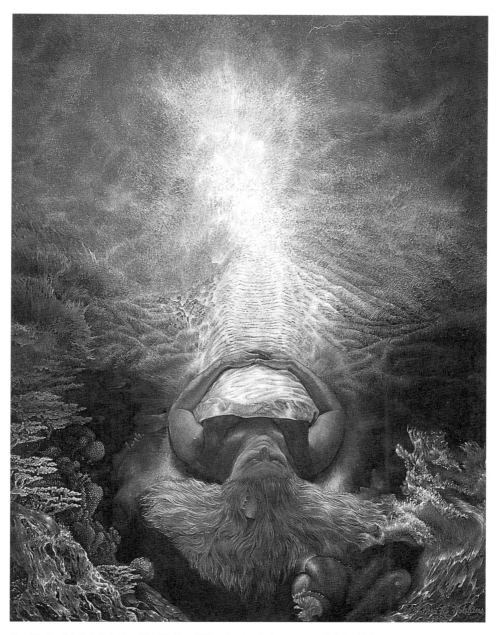

Fig. 31 Cynthia Ré Robbins, *The Healing*, 1995, mixed technique on panel, 24 x 18 in.

arrived. I turned to her and said, "Please stand by the wall. I have something to show you." After much drama, I had convinced the nurses to bring in a walker. Sandra already had been advised by the doctor, before coming into my room, that I may never walk again.

Not knowing whether I *really* could walk but believing that I could, I sat up and pushed my legs over the side of the bed with my arms. I stood there balancing on the walker, most

of my strength already spent to get this far. But I was standing, my arms supporting my body with the help of the walker. And then, letting go of the walker and moving it aside, I walked on my own … one foot in front of the other, three or four steps, my eyes watery with happiness. I walked toward my wife's arms and kisses. On the last step she embraced me, and we both cried. Eighteen hours after the operation, I was walking. Goddamn it, I was walking! I insisted on going home. I had to get out. I did not feel that the atmosphere of a hospital was conducive to my healing process. The guy in the bed next to me could sleep only if the television was blaring. Down the hall, seemingly on the hour, a man would moo like a cow as his pain overtook him. I told the staff I wanted to go home. They told me that I could be released only if I could urinate three hundred cc's on my own, as they feared I may have permanently lost my kidney and sexual functions. The next day I was released from the hospital after a successful urinary demonstration.

At home, I couldn't sleep. I was in some unworldly state. A state of grace, a state of holy, creative fire! I had tremendous energy and was in a state of ecstasy. Although my kidney function had returned, my sexual function had not. I was depressed and had anxiety over this but was distracted by the intoxicating state of inspiration I was in. After about five days, my body responded sexually to Sandra's attentive love and care ("*Oi*, a great miracle"). Could I have gone through life without the power to play with love, without being a love-maker?

Sandra had to return to school and departed for New York, after making me enough homemade frozen dinners for the next ten years. Sandra's culinary activity served as therapy as much for her as it did for me. I was not allowed to be alone and was now receiving home care from visiting nurses and physical therapists. My mother kept the watch, for if I were to fall, I could go into a coma or revert to irreversible paralysis. I couldn't sleep and I could not stop writing or sketching. Over a period of seven days I wrote the core of this book, the essence of it drawn from a thesis I had written a decade ago, now adding the experience gained over these ten years. Conversations with Ken Wilber initiated a positive process of refinement that extended its date of completion by several more years. While I was laid up, Ken would call me and offer his support, encouragement, and philosophical reflections on my ideas and writings. He would recite poetry, too, suggest alternative ways of seeing and understanding things. He would call me frequently during my convalescence and was very sweet and nurturing and an incredible source of comfort and inspiration to me. His integrated understanding of the mind, art, philosophy, sciences, psychology, history, religion, the artist's nature, the process of creativity, and the "unfoldment" of consciousness, is astounding and continually provides me with another way of looking at something that I had just thought I had come to know.

I was blissful, full of energy, and amazed over what seemed to be a miracle regarding my recovery. I roamed around all night long like some geriatric mystic with my hands glued to a walker, a portable urinal hanging from its bars. I moved like a mad ghost around the apartment, saturated with inspiration, sometimes swinging my walker ahead of me and other times forgetting I needed it, hobbling dangerously on my own. Although I was told

by the home care nurse never to let go of the walker, I would walk, stumbling but not falling, a few feet at a time, without the aid of the walker. At other times, my aluminum walker led the way, supporting me like a metal detector through some alchemical and transformative experience. I was supposed to use the walker for up to three months before I was allowed to walk on my own, but already I was letting go of it just a few days after the operation.

The creative fire was upon me. If anyone interrupted my state of inspiration I would become agitated, sometimes enraged. I was not in control of my emotions; there was nothing I could do. I was under the control of something greater than myself. I was possessed by spirit, by the muse: she owned me. I was ecstatic and could barely contain myself. I felt as though I would break out of my skin, like my blood was boiling with little thunderbolts. I felt stolen by something greater than myself, but "stolen" is too harsh a word, for the creative fever is a pleasurable mad-dog frenzy on some level. For others, observing such an episode, it can be uplifting or frightening, depending on their own personal experience with states of inspiration. I alternately sketched and then worked on this book in a state of exaltation, feeling a sacred power within me, struggling to recognize the traumatic state of my condition, trying to acknowledge the essential need for rest. But I could not rest. For seven days I just wrote, barely sleeping, perhaps an hour or two here and there. My mother was alarmed by this, fearing that I might fall, afraid I could destroy myself, my chances for health and recuperation. But I could not stop … could not sleep … could not stop writing. How had a broken neck and big angels changed or heightened my awareness? As my body faded from function and then regained its purpose, each moment became very precious. An hour was no longer an hour. Time became a fountain filled with sounds, perfumes, colors, feelings, and plans once again.

After offering great care, tolerance and patience, my mother returned to her apartment in California, and my niece, Lena, who shares her uncle's wild streak and sense of humor, took over the watch for two weeks, followed by my beautiful and loving friend, Joanna McKenzie, who moved in for a month to nurse me. The living fire in me continued to burn. Every field of creative endeavor is dependent upon that fire. Extraordinary scientific discoveries, brilliant philosophical revelations, artistic masterpieces, and so-called medical miracles are none other than the potential that lies in Infinite Mind, in inspiration. Just as a seed germinates under ideal conditions of light, warmth, and moisture, there is likewise a favorable climate in which higher inspiration, healing, and ideas take form. Sometimes it is like a storm that swoops up anyone fortunate enough to be in its path. For example, Handel, who wrote *Messiah* in twenty-four days, took little time out for rest and nourishment, for his life was tied to the openness of, madness of, and receptivity to inspiration, which always favors the free-flowing spirit and the open heart. Another musical giant gives us the following account:

When I am, as it were, completely myself, entirely alone, and of good cheer — say, traveling in a carriage, or walking after a good meal, or during the night when I cannot sleep; it is on such occasions

that my ideas flow best and most abundantly. Whence and how they come, I know not; nor can I force them. Those ideas that please me I retain in memory, and am accustomed, as I have been told, to hum them to myself ... Provided I am not disturbed, my subject enlarges itself, becomes methodized and defined, and the whole, though it be long, stands almost complete and finished in my mind, so that I can survey it, like a fine picture or a beautiful statue, at a glance. Nor do I hear in my imagination the parts successively, but I hear them, as it were, all at once. What a delight this is I cannot tell! All this inventing, this producing, takes place in a pleasing lively dream ... The committing to paper is done quickly enough, for everything is, as I said before, already finished; and it rarely differs on paper from what it was in my imagination ...

— Wolfgang Amadeus Mozart[3]

I saw clearly, after my experience at the hospital, that inspiration is available to absolutely anyone. Inspiration from some higher order of reality is never withheld, though there are times when we ourselves may be out of tune with it. At those times, we are simply *uninspired* because we are *unreceptive*.

At home from the hospital, I had the actual physical bodily sensation that God was pleased with me when I was inspired and creative. I actually felt this tingling, warm sensation throughout my body and on the surface of my skin. This may sound parental, God watching over his human kindergarten from some rainbow-stuffed cloud in the sky, his divine white beard made of stars and flowing in the cosmic winds. Personalizing God is strange to me, yet I felt a relationship to some divine agency, some force in me and around me but not other than me. I felt my body glowing with a warm happiness as I healed. I felt God seeking expression through me, through all of us. I felt the One looking out through the eyes of the many. The Infinite waiting for our attunement to its body, its divinely inspired ideas and love. I felt God taking pleasure in the collective creative potential of humanity as we move toward a more complete expression of the divine through our own being, the true definition of evolution — through ourselves. Creating brings us closer to Godhead, and art is a sweet tool of navigation that maps and unveils the invisible behind the visible.

GODS NOT HOME

After the bout with paralysis, an operation leaving a metal plate in my neck, and an intense six months of physical therapy, I returned to work, three months earlier than I should have. I was still in a condition known as Post Traumatic Stress Disorder (PTSD), not apparent to me at the time but definitely affecting my behavior and judgment. My life began to fall apart.

While serving as the dean of continuing education at a contemplative university for six years, I founded and directed a new school in that endeavor. Even at an alternative school that was creating "on the edge" programming, enlisting new teachers, trying radically new ideas, I was considered by some to be too radical for the radicals, a renegade visionary

threatening change and academic integrity. Truly no college, alternative or otherwise, meets its mission perfectly and, in my opinion, educational programming almost anywhere you look often seems uninspired, outdated, dried up, yesterday's mind. The vision I would try to usher in with the tremendous help of a marvelous president and a staff that I had hand picked and made up of incredible human beings with great ideas of their own would, at times, bump up against an intense fear of change from some academics, administrators, and the bureaucracy. While the PTSD continued to overtake me and affect my judgment, I continued to take all of the heat in the birthing of an entire school-within-a-school, and the politics fumed. Trying to plant new seeds while other people would dig them back up, with my social and professional behavior getting more and more similar to William Blake's, my patience ran out, the PTSD went up, a mid-life crisis jumped in, and I ran out, quitting my job and slamming the door behind me. But not without birthing a brand-new bouncing baby school of extraordinary programs.

Creativity can become a great juggling act in the service of the many. In my case, this became a point of frustration at Naropa with the slow response to my ideas and those of my staff. Although, as time passes, I see my ideas taking form on the trail I left behind me. The situation became more complicated by a string of crises in my personal life that I couldn't stop from seeping into my professional one. A series of critical events bled into the trauma of nearly losing the use of my body forever. My mental and emotional health began to erode as well. I lost my sense of direction, my ability to see the truth in situations, and my self-discipline. I lost trust in those close to me. As all of my refined skills reverted to a raw, shadowy version, my behavior went the way of Blake's and van Gogh's, as I, too, alienated almost everyone around me. In turn, I felt unsupported and, most of all, abandoned by everyone. In time, my wife would also disappear — divorce following behind her.

Temporary experiences of depression in many artists and mystics are in fact a natural reaction to the high tension of an earlier experience of illumination, especially in a sensitive mind prone to oscillation between extreme psychological states. The otherworldly visitors who brought an illumination and ecstasy and catalyzed my remarkable recovery were now only a memory of light, and that light grew faint, ever darker. I sank into the dark night of the soul, and my depression was becoming severe. This phrase, "dark night of the soul," is taken from Juan de la Cruz (John of the Cross, 1542–91, a visionary-priest in the Carmelite order) and is generally applied to the common though not universal experience of mystics who *after a period of illumination* experience a *swing of the pendulum back to emptiness and desolation.* The dark night is split between the night of the senses, the purgation of the lower part of the soul, the bodily senses, imagination, and emotions, and the night of the spirit, the purgation of the higher part of the soul, the intellect, and will. The enhanced awareness of *divine perfection* leads to a deeper sense of *human imperfection.* Juan de la Cruz writes, "That which the anguished soul feels most deeply is the conviction that God has abandoned it, of which it has no doubt; that He has cast it away into darkness as an abominable thing." "He acts," says

Eckhart, "as if there were a wall erected between Him and us." "It is," says Angela of Foligno, "a privation worse than hell." But the mystics also see it as an agonizing but needful time of testing. In Sufi terms, this alone will produce the *Fana,* the dying–to–self, which is the precondition of *Baqa,* eternal life.

On the brink of the dark night, teetering at the edge of the black pit, I had a full-blown "creative heart-attack." In my feelings of being restricted, restrained, and my creative power and love imprisoned ... I resigned from my job as a dean, giving up a small but steady income without having another position lined up or any savings or any other financial means or prospects to rely on. Then it began, one thing after another. Everything in my life fell away with nothing left for me to hold, hug, or have. I was broke, not fully recuperated, and still suffering severely from post-traumatic stress, exhaustion, and irritability. My wife, dealing with a life-threatening illness of her own, needed support for health costs, school, and living but now was totally on her own in Brooklyn. I had no means to help her. She had been doing postgraduate work for the previous three years, was several thousand miles away, and eventually, as mentioned, for reasons of her own, suddenly stopped communicating with me altogether, never calling again and never to return home again. I had lost the greatest love of my life.

My erratic behavior, depression, and emotional intensity had alienated my co-workers and friends; they severed me from their lives. One of my brothers was in serious legal trouble, and I could not help him despite my best efforts — another loss. My sister lost her job and had children to take care of. How could I help her? It did not stop there. A woman who was many things to me — besides being my model, she was an invaluable assistant and my student, and, so I felt and thought, a very dear and trusted friend that never really was — vaporized like a dream, never looking back as she, among a few others, scrambled for whatever opportunities lay beneath the shadows and footsteps of my triumphs and the fallout of my failures. I had not thought about how my leaving work, quitting, would affect others; at the time, I didn't realize the effect I had on other people, which apparently, was considerable.

My entire life got up and walked out. Ultimately, I felt abandoned even by God. He just wasn't home any more. I could not find him in me, I could not see him outside of me. What the hell was happening? Where did my life go? Did it leave me, or did I leave it? I could not see my part clearly; I had lost connection to myself. I sank deeper into the darkness, the abyss, and I stopped eating for weeks. I did not seek professional help nor was it advised by others. I was neither on prescription medications nor self-medicating drugs of any sort, yet I began to see things and hear voices that frightened me. Such things had never frightened me before. I was quite detached about such experiences and merely witnessed what was presented while waiting for it to swell like waves of inspiration that became art. But not this time. Inspiration would not come. A severe depression and despair came over me, and I was devastated, my soul shattered into oblivion.

Ken and Mary Jane, two people who allow others much space in life and have great compassion and understanding, would call and tell me to remember that these feelings

would pass. They would tell me not to assume one hundred percent of the responsibility for everything, that the people involved had their part in the situation, too, and that I should be good and kind to myself. Ken could get me to laugh while I was in the most dreadful states. Mary Jane's love and wisdom was lifesaving. They would both encourage me to paint through this situation, but literally immobilized by depression, I could not pick up the brush and paint. I could not even move.

What we discover at times like this is that what we resist will only build a stronger presence until we look at it. I resisted the call to paint my soul. Mary Jane, who seemed so far away and I wished were close by, continually phoned me from her Montana home and repeated the mantra, "Paint, Muck (her nickname for me). Muck, you have to paint. Paint — you must paint!" Finally, I arose; that is, I stopped staring at the ceiling for days, weeks, on end, paralyzed with what felt like a two-ton weight on my chest. I got up to paint. As I walked down the stairway to my studio, I descended into the sorrow within me. I walked without any interest in life, and with what energy was left in me I placed a fresh canvas on the easel. Some of us feel everything very deeply, and for an artist this is a great asset but also a mixed blessing. It took every ounce of my will to sit up, to rise from depression. In truth, it took more out of me to overcome the paralyzing effects of depression than it did a herniated disk and a severely pinched spinal cord.

I began to paint my feelings into form. I began to cry and wail and work with the paint. My eyes flooded with tears. I could barely see what I was painting and yet I didn't have to. I had only to give into the sorrow within me and let it rise up like lava, raining red pigment on the canvas. My tears and anguished weeping literally mixed with the paints on my palette and found their way to my brush. As I wept, I pushed the paint with the brush, my fingers, my fist. It felt good to have my sense of hopelessness, my loss of love, become palpable. It felt good to have the terrible emptiness within me become a visible something. The sacred mirror of the canvas became a container of the pain buried in me. This silent scream loosened the losses within. As I looked at the canvas, the artistic reflection, the pain slowly began to dissolve, and despair loosened its hold on me. When we really look at something, anything, we see right through its illusion, leaving nothing but the true reality in view. Illusion loses its grip, confusion disperses, and our murky feelings and heaviness are lifted by the truth, and we are free again.

The raw image finished, I stepped back and dried my eyes to see what I had done, as I was painting from some place so deep my analytical mind had fled. The twisted, plummeted, contorted face, its decaying green skin with blue micro-heart tattoos, would later converse with both silver-plated and gilded words of gold. In time, the painting would show its face of meaning, but for now it kept me tied together, as I stood and then walked through the flames of the black fire.

I had done many paintings from the dark recesses of the unconscious, but this painting, *Gods Not Home*, 1997 (see Fig. 32), was of a different order. No, this was not the realm of unconscious symbols, nor was it angelic, beautiful, or ethereal; it was full of despair, it expressed the entry into the dark night on both sides of the doorway. I would write,

without recollection, reflections of my experience in the studio. The next day I found a little piece of paper crumpled up on the floor with scribbling on it:

I have reached such an exhilarating state of madness, I no longer take up or need the brush. Instead I put a single color on the palm of my hand by simply rubbing it on the palette, and then I move my palm across the pristine surface of the canvas. The wet paint on my skin seems to serve as some bridging agent between the invisible and visible worlds, for images seep through the pores of my skin like a living blood and impress their forms upon the canvas of their own accord. The life of the painting bleeds through my hand. The forms, like millions of tiny and incredibly varied beings from other realms, appear in landscapes where pure spirit resides. They were alive and moved around the surface of the canvas; all I need do is touch them with a fine brush and they would become captured, fixed in this world.

The painting was more disturbing than any work I had done in more than twenty years, since my dream paintings and explorations of the unconscious. The painting reflected three souls: my wife's in the blue-hearted face, that of my model in the words, and mine in the eyes and tears. The act of painting moved me through a major transition in my life. I painted to heal my broken heart, to center my mind, to express and release the pain. I painted to save my life through the power of artistic action. This painting is not a pretty sight, but I feel good about its truth. This painting had given form where there was only fragmentation, as I had forgotten that eggshells break to reveal new life. Clarity lives in the alchemy of the soul, in the secret, cathartic release, and it does its invisible work in the painter as in the responder who resonates to it.

After months of silence and not a single call from my former friends and co-workers, I initiated an invitation to reconnect with each of them, one by one, as it seemed I would never have heard from any of them. Most of the people I recontacted turned around, responding to my occasional but steady persistence and invitations to reembrace, find a balance, and heal. When you really love someone, it is impossible for that love to die. Remember being upset with someone you really adored? We try to box people into containers that fit our anger. We try to reduce them to a vision of insignificance. We try to deny them and erase them, for loving them has disturbed us, hurt us. But *if we really have loved* them, then no box we create in our minds will ever release them from our hearts. In truth, if the only thing you can do is deny that love and suppress the awareness of the infinite within yourself, then that boxed anger eventually turns to sadness. People do not *cause* our suffering so much as it is how we have chosen to *respond* to them.

What else can love do? In order to reemerge from the suffering, carelessness, or cruelty we have inflicted on others or received, we must drink the nectar of forgiveness. As I related in the story of Rufus and the mini-race war, forgiveness is the energy of creativity — it is regeneration, it is rebirth. To the degree we refuse to forgive ourselves or others is the degree to which we are condemned to live with resentment, sadness or anger. We become stuck, always seeking an occasion to get even, to have revenge against those who

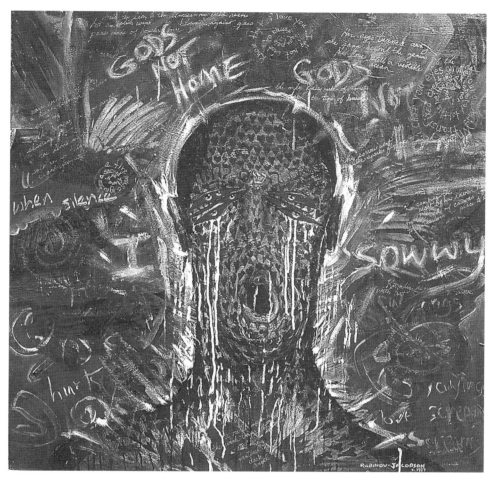

FIG. 32 Philip Rubinov-Jacobson, *Gods Not Home*, 1997, oil on canvas with silver and gold inks, 36 x 36 in.

have wronged us. Or we attempt to hide in the pit of denial, and once we enter, the exit may be very elusive.

Pain results from a judgment we have made about something. Remove the judgment and the pain is vanquished. God is in the pain and the joy, the tears and the laughter, because there is divine purpose in everything, and that is to see the freedom of God being God, for we cannot create anything, including our own circumstances which are outside of God. We are That. We learn to remember, always, that suffering has little to do with events or situations, but only with our response to them. Suffering is not the way to God but an acknowledgement that there is still something we need to learn of God, of ourselves.

Joys impregnate. Sorrows bring forth.
— William Blake [4]

Only when light has been fully thrown upon our experience, and with great effort, do we unfold the meaning of what has been felt. Sometimes when we are suffering, our thoughts, as though stirred by perpetual winds of change, bring up within our range of vision, as in a storm, that boundless world of which we have had no view from our ill-placed window of serenity. The calm of happiness can, at times, leave everything smooth and below our vision.

A foggy day. Spending the day on the dark path, feeling out my own resistance. The yearning to be connected, and my unwillingness to reach out. The terrible wish to create, and my reluctance to do it. Feeling, observing, agonizing.
— Burghild Nina Holzer[5]

Our vulnerability, even our pain, is a doorway to receiving and giving love, and love is the vehicle that gives life to creative expression. If we become overly identified with power and deny our vulnerability, we may be able to accomplish a great deal but will lose out on life's spiritual and emotional rewards. Yet, without our creative power we cannot accomplish our goals in life, share our gifts, or properly protect ourselves. By honoring all the feelings, thoughts, and experiences that arise, we can befriend all aspects of ourselves. Then we have access to the full palette of our energies, and even the duality of mind locked onto our experiences begins to dissolve, and we can then approach life with more vigor. Challenges and experiences are met with more creatively than when we were stuck in rigid roles or patterns.

Sitting outside my home in Boulder, looking out at the mountains, reviewing the dark nights and illumined states, the places I have dwelled, and the experiences I have had, I am practicing remembrance.

I know I am august,
I do not trouble my spirit to vindicate itself or be understood,
I see that the elementary laws never apologize,
I reckon I behave no prouder than the level I plant my house by after all.
I exist as I am, that is enough,
If no other in the world be aware I sit content,
And if each and all be aware I sit content.
— Walt Whitman[6]

RETURN TO LIGHT

Although I begin to know and live the knowledge of my yesterdays, I am at the same time not my yesterdays, and I create my most radiant tomorrows. The painting *Gods Not Home* had reawakened my power of resilience and regeneration, and it had initiated a return to light. As I previously discussed, in the dark night the soul is emptied and dried up. In the

same way that an earthly lover fears abandonment by the beloved and is wounded by rejection, so the soul, in its intense thirst for love, feels forsaken by the divine and as dried up as a lost wanderer in a desert wasteland. This dark night of the soul is a place of deep poverty and wretchedness. So, one may ask, where is the fun in that? Or, as a onetime muse often said to me, "Why go there?" For some artists and mystics, there is no choice. It is the path they have chosen long ago, occasionally erupting from a tradition so ancient that the journey must be completed in this way. It is not without its joys, its prizes, its presents and illuminations. Through it the soul is being purged, forged, purified in the fire. Herein God secretly teaches the soul and instructs it on the perfection of love, for in the dark night, the soul is bathed in humility, becoming ever more vulnerable and open to receiving sacred teachings.

In this abyss one is plunged into paradox. The stress, anxiety, deprivation, and trials are all part of a process for an unfathomable breakthrough and transformation. What the abyss asks of us is simple, and that is to surrender. From the descent into the abyss can come the gift of love through a humble surrendering. Many artists and mystics have lived at the edge of the abyss. Surrendering to the darkness, passing through the abyss with remembrance of light, assures us transformation and reunion with our divine nature. Having passed through the fire of opposites at the bottom of the abyss, one arrives at a new place of non-dual existence. In this place we learn that it is by sitting and resting rather than by striving that one finally comes to understand. The descent into the abyss culminates in the ecstasy of union, the mystical marriage, the mystic's goal. This is the intoxicating truth that the addict learns, if he survives, by falling into the abyss — that the mystics learn by descending the staircase of the dark night, and the artist experiences by diving with creative wings of fire into the dark well of blackness.

Crawling out of that darkness and into the light of day peels the ignorance that clouded the eyes and heart of the soul. The first thing one notices is that one's heart is more open, that one is more accepting, less judgmental, more expansive and encompassing, more empathetic and sensitive. Where we took life for granted before, now the simplest things will arrest our attention, catapulting us to new levels of sensitivity and insight. Awareness leads to appreciation, a precondition for artistic expression. People may live in a house for years and never notice the exact color of the floor as the sunlight hits it every morning or the texture of the bark on a tree right outside their door. These moments of awakening prime the artistic sensibility.

My personal experience with dark nights and subsequent illuminations has been that vision comes when ordinary imagination is void and spiritual imagination is transcended, ignored, or exhausted. It is a light devoid of all attributes and is more of a feeling for me than a vision, although I am bathed in a perceptible living light. It sometimes comes to me when I am in a state of ecstasy. It is a mysterious light in which I finally disappear, and sometimes I am dissolved without a trace. At other times, when the experience is more externalized — that is, I am seeing light as a manifestation apart from me, as a witness — I am very present and aware of my

surroundings, peaceful inside. At such times, my eyes and heart are one. I am the light and the enjoyer of light.

The imagery of light is strong in the Bible. It is strong in parts of the eastern Mediterranean. It is powerful in Persia with the warfare of Light and Darkness; in all the astrological religions which depend on sun, moon, and stars; in Egypt with the exaltation of Ra and the Aten; in the Hellenistic mysteries where illumination might be expressed in a blaze of light. Then there are the mystics who have had direct experiences that they can describe only as images of fire and light. Mother Isabel Daurelle says, "The light which has filled my soul has come not from books but from the Holy Spirit." Hildegarde of Bingen offers a particularly good example. She was a visionary who saw all her visions through a dazzling light. "From my infancy," she says, "I have always seen this light in my spirit … more brilliant than the sun." She calls God *Lux vivens*, "living light," and reality she calls the "cloud of the living light" (an interesting parallel to Maya in Hinduism). She illustrated her writings, and many of them show a group of shimmering points of light, moving as waves.

Hildegarde (1098–1179) was a Benedictine nun and the first great mystic of Germany. She was a visionary, and she says of her visions, "These visions which I saw, I beheld neither in sleep, nor in dream, nor in madness, nor with the eyes of the body, nor with physical ears, nor in hidden places, but wakeful, alert, with the eyes of the spirit and with inward ears, I perceived them in open view and according to the will of God." She speaks of a blazing red light: "From my infancy up to the present time, I now being more than seventy years of age, I have always seen this light, in my spirit and not with external eyes, nor with any thoughts of my heart, nor with help from my senses. But my outward eyes remain open and the other corporeal senses retain their activity. The light which I see is not located, but yet it is more brilliant than the sun, nor can I examine its height, length or breadth, and I name it 'the cloud of the living light.'" Hildegarde continues, "But sometimes I behold within this light another light which I name 'the living light itself'. And when I look upon it every sadness and pain vanishes from my memory, so that I am again as a simple maid and not as an old woman." Hildegarde was an ecstatic with healing power; the illumination she experienced passed abilities on to her. She wrote books on the spirit, on natural science, plants, and medicine; she painted beautifully, composed music, and was a person of high intelligence and practical competence. She was something of a scientist, something of a theologian, something of a poet and artist, and her correspondents included popes and emperors.

For some mystics, light seems the very essence of their experience. To Augustine, contemplation aims at "a kind of spiritual contact with the unchanging light." For Angela of Foligno (1248–1309), the sacrament would shine more brilliantly than the sun, and what she experienced she could only say was the "supreme beauty." Even her scribes could not do justice, for, as in her case, to express this in language meant wrestling with experiences that have no vocabulary to express them. When Sadhu Sundar Singh (1889–1930) was converted to Christianity, he thought that the room was on fire. The life of this *sadhu* is an interesting one. Sundar Singh was brought up a Sikh, but he said, "I was not a Sikh but a

seeker — after Truth." He was seeking peace in the sacred books of the Sikhs, the Hindus, and the Moslems. He turned to the Bible, and it repelled him. Then at 4.30 a.m. on December 18, 1904, Sundar was fifteen years old and, as usual, was at prayer. Suddenly the room filled with a blaze of light, and he saw a vision of Jesus Christ in glory and love, saying to him in Hindustani, "How long will you persecute me? I have come to save you; you were praying to know the right way. Why do you not take it?" With that he became a Christian and renounced all possessions. He took Francis of Assisi as his model but felt no impulse to form an order. His life was passed in prayer and preaching. He had a continuous sense of the presence of God as well as a succession of vivid, Christ-centered visions. Sundar never sought ecstasy; when it came, it overwhelmed him. In it he experienced three heavens: Heaven on earth, the intermediate state of Paradise, and the true Heaven. He described ecstasy: "There are pearls in the sea, but to get them you have to dive to the bottom. Ecstasy is a dive to the bottom of spiritual things. It is not a trance but like a dive because, as a diver has to stop breathing, so in ecstasy the outward senses must be stopped."

What I like about Sundar is that he insisted that every human being has the capacity for religion, prayer, and meditation, that it is for everyone; but it is for God to grant ecstasy. What I like even more is that Sundar also insisted that visionary experience must lead to active service. Sadhu Sundar Singh is of particular importance as a twentieth-century mystic, as he was able to discuss his experiences with a high measure of objectivity because of his ability to bridge Hindu, Muslim, and Christian mystical experience. In 1929, he disappeared into the Himalayas.

Indian mystical philosophy makes much of light as the manifestation of pure being. The *Chandogya Upanishad* asserts that this light, which shines in the highest worlds beyond which there are none higher, is the very light that shines within the heart of man. So, too, at the moment of illumination, the Buddha perceives the Pure Clear Light of the Universal Void, colorless, without spot or shadow, the light of the dawn sky, and this symbolizes the Buddha state.

Among the Eskimo shamans, clairvoyance is the result of *qaumeneq*, which means "lightning" or "illumination." This is a sudden burst of light that the shaman feels in his body, inside his head, within the brain, enabling him to see in the dark, both literally and metaphorically. With the experience of the light, there is also a feeling of ascension, distant vision, clairvoyance, and foreknowledge of the future. There is an interesting parallel in the initiation of Australian medicine men who go through a ritual death and are filled with solidified light (dark night of the soul … ecstasy and illumination) in the form of rock crystals; on returning to life, they have similar powers of clairvoyance and extrasensory perception.

In the Qur'an (24, 35–42) the "Light verse," which starts from the thought of God as light, has been a constant source of inspiration to Moslem mystics. In Islam, in the account of the Beatific Vision by al-Arabi (died 1240), the Vision impregnates the elect with divine light, which pervades their very beings and radiates from them, as if reflected from mirrors. In general, Moslem mystics express their experience through the imagery of light. For

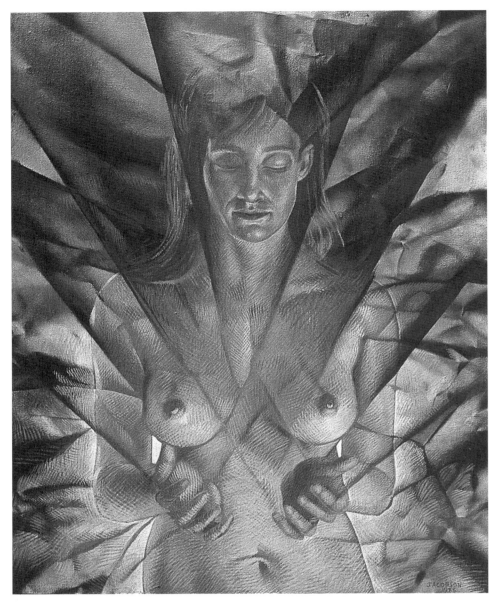

FIG. 33 Philip Rubinov-Jacobson, *Into Light #IV*, 1988, egg tempera, oil, and enamel on canvas, 30 x 24 in.

example, at one stage of the mystical journey, seven colored lights appear successively to the inward eye, and in the deepest experience "the fires of the *dhikr* never go out, and its lights never fade ... You always see some lights ascending and some descending; the fires around you are bright, very hot and flaming."

For the Orthodox Greek Christian mystic, Gregory Palamas (1206–1359), "The divine Light is a prerequisite of mystical experience ... He who shares the divine energy ...

146

becomes himself, in some sort, light; sees in full consciousness all that is hidden from those who have not received his grace." Palamas built a whole mystical theology around light. Basically, he maintained that the human being "cannot know the invisible, incommunicable Divine Essence. He can only know the energies or activities of God. God is not a being, for he is above all beings. Nothing created can have communion with the Supreme nature. But through his energies God communicates himself to man, and because God is Light, he communicates himself in the form of Light, not physical light, but uncreated light." And Symeon, the New Theologian, saw a light like dawn shining from above, growing brighter and brighter, and himself at the center of the light; he saw the light permeating his physical being and turning him completely to fire and light, destroying for him all awareness of the shape, position, bulk, and appearance of his body.

This great light within or its outer manifestation as vision or visitation is also not God. As in Buddhism, the Kabala and Zohar in Jewish mysticism points out that God is nothingness. Just as I previously stated that anything that fills in the statement "I am —," so it is with God; "God is —." The sentence "God is …" is a statement that cannot be completed, even if it were "God is Light" or "God is Spirit" or "God is Love." To complete the sentence would be to place God in the same limited realm of something else. The true nature of God cannot fit into any category.

Human beings may, at some point in their lives, find an illumination that never left, ever shining, even in the dark. They may find and establish a greater connection to the One without a second. Suddenly, this illumination may not only enliven their inner life, but the outer world takes on a new light and life as well. In truth, nothing inwardly or outwardly has changed; rather, what has always been and always is, has been discovered or uncovered. With this new discovery or awakening we begin to *create* in our daily lives. Creativity emerges through the simplest acts: preparing dinner, gardening, taking a walk. What began as an imprint from the outer world may lead us to an intuition originating from a realm beyond nature. In other words, an awareness of our immediate environment can serve as a doorway to higher orders of perception. Rather than thinking about otherworldly abstractions, we give complete attention to what is right here and now. Anything perceived with complete attention can lead to a higher order of meaning merely through the act of focused seeing and feeling, and thereby an experience of peace, joy, and inspiration unfolds. Most of us operate with habitual thoughts and conditioned responses that can deaden our immediate awareness and interaction with life. Life is not a dress rehearsal; it is a precious, living moment in achieving sacred appreciation, reconnection, upliftment, and co-creation. Responding to life with awe and playful aliveness, we recapture a sense of the mysterious; the creative eye awakens in us.

When we drop our habitual mind-sets and learn to live in the present moment without relying on conditioned patterns to guide our response to life, then we enter the realm of the sacred. We learn to live without preconceived notions that dictate how we should perceive life and how we should respond to it. Cast adrift from the dead weight of the past and any anxiety over the future, we enter the present moment open and vulnerable,

unfettered by the mind's reducing valve. In this free state we still feel both joy by the light of inspiration and distress by the misery of humanity. We see the world in its naked reality, for barriers between ourselves and others are dissolved. No longer can we keep our eyes shut to the actuality of things within and around us. Nor can we keep our mouths shut. Many people try their best to achieve happiness by screening their vision from the pain and sorrow in the world and by covering over the many conflicts of their subliminal nature. The beauty warriors, however, open themselves to all. They are indiscriminately aware, vital, sensitive, and occasionally suffering by what they see.

Every feeling, every thought, every word uttered is creative, and to the level of intensity that we hold these things as real and true will they be manifested. Our only real purpose is to experience our divinity in its fullness, and that can never reach an end, because *God* is infinite and we are the *same*. When we were created "in the image of God," that does not mean our faces look like God's or that we can swap or borrow one another's clothes. It means we are of the same essence, possessing the power to create.

We begin to know ourselves

as the Creator,

by creating …

by co-creating.

PART TWO:

PUSHING FLESH TO HEAVEN

Creative Coma, Spiritual Amnesia, and the Masquerade Ball

I am still learning.
— Michelangelo[1]

EDUCATION: CREATIVITY IN JEOPARDY

University, institutional, and elementary art education are relatively new ventures since the guilds and the relationship of master and apprentice began to die in the early nineteenth century. Art and education needed to come up with an entirely new mode of cooperation in order to facilitate the transfer of knowledge, but instead, art became relegated to a lower function, its intrinsic value ignored and absorbed in the shadow of scientism and industrialization. Is it the function of education merely to help us conform to the pattern of social-industrial needs, or is it to give us the freedom to discover and create?

If industry requires hordes of people to operate and monitor its machinery and technical functions, performing an automaton service that fundamentally opposes individual creativity, it follows that it is not in the best interests of those in power to encourage the freedom of personal expression. Indeed, education is still in the business of supplying human batteries to run a technocratic, monolithic machine that collectively serves a corporate, monological, and myopic vision of life itself. As a result we have masses of people suffering from a creative coma, who distrust their capacity for original thought and who are willing to accept whatever truth is fed to them. People read newspapers, listen to the radio, and watch television as though they were plugged into an infallible and absolute truth. Occasionally, some people stir like sleepwalkers who awaken and hear a "still, small voice" within, whispering an image larger than the life fed to them through mass marketing and the media. The mix of subliminal seduction and blatant advertising is obnoxious and toxic. The relentless bombardment of messages from corporations, government, religion, and educational institutions can seem overwhelming in its pervasive grip on human beings. I confess to being both enraged and saddened by it all. At the same time, I recognize the limited power inherent in the visible world (gross sphere). I acknowledge a higher source and power behind the visible, which is the subtle creative force (the sphere of the invisible), all forms being "printouts" of the divine mind — solidifying at various rates of atomic vibration. This comforts me, and I am committed to creating an environment more fertile and positive in my own small way, as others can in theirs. We must insist on establishing an atmosphere of freedom so that we can all live creatively and find out for ourselves what is true. In this manner, solutions can be found, changes can be made, and new directions can be followed.

In order to grow as creative workers who can be positive agents of change, we should

turn away from the giant nipple of the technocratic breast and stop sucking on the gross vision that is provided. If we dare to see for ourselves, we are immediately nurtured by more subtle sources of nutrition, inspiration, beauty, and truth. If we turn within to find these resources while expanding our external view and field of action, we become creatively empowered and confident that the divine is never far from us, always near us, always already with us, always already *us*. One of the most important things we may learn as creative workers is to cling to our intuition and follow the guidance it provides, not in a nondescript effort but within the goal of uniting with spirit. The creative children of the universe are under no law of man but would be wise to develop a service-oriented relationship with the divine forces of beauty, truth, and goodness.

We were Lawless people, but we were on
pretty good terms with the Great Spirit.
— Tatanga Mani, Walking Buffalo [2]

It is not surprising that our age is one of anxiety and frustration. In our mechanized, fast-paced era, humanity's need to find a creative outlet is paramount. People of all ages can rejuvenate and rest from the uncertain, hyper-transitional world in which they live by using or appreciating a craft, an art, to express themselves, connecting to an intrinsic source of inner peace. In their private and sacred domain of creative activity, truth can be found. As civilization "advances" and becomes more secular, we increasingly live in a state of forgetfulness about our unity with nature and with each other, and of this, art can remind us. When education fails in its promises to promote *original thinking* and ignores compassion and wisdom, then we must cultivate it on our own, at least until education can achieve its true purpose.

A true education should open a way to self-realization and communion with the divine through our own divinity. Art itself can assist in such a noble effort. Art can be a Yoga ranging from Zen strokes of humor containing paradoxical truths to a conductor's wand magically and musically cutting through the shadows of the psyche. Currently, education does not make good use of this power of art. Modern education distrusts the deeper facets of human experience, and this is reflected in western culture's values. Reading, writing, and arithmetic has been and still is the limited mission of education, whereas the spirit in art, in life, in human experience, remains secondary. Specifically, western culture does not acknowledge the truly *spiritual* element of human life. By spiritual I mean a receptivity to the more subtle, interior aspects of our experience: a search for a deeper meaning of existence than is offered by the intellect, social convention, or science. The American worldview imposes a moralistic, materialistic, rational discipline on an inward receptivity. In this western culture, the truly *spiritual*, a different concept altogether from *religious*, is relegated to the mystical and romantic alone, and that, sadly, has come to mean something negative, out of touch, irrelevant, immaterial (not material, not physical, not corroborated by the senses or science) — so not "real."

In America, support of creative activity both for artists and art education is disgustingly and dangerously weak, even though "invention" is a highly praised and marked characteristic in American culture, which in its short history has produced more patents than any other (that is, "American ingenuity"). Certainly all cultures impose discipline and a degree of conformity and restraint on the individual's creativity, and in many ways American culture *is* individualistic and liberating in comparison to many others. But this individualism is almost exclusively economic, competitive, and superficial, and the word *creativity* has become vague, diffused, and so corrupted in language that its meaning is distrusted and diluted.

To become more familiar with what creativity and art really are and understand their importance and relevance in education, we must begin to look at their roles. Transpersonal art serves to revive us, stirring us to remember ourselves. If the arts are not truly relevant to the existential needs of humanity, it is difficult to account for the fact that the arts have been a permanent feature of human existence. We have insights into other cultures and ages mainly through their artistic legacy, because art gives a unique view of these things from the inside out. From the earliest primitive cave paintings to the galleries of today, from the classicism of Greece to the folk art of every society, humanity has been unable to live without some form of artistic expression. There is an inherent value and need for the arts in education and in basic human existence that points beyond material needs to a state of self-actualization. Some educators still insist that the arts are superfluous and not deserving of serious inclusion in the preparation of people for the arena of life. Others view the arts with an aristocratic haughtiness, while some outside the field of education regard art only as an investment. American public education at the state level places fine art either at the center of things as "high culture" (but usually only in the "lively arts," which have come to mean "entertainment"), or simply considered as fun and games and of no inherent value to us. America's negligence in support of the artist and the arts is reflected by Congressional decisions to decrease, even eliminate, support (grants) to *individual artists* through the National Endowment for the Arts.

Perhaps the best efforts in integrating self-actualization through education over the past two decades have not been in the mainstream but in some programs put forth by various holistic centers. Both accredited and non-accredited alternative and contemplative education centers can be found around the United States, Canada, Eastern and Western Europe, and Russia. These holistic education centers include more than sixty established institutes in the United States. These institutions attempt to explore the call for a deeper meaning to existence, and their programs include ancient teachings alongside offerings by contemporary leaders in the consciousness movement. However, ironically, although Plato, Plotinus, Kant, and many other great philosophers have made it emphatically clear that art is central in responding to the call for a "deeper meaning" and serves as a major force in the integration of spirit, the study of art in these programs is often less dynamic and more narrow than can be found in mainstream education. Why?

When art — visual art, music, dance, and drama — is included within the core of a

holistic or contemplative curriculum, it is often encased in a dogma that was layed down in founding that center in the first place. We can see this reflected in these centers' insensitivity to the broad range of experiences afforded by each of the arts. At many holistic education centers this is most *visible* in the *visual* arts, where the resulting aesthetic container is usually extremely small and narrow, pedantic and inflexible. A strongly enforced doctrine of conformity can limit students and their individualized creativity and expression. In these holistic environments where open learning is often claimed, promoted, and sold, "expressive art" is often looked upon by the insiders as inferior to the dogma "art" sitting at the center of the curriculum. The administration, educators, and students can be vacuumed up into a preprogrammed, tiny aesthetic hierarchy instead of experiencing an expansive journey that truly expresses one's interior, artistic space. We can measure the broad nature, the spectrum of vision, the flashing lightning of creative power, the love and knowledge of any educational center, mainstream or alternative, by their program in the arts. Indeed, it is here that we find the *heart* of institutions (or lack of it).

In educating people, we should be careful not to be either rigid or reactionary while designing integrated forms of learning. As I have mentioned, we gain an understanding of the life, the spirit, and the belief systems of other cultures and ages mainly through their artistic legacy. An integrated understanding evolves through an appreciation of the diversity of cultural creativity. This insight springs forth from a subjective experience as tangible as any form of scientific material evidence. There is an inherent value and need for the arts in education and in basic human existence. So often we are led to believe that primary needs are all materialistic in essence. The arts serve well in the motivational dynamics of life by pointing beyond material needs to the state of self-actualization. All education centers would do well to recognize and acknowledge that the omnipresence of the arts in all ages and cultures cannot be explained on the basis of one dogma, one aesthetic, or a singular system of philosophy, religion, economics, or the like.

Part of the problem with current education is that it has inherited an ignorance of art and what its true gifts really are. By the middle of the twentieth century, an applied, fundamental agreement of a definition of art no longer existed, confusing its role in all areas of life. Yet, in a warped sense, this led to a kind of accomplishment, a sort of attainment in openness and broader vision. Skeptical positions on a definition of aesthetics became popular, holding that it is impossible in principle to define art, consequently opening the door to anything and everything, by anyone and everyone, "art for art's sake." Although inaugurating a wonderful liberation for individual expression (which actually has roots in early Renaissance art), this has also invited all attempts at expression for sale, creating a kind of free-for-all. At the same time, it has devalued the spiritual in art, lumping (not integrating) materialist attitudes with the sacred path of aesthetics, thereby declaring that all art serves *nothing* (other than Art talking to Art) but does have an "entertainment" value.

In the wake of modern thought, art in education continues to crown what I have termed a "nondescript aesthetics," which has dethroned Plato and his heir, Plotinus, and a host of other philosophical protectorates of the sacred in art, generation after generation.

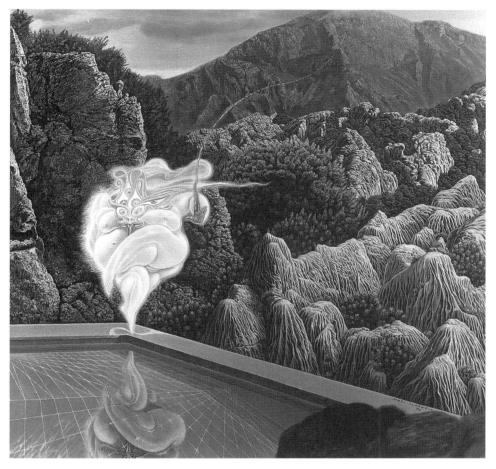

FIG. 34 Mati Klarwein, *Art Critic*, 1972, egg tempera and oil, approx. 32 x 32 in.

In light of all this, the transpersonal artists remain immensely challenged in their mission to shake up the propaganda of dis–integration, to rebuild anew and replace by serving the Beautiful, the Good, and the True. The artist as educator should address the widespread ignorance and neglect in academic programming whenever possible and should be able to do this without fear of consequences. This neglect of art in the curriculum reinforces the lack of educating students to "feel" and realize and express emotion. Since art is a subjective language, a personal communique to the responder, it also makes little sense to demean an individual's artistic taste. Since change begins with the individual, then our concern might better be directed toward addressing the total educational system and the enjoyment, encouragement, and study of the arts.

Art critics can play an integral role in art education for the public and wield a strong influence in supporting awareness and reward. Some art critics insist on analyzing the arts with the scientific precision and coldness of the dissecting table. Others insist on informing the misinformed, ill informed, or uninformed of the "real" meanings and significance of

certain artistic endeavors. As a result the uniquely vital human element can be lost. True education can be lost. What is lost is the possible glimpse of personal human understanding — the human condition received and comprehended in the purest sense as affect, insight, or intuition. At worst, this amounts to the unwarranted imposition of values, the net result of which involves a process of dehumanization and loss of self in the responder who is not allowed to apprehend, develop, or actualize his or her own human insights. This phenomenon is demonstrated in the fairy-tale *The Emperor's New Clothes*. Members of the public, left in fear, become afraid to respond to art in a genuine manner as they may appear *naked* or stupid in the eyes of "artistic authorities," or in front of the king (the curator or critic) on the Royal Road of Art.

However, not all critics seek to rob the responders of their unique experiences. Those critics who have a psychoanalytical skill grounded in the transpersonal with an openness of spirit may indeed assist us in reaching for a deeper insight and feeling a unique experience with a work of art. These critics understand that the responder must maintain enough independent space to develop his or her own experience in the arts. This type of critic is a rare individual indeed, nearly impossible to find, and we are in great need of more people of this caliber.

I dream of the arts being used as a tool for creative empowerment by becoming a mandatory component in education, *equal* alongside all the other disciplines, and this may be of particular value for students in business and politics. Albert Einstein told us:

It is not enough to teach man a specialty. Through it he may become a kind of useful machine but not a harmoniously developed personality. It is essential that the student acquire an understanding of and a lively feeling for values. He must acquire a vivid sense of the beautiful and of the morally good. Otherwise he — with his specialized knowledge — more closely resembles a well-trained dog than a harmoniously developed person. He must learn to understand the motives of human beings, their illusions, and their sufferings in order to acquire a proper relationship to individual fellow-men and to the community.

These precious things are conveyed to the younger generation through personal contact with those who teach, not — or at least not in the main — through textbooks. It is this that primarily constitutes and preserves culture. This is what I have in mind when I recommend the "humanities" as important, not just dry specialized knowledge in the fields of history and philosophy.

Overemphasis on the competitive system and premature specialization on the ground of immediate usefulness kill the spirit on which all cultural life depends, specialized knowledge included.

It is also vital to a valuable education that independent critical thinking be developed in the young human being, a development that is greatly jeopardized by overburdening him with too much and with too varied subjects (point system). Overburdening necessarily leads to superficiality. Teaching should be such that what is offered is perceived as a valuable gift and not as hard duty.[3]

In spite of Einstein's warning of educational systems producing specialists, we have indeed

become a secular society of professionals, and for many of us, our only object of dedication is our specialized pursuit, a private life centered on nothing but itself. The future of education calls for experimental models that promote *truly* open learning and an *integrated* curriculum. The traps of a dogmatic and static curriculum and the need to develop new perspectives are a constant challenge for all centers of learning. Educational institutions need to acknowledge and address a fear of change and a lack of true openness in order to create a heroic and creative environment of learning. A classroom activity in which creativity and love are incorporated offers the opportunity for children and adults to work together to foster invention and solutions. It is through an art in which creative workers take the content of fantasy and shape it, control it, limit it, and create from it something humane. Educational institutions have a responsibility to cultivate original thinking in human beings in a transpersonal manner. Schools should be centers of inspiration, hotbeds of ideas that prepare students to face the challenges being presented, and the changes that are inevitable, and arrive at creative solutions. I am comforted in the knowledge that institutions that resist change, that resist the call of the spirit, will eventually fall away like old skeletons and become dust.

Through observing creativity in myself, in other individuals, and in group dynamics, understanding difficulties in education becomes clearer. A controlling approach to learning does not allow for magic or tolerate children who will not surrender their creativity. Success in the modern school system is directly tied to ideals of capitalism, nationalism, and a meritocracy. An almost unchecked competition among individuals for social, material, and economic status was and still is pervasive as a baseline in supporting the agendas of power-oriented cultures and nations.

Modern education is competitive, nationalistic and separative. It has trained the child to regard material values as of major importance, to believe that his nation is also of major importance and superior to other nations and peoples. The general level of world information is high but usually biased, influenced by national prejudices, serving to make us citizens of our nation but not of the world.
— Albert Einstein[4]

The mystic, at any age, whether a child or adult, is less dependent on a sense of self-esteem from such external conditions. In the world outside of the Creative Mansion, the external standards for success are overwhelmingly competitive and materialistic. Whole realms of human experience, notably the aesthetic and spiritual, do not count as qualifications for the job market or as emblems of achievement. Capitalism promotes individualism and self-assertion in social and economic terms but places far less value on self-understanding, critical intelligence, compassion, or spiritual discovery in the public school systems. Practicality and productivity are more important than contemplation or inner questioning; meditative practices are held in disdain. Most of the dominant modern cultures are suspicious of contemplation that does not demonstrate its immediate practicality and

profit. We must produce *profits*, not *prophets*. Just as the religious tone of American culture encourages sinner-based moral discipline, rather than spiritual inspiration, capitalism demands material results, not self- or inward-seeking realization. In the realm of art, artists are financially rewarded depending on their alignment with these views. Thus, the more immersed an artist becomes in the transpersonal, the less he or she is honored and supported financially.

Despite the emphasis and accomplishments regarding liberty, freedom, independence, and individualism in American history, and despite the incredible and absolutely beautiful and liberating achievements that have been established by this democracy and the western world, the dominant view still does not trust the spontaneity and self-expressive creativity of the individual. As a result, most of our visionary artists are seen only by other members of their "invisible tribe," their art going on unobserved and their being unrewarded financially, and they are rarely, if ever, called upon to share their experiences in educational settings. Some creative mystics openly shrug their shoulders at the disapproval of their culture and the maligning from their fellow beings but continue to follow the guidance of their creative inner power toward expression, and too often are forced to depend on the charity of others. Education should invite those who live a deeper life, draw from a deeper well, express that artistically, and can share their transformational experiences. Education should radically change its soul in order to speak, share, and teach the truth of what really matters.

ART, EDUCATION, AND LIFE IN THE NEW AGE

The New Age movement has given us many profound shifts in education, medicine, self-awareness, an increased sensitivity to our environment, and an enhancement of our communication skills in relationship to one another. It has added some very positive elements and significant changes to culture. The consciousness movement, of which the New Age could be considered a component, has colored many holistic education centers and a number of mainstream universities in various positive ways. But in the shadows of these changes there have been negative outcomes as well.

As in the art world, where the nondescript "anything goes" aesthetic has opened the doors to the less than genuine, the openness and eclectic nature of perennial philosophy as adopted by the New Age movement have also created the opportunity for charlatans to speak alongside our genuine spiritual teachers. In addition, people are running into the past to adopt a "pure" means of living their present lives. But spot-cleaning one's life by dissecting an ancient, sacred puzzle to find a *piece* to fit into the picture of a contemporary existence simply does not work. One's discovery of ancient pictures of "purity" often neglects the imperfections and indiscretions that went along with that "picture past." The selected piece of the puzzle is taken out of context. The complete image of the past is ignored in order to fit the selected piece into a personal and present agenda. It is an innocent desire, a longing for the "sacred," but the result is a path of partiality, a

piecemealed spirituality. Holistic centers that lack an integrated view are unable to provide a truly holistic direction and feed into the dis-integration. The outcome is a catalog of historical lifestyles, rituals, ideals, paths, and practices for adoption (not adaptation or integration) that are listed like items for sale at a holistic department store. Certainly, there have been genuine attempts to offer a track, a path, a progressive practice of development within the context of "ancient futures." There are also intriguing experiments in learning offered by some centers that are daring and knowledgeable enough to venture off "formula" experiences. Such programming encourages purely traditional ways or may successfully synthesize past and present practices that offer unique transformational experiences.

In the "free play" of spiritual education, some of the alternative educational centers were founded by charismatic leaders, and yet others have their roots in the eclectic nature of the New Age movement itself. During my tenure at Naropa University, the question of spiritual quackery and New Age teachers became a central issue, as it would at any center truly concerned with the authenticity and integrity of its offerings. As a dean, I would never accept or assign an automatic credibility to any person claiming to have a gift or a special awareness that they charged a fee to exercise. Nor would I give in to political pressures or agendas that did not sit right with me (which did not make me the most popular guy on campus). But in sifting through hundreds of proposals, an unusual but effective process of evaluation would unfold. Whether teachings are based in tradition or offered in contemporary forms — such as Visionary art or insight meditation; Buddhism, shamanism, or somatic psychology; methods of divination, hypnogogic breathing, or mosquito channeling — it is all metaphysics to me. Whether modern humanity is practicing an ancient tradition or biofeedback, we cannot escape doing this within the context of our era, our time. When reviewing the myriad proposals by those who wanted to teach at a contemplative institute, I was in the position of making value judgments on teachers and teachings to determine which were authentic and which were lacking integrity. I had to rely on my personal experience and the reflections and advice of my staff and others, and remain as objective as possible. It was a big responsibility and I loved it. But without direct experiences and an involvement in contemplative practice(s), combined with an informed study of the wisdom traditions, the academic fields, and an understanding of the diverse faces of perennial philosophy — at the same time remaining open to the many new approaches to personal development — centers of education are extremely vulnerable, as are individuals, to characters peddling spiritual wares.

Many New Agers have revived the mythical images of the ancient world, returning to a magical perspective in which the universe is filled with a living energy yet running on the batteries of scientific thought. This began in the sixties as a kind of corporate spiritual merger. However, this merger is, in essence, bankrupt of any sound meaning, and upon close examination it is categorically absurd. Science has no province over, nor provides understanding of morals, ethics, philosophy, art, or aesthetics. Within the view of scientific

materialism, all attempts by art to explore the perennial questions are flattened. This dilemma is investigated and beautifully explained in Wilber's recent book, *The Marriage of Sense and Soul — Integrating Science and Religion*. In a frantic, nearly unconscious backlash against scientific materialism, New Age images are borrowed from every religion, pagan and otherwise, bombarding the minds of the New Age spiritual imagination from every direction. Yet, the word "God" is avoided by today's New Agers, in part because of its domineering and masculine associations,[5] the influence of science embedded in our culture, and the mistaken notion that "evolution" is a contradiction to the divine process of creation and consciousness.

In general, I believe these New Age proponents have good hearts and good intentions, but unfortunately, due to the lack of cultivating creative courage and original thinking, a kind of flat perception becomes all-pervasive. In my view, this kind of thinking treats education, art, economics, religion, psychology, ecology, medicine, politics, philosophy, and virtually everything else that is important with non-discriminating eyes, a fundamentalism that prevents deeper integration. Any fundamentalist view, whether it is a radical Hassidism, born-again Christianity, a militant Islamic faction, or the channeled dictations of Saint Germaine by somebody in Sedona, Arizona, all leads to separation. It divides people and consciousness. Through a genuine urge to explore and become One but mixed with a twisted need to rule "everything Invisible and Visible," the New Age movement can divide or go to the other extreme and become an ideological stew. The soup, first heated up on the counterculture coals of the sixties, has been simmering ever since. Adding traditions and rituals as ingredients, they sometimes lose their purity, and in other cases become a tasteful addition through assimilation. In their innocence, New Agers, mere descendants of a Romantic movement now nearly two centuries old, desire Oneness, but in their fervor and narcissism move closer to a duality rather than a unified flow with all of life.

As mentioned, the New Age has brought positive changes to the human condition, particularly an increased openness to explore the multidimensional layers of mind and an interest in spirit. But this openness has devolved, like a self-centered aftershock of genuine, earthquaking exploration and awakening that began from true inspiration. Today, the guise of "new" paradigms in consciousness is an obstacle to a new humanity of intuition and non-duality, which is very pricey. I would describe this cost as a kind of New Age island that "terra-forms" a ground where the "me" generation lives and practices abundance and *manifests* its personal power and prophecy while finding it nearly impossible to look past the tip of its nose. Some of these New Age Islanders claim a special authority via some deified being that may or may not possess a name that is spiritually recognizable but that personally consecrated and licensed them to be a messenger, a channel of the divine. Some of these channelers and their followers, instead of offering positive spiritual guidance, chastise us if we are not already willing to agree with their proclamations before they are even spoken. If our skepticism is noticed, then we are deprived of their proclamations and therefore damned to suffer the inevitable

consequences along with all the rest of the world not privy to or worthy of their "special" divine information.

They may also look down upon us, even insult us for not manifesting *abundance* in our personal lives or if we haven't already cured a *disease* that *we created* for ourselves and are suffering from. Or perhaps we were an unfortunate victim of a *terrible crime*, but because of our *bad* karma, we are simply told that we *deserved it*! Where is the loving, spiritual compassion in this? (To this day, I stand by my simple rule: If it ain't got no love in it — stay away from it.) Yet others caught in certain waves of the New Age ocean spout apocalyptic threats, perhaps channeled by some race of evolved lizards they have just read about in the latest reptilian newsletter or book. With angry, cataclysmic voices, not unlike some TV evangelists, they assign directions, judgments and prophecies on all humankind. You rarely hear exact dates for these apocalyptic earth changes or extraterrestrial events, and if a date is given and it peacefully passes by, it is conveniently changed to a new one. Yet these New Age followers completely ignore any positive actions that can be taken *right now*, at the center of their lives, within their own sphere of action, that can uplift others. How many of these people have devoted even an hour of their time at a hospital or soup kitchen? How many have sent their dollars to save whales while their fellow humanity drowns in a sea of poverty and abuse?

Some New Agers involved in cults or with oversimplified cataclysmic-transformational philosophies of salvation are often required to surrender their free will (or wallets) to their leader (whether in flesh or spirit) in order to become "special." They are thus *spared* the cataclysmic wrath of the cosmos in which *the rest of us* sit, perched and paralyzed, on the edge of being punished along with all the other "noninformed" people. They are special and are saved before the End Times arrive. Yet others riding another wave, too egotistical to follow anything or anybody real — that is, spirit in the flesh — conveniently attach themselves to an "ascended master," an angel or extraterrestrial in spirit, so as not to be challenged at either end, as a student or as a teacher. They become immersed in a kind of self-centered universe, a narcissistic world in which they are king or queen of everything they know will someday come to be. Yet their royal robes aren't real at all, they are really the subjects at court, the followers of a spoon-fed philosophy that is usually simplistic, exclusive, and selfish. Is that so different from following any other dogma or materialistic or dualistic belief? I am genuinely alarmed and concerned by this activity as much as I am by the actions of any fundamentalist group that becomes encased, solid, and hardened in a view that maintains "the highest and only knowledge" of the divine.

It all just looks like sheep herding to me, in which personal responsibility, creativity, and choice are given up to follow a New Age shepherd who is cashing in on a lot of wool. Through this the New Agers believe they have a spiritual life insurance plan. Securing salvation and needing everything to be in a happy state at all times is born of the belief that one is spiritually evolved only if one is constantly happy. Intentions may be good, but such ideological systems often lack integration, real psychological-spiritual work, and a basic humility and compassion for others in states of weakness, pain, and need.

The really sad thing about these people whose intentions are basically good is that they are caught up in the *schpuck* and starve for spiritual authority and self-importance and consequently start to really believe that they have become all-knowing, enlightened overnight, and unquestionable emissaries of the divine. In fact, they have maneuvered themselves into positions of being set up and are little more than disempowered amplifiers of rote learning from a "channeled" book, person, or group, which, in spirit, is less than *unifying*. When something denies the fruit of co-creativity, which is true abundance, true courage, and a self-empowerment that requires self-responsibility and love, then something isn't right. When something does not inspire us to move toward a non-dual spirit, unifying us, then that something is wrong — not bad but simply weak or lacking in truth, beauty, and love. Divinely *exclusive* information reserved for the spiritually elite is none other than a regressive, self-serving philosophy that supports all the other elements contributing to a dissociated modernity and a pathological dualism. When one meets someone who is truly sharing a glimpse of the divine, all others know it by their inspiration. There is also a self-empowering of others who come into contact with them, and feelings of inspiration are felt in their presence.

In regard to the New Age and education, to experiences in learning, knowing, and loving more, I propose that people stop following like sheep, try things out for themselves, attempt to be more creative in all situations, and help others *now* through their own daily sphere of influence. I am suggesting that we do not wait for an Intergalactic Lizard Solution, a UFO Rescue, or Crystal Communication from Planet Comecum. What message are we giving to our children when we tell them we are all helpless and that our destiny is in the hands of some off-world civilization, or sapphire-eyed angels, or frog-footed zebras from the Amphibia Galaxy? Some people do just the opposite, telling themselves and their children that they have incarnated here as one of the "saviors," one of the perhaps 144,000 future holy survivors of the apocalypse that will transform our sorry-ass world (no heavy pressure on a child in that one, now is there?).

Are we all dead, irresponsible, worthless, and ineffective people who must wait for some great rescue operation initiated by forces outside of our control? Are we really all sinners, pieces of "soul-poopy" dependent on the pity of God's "*only*" son" Jesus Christ, the rest of us being mere illegitimate but somewhat spiritual orphans, created by God as eligible for "adoption" through "programmed services" but only if we are good and follow all the rules? Or maybe we are at the mercy of giant, invisible grape-seed creatures from an etheric vine dimension. Are we not alive, creative, beautiful, and empowered right now? Isn't there something good, beneficial, and transforming that we can do right now? We should really try to include the best of our evolutionary wisdom while transcending all that has come before. Only spirit alone, which is beyond all forms, but has become all forms, can induce such a radical "formless intuition," infusing us with the evolutionary and spiritually radical impulse toward *unity*. Transformation awakens in the action of unity awareness. We are spirit *now*, and not a long time ago in a galaxy far, far, away, nor in some distant future.

It is also true that sensitive men and women in all times have been anxious about the

future and in fear of or exhilarated by the feeling that theirs was an age of unprecedented change, particularly at the end of a century. But there is a new quality to the mutability of our age. It is not only swifter and more pervasive, but for the first time, the whole society is explicitly organized to promote it. Each of us contributes to it. Each of us is working on next year's model, the latest catalog, the newest wonder drug, the latest industrial complex that will require the next skyscraper — which will produce the next alteration in the cityscape, the next accumulative addition to scholarship that will change our view of the past, the next fashionable artistic style. Although the theme of this book underscores the value in our inherent creativity, the challenge facing the human race is not simply to learn to be more creative, but to see how we use that awesome and life-transforming power. One could argue that we are too zealously creative now; even as we create a superabundance of people and things, we find it easier to continue to create more and more of both than to work to adapt and integrate that which exists. It requires a great deal of creativity to solve the problems involved in placing an airport in the middle of wetlands, obliterating a natural environment and replacing it with an unstable, artificial one, but there are good reasons for regarding that creativity as misplaced, even destructive. As we integrate internally, our creativity naturally moves toward cooperation externally, and our inventive powers can flow with the unity of life.

We live in a universe of spirit and law. From one we are to draw inspiration, from the other we are to utilize power. Each is a complement to the other and both are necessary to existence. How lovely and beautiful that this universe we dwell in is of a spiritual nature, that it is intelligent and creative, and it is a thing of law and order. It is God's universe, a divine idea and thought that have become manifest, God becoming that which He has created through the law of His nature. It is one stupendous whole, with God as both cause and effect. Idea and manifestation, and the law by which one becomes the other, are all one in the inherent nature of God.

Each one of us is an individualized center of God-conscious life, a point in the infinite sea of life, and an intelligent, self-knowing point. The human being is the outcome of God's desire to express Himself as individuality. The whole meaning of experience is to promote this individuality and thus provide a fuller channel for the expression of the supreme spirit of the universe. The universal mind contains all knowledge. It is the "potential ultimate" of all things. To it, all things are possible. To us, as much is possible as we can conceive or absorb, and it is infinitely available. We do not need to add Galactic Lizard knowledge or crystal balls to that which is already abundant within and all around us. We do not require a restricted spiritual diet-philosophy that is the "only way." What is necessary for the unfolding of spirit in a human being are intellectual and scientific freedom, religious liberty, artistic exploration, and spiritual experience. There is no "secret" information reserved for a select group of souls channeled by one "special" person and no one else. To what divine bias would that be assigned? Whatever is true is free to all alike. We cannot cover the infinite with a finite blanket. It refuses to be concealed. God has no favorites and knows no privileged class, and everyone is invited to the party!

THE KINGDOM OF LIONS AND THE MASQUERADE BALL

In my experience, learning, teaching, and creating involves working with the spirit of things. Spirit embraces love, beauty, and truth, all the human gradations inbetween, and infinitely more. So the aim of the transpersonal artist is to create and bring forth what has stirred from within and has been inspired from outside. Art, culture, and education are merely aspects of a larger challenge, that of the voyage of being genuinely human. Art opens a way to self-realization and communion with the divine through our own divinity and creative power. Paradoxically, art uses illusion to unveil the reality behind the grand illusion. Through us, God loses Himself in a sport, a play of consciousness, for the fun and creativeness of finding Himself. It's as though all of us, gods and goddesses, went to a grand masquerade ball and had so much fun playing and pretending at the party, we forgot it was a masquerade. We forgot to remove our masks and continued to play and veil our true nature, our divine nature. Our external identification with life situations reinforces our illusions, our dreams, our playing. We forget the source of our creative power, which is also our immense love and union with Spirit.

Hypnotized by our culture, mass marketing, and industrialized education, we are encouraged to believe that our mask *is* our true self; we gradually lose contact with our true essence and attach ourselves to a limited and false identity, a frozen ego. We go into a creative coma and systematically develop a spiritual amnesia. When we begin to watch our footsteps while dancing at the ball, or when we just choose to leave the masquerade party, we can turn to a transpersonal art or contemplative practice to gently remove our mask. Then it begins: a true experience of being "born again." Spirit purrs inside us — a soft lion's roar echoes through the wilderness of the soul. In my travels, I have seen the birth of a spiritual life reflected in many eyes, masks falling … floating to the ground, the happy aftermath of a metaphysical Mardi Gras.

In the spring of 1996, six months after the operation on my broken neck, I was invited to teach and lecture at several holistic education centers in Russia. Still suffering physically and using a cane to walk, the postoperative and emotional stress continued to bear down on me. I nonetheless accepted the invitation, believing that the inspirational nature of the journey would be healing, and I could never resist an adventure. I asked my bright young friend and camper extraordinaire, Saul Kotzubei, to join me, and I made arrangements for him to offer *Vipassana* meditation while I lectured on creative empowerment and transpersonal art. We traveled to Moscow, as well as to the remote city of Ekaterinburg in Siberia. Ekaterinburg is the last metropolitan frontier before the wastelands, and it's the city where Czar Nicholas and the royal family were put to death by the Bolsheviks. In this eerie place, we offered some tools for self-awareness.

The question most important to our Russian friends was, How can you tell if a guru or spiritual teacher is authentic? In a vast country where a new freedom has opened doors and unleashed the thirst for self-realization, various religious factions, from Scientologists to born-again Christian fundamentalists, vie for the two hundred dollars or less per month

that the average Russian earns. Questions that address discernment and empower the inner teacher are fundamental for spiritual seekers not only for holistic education centers, or those residing in Russia, but anywhere at all. Original thinking is basic yet requires us to meet phases of anxiety that arise as one achieves the freedom born from creative courage. Creativity grows from a willingness to differentiate, to move from the protective realms of parental or spiritual teacher dependence to new levels of choice, discernment, decision, liberation, and integration. We must enter the cage, look into the darkness of the lion's jaws. Each creative piece of work we do in the world, whether it is a painting or a newly implemented and humane employment policy in the workplace, reflects a stage of this creative growth.

Creativity grows in us as we move through phases of self-doubt. Veneering the deep within us or skipping over stages of development will only cause the neglected psychic material residing at a particular stage to fester and blister, later rising to the surface of attention like a deep-seated virus or spiritual rash. We will pass through many stages, and these will not usually be successive. The Zen teacher, Joko Beck, uses an analogy to explain progress on the journey: It's like being on an elevator, getting off on the ninth floor, and in the next hour being back on the third floor because certain psychological patterns return as unresolved issues or unfinished teachings of various kinds. She suggests that in the expansion of consciousness, we may slide back and forth, side to side, up and down in accomplishing awareness. However, we cannot skip over stages of development avoiding certain dangers that may keep us from true integration. In truth, we are not "going" anywhere on a spiritual journey; we are merely transitioning through stages of development until we reach the core of our being.

To make these transitions requires courage — not only at the most obvious stages, as when breaking with parental protection and teachers — but at many of life's other transitions as well: going away to school; living in a foreign country; crises of love, marriage, divorce; facing death; and moving from secure, familiar surroundings to breaking the boundaries into the unfamiliar. Through successive stages, births of true self-awareness and deaths of false identifications, we become stronger, and it becomes easier to enter the lion's kingdom of creative courage. Within this kingdom we discover that the opposite of courage is not cowardice; it is simply that some vital potentiality is unrealized or blocked. The opposite of courage in our particular age is a "collective block," a widespread *automaton conformity*. What many fear the most and why they lose touch with their creative powers is the dread that is experienced in being out of the group, not fitting in. People block their ability for original thinking through their fear of being isolated or being laughed at, ridiculed, or rejected for their creative ideas, artistic expressions, or any suggestions that are contrary to the norm. If one sinks back into the crowd or becomes an automaton, one does not risk these dangers in life, love, or art, but as a result, one's spirit dries up, and one may take on the look of death, or that of a robot.

I strongly believe that it is really important for young people to live in an environment

in which there is no fear, otherwise the thirst for learning can be destroyed and the courage to create is in jeopardy. As a result, we become frightened as we grow older — we are afraid of living, afraid of losing a job, afraid of tradition, afraid of nontradition, afraid of changes or innovations, afraid of the neighbors, of bosses, of what others think of us, or what the wife or husband might say, afraid of being politically incorrect, breaking social rules that are idiotic, afraid of death. Krishnamurti's insights into the blocks to learning and living included an awareness that all of us have fear in one form or another to be moved through and overcome. Where there is fear there cannot be a completely crystal-clear intelligence, a loving heart.

If education is to encourage true learning opportunities, it must create an environment without fear, an atmosphere of safety and freedom. Freedom not just for students to do what they like, but to understand the whole creative process of learning, expressing, loving, and living. Education in America, while there has been some movement and innovation, is still stuck in its pedagogical origins which were determined by Protestant and Calvinistic ideas. Since Calvinism taught that the individual is tainted by original sin, that an innate tendency toward evil could only be curbed by stern discipline, it followed that the child's spontaneity, and therefore creativity, must be discouraged, if not altogether crushed. Even today, conformity often replaces creativity in the classroom. In this context, a *playful, dynamic, creative, and pleasure-loving child* is considered hell-bound, a troublemaker, a problem child who will surely be redirected, even punished.

Not to imitate but to discover — that is true education. The awakening of the creative power within each one of us is not just important, it is essential. The discipline of art alone, however, is not sufficient. It is here that the arts should join the spiritual paths, the humanities, the physical and social sciences, in creating an integrated and united front. We would do well to develop an interdisciplinary mode of rigorous scholarship in human affairs that is imbued with an artistic judgment of proportion and allows for spiritual opportunity. However, many people today still view art as an activity reserved for a highly trained, elite group of specialists. This belief system creates little enclaves of artists sprinkled here and there among large masses of "non-artists" who seek to be entertained by those who are "genuinely" creative. We can also trace this attitude of widespread creative impotence to the birth of the industrial-modern age, which values efficiency, routine, technology, and specialization and depreciates creativity, original thinking, and imaginativeness.

How do we inspire and cultivate creativity as noble and as strong as a lion's courage in the human spirit? I believe, without hesitation or doubt, that inherently we all have the capacity to be creative in any endeavor we choose, but these powers have often either been disowned or wounded. We seek to "revive" them through specialists called "artists" in an almost unconscious desire to reclaim the original sensibilities that lie dormant. It has been my experience as a teacher that everyone has a capacity not only to appreciate art but to create, to express their spirit in some form. On numerous occasions I have had a student who had never taken up a pencil or paintbrush and succeed in the studio. Although hard to believe, in many cases a student's first attempt equaled or surpassed the work of those

who had been studying art in mainstream universities for years. Of course, not everyone is meant to paint. How boring that would be. My point is that everyone is meant to express his or her unique spirit in some chosen form. People can cultivate their courage to create and find a means of expression, sharing with humanity what is theirs to give, or simply using their creative energy as a personal practice for self-growth, thereby enriching life as a whole. Mastering one thing in life enables one to approach all things with that same creative power, confidence, and skill that brought about that original and singular accomplishment — and this spills over into all the other areas of life. Consequently, whatever is approached next in learning is usually imbibed and accomplished with grace.

Part of reclaiming creativity through art or a contemplative practice involves a stage at which we confront our damage and the forces that caused damage. I would recommend that anyone lifting the lion's nose ring should knock on the transpersonal doors of the Creative Mansion to seek out a guide, one who has traversed the rooms and hallways of inner vision. I have touched on this subject and will again later, but this is a good time to further discuss the distinction between the work of an experienced and accomplished transpersonal artist and one standing fresh at the doorway. This is a vital stage in the spiritual life of a creative worker. Some of us simply must stand alone at this point for reasons unknown or later to be understood and integrated within us. However, if choice and the opportunity for a mentor are available, one should not hesitate to reach out and ask for help.

Great transpersonal artists who have experienced the dark nights, illnesses, visitations, or attacks by unfriendly forces have learned to use their experience of non-ordinary states of consciousness and unwelcomed forces in the service of art, a holy art. The transpersonal artist can journey within, explore, and, if necessary, battle inwardly and outwardly and return. We see it in their work. Whereas, the paintings of the untrained and unguided can sometimes reveal that they are at the mercy of the inner self, the massive unconscious, the dark realms, and confusing spirits. The unguided may eventually differentiate between "dark illustrations" and their other works, but "meaning" may escape them, leaving them lost and confused, even frightened. Where problems of the mind are concerned, the understanding must be found where they originated — that is, from *within* — or from someone who has been there before, a *consciousness cartographer.*

We can follow the path of an aspiring transpersonal artist like an aesthetic map revealing a path of inward struggles that may or may not find the illumination necessary to open the locked doors to subtler states. The soul remembers and it will, in time, provide the inner guidance necessary to untie the dark knots through the creative healing powers of art. And it should be remembered that even when we are fortunate to have the guidance of one who has gone before us, ultimately, like all spiritual practices, the transpersonal path places the central responsibility for change upon the individual, rather than making him or her rely exclusively upon conditions imposed from outside, or offered by a *teacher.*

It was a journey that one must make, walking straight and alone. No respite or short-cuts were permitted. And one's will had to hold against every challenge of triumph or failure, or the praise of

Vanity Fair. Until one had crossed the darkened and wasted valleys and come at last into clear air and could stand on a high limitless plain. Imagination, no longer fettered by the laws of fear, became as one with Vision. And the Act, intrinsic and absolute, was its meaning and the bearer of its passion.

— Clyfford Still[6]

SOULCRAFTING

This entering into the Creative Mansion also involves what I call *soulcrafting*, which I do not mean as an exclusive act of the will but as a balance between *will* and *surrender*. This step is about transforming the lion's cage of fear into Daniel's den of lions. By confronting the sources of fear and pain that are isolated in our shadow realms with compassionate eyes, including an acceptance toward ourselves and others, we can achieve a greater fearlessness. Incorporating psychological and spiritual techniques that are integrating, we can understand and heal childhood trauma, adolescent crises, and move through life's transitions, confronting and transforming the personal demons in our "issue box." In the *years* in which this work takes place, we heal and feel the empowerment of gaining a personal freedom.

This freedom arises from the courageous act of dissolving our fears one by one, by first using *vision* to look at a particular fear, really *see* it, then look *through* it, thoroughly *know* it, completely *feel* it, and finally *pass through* it, leaving the carcass of that fear behind us, never alive in us again to frighten, restrain, and restrict us. One of the many keys we can use, to unlock such fears from our inner prison that creatively blocks us, is to learn to initially be okay with unresolved questions, the *unknown*. This is education at its finest hour, when we can be inspired by the questions, instead of longing for the security of an answer.

Journal entry:
January 2, 1999 *Boulder, Colorado*
My year of the Lion

I have spent the last two years in limbo, in the air of unanswered questions. I learned to have patience with unresolved questions. I learned to live with everything unresolved in my heart, and I learned to love the questions themselves as if they were locked in treasure chests, in the unopened rooms of the Creative Mansion inside me. I learned to stop searching for the answers, which could not unfold or be given ... because I could not live them yet ... not now ... and yet I learned that I must live everything now, especially the questions. And I have come to know that one day, like breathing, without even noticing it, I will be living the answers. And then I will see that all of my questions were truly lived with courage and creativity, with faith and love.

P. R-J

This independence can entail a lifelong journey of heroic self-challenge, spiritual conflict, risk-taking, individuation, and growth. Every inch of personal freedom that is gained is supplemented with a collective light, love, creativity, and courage. Each moment that expresses our individual experience begins to also be imbued with a universal fire. This is not only important, it is essential.

As a child, soulcrafting for my siblings and me also involved the experience of not having an abundance of toys, so we relied on our sense of adventure, creating secret places and using our imaginations to entertain ourselves, to explore and learn. Everything was *secret* from the harsh, vulgar, and seemingly dead adult world, and we were magical. There was the secret junkyard, the secret playground, secret formulas for regenerative-power juices, and so forth. In my case, this also included pushing coloring books away and having parents who were okay with my not staying within the lines, affording the opportunity to expand my boundaries to create new and wider secret ones. A child, aware of his or her parents' love and protection in proportion to his or her degree of immaturity, can take the occasional risk and crises without overwhelming his or her growing courage.

Our family went on many picnics and camping trips when I was young. On one such trip, when I was four years old, my father noticed that I had wandered off and saw me atop a railing on a nearby wooden bridge. He watched me as I crossed over a shallow river ravine. Like a miniature trapeze artist, I walked atop the railing on the side of the bridge, balancing my way across. I heard my mother scream to my father, "Izzy!" and I turned my head to see whether I was in danger by checking my father's facial expression. He glowed with a calm confidence and pride in me, he winked and smiled at me, and I continued on my way. However, my parents did not require me to stand alone on any "bridge" to a greater degree than I was prepared to do. My father's closeness to me and his confidence in his own physical prowess assured my rescue, if necessary. The child's creative courage grows by a balance between risk taking and feeling safe (safe enough to venture out). If parents need to force a child into a role, dominate or overprotect the child out of their own anxiety, the child's task is made that much more difficult, and the light of creative power is already dimming.

Parents who have doubts about their own strength and creativity often act in one of two extremes: either they pass on their fear to their children, or they tend to demand that their children be especially courageous, creative, independent, and aggressive in an attempt to compensate, alleviate, or transgress their own fears or issues. They may buy the son boxing gloves, push a daughter into gymnastic competitions, encourage their children to act wild, exhibit abnormal or criminal behaviors, or do exceptionally well in school. Generally, parents who push a child, like those who overprotect a child, are showing actions that demonstrate their own lack of confidence in the child. The child picks up on this. Just as no child will develop courage by being overprotected, no child will develop bravery by being aggressively pushed beyond their own conquered and secret boundaries of the moment.

Soulcrafting in children occurs as an outcome of their own confidence, generally

unverbalized, through their own powers and intrinsic qualities as human beings. This ground of confidence swells from a parent's loving belief in the child's potentialities. What children need is help to utilize and develop their own power, feeling that their parents see them as persons in their own right. Loving them for their own particular capacities and values recognizes that the craftsmanship at work in an individual's soul is not the exclusive handiwork of parents alone, the child alone, or for that matter, anything at all separate from all the forms and energies of life and Spirit itself. In most modern societies — especially in the West, which is basically nontribal and polycultural, with the extended family dissolving and the nuclear family in shreds — the ideal time to begin the journey through art, a wisdom tradition, or a contemporary practice toward independence and warriorship is long before marriage, or at least, before children. Marriage and the creation of children require us to trade in a great deal of our independence for interdependence. Thus it is essential that we have our bearings set, that we know who we are before we use our divine power to create children. If we have not attained a certain level of inner freedom, then in our dependence we are likely to end up teaching our children to take care of us. Our children, as a result, will develop a false identity so as to meet the emotional needs we have. Too many families become dysfunctional and destructive and dissolve because a great many people are mating and having children before developing independence. And without independence there is no invention, no original thinking, and less chance for creative solutions to problems as a whole. We will always be challenged with problems; it is how we deal with them, how we creatively move through them that is the key, not how we can rid ourselves of problems forever, which is unlikely to happen.

THE JEWEL IN BEING GENUINE

We could say that our creations as well as our responses to everything in life simply are born from one of two sources arising from within us: either love or fear. These two experiences are directly related to our ability and choice in being authentic, being real, genuine. Having left the masquerade ball, we now face the fear of being maskless, unveiled, of being seen, of loving and being loved. To continue we have to recognize that a process is required that is inwardly supporting us as we acknowledge the frightened aspects within us. We must have some love and faith in ourselves and in a power greater than ourselves yet available to us to inherit eventually this precious jewel of love, beauty, and truth.

We shouldn't push our fears, nor should we deny them. We shouldn't take steps bigger than our fear can handle. We should take smaller steps, move through stages in which our fear becomes less and less an obstacle to our creative endeavors. If a child is afraid of horseback riding, would we put them in an equestrian high-jump competition? Of course not. We would put them in a place where they are gently and lovingly guided, and the child can express everything that is going on. For the development of creative courage we use our growing strength to expand our vulnerability and sensitivity. Like the child who feels cared for, encouraged, and listened to, we become less frightened. If we don't take steps

larger than our fear can handle, we will progress, the fear dissolves, and our strength grows.

A great deal of the work necessary to equip and activate the mind for the spontaneous part of invention and creativity must first be done consciously and with an effort of the will. Mastering accumulated knowledge, gathering historical and new facts, reorganizing old and existing knowledge, observing, exploring, experimenting, developing technique and skill, marrying *techne* with *psyche*, refining sensibilities and discrimination are all more or less conscious or voluntary activities. The sheer labor of preparing technically for creative work, consciously acquiring the requisite knowledge of a medium and skill, is extensive and arduous enough to repel many from achievement. After all this is in place, we must add the larger part of artistic service: being genuinely human, original thinkers, receivers and givers of the heart divine.

When I am in the role of teacher, I work with the creative process as a catalyst for awakening and healing. I am in a secret and sacred conversation with each student's inner teacher. It has become clear to me that each student will draw and awaken his or her own inner knowledge by resonating with the teacher's creative energy. This occurs in direct correlation to the student's openness, willingness, and ability to receive. An openness, respect, and vulnerability, *without loss of discernment*, personal power, and choice, is required of the student. Integrity and generosity of spirit is required of the teacher. In this relationship, a transpersonal experience can manifest itself between teacher and student, a dialogue of spirit whereby a connection is established from the rhythm of the beginner to the reservoir of liberated forces residing within the teacher. A line of communication is intuitively developed between the inner witnesses in both student and teacher.

When a person comes to my studio, I never suggest, command, or influence what he or she should paint. It is essential that the idea or feeling is entirely their own. This particular approach demands a considerable amount of patience. It may be some time that we are both obliged to wait for the rebirth of creative power, but I know that it is inevitable. Although a teacher of art may be a virtual warehouse of knowledge (and today this is an extremely rare occurrence) in methods and materials, art history, psychology, philosophy, comparative religions, and inspirational stories from direct life experience, all this still plays only a small part in the liberation of a person's creative power. The teacher is also granting permission to the creative worker's inner power to awaken and guide the student from the inside out. Beyond this, as a teacher of art, I aim to create an inspiring atmosphere of acceptance in which anything is possible, anything can be dreamed or envisioned by the students without ridicule; I provide the necessary methods and materials of *techne* to support *psyche* in order for them to manifest their vision.

In essence, the teacher is merely granting permission to the students to be creative, to find their own source. In an informal conversation with my friend, Sam Keen, author of *Fire in the Belly*, and mentor to many, he told me that his term for this kind of teacher is a "permissionary." I love that word. It is perfect in describing the teacher's role in the arts. If a person is prepared to come to the studio and spend some time with me, then I must be prepared to join in the vigil. My own method of teaching involves being outwardly as

passive as possible while being dynamic on the inner spiritual levels. This does not mean I'm being quiet or boring, but I will refrain from suggesting any imagery or responding to a request to do so. I feel that this would alter our creative relationship. It could also result in carbon copies of my own work, pictures produced to please me rather than for students to express, quite freely, the dynamics of their own psyche, feelings, and spirit. I will impart my genuine belief in them (not in their personality but in the creative power dwelling within them, asleep, waiting to awaken). This is quite a different approach from what is found in most artists who teach, or in art schools. I have come to trust completely the awakening of creative power in others. I believe and know it will happen. In serving psyche, the true value of a work of art must be elicited from the author, and in this way the awakening of creative courage is cultivated and assured.

When we are in a relationship with a lover, a teacher, or guru, it is vital that we remember that they are the *spark*, but that we are the *flame*. When we are with a lover, although we are in love and it seems we are given new and wonderful things or qualities by the other, we are really only experiencing our own qualities and potentials being seen, acknowledged, awakened, and inspired. These qualities arise from within us; they are not given. These potentials and qualities are intrinsic to our nature. They cannot be given, but the light within us can grow by the warm kindling energy, love, and wisdom of others. This is fundamentally different from giving away our power in any relationship, whether it is to a lover, teacher, or guru.

But first we must make an initial move on our own. Perhaps we must experience some embarrassment regarding our inability to draw a straight line, write a book, design something, invent a product, or create masterpieces *instantly* for fear of not appearing perfect and grand to others immediately. We have to make a leap and just begin to do it from where we are standing at that moment, compromising with or ignoring the inner critic, and begin to be genuinely who we are. That is always enough: who we are. It is not that we lack anything and need to add something to ourselves in order to experience creative power — we have that already. We need only to remove the veils of false identification that prevent us from experiencing our true nature.

One way to achieve artistic truth is by a reconnection to playing, recalling the feeling we had in childhood of using our tools of imagination. Remember, as a child, the feeling of being delightfully lost in the world of creative power? Like playing and swimming in the water, lips turning blue, bodies shaking from the cold, but having such joy that we didn't want to leave the water. We would ignore our freezing little bodies, quivering blue lips, and our shaking knees because our play, our creative games and joy, was greater. Letting go of all our baggage at the moment and recapturing the power of being a little person is a good method to reclaim creativity and genuine spirit. This means foregoing a lot of so-called adult behavior at times while retaining the maturity and wisdom gained in our adult years. The more vitally creative the artist, the less he or she thinks of drawing on past associations of thought and experience, yet the feeling of childlike play is never only in the past, it is always available in the present, regardless of age or what "time" we think it is. The

creative mystic lives in the *present*, seeking to catch those subcurrents in the tides of time that never take one in exactly the same direction twice.

In order to reach depth while tapping into creativity, one can add the essential quality of honesty. "Self-honesty" will conjure up the creative power from the deepest recesses of your being. An acceleration of your creative growth and connection to pure spirit will occur through being genuine. The spirit of art responds to the call of authenticity. I believe a weaker art is only that which is vacant of feeling. Vacancy of feeling is often a result of superficial gestures, passing over the call to be genuine, or veneering the *deeper*. One of the reasons why creative activity takes so much self-honesty and courage is that to create moves us toward freedom and away from the bondage to our infantile and immature past while it retains the childlike wonder and play and power to imagine: the matured child mind. Creating from the inside out involves breaking the old in order for the new to be born. Creative power in art, business, or anything at all entails developing one's capacities, becoming freer and more responsible; these are aspects of the same process. Every act of genuine creativity means achieving a higher level of self-awareness, responsibility, and personal freedom. This is rewarded with the joy of truly being ourselves, the immense gifts in our inherent natures becoming ever more accessible, and we are in a *flow*.

We would do well from the beginning to use our creative energy in a genuine manner. Even the most adept artists struggle to be genuine in their art. Many of the greatest draftsmen, technicians, and craftsmen never attain it. Yet some of the most innocent and naive artists have been our most authentic. Chogyam Trungpa Rinpoche offers a reason for this:

Iconography plays a very important part in this regard. It deals with how you can properly see your world, your life. You can't reject your Waspness or your Jewishness, your Italianness or your Polishness. Your background is definitely and completely sealed. Your body is made completely out of those elements, and you can't pretend not to be one of those. You don't have to change; you don't have to regard this world as shitty and terrible and feel that you have to get into a greater, better, more civilized world. That is a somewhat farfetched idea: you cannot do it. And that mentality of looking for a better world is called spiritual materialism. So you can understand symbolism if you are actually able to see through the aggression and ego. It is possible for you to do that and by so doing you actually can unify the two worlds.[7]

There are many ways of learning to see more and to see better. It is a shame that so many of us see much less than is visible. If one could buy a pair of spectacles guaranteed to reveal everything in a far more genuine light than before, wouldn't that person rush to purchase them? If one can learn to see more than he or she now sees — see farther, see more beauty, and see more clearly the shape of one's own nature, then one should not hesitate to start learning. A clarifying vision such as this might save us from a revolving door on our journey. Yet creative workers have varying success in the task of capturing

a vision with exceptional clarity and expression, attempting to recreate the feeling-vision in reified form. The concept itself may continually undergo change, modification, and development while the work is in progress. I find that that is true in my own creative process at times.

Most artists frequently deal with the same general concept over long periods — years, decades, or even lifetimes. Ernst Fuchs continues to express Judeo-Christian themes that sometimes rub up against an erotic and fiery mysticism. DeEs Schwertberger's fundamental rock paintings are another good example. These powerful works span more than twenty years and culminate in the final act of his "rock men's" solidifying and liberating themselves into three-dimensional sculptures born from the flat womb of his inspired paintings. A prince among painters, DeEs's recent visionary impressionism represents a courageous departure from his previous paintings of extraordinary precision. Likewise, the radical renegade genius of Mati Klarwein's work has maintained an extremely recognizable look and energy of the Fantastic, but he has also taken brave and brilliant excursions here and there, occasionally venturing into foreign territories. Sandra Reamer's works have traversed realms ranging from classical realism to Fantastic romanticism and divine geometry to figurative expressionism to a spiritual abstract art (that includes cosmetic minimalism) to somatic color fields. Her path in art has truly and physically embodied the term "Transformative."

Robert Venosa's captivating crystalline worlds continue to be explored and reified after thirty years of focused discipline. They are snapshots of heaven that transpose us, allowing us to sit with the angels for a while, hear their music, and even receive the blessings of the divine. Alex Grey's anatomical universe of multidimensional layers of being and energy is a central focus in his art after many years of study, discipline, and production. Alex's work almost shocks us into seeing the absolute reality of our paradoxical and fleeting existence, the temporal body encasing an eternal consciousness, the finite kissing the infinite. His images remind us of impending death or the changing of our body-clothes, and at the same time, we recognize our illumined life and the living network of "deathless" divine energy that connects to everything within the eternal moment of spirit.

My own work takes many forms of expression, many styles. As time passes, I am more inclined to work spontaneously. When I am meticulously reifying a vision, although in a meditative state, I sometimes feel less free and flowing than when I am painting in the moment without a preconceived notion. Each worker must find his or her own way of *being* with their particular creative process and mode of expression. Clearly, it is not that one way is better than another, only that a certain way is suited to one's unique nature and temperament (which may change over time), and that one finds and follows and flows with their love and purpose.

Today, artists may actualize their spiritual experience in many ways besides the meticulous approach that many Visionary artists take. They may emphasize human process by leaving such telltale signs in their work as distinctive marks, brushstrokes, or impasto.

FIG. 35 Sandra Reamer, *Raining Cry*, 1996, mixed media on paper, 10 x 10½ in.

Some artists work with little or no concern for concept and are involved in the pure feeling or states of spirit. In Sandra's current work I see a collection of markings that trace the passing moment or moments of her artistic path. These markings continue an evolution of their own and map out a spectrum of spirit that can range from subtle visits to celestial realms to stormy strokes of emotion embodied in mysterious symbols. Her latest works include an auspicious language: markings made with lipstick, mascara, and other cosmetic media. Deep, simple, and intriguing symbols arise from these applications of makeup and paint. I find the series intriguing and wonder, "Isn't this a feminist statement of some kind?" But Sandra doesn't think so, and in my last conversation with her about these works, she said, "I don't think they are feminist; however, they are about me, and I am a woman. In that sense this body of work is about my life and therefore inclusive of my womanhood. They are direct imprints of my body." I asked her what she

meant by that, and she replied, "I use my fingers and my lips." I then asked her, "But does that have some meaning for you?" Sandra responded, "Yes, of course. When I am painting or drawing, my art making acts as an interface for my layers of being and fosters a harmonic, visceral intelligence and intuition. I explore that which is known and not yet known, offering me the opportunity to participate in the mystery of life and in the art-making process." Sandra paints with her fingers, makes impressions with her lips, breasts, nipples — her whole body — and she states that her physicality with the painting is an attempt to bring her subconscious reality to the surface through her physical form. Through the immediacy of the gesture and mark, Sandra penetrates her emotion, passing through textures of feeling to the energy underlying the emotion. I see this as a kind of artistic-somatic-psychological process that literally moves the soul from body to mind through to spirit.

One could consider this activity as an expressive form or fierce version of the work done by certain Zen and Chinese artists from certain traditions. It should be understood, however, that the Chinese ideal of concentration and spontaneous execution, quoted by various western critics as a parallel for modern techniques of unconscious or superconscious painting, is not a valid comparison. Unconscious painting as used by the Surrealists or the spontaneous and undirected work of some Abstract Expressionists is almost completely the opposite of the eastern approach. The traditional Chinese painter worked spontaneously only after an elaborate preparation, consisting of meditation on an idea or extensive concentration on an object, which required training and cultivation, and only after he had a perfected technique of expression. The result to which he aspired was not an expression of his own subconscious imagery but the embodiment of a concept which he had painstakingly achieved by deliberate concentration and the enhancement of his mental energies into harmony with the world outside.[8] Nor was the Chinese painter guided by the materials used in the act of painting and the "accidental" qualities of the medium itself, as Sandra with her cosmetic materials and other artists with theirs. The modern idea that an artist may or should be guided by the accidental qualities of his or her materials during the execution of their work of art is foreign to the Chinese tradition. Contemporary Chinese artists are very much involved in producing paintings that are hyperrealistic and often take the form of portraiture and figurative works. They are very simple compositions, but the figures do not leave us with a cold feeling.

The essential difference throughout the centuries between the western evaluation of art as compared with Chinese art critics rests in the absolute recognition of spirit as perceived through Asian eyes. Until very recently, art criticism in the West was, for the most part, technical or devoted to description and appraisal of the artist's subject matter, or it was concerned with other functions — educative, propagandist, decorative, liturgical, and so on — which the art was made to serve. Although these themes appear in Chinese art, they never take a central focus. Such themes in the Orient remain secondary and are kept subordinate to the demand that the work of art shall always be embodied in its own

structure and rhythms, the spirit of the Tao. The Tao, the very energy which vitalizes all nature, organic and inorganic alike, is at the very center of the art and the art criticism of the East. In this, there is a common ground, for example, with what Sandra Reamer seeks in her own work. Dr T. P. Kasulis offers these words in regard to conceptual and nonconceptual approaches in the arts:

It is a commonly accepted rule of artistic training that the student must first learn technique in order to transcend technique. To learn technique is to be conditioned by cumulative experience to perform certain acts in a certain way — the holding of a brush, the fingering of a bamboo flute, the cutting of flowers. But to be conditioned by these rules only opens up possibilities of response. One must overcome the danger of being determined by these rules, of becoming so attached to these conditions acquired in the past that the present is no longer creative. To transcend technique is to respond to the presence of the moment now before us. The determinateness of past conditions must vibrate in unison with the openness of the present. A Taoist principle states that a painting should be done in one stroke. In a literal sense, this is usually impossible, but the point is that the painting must, in every instance, be one act without the interference of conceptual reflection. Like making a single stroke with the brush, the painting of the picture must be an uninterrupted response to the present. Only then do the artist and the artwork ring true.[9]

To ring true … There is a delicate balance to be achieved between intense personal feeling and the communication of that feeling to others. It is not important that the responder get the same feeling or vision as the artist, but only that their spirit has been stirred. Every artist must figure out for himself or herself how best to accomplish this. There should be a conscious effort by the artist to *communicate* what is genuine in order for the work to be of value to others. Before our modern era, no one ever equated mere vagueness, unpredictability, or confusion with originality, and certainly never with being genuine. Instead of genuineness, obscurity has become the vogue, a weak and false replacement for the mysterious. Many artists feel superior to others when people admit frankly that they can't understand them, a situation occurring more frequently in our postmodern era.

The original and pure goal of abstract art was to seek an essence beneath the appearance of the materialistic world. By transcending a demand for an art that is only imitative or narrative, the artist's function became prophetic again. The eldest son of Ernst Fuchs, Johannes Elis, embodies that pure goal and takes it a step further. His work is part of a practice that is not just an aesthetic excursion but remains central to a spiritual path, which he has refined and focused over many years, of artistic experimentation and the search for truth. His early works reveal the same attraction to the acquisition of meticulous abilities that most Visionary painters experience, but as Elis matures as an artist, he ventures ever deeper into a devotional abstraction, depicting subtle realms and fields of color that radiate a heavenly motion, music, meaning, and feeling. He is always "surrendered" and thereby is sure of his goal. Even when his objectives are unknown, exploratory, and

FIG. 36 Johannes Elis, *Treedreaming*, 1966, pencil over watercolor, 23½ x 19½ in.

adventurous, he stays his course. It is hard for some Fantastic artists to see the merit in abstract works of art. For me, realism or abstraction is no different from a mountain or running water. Both are beautiful to behold, both can afford a different feeling, both lead one to the beautiful. The important thing is that one stays true to the path up the mountain or the down the course of the river.

Perhaps an abandonment and even betrayal of the original goal in abstract art was a contributing factor in the episodes of severe depression and suicides that haunted many of the founding artists of that movement (particularly the New York Abstract Expressionists). Repeating image formulas for the sake of sales and obfuscation can lead to material prosperity but also to spiritual bankruptcy. The lure of fame and fortune caught many of these artists in a revolving door that twirled them in an endless loop of

copying themselves, reproducing paintings that sold well on the market while losing their originality and spirit of authenticity. Genuine art is communication, not duplication.

Success is dangerous. One begins to copy oneself, and to copy oneself is more dangerous than to copy others. It leads to sterility.
— Pablo Picasso[10]

Contemporary writing and thinking about the arts still targets art as a means for expressing, and communicating from person to person, states of feeling and inner experience that cannot be communicated with precision in any other way. Art is certainly another language, a language of the spirit. In his book *Art and the Spirit of Man* (1962), Rene Huyghe states the following:

Its essential, unvarying role, from the very beginning, has been to serve as one of mankind's modes of expression … There exists a language of the intelligence, which has come down to us as the language of the word. Art, however, is a language of the spirit, of our feelings as well as our thinking nature, our nature as a whole in all its complexity.[11]

A work of art, once created, is frequently thought of as having a certain life and independence of its own, not entirely bound by the personality or intentions of the artist who created it, yet somewhat affected by the time and place of its production. The inspiration of a work of art may often be derived from unconscious levels in the artist and may not be wholly open to conscious apprehension. Hence, the created work may embody fuller wealth of import than the artist himself is aware of. This also explains how a brute like Picasso, a savage like Gauguin, and a foul-mouthed dwarf like Lautrec can produce works of monumental importance, truth, or beauty. Certainly I cannot count the number of times I have seen another artist's work and understood its communication more clearly than the artist who rendered it and have been affected by its qualities more than the artist who produced it. Equally, I have experienced finishing my own paintings with no clue as to the meaning or essence they contained. It has taken months, even years, to understand some of my own works, and when I believed I understood the full import of a certain painting, hidden meanings that went unnoticed were brought to my awareness by others. Many who made me aware of things in my work were not artists themselves; they were simply being genuine, creative, insightful, and sensitive.

The sensibilities of most of us are cultivated to only a fraction of our capacity. We can live out our lives in the myopic delusion that only the commonplace exists, occasionally rising to the rare altitudes of the extraordinary, the wonderful, the beautiful. If we integrate aesthetics into our experience and look upon learning as an act of waking up and value contemplation as a sense of journey, then we have the

FIG. 37 Philip Rubinov-Jacobson, *Dark Angel Bathing in Her Own Dream*, 1997–99, egg tempera and oil on canvas, 30 x 24 in. Collection of Heinz Hübner, Payerbach, Austria

opportunity to live our existence in a unique and revelatory manner. Then the commonplace is never dead; everything under and beyond the sun is new, just born. The freshness of our vision fills us with an incessant delight in communicating and sharing our genuine nature. Our eyes will be opened to the perpetual miracle of being, for we will have found a treasure and discovered an immense wealth through a simple spiritual gem, the jewel of being genuine.

By a slow and steady interaction between the response to beauty and the creation of beauty, humankind finds in life a new principle of operation other than the principles of goodness or holiness. It is the principle of beauty, an ambrosia of the spirit. When a person's spiritual eyes have opened to God as beauty, then he or she has discovered yet another way by which to live.

I think that art and this knowledge of what art is can be the modern Western way to illumination. It will release you from all kinds of linkages. It will not keep you from practicing all those things you hardly believe in, but it will help you in achieving the esthetic before you become linked to the objects of your life.

When you distinguish between good and evil, you've lost the art. Art goes beyond morality. The reach of your compassion is the reach of your art.
— Joseph Campbell[12]

In my painting *Dark Angel Bathing in Her Own Dream*, 1997–99 (see Fig. 37), the woman is just awakening from a dreamy state of self-absorption to the divine knowledge within her. It is the moment when the veil of vanity and ignorance is lifted by a slow and gentle breeze of awakening that blows over the boundary between self-delusion and self-awareness. She is right at that edge of awakening to her own truth, or betraying herself, and therefore others. After months of working on this piece only now and then, an hour here and there (I may alternate between six to twenty-four pieces at a time), its meaning began to unfold. As we look at the painting, we almost feel as though we are invading her privacy, interrupting her tantric dream, and perhaps we are even uncomfortably aware that our voyeurism may disturb her.

 She is content and natural in the pleasure of her own beauty. As the painting neared completion, it revealed its very soul to me. As my gaze penetrated it, the darkest shadows that preserve its mystery began to blend with a pallid but smoldering light. The rising smoke suggests fire, a passion controlled and cooled by her own fear. There are sounds of a distant music. Beyond the shadows, beyond the light of night appears that which is neither light nor shade but something like a "dark light," as Leonardo had shown to me in a dream more than twenty years earlier. And, like a miracle, more alive than life itself, there stands forth out of this dark light the face and naked body of a Jewess, a giant goddess seductively beautiful and framed with holy flames. She connects the holy streams of a flaming heaven and earth. Her raised hand dips into a watery blanket of stars while her feet touch the earth of the ocean floor. She is a living conduit silently singing the sacred words, the mantra of a great rabbi: "… to merge with the tranquility of the Name (and the Name is God)"; the holy letters bleed through her, tattooing her dark skin.

 Dreamy, soft, and sensual, the bliss of that knowledge within her rises up slowly like a half-forgotten illumination, a dark fire, a dream of what she could become. The name of

the One God, printing out from the divine mind, in her, through her, from her, and on her, is illuminated by some mysterious light passing through an improbable window. It is improbable enough that the whole event may pass from her as a kind of personal dream, drenched in vanity, or may lead her to greatness. The delicate balance and quietude of her self-absorption is both sexual and sacred at the same time. She is in hallowed waters that run deeper than the surface of her body, informing us that we all share the dream, we all choose when we are ready to see the truth beneath our own form, beneath all forms, behind the appearance of all things, the invisible behind the visible.

Beauty unleashes courage by enabling us to see inwardly through outer forms, revealing an underlying truth. A creative process of discovery is developed through the courageous activity of art. It promotes change, development, evaluation, and transformation in the organization of subjective life and becomes manifested in our daily activity. Creativity and knowledge is appropriately veiled or released by our own inner mechanisms. Bringing beauty to this world can be an arduous task but a very noble path, a royal road. Each artist takes on this juggling act in the outer world equipped with different degrees of skill. Dr Kay Redfield Jamison gives us the following observations on the artist's trapeze act of trying to stay balanced while striving to be genuine in a less-than-genuine world:

From virtually all perspectives — early Greek philosopher to twentieth-century specialist — there is agreement that artistic creativity and inspiration involve, indeed require, a dipping into pre-rational or irrational sources while maintaining ongoing contact with reality and "life at the surface." The degree to which individuals can, or desire to, "summon up the depths" is among the more fascinating individual differences. Many highly creative and accomplished writers, composers, and artists function essentially within the rational world, without losing access to their psychic "under-ground." Others, the subject of this book, are likewise privy to their unconscious streams of thought, but they must contend with unusually tumultuous and unpredictable emotions as well. The integration of these deeper, truly irrational sources with more logical processes can be a tortuous task, but if successful, the resulting work often bears a unique stamp, a "touch of fire," for what it has been through.

Artists and writers, like other individuals, vary enormously not only in their capacity to experience but also to tolerate extremes of emotions and to live on close terms with darker forces.[13]

The good doctor's book, *Touched by Fire*, is a brilliant thesis on the nature of artistic temperament, genius, and pathology but in my opinion neglects to emphasize with greater strength the transpersonal view or the "transrational" aspects and the spiritual sources of inspiration artists can connect to. The act of painting can draw on a spectrum of sources from the terrifying to the sublime. A subtle dialogue is set up, filtered, and released from the inner life that passes through membranes of consciousness and finds its second life on the surface of a canvas. We can find these potential forces and processes in all the arts. Every creative worker should try to attain a level of skill, ingenuity, and flexibility in order to construct a device which, when responded to by others, will inspire their experience as

potently as his or her own experience was organized in the moment of expanded insight. All great works of art have a simplicity of order, which reveals itself rather than its origins or how it was made. In the final result, there is an unmistakable authenticity, a genuineness of expression.

I am reassured when, after finishing a work of art, a person first strongly responds to the image itself with a "Wow!" or a gasp or even is rendered momentarily breathless and only later might ask, "How did you do that?" The content of the work is of primary concern and impact. Content is most important — it is the offspring of *psyche* — but it is only as powerful as its handmaiden, *techne* (unless we are speaking in terms of primitive, naive, or folk art). However, *psyche* is a "bigger" thing; *techne* is "smaller." If a painting is captivating only from the standpoint of its technical achievement, it will fascinate us for a while, but it will probably lack feeling and depth, and appear *flat*. When the scale of *psyche* and *techne* are in balance, then there is a flow, like a breath of God exhaling from deep within us.

When technical knowledge becomes second nature, then spirit rushes in where mind fears to tread. There are no longer any frustrations or questioning "How does this color go with that color?" "How does this musical note go with that one?" or "How is this word in that sentence?" When the mind is quiet and free from thought, the self shines through or, like the sun, reflects perfectly off still waters. Essence becomes the quality of artistic engagement, and the spirit of art becomes paramount, and what is most important is that you are genuinely who you are in the creative moment and move toward a greater connection and expression of Spirit. As we use the tools of art to widen perception, our mental tendrils grow and become increasingly more sensitive. By seeking to communicate with the world around us, we may be doing more than developing our sensitive awareness. The world, too, may have the capacity to respond in some way.

I prepare myself to be a creative vehicle of spirit through a daily act of remembrance, by gradually dropping habitual mindsets and learning to live in the present moment. I do this by not relying on conditioned patterns to guide my response to life, and in this way I am genuine; I enter a sacred path. I am in this world but not of this world. I am receptive to the darkness and the light. I learn to live without preconceived notions that dictate how we should perceive life and how we should respond to it. I am not always successful, and sometimes I may even fall back into patterns of unfavorable behavior, but like in any contemplative practice, I remind myself to return to the center of my awareness, to my self. It is always an act of *remembrance*; it is always a *practice*.

Casting adrift the deadweight of the past and any anxiety over the future, I enter the present moment (or canvas), open and vulnerable, unfettered by the mind's reducing valve. I paint what comes to the brush. Sometimes a vision appears on the screen of the canvas, and I just trace the elements before my eyes. At other times, "I" am not present at all — something else is painting, and I awake to its birth upon later inspection. In another session I may be totally present and merged in the moment of each stroke of the brush. I may paint "precision mysticism" on one canvas and caricatures, abstract fields, or expressionistic

feelings on others. It doesn't matter to me that I am not being consistent in style. What does matter is that I am consistently genuine in the moment of painting. The intensity of our creative power is inextricably tied to the level of our genuineness.

… Serious art has been the work of individual artists whose art has had nothing to do with "style" because they were not in the least connected with the style or the needs of the masses. Their works arose rather in defiance of their times. They are characteristic, fiery signs of a new era that increase daily everywhere.

… What appears spectral today will be natural tomorrow.

Where are such signs and works? How do we recognize the genuine ones?

Like everything genuine, its inner life guarantees its truth. All works of art created by truthful minds without regard for the work's conventional exterior remain genuine for all times.
— Franz Marc[14]

The study of creativity as a force of transformation has been neglected, but a body of knowledge over the last forty years or so has been accumulating from psychoanalytic investigations, experimental psychology, and the study of persons who have demonstrated creativity in thought and action. On bookshelves everywhere, there are rows of books dealing with creative empowerment and daily exercises to achieve that objective. Some of these are good and some, of course, are not. However, continuing studies of the process of invention can help in providing the most practical solutions for dealing with our greatest challenges and for producing our greatest achievements, as we come to believe in the sanctity of co-creation.

The creative process is powerful and exciting, tranquil and exuberant, spacious, empty and, at other times, overflowing. In every individual there lies unlimited potential. One needs only to cut asunder the snare of mind and addiction to the physical senses, acknowledging the finite while including the infinite. This is the Royal Road of Art, this is what I believe true education is, and this is what we need now. Once a person can catch a glimpse of the infinite reaches of awareness, the perfect forces, the wide expanses of knowledge, and the joyous freedom of being which awaits one in the unexplored regions of existence, there will be no turning back as one takes the path leading to expanded creative power and consciousness.

Nothing will mean so much
as the treasure
of his or her own
enlightened being.

FIG. 38 Philip Rubinov-Jacobson, *Wind of Embrace*, 1987, pencil and conté crayon on paper, 36 x 24 in. Collection of Almut Stamer, New Mexico

Fig. 38A Ernst Fuchs, *Carmel*, 1963, (detail), Chinese ink drawing. Private collection

Chapter 6

The Transpersonal Artist and Lover: Wings of Creative Fire

Love is justly called Ruler of the Arts, for a man fashions works of art carefully and completes them thoroughly, who esteems highly both the works themselves and the people for whom they are made. There is, then, this fact, that artists in each of the arts seek after and care for nothing but love.
— Marsilio Ficino[1]

THE YOGA OF ART

In conversation with Ken Wilber, he refers to a *mystic* working as an *artist* as a "*transpersonal artist.*" I like this label, for it is coming to be realized more and more clearly that it is the mission of the artist not so much to entertain us as to inspire and enlighten us. In this sense, it is the function of art to brush aside everything that veils reality from us, in order to bring us face to face with the real, the true. This is a function that is both personal and beyond the personal, connecting the two in a union of realization and transformation. The transpersonal artist endeavors to see reality in its infinite aspect and tries to reveal it in some form of expression. Having heard the music of the spheres, he or she tries to weave it into melodies that others can understand and be uplifted by.

To the visionaries we owe all the symbols, ideas, and images of which our spiritual world is conceived and constructed. We take its topography from them: the divine dark, dark night of the soul, the beatific vision, union, ecstasy, illumination, and of course, all the terms and descriptions of beauty from the East. This language that has come from mystical experience and is expressed by the artist has evolved to describe another world, existing in the now, to give us a key to unlock the transpersonal, to induct us into its mysterious delights. It is by the means of this world and its symbols that human consciousness is enabled to actualize its most elusive experiences. The transpersonal artists communicate their personal contacts with the universe, or Godhead, to others through description and suggestion. The span of this communication can range from the language of great contemplatives to the pictorial descriptions of reality crystallizing into visions, voices, music, or other psychosensorial expressions. At one end of the spectrum can be a vivid, prismatic image of revelation; at the other, a fluid ecstatic poem.

Language can be a doorway to the wordless, like Whitman's line, "Light rare, untellable, lighting the very light." The mystical poets offer us an extraordinary genius and method by which they communicate their vision. Their works baffle analysis and reveal a starry grace. They are artistic representations of direct apprehensions of the infinite and come to us as either cosmic, impersonal accounts or as personal and intimate contact with the divine life. Language as a gateway of expressing mystical experience has a subspectrum

of doorways within itself, as each of the arts does. We could explore this extensively, but for now we can say that one of the doorways through the gateway of language belongs to the mystic-poet and comes to us from those temperamentally inclined to that pure contemplation which has no image. These poets are closer to the musician and mathematician than any other type of artist, though they can draw on material from all the arts. On the "creative tree," this branch involves expression by means of formal structure: the branch of linguistic symbols. The painter resides on the branch of visual language in which the means of discourse are totally abandoned and another symbolic form is incorporated. The performing arts of dance, theater, mime, and the like rely on a communication in which the body itself serves as the tool of expression, and they are stationed on the branch of somatic gesture. Through a Yoga of art, it is possible to climb the creative tree, mastering each limb, aesthetics at the service of the divine. Creativity is literally "going out on a limb."

Mystics naturally inclined to visualization tend to translate their supersensorial experience into concrete, pictorial images, into terms of color and form. These mystics use the methods of the painter, the descriptive writer, and sometimes the dramatist, as opposed to the musician or lyric poet. Picture-making artists may be inspired as a result of deliberate action or involuntary action. In the involuntary case, the artist expresses visionary experiences that are outside of the self's control, yet they are not hallucinatory; whereas in the deliberate case, the artist expresses experiences that result from poetic apprehension of truth or from intense meditation, which demands a symbolic and concrete form for its literary expression. When art is created without effort, it is the difference between *conjuring* and *receiving*. Psychological inquiry and a contemplative practice will increase sensitivity, refine aesthetics, and fortify us for life's challenges.

Through a Yoga of art we benefit from learning to work with our minds. Just as the sun still shines regardless of whether the sky is clear or cloudy, through meditation we discover that consciousness remains blazing and brilliant like the sun whether there are thoughts or no thoughts in the mind. As we continue the practice of meditation, we begin to recognize particular patterns of thought that repeat regularly. These patterns begin to dissolve through nonidentification, and they slowly lose their grip. We develop a sense of humor about ourselves. In a way, we are befriending ourselves, because we are not judging anything that arises from within. This openness actually fosters creative forces and power. We do not become thrilled over beautiful and spiritual thoughts, and we're not overcome with remorse when so-called bad ones come up. Eventually we learn to witness how thoughts originate, how they temporarily flit across the screen of the mind, and how they pass away.

We also learn that we don't have to act on our thoughts, which gives us a great sense of freedom from our conditioned patterns and more discretion in our creative projects. Freeing ourselves of restraining psychological patterns, false identifications, and cultural conditioning opens us to new vistas. These new vistas may open up to us involuntarily, uncontrolled by the surface intellect. A new vision may also evolve from a "divine

madness" as described by Plato, or a higher vision may evolve slowly, in complete clarity, with an inspiring force gently guiding us. Other times, intuitions are woven up into pictures, descriptive words: a psychosensorial automatism. Experiences can be received as a message of reality in a pictorial or verbal form that comes into the body/mind, saturating our very spirit until it spills over in a fluid expression.

CREATIVITY IS FIRE AND LOVE

The mystic, when called, may also serve as an artist and can pass through a creative fire, a kind of purification of spirit, preparing for a great privilege and obligation, although many would describe such a mission as a blessing and a curse. And as previously discussed, many mystics and some artists recount a common experience of light while in non-ordinary states of consciousness, but also quite common is the feeling that they are being consumed by a sacred fire. Maria Magdelena de' Pazzi (1566–1607) was an ecstatic saint and Carmelite nun who could not wear woolen gloves in winter "because of the fire of love burning inside" her. On one occasion the fire within her seemed to be consuming her from outside, and she had to dash to a well and soak her whole body. Catherine of Genoa (1447–1510), a profound visionary, in her last illness had continual sensations of burning. According to her biographer, a bowl of cold water was brought to her; she plunged her hands into it for relief, and the water became perceptively hot. For hours after her death her body retained abnormal warmth. The imagery of fire is commonly used to describe mystical experience. Mechtilde (1217–82) saw deity as a stream of fire flooding over the world. She was twelve when she experienced her first ecstasy. This German mystic and writer wrote, in both prose and verse, of her visions and revelations in *The Book of the Flowering Light of the Godhead*. Historically, many Visionary artists inflamed their paintings with a mystic fire. The work of Bosch, Blake, and even van Gogh can sometimes appear as though you are looking at it through heat waves as the image twists into an undulating scene of steamy but clearly strong, flaming color. Fire burns away impurity and makes the things set in it incandescent like itself. Richard of Saint Victor (1123–75) was a Scot who made his life at the abbey of Saint Victor. In Paris, he developed a highly refined Platonism and contemplative steps toward revelation. He compared the soul's being plunged into divine love with an iron being plunged into the furnace: they both transmute into a different quality of being. Ruysbroeck had a vision of union as "every soul like a live coal burned up by God in the Heart of His Infinite Love."

I am in total agreement with Ficino when he said that artists seek after and care for nothing but love — most of the transpersonal workers I know eventually are ruled by this ultimate muse. In addition, the creative worker, in the manner of a whirling dervish, spins matter and creates new forms out of kisses from a muse and then dances in revelation from the sweet love of God. At the summit of artistic endeavor the inspired worker has a joy that cannot be described — at least, I find my ability in words to be lacking. I can

only say that when I am bathed in inspiration, in the light of co-creation, it is ecstasy. This spiritual ecstasy is active, a creative participation with divine life. Reason is no longer preoccupied with itself, will and love are no longer in conflict, the soul becomes spotless, and a creative force pounds in your heart. There is a feeling of being embraced in a divine, unitive love. In this creative, fiery affection, my soul loves and is loved in return, my soul seeks and is sought, calls and is called, holds and is itself held, creates and receives the created and by the bond of love unites to God, one with One.

This union, this ecstasy I speak of, has been expressed by an endless train of mystics and artists throughout time and in all cultures. These creative workers have expressed this divine union in forms that have ranged from overt sexuality to the gentle embrace of mother and child. The term "spiritual marriage" has been used all over the world to express the inspired relationship between spirit and human. The mystic burns with a fire in the heart, kindling a joy because of the proximity of the beloved. Love leads to knowledge and expression. Love and creativity are eternally wed. For many transpersonal artists and lovers, love is the pure and holy communion that binds itself to creativity, bringing the experience of divine inspiration and ultimately promising spiritual unification.

Sam Keen, like Ruysbroeck, binds the fire of inspiration to love. Sam, wise friend, philosopher, and author of many books, states the following:

Love and creativity are entwined beyond the possibility of separation.

He continues:

In fact, love and creativity have traditionally been identified as forms of enthusiasm or divine intoxication. In both cases something sacred or godlike enters, inspires, and takes possession of us. It is because of this proximity that the current of love and creation flows both ways. Love sparks creativity, but co-creativity also sparks love. That is why a lively workplace, a school, a building project, a political-action caucus where people are joined in a creative effort is a much more propitious place to meet potential friends and lovers than a bar or a cruise ship.

In summary, he says:

Creativity and love have this in common. Each involves separate entities coming together — ideas or persons — in a way that they become something more than either was in isolation ...[2]

A COSMOGONY OF THE ARTIST

Although the arts are the offspring of love, artists work at various stages, and each stage is reflected in their art and in their behavior, although more often than not, the two rarely fit together. We can begin to understand the nature of artists through historical, mythological, sociological, psychological, and spiritual relationships. For example, today the word "artist" denotes a much different meaning from the actual vocational and spiritual roles the creative worker has held through the greater part of history. From antiquity to the Renaissance, the great artist was the master builder. When

FIG. 39 Ernst Fuchs, *Carmel*, 1963, Chinese ink drawing. Private collection

architecture was a pure art form — that is, when it came from and moved toward spirit — the artist was recognized as the political man par excellence, a "builder" who, through his forms, design, and construction, gave special expression and spiritual life to the community. Indeed, for what do we remember the great civilizations but for their sacred art and architecture, the meeting points of heaven and earth?

Two twentieth-century scholars who have shed light on the nature of the sacred are the German Rudolf Otto and the Rumanian Mircea Eliade. Otto coined the word "numinous" to express the awe-inspiring power of a divine revelation or presence. This sense of numinousity can be felt at many traditional holy places, at sites designed by artists and architects, and simply in nature itself. Eliade contrasts "sacred space" with what he calls "profane space" — literally, that which lies outside the temple — and uses the word "hierophany" to express a manifestation of the sacred. For animists, such as Shintoists, who believe nature is imbued with spirits, this could be a tree or rock. In fact, the holiness of some places has stemmed directly from a hierophany: Mount Sinai, for example, where the One God appeared to Moses, or Iona, the island where Saint Columba saw visions of angels and performed miracles.

The great builders of monuments — whether they were inspired by a natural environment, the sacredness of places associated with saints and spiritual teachers, or the sanctity of the afterlife, or whether they simply expressed a higher order of reality through an act of personal intention — could imprint the symbol of a goal of life to which everyone felt tied, and, like a light, they led the community to its perfection.

The footsteps of spirit are often manifested in places where holiness and artistry marry. They are found everywhere: the summits of Jebel Musa, or Mount Sinai (as mentioned), sacred to Jews, Christians, and Muslims alike; the Mahabodhi Temple at Bodh Gaya in northern India; the temple of Artemis, one of the seven wonders of the ancient world, in Ephesus on the western coast of what is now Turkey. Other places include the megalithic world of prehistoric Europe that stretched from the Atlantic seaboard in the west to the shores of the Black Sea in the east: the sacred burial ground at Newgrange in Ireland; Stonehenge; the passage grave of Anta do Silval; the burial structure of Els Tudons; the long, stone chamber known as *hunebed* near Borger; and the extensive alignment of the stones at Carnac, France.

Such places are seemingly endless. The tomb of the first emperor of China, Shi Huangdi, is a vast grass-covered mausoleum that is still being uncovered. A half-million workers were engaged in an astounding artistic effort to calm the young emperor's fear of death. The main tomb is still unexcavated, but discoveries in the burial pits that surround it are mind boggling. In the first pit, for example, an army of six thousand terracotta soldiers, standing upright and proud, all larger than life size, have been discovered after twenty centuries. Their faces, no two of which are alike, show the stamp of individualism in both the ruler and his people. The statues were all armed with real weapons. Likewise, the Pyramids of Giza stand still in time and remain a potent symbol of ancient Egypt and a testimonial to its god-kings, or pharaohs. Monuments to individuals and the love of individuals, which built the Taj Mahal, cover the earth. Like a mirror to Egypt, the terraced "Pyramid of the Sun" dominates the site at Teotihuacán, Mexico, which at its height in A.D. 500 was the largest city in the Americas.

Numerous monuments to spirit are also found in Delphi, at the Indian mounds of North America, the Rock of Cashel in southern Ireland, the spectacular Cologne

▲ Plate 21 Alex Grey, *Birth*, 1990, oil on linen, 60 x 40 in.

▼ Plate 22 Carmela Tal Baron, *The Seven Veils*, 1989, a lightbox created as a product of synaesthesia inspired by Mozart's *Requiem*, 5½ x 5½ in.

▲ PLATE 23 Johannes Elis, *Sort of a Landscape*, 1984, oil on panel, 27½ x 39½ in.

▼ PLATE 24 Martina Hoffmann, *Birthscape II*, 1988, oil on canvas, 39 x 39 in.

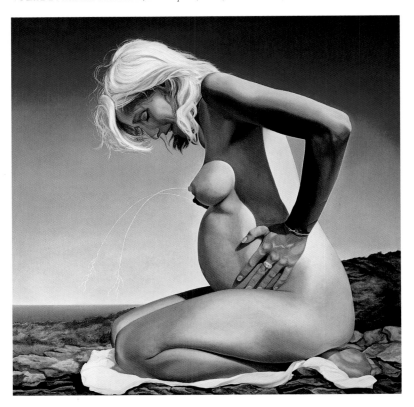

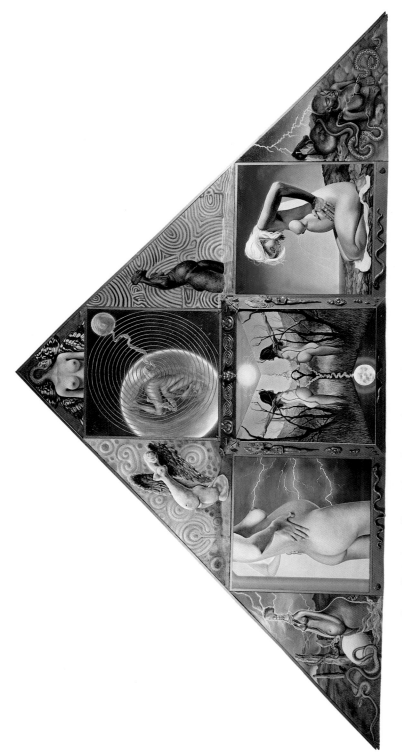

PLATE 25 Martina Hoffmann, *The Goddess Triangle*, 1995, multimedia installation in oil, clay, and sound, 10 x 20 ft

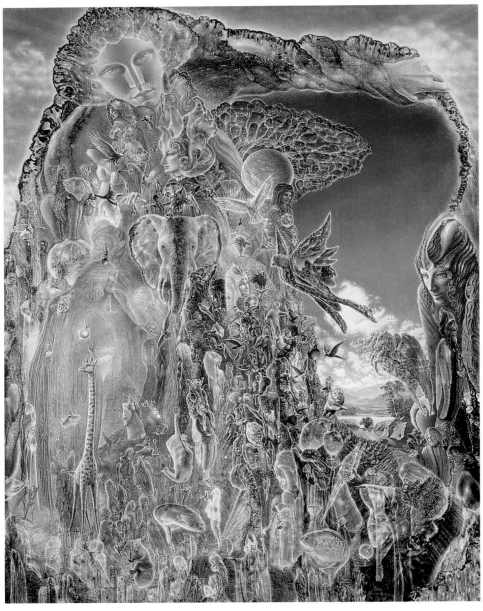

PLATE 26 Robert Venosa, *Astral Circus*, 1976–78, oil on masonite, approx. 45 x 35 in. Private collection

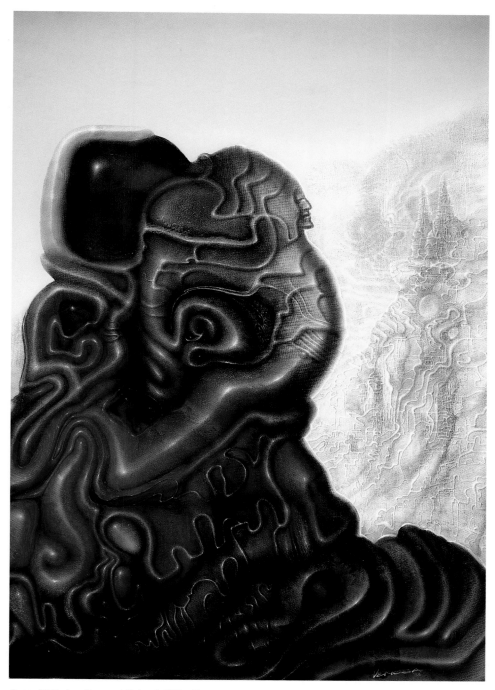

PLATE 27 Robert Venosa, *Mindsend*, 1983, oil on canvas, approx. 10 x 7 in.
Collection of Dr Christian Schmidt, Munich

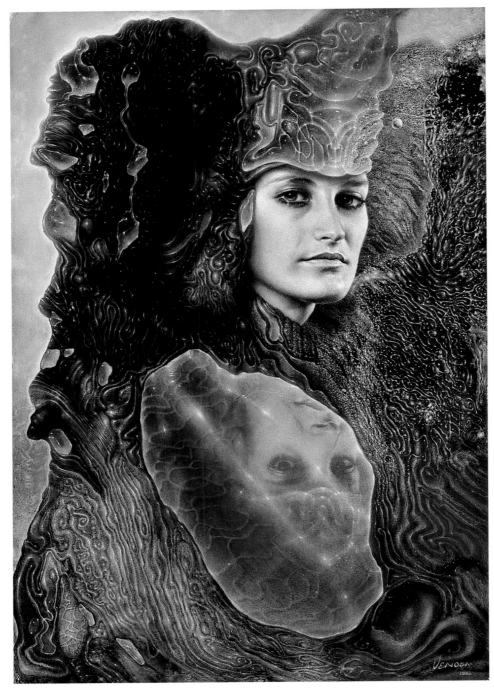

PLATE 28 Robert Venosa, *Isabel Sanz*, 1980, oil on canvas, approx. 22 x 15 in.
Collection of Dr Luis Sanz, Barcelona

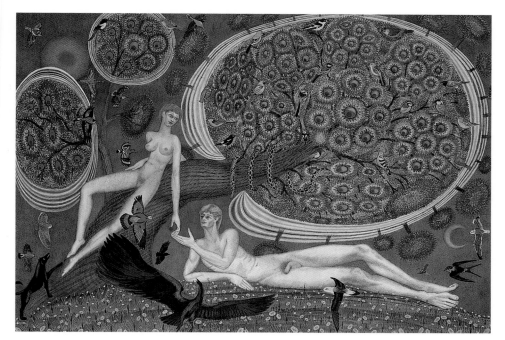

PLATE 29 Eva Fuchs, *Adam and Eve*, 1983, watercolor on paper, 20 x 28 in.

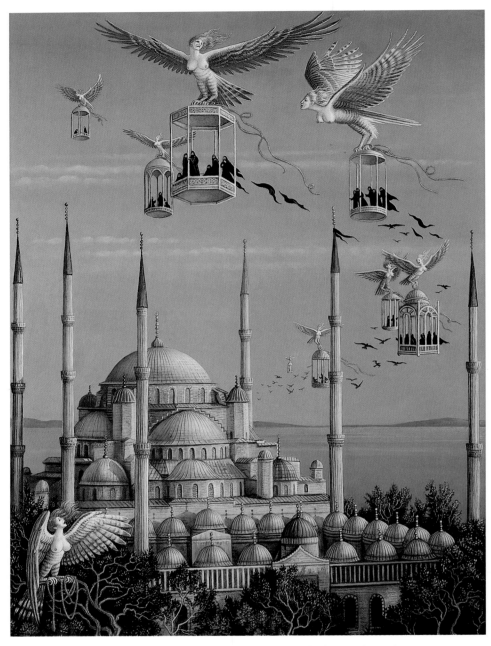

PLATE 30 Brigid Marlin, *Sailing from Byzantium*, 1996, egg tempera and oil on panel, 48 x 36 in.

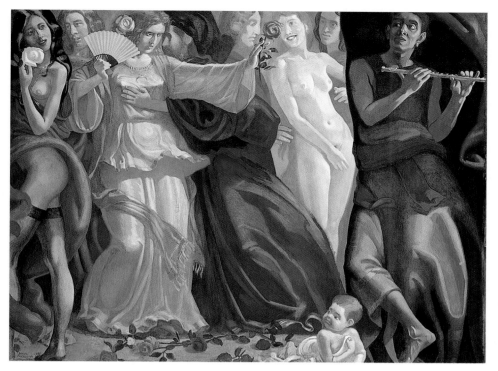

PLATE 31 Daniel Friedemann, *Wedding*, 1996, egg tempera and oil on canvas, approx. 27½ x 35½ in.

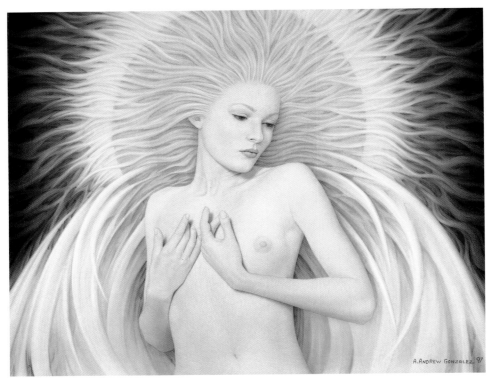

▲ PLATE 32 A. Andrew Gonzalez, *Aura Gloriae*, 1997, acrylic and air brush, 16 x 20 in.

▼ PLATE 33 Cynthia Ré Robbins, *We Have Wandered Far*, 1994, egg tempera and oil on panel, 22 x 28 in.

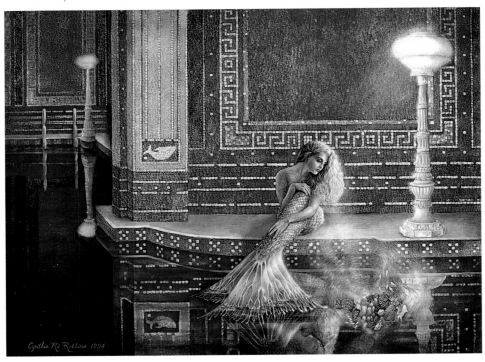

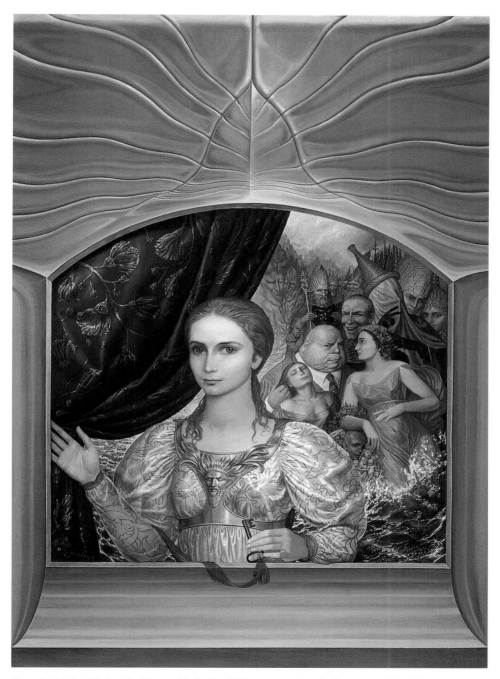

PLATE 34 Michael Fuchs, *The Woman with the Key*, 1992, egg tempera and oil on canvas, 39 x 33 in.

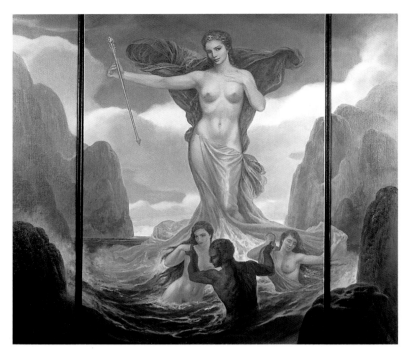

PLATE 35 Michael Fuchs, *Filia Maris (Daughter of the Sea)*, 1992, egg tempera and oil on canvas, 39 x 47 in.

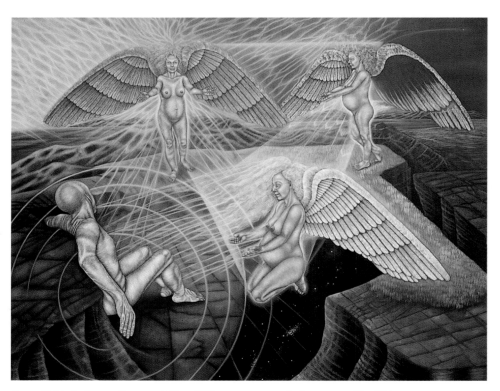

PLATE 36 Mariu Suarez, *Unsuspected Glory*, 1999, egg tempera and oil on canvas, 60 x 72 in.

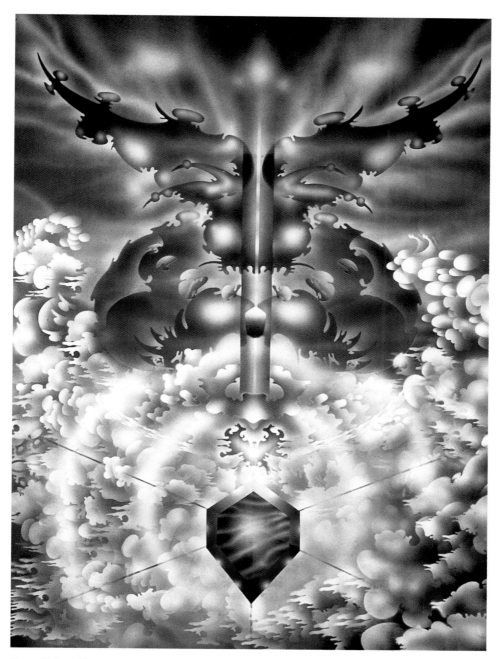

PLATE 37 Isaac Abrams, *Diamond Sutra*, 1981, acrylic and air brush on panel, approx. 60 x 48 in.

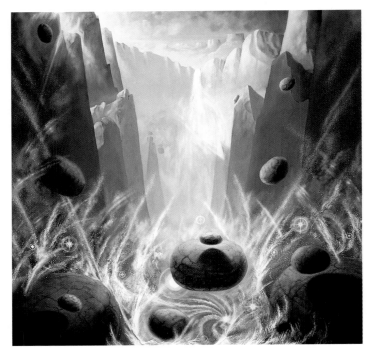

▲ PLATE 38 Ingo Swann, *Floating Canyons #3*, 1980–81, oil on canvas, 67 x 67 in.
▼ PLATE 39 Ingo Swann, *Cosmic Conscious-ness #1*, 1981, oil on canvas, 50 x 50 in. Collection of the National Aeronautics and Space Museum of the Smithsonian Institution, Washington, D.C.

PLATE 40 Mati Klarwein, *Illusion, Projection and Reality*, 1997, egg tempera and oil on canvas mounted to board, approx. 47 x 27½ in.

PLATE 41 Mati Klarwein, *The Daily Miracle*, 1998, egg tempera and oil on canvas, approx. 39½ x 39½ in.

Cathedral in Germany, and the Royal Mosque of Isfahan. From the Golden Temple of the Sikh community to the Sistine Chapel in Italy, the Grand Shrine of Ise in Japan to the City of Lights in Varanasi on the River Ganges, humanity has found, built, and bathed in the grace of its sacred sites and places. But today most builders or architects no longer design and create magnificent structures as sacred sites for communal gatherings, but serve to construct the bases of operations for the corporate empires. In the past, those on pilgrimage found their spiritual homes easily by merely gazing at the horizon and being drawn to the spiritual centers of the community, because the temples were always the tallest in view. Today, the tallest buildings in view represent monuments to materialism, and the sacred sites are dwarfed in their shadows.

In trying to comprehend the nature of the creative, the *builder*, we should also recognize that the charisma and character of the artist is rarely far away from the persona of the confidence man. Like the confidence man, charismatic artists know how to insert themselves into our very marrow until we, too, become either afflicted with their torment or inspired by their blazing energy, brilliant vision, and transformation. Yet there is a profound difference between the charisma of the artist and the stage presence of the actor-like confidence man. Unlike the charlatan, artists, by penetrating the very marrow of our bones, allow us to join them in their salvation. This sublimation that the artist undergoes helps us to make sense of our own experience. We become angry at the confidence man for stealing our sources, our power, and we are rattled by the person with the personality disorder who makes us cry, but when a great musician, writer, or painter makes us weep, we thank them for catharsis. Artists transmute their own bitter poison into our medicine. We are also grateful to them for recognizing, inspiring, and kindling our own new-found talents, abilities, or expression.

Cognitive psychology and psychoanalysis are still somewhat feeble in explaining the paradoxical power of an artist's ability to transmutate pain into healing but recognize the phenomenon and its importance. Only by paying attention to emotion, the environment, and history and adding integrated insights from psychology, the wisdom traditions, investigative research into the process of invention, and the correlations between the artistic worker and the traditional shaman can we ever hope to understand the pain-healing process of the artist. Even then, only a sketch is possible, for such transformational forces are forged from spirit, and are, by nature, mysterious and not entirely understandable.

Sigmund Freud suggested that artists are not like other people in that their constitution includes a strong capacity for sublimation and a deeper laxity in their repressions. This lack of repression in the artist serves as a liberating agent and healing force. It is also a promise of acceptance and tolerance of others, allowing people to derive consolation and alleviation from their own suffering, releasing pleasures and insights that were previously inaccessible to them. If artists can release pleasures, healings, and insights, then those among them with the clearest and furthest vision can convey their experiences to a greater number who see less well, and the general level of human vision rises and,

with it, the level of participation. We have a responsibility to enter into this process at the highest capacity to which we can elevate our sensibilities and compassion.

It was not so long ago that people approached everything in an artful manner. This is still exemplified in the culture of Bali. In Bali, there is no word for art. Art is in their blood, and there is no hesitation in making a chair that is equally graceful and sturdy. And in the West, up until the battle between the Romantics and those proponents of the Age of Enlightenment and the ensuing Industrial Revolution, most everything was approached in an artful manner. Artful means was ingrained in the day-to-day experience and environment of the human condition. In his book, *Architectura Caelestis*, Ernst Fuchs reminds us that the old civilized nations considered the command of any situation an art and so practiced and highly honored it. Whether it was irrigation, cooking, or pottery, all areas of life were commanded by art. We can also see this in the organization of ancient, medieval, and even eighteenth-century court life. For every imaginable activity, an artist was appointed who artfully carried out its action while also teaching the art. This is not to say that just because art had a more central role in the fabric of history that the past is better than now; however, humanity has embraced the arts as being crucial to its very existence. Talent plus accumulated experience has certainly been, and remains, a necessary condition for the development of the human species.

Is an artist really a "type" of person? In Freud's view, the artist is an introvert who is oppressed by excessively powerful, instinctual needs. He also said that the artist's desire to win honor, power, wealth, fame, love, and sex is charged with charismatic forces, but artists lack all the means and social skills to achieve these things. So Freud concluded that artists turn away from that reality and transfer all their energies, and libido also, into construction and invention by employing the power and defense mechanism of fantasy. Freud also noted that the artist, unlike the psychotic, takes this valuable power into the public domain as an attractive phenomenon to be shared beyond his or her own personal process.

The myths of ancient Greece reveal the seeds of contemporary attitudes toward artists and offer certain insights on the true characteristics versus the stereotypes that have been molded. In addition, myths also reveal archetypes that may have been adopted by many artists. In the court of Zeus on Mount Olympus, Hephaestus, the forger, lord of fire, is artisan of the gods and can make what is needed and does so beautifully. As a god, Hephaestus (Vulcan in Roman mythology) is assigned little personal authority over the mortals, nor does he hold much status and respect among the gods. After having been given Aphrodite (Venus) for his wife, he comes home only to find her in bed with Ares (Mars). Although one is usually referred to as an artist because of skill and grace in creating, Hephaestus is clumsy and has a clubbed foot. He is unrefined in his manner and not very intelligent. So, in the West, long after the great pyramids have been constructed, we inherit this Grecian, double-edged perception of the artist. Along the way, the artist will be beggar and noble, pauper and king, jester and genius, worshiped and despised.

And what of mortal artists? The ancient Romans give us the story of the artist of

genius in a mortal, a woman. It is a message of oppression: the repercussions of any mortal possessing creative genius. Arachne was a mortal, female artist and creator of magnificent tapestries. The weaver among the Olympians was the goddess Minerva. Quite naturally, Minerva considered her works the finest and unapproachable in beauty. Minerva was outraged when she heard that a simple peasant girl named Arachne declared her own work to be superior. The goddess challenged Arachne to a contest. Both set up their looms. Minerva did her best and the result was a marvel, but Arachne's work, finished at the same time, was in no way inferior. The goddess, in a state of fury, destroyed the mortal's work and beat her. Arachne, angry and disgraced, hanged herself. In a moment of repentance, the goddess transformed the limp body of Arachne into a spider (arachnid), and her skill in weaving was left to her.

So we have a clumsy god, Hephaestus, on the dim side of intelligence, as the artist of Olympus but a social misfit and outcast. He suffers from the unfaithful actions of his wife, the goddess of beauty. The very one he worships and serves betrays him. On earth we have a mortal artist (Arachne) equaling a goddess in an artistic competition, only to be punished for her genius. So artists inherit their western image, they are either divine-like but clumsy, social misfits, or they have creative powers equal to gods but are considered blasphemous should they use or proclaim their arts against the ruling order, and thereby become subjected to great criticism and likely punishment.

In the nature of the creative mystic, the emphasis always lies on transpersonal factors. According to Carl Jung, the creative person is never capable of the psychic matricide necessary for the liberation of the anima. Whereas the typical person in western patriarchal civilization to a great extent pays for his or her adaptation to the social order with a loss of creativity, the creative worker who is adapted to the requirements of the unconscious world and the feminine often pays for his or her creativity with loneliness, the result of a relative lack of adaptation to the community. Of course, this characterization applies only to the extreme positions, between which an endless number of transitions and shadings are possible. Michelangelo responded to those who complained of his apparent antisocial nature and that of many outstanding artists with the following:

There are many who maintain a thousand lies, and one is that eminent painters are strange, harsh, and unbearable in their manner, although they are really human and humane. And these fools, and not sensible persons, consider them fantastic and capricious and are loath to tolerate such characteristics in a painter. It is true that for such characteristics to exist the painter must exist; and him you will scarcely find outside of Italy, where things attain their perfection. But idle, unskilled persons are wrong to demand great ceremony from a busy, skillful man, since few persons excel in their work, and certainly none of those who bring such accusations. For excellent painters are not unsociable from pride, but either because they find few minds capable of the art of painting or in order not to corrupt themselves with the vain conversation of idle persons and degrade their thoughts from the intense and lofty imaginings in which they are continually rapt.

Michelangelo continues:

Why seek to embarrass [the artist] with vanities foreign to his quietness? Know you not that certain sciences require the whole man, leaving no part of him at leisure for your trifles?

And I would even venture to affirm that a man cannot attain excellence if he satisfy the ignorant and not those of his own craft, and if he be not "singular" or "distant," or whatever you like to call him ...[3]

A PATRON SAINT

The periods of loneliness and solitary struggle that many artists experience are demonstrated in the life of van Gogh. For me, Vincent van Gogh was not only courageous, he was a saint. He was the victim of the terrible intensity of his convictions. With incredible determination and courage, leaving his original intention (and studies in England) to become a priest, he taught himself to find an expression in paint for the desperate violence of his spiritual hunger and love.

He left a body of work the mere bulk of which might well have occupied a lifetime, though there were barely ten years between his painful beginning to teach himself to draw and the fatal pistol shot. (There is strong evidence today that the pistol shot need not have been fatal, that the fatality was actually due to the doctor's gross neglect of the injury and a decision not to treat the infection of the wound.) In his short span of creating, van Gogh had produced more work (approximately nine hundred drawings and eight hundred paintings) than Cezanne did in his more than forty years of painting. That those ten years of van Gogh's artistic output includes his training time, and that he was for the most part self-taught, is truly amazing.

Van Gogh's courage was in his capacity to stand on his own convictions. There was no choice for him, no visible choice. Everything in his life was settled for him by his own irresistible compulsion and inner conviction. The violence of that internal conviction was so extreme that hardly anything from the outside world could penetrate to him or leave its mark on his agitated spirit. In art, he proved to have innate powers. In the pure subjectivity of his experience, some have said that he was mad from the beginning; others would like to take solace with theories that van Gogh suffered from a rare disease that caused ringing in his ears (Ménière's syndrome), schizophrenia, porphyria, absinth poisoning, or simply from epilepsy, and there is a current argument for a severe case of manic-depression.

Perhaps he was mad. In all the turmoil of his inner life, the one dominating, supreme impulse was a passion of universal love. It was a love so all-embracing that it could scarcely attach itself to any individual; it was for all people and even for all things. The tragedy of his life lay precisely in this: that only in his painting could he find any sort of expression for this love. Perhaps it was madness that Vincent loved so deeply, so strongly, in an unloving world. We should all be so mad. We should all aspire to become such a transpersonal lover as this one was.

Yet when he approached people, the very intensity of his feeling obstructed and distorted his expression, and instead of attracting and soothing them, he infallibly irritated and repelled. In a peculiar irony, his feelings translated themselves in speech and manner into the opposite of what he meant. His love made people avoid him, and the utter self-abasement and humility, which his love inspired, translated itself into arrogance, harsh judgments, and violent acts. Even van Gogh's brother, Theo, whose goodness and patience were without bounds, could approach him only at rare moments. Otherwise, van Gogh was alone yet always willing to give his love, endlessly. He tells us:

Love a friend, a wife, something, whatever you like, but one must love with a lofty and serious intimate sympathy, with strength, with intelligence, and one must always try to know deeper, better and more.[4]

Van Gogh's emphasis on love exemplifies how intimately connected love is to creativity. Art is born of love; it is an unconditional offering. When we have hit a hard place in a relationship or situation or have gone to a place where we aren't sure how to respond or act, we can ask, What would Love do? What should Love do? What can Love do? I ask these questions when facing the blank canvas, the lump of clay, the white emptiness of paper, as well as in life situations. Spiritual imagination and love are two rhythms of the creative impulse that play in our veins, inspiring us to mimic the process of grand creation.

Creating works in art, business, or other endeavors and in creating one's self — that is, developing one's capacities, becoming freer and more responsible — are all aspects of the same process. Every act of genuine creativity means achieving a higher level of self-awareness and personal freedom, and that may involve considerable inner conflict. For van Gogh, artistic expression and creative courage were imperative for his "survival." We thus get a life seen from within, turned inside out. This is precisely why van Gogh was forced to live only by the "reason" of art and his incredible creative energy.

My having a definite belief about art also makes me know what I want to get in my own work — and I shall seek to get it even if I myself perish by it.

... Sometimes I know so well what I want. In life and in painting too, I can well do without a good Lord, but I cannot, suffering as I am, do without something which is greater than myself, which is my life, the power to create.
—Vincent van Gogh[5]

Van Gogh was not primarily an artist, and his personality only burst its way through into a tortured and difficult expression in paint because it met fatal obstructions elsewhere and was bound to find some outlet at whatever cost. Here lies the secret of van Gogh's magnetic art. It is simply true. It is absolutely genuine. It is fearless. It is courageous and raw. It is just who he is. It is love and piety looking out and in.

When one realizes this, one sees why van Gogh's pictures are not in the least like other

pictures. Their origin is different; they are the outcome of a different kind of emotion toward a visible universe from that which governs the creations of most painters. Van Gogh's paintings are pure self-expressions. The strange thing is not that, as pictures, they are so imperfect, but that judged by purely visual standards they are so free from aberrations. The purity of van Gogh's nature was so absolute that, puzzled and slow-witted as he often seemed, he was incapable of making the sorts of mistakes that one would have expected. One would have supposed that this profoundly religious nature, whose one longing was to devote himself to humanity, would, when he turned to painting, lose himself in one of the many delusive bypaths available to the modern artist, but van Gogh's creative energy made his judgment infallible. He saw through his peers' academic, aesthetic, and feeble reverence. He realized that his own love was so universal that he had no need to choose subjects in order to express himself; he saw that his religious feeling could find expression far more clearly in a vase of flowers, a chair, or a brothel than in any "religious" subject.

In van Gogh's work we have the opportunity to see something of an extraordinary artistic adventure being accomplished in an incredibly short time. It is characteristic of his intensely personal and subjective talent that in each painting, each session at the easel, he manages to convey so much of his beliefs and his passions. Perhaps no other artist has illustrated his own soul more fully and has been the passive, humble, and willing instrument of whatever force held him for the time being in its grip.

Art, although produced by man's hands, is something not created by hands alone, but something which wells up from a deeper source out of our soul ... My sympathies in the literary as well as in the artistic field are drawn most strongly to those artists in whom I see most the working of the soul.
—Vincent van Gogh[6]

What strikes one all through his work, and with fresh astonishment every time one sees it, is the total self-abandonment of the man. He never seems to be learning his art. From the very first, his conviction in what he has to say is intense enough to carry him through all the technical difficulties, hesitations, and doubts that beset the learner. He works as a child who has never been taught, with a feverish haste to get the image that obsesses him externalized in paint. At the summit of creative courage, the individual dares to go his or her own way, to be absolutely alone in unknown places and directions in which there are no signposts or security. This creative courage allows us to be with our pleasure or pain, anger or peace equally. It allows us to express our suffering or joy equally.

In the daring simplicity and vehemence of van Gogh, we get a measure of his originality and the great liberating forces within him. As time moves on, his canvases show a rapidly accomplished evolution. His brushwork becomes more agitated or, rather, the rhythm becomes more rapid and more undulating. The forms tend to be swept together into a vortex of rapid, parallel brush strokes. The canvas was a perfect mirror of the inner

state and moods that van Gogh experienced. With reckless fervor, he forced it somehow or another to convey his insistent feeling. He was often rewarded beyond what one could have predicted, and his heavily loaded paintbrush takes on at times a strange, almost crystalline beauty.

It was this peculiarity of van Gogh's genius that made his influence on the next generations so considerable. His power of communication was so great that it was impossible even for the most casual spectator not to be arrested by it. The very fact that it was so elementary, so sincere, so pure in raw, unadulterated feeling and truth, shows that it was and is an impressive force in a sophisticated society. Van Gogh's sincerity was inevitably tied to his artistic eruptions, an unbridled creative expression that was directed by a fierce need to communicate his love.

The truth is that sincerity in art is not an affair of will, of a moral choice between honesty and dishonesty. It is mainly an affair of talent … For in matters of art, "being sincere" is synonymous with "possessing the gifts of psychological understanding and expression."
— Aldous Huxley[7]

If we enter into a relationship with a work of art, we sense all the tenderness, joy, and sorrow in the world as expressed through this one object of human expression, as van Gogh did when he saw, and painted, an old pair of shoes, telling so much of the person who is not there but who wore them.

WINGS OF CREATIVE FIRE

The accomplished transpersonal artist's subject matter is often fantastic, grotesque, beautiful, or mystical and may take many other different forms of expression. He or she depends to the utmost on the spirit of that communication between the art and observer that some critics tend to believe is facilitated by rules and general principles but is finally determined by the unique response of the individual to all phenomena. When flowing in a healthy, creative process, an artist drops all defenses, responding openly and honestly to the shifting requirements of each moment, each work of art he or she makes, each situation he or she is in — and this takes courage.

This process requires a courage of a rare type, enabling the cultivator to face the chaos of the world outside and the sometimes frightening darkness and light of the transformative inner journey. I have discussed how this can initially breed loneliness and aloofness in the artist. This is not necessarily due to any separative, psychological tendency but to the nature of the way itself. For a time, the creative mystic may experience a seemingly irreconcilable contrast between his or her own life forces and those emanating from the world in general. All that is left for these creative workers is to connect to their own inner guidance and to find their way home. Regardless of whether or not their work is rewarded or recognized, they must and they will continue.

With all this talk about the nature of the matured artist, it is important to remember that from the very beginning, the creative power is present in everyone. Oppressive forces from outside, operating against this inner force, are inevitable. Mystics, seekers, and creative people are stigmatized by their inability to abandon the self's directive toward wholeness in order to adapt themselves to the conditions of the environment and its limited, dominant values. Seekers and creative people, like the heroes and heroines of myth, stand in conflict with the world of the fathers (that is, the dominant values) because in them the archetypal world and the self that directs it are such overpowering, living, direct experiences that they cannot be repressed. From a Jungian perspective, many people are released from this heroic mission by their institutional education and conditioning toward identification with the father archetype and so become well-adjusted members of their patriarchally directed group culture. In creative people a predominantly mother archetype is at work, and the uncertain, wavering ego must itself take the exemplary, archetypal, and heroic way. They must slay the father, dethrone the conventional world of the traditional canon, and seek an unknown direction, inwardly guided by the feminine, the muse.

I have referred to Jung's psychology and his use of archetypes on several occasions in this book; however, I am no more a Jungian than I am a Freudian, or any other "ian" for that matter. In fact, beyond the few cited examples and quotes from Jung and my respect for his work with symbolism, I am a little surprised and sometimes annoyed with scholars, teachers, and therapists who idealize Carl Jung, even see him as a guru. I remind these people to put their idealizations of Jung alongside his anti-Semitism, his initial blindness to Hitler's evil, his chauvinism, and his self-indulgent exploitation of his wife and mistress, and that much of his psychology tends to be like a floating head disconnected from a body. Jungian psychology, although more transpersonal than the psychology of many others, is not a wisdom tradition. I recall several occasions when my late friend, Lex Hixon, author and spiritual figure, remarked on Jung to members of the psychology department at Naropa University: "Jung is an entrance, one door, not a sacred path or contemplative practice toward Godhead." Certainly, Jung has left a fascinating map illustrating aspects of the mind and human nature. Jungian psychology is a science of the psyche. It is not a spiritual path to enlightenment, but it can inform us of the multifaceted and multidimensional aspects of our nature, which might lead us to more "aliveness."

We know that we're fully alive when we feel the heart's tenderness. If in our responsiveness to life we say, "I don't feel anything at all," we know that we are not being completely genuine or vulnerable. We cry because we sense the fragile beauty that arises from life's transitoriness.

When I see pieces
of who you once were to me
I see the world transient
Like perceiving my own death
I freeze to the bone
— Alan Sparks[8]

To fall back into the security of our "habit patterns" is a form of weakness, because in a sense we fail to meet life head-on. Tapping the creative power at deeper levels absolutely demands that we contact a higher amount of energy and make it available in every one of our encounters. Most live with a sense of lethargy. Our life energy is usually not available in the moment, for if it were, we would respond to life in any number of unpredictable, spontaneous ways. When we learn to drop our habits and conditioned thoughts on the spot, lethargy instantly departs, and suddenly we experience life with intensity and alertness. All of our responses become more graceful and appropriate. This enlivened sense of being draws from a reservoir of strength and resilience deep inside us.

We are all more resilient when we have a firm sense of who we are and that we are lovable and loving. Where do self-esteem and self-efficacy come from? Psychology would have us believe that self-esteem and resilience are merely a healthy access to appropriate defense mechanisms for the ego that work at the appropriate times. I believe it is also the ability to appreciate the relativity of situations, the ability to take a historical view, and, in the creative worker, the exceptional skill of tolerating paradox and pain. Resilience is a form of love that moves through fears of all shapes and sizes. In the creative worker, a vision tied to a mission gives him or her a hope and faith that encompasses an essential facet of resilience and aids the artist's wound. The artist's ability to hold and work with paradox gives him or her an immense power of resilience and healing, which can also express itself as an invisible essence contained in a visible art.

Creative courage allows us to move through our fears and experience love in a greater measure. Like some yogis of the East who have renounced the comforts of life, there are some western artists who have also done the same for the sake of their creative work. Whereas the *Thangka* painter, the lamasery artist, the ashram artist, and the icon painter may find refuge in a sanctuary, a sangha, a guru, or a church, the western mystic artist is usually supported only by the spirit of art. Carl Jung says:

Art is a kind of innate drive that seizes a human being and makes him its instrument. The artist is not a person endowed with free will who seeks his own ends, but one who allows art to realize its purpose through him. As a human being he may have moods and a will and personal aims, but as an artist he is "man" in a higher sense — he is "collective man" — one who carries and shapes the unconscious, psychic life of mankind. To perform this difficult office it is sometimes necessary for him to sacrifice happiness and everything that makes life worth living for the ordinary human being …[9]

Tricks, devices, drugs, or disciplines are useful to the creator only insofar as they support the action or empower the organism that acts. The less the creative worker needs to depend on external things or circumstances for inspiration or skill, the more potent and creative he or she becomes. Drugs may introduce a creative worker to various realms of experience, they may open the eyes and heart to the marvelous, but they should be understood for what they are — a finite and limited experience. One will grow further

from one's self after a certain stage or a realm of mapping of the states experienced. Creative workers who depend on alcohol, LSD, hallucinogenic mushrooms, and other plants, or on paper of a specific size or texture, or on some single favored environment or technique in order to see, hear, feel, or get their work done have narrowed their experience and freedom of action. They are resorting to control crutches instead of relying on their love and natural skill, their wings of creative fire.

AGENTS OF CHANGE — PARTICLES OF GOD

Perhaps the future of art and artists will not lie entirely with the creation of enduring master works, transpersonal or otherwise, but in part with the exploration and definition of alternative social and cultural directions. Although the individual work of art is important, the overall context, or lifestyle and attitude within which it is produced, is extremely valuable to us. As emergent possibilities, these social-psychological contexts may well lead us to further redefinitions of art and culture. We may speculate, therefore, that whereas past societies have tended to be dominated exclusively by one calculus or measure for social or cultural worth, such measures could become more diversified in the future. Where previously, for example, the military — or more recently, the economic — calculus was the dominant measure for evaluating individual or collective activities, we may emerge into societal forms in which the aesthetic calculus becomes a dominant measure, producing a highly creative culture. Ancient China selected its most prestigious officials based partly on their performance as poets and calligraphers. We may, in the future, consider the poet or painter as no less qualified for public office than the lawyer or businessman, should such fixed occupational roles still exist.

All of us could look at "re-visioning" our role as a versatile agent of change. This re-visioning can become an ordinary and daily act. Though individual acts are unlikely to immediately change governments and the world situation, individuals can cause change. One of the most powerful things any of us can do to change the world is to change the nature of our own beliefs to something more positive, and to begin to act. The Buddhist teacher, Chogyal Namkhai Norbu, offers the following:

We need to behave with awareness, too, in our relationship with society, so that the individual's inner development can really evolve to a full maturity. Many political ideologies encourage the individual to engage in a struggle to build a better society. But the way they propose to do this is through overthrowing the old society, perhaps by means of revolution. In practice, however, the benefits produced by such means are always relative and provisional, and a real equality between social classes is never achieved. The truth is that a better society will only arise through the evolution of the individual. This is because society is made up of millions of individuals. To count to a million, one has to start with number one, which means one has to start with the individual, the only real place one can actually begin to change something. This doesn't mean putting oneself first in an egotistical way, but rather it involves our coming to understand the condition of the whole of

humanity through understanding our own experience. With this experience as our guide, we will know how to behave with awareness in any circumstance in every type of society …[10]

The idea of revolution's coming from outer conditions, scientific or technological, is an impotent concept. To affect culture, change sociological elements and collective thinking, a transformation in consciousness has to take place in the soul, the mind, and the willpower, whereby we come to see ourselves as the stewards and not the victims of our circumstances. The artist and writer, Suzi Gablik, emphasizes that this revised self-image, from being passive victims to being active agents of transformation, is the most important factor in becoming a creative force and bringing positive change into the world. For if we think of ourselves as unchanging beings, unable to alter the patterns that determine our behavior, then we are in a real sense already dead. Every time we speak of how we are victimized by the oppressive forces at work within the world, we are giving up our responsibility, giving away our freedom, substituting for it a feeling of impotence. I cannot expound a way for everyone to achieve transformation, but I can assure everyone that one exists, tailored for the unique spirit they possess. I can also assure you that as you transform, others will, too, who come into contact with you.

In looking at the nature of creativity and creative workers, I see that many of today's artists have become limited, refusing to even look at other fields of knowledge. This is disturbing, given the artists' versatile heritage. I am amazed at how many artists today have dispensed with art history altogether. I have seen in many of my peers a fear of being influenced by another artist's work, concerned about losing their originality. They avoid looking at other art yet expect all to gaze and gasp over their own work. Usually, their original work was derivative or influenced in some way by another artist. If these artists had been informed by studying art, other artists, and other fields, they would see the links in the chain. I stand on the shoulders of all the great men and women who have come before me. I see far because of them. We all do.

A hundred times every day I remind myself that my inner and outer life depend on the labors of other men, living and dead, and that I must exert myself in order to give in the same measure as I have received and am still receiving …
— Albert Einstein[11]

Mainstream psychology states that the nature of the "creative" is characterized by a complex constellation of traits, some of which even appear to be superficially incompatible. In spite of the elusive qualities, forces, and paradoxical, almost contradictory character traits found in the creative individual, some tentative conclusions have been reached, and I have addressed some of these earlier. But I suggest we also ask the following questions: To what extent and in what way do genetic and environmental factors interact to produce creativity and psychiatric illness or health in the creative? How does the prodigy fit into the whole picture? Are there any physiological, neurochemical, or

psychological variables that can act as markers for the creative person in general? What is intuition and how does it relate to creativity and the creative process? What is inspiration? What is the source of inspiration? For the study of creativity through the field of psychology, such questions are too compelling to be ignored and demand that the study already undertaken by a number of investigators be continued with increasing refinement and openness. Still, in the face of such careful scientific investigations, I wonder, how can one analyze the reasons and motivations of the manifestations and workings of the imagination? How can one define genius, otherness, or the invisible? How can one who works solely in the "visible" world have the capacity to fully understand and analyze those creative workers employed by the "invisible" world?

Standing on the bare ground, — my head bathed by the blithe air, and uplifted into infinite space, — all mean egotism vanishes. I become a transparent eyeball, I am nothing. I see all. The currents of the Universal Being circulate through me; I am part or particle of God.
— Ralph Waldo Emerson[12]

How do we analyze Emerson's inspirational experience? Certainly we can share in his experience through his words, his art, and through the art of others who have turned their face toward the infinite. Art can describe or plant the seeds of descriptive discovery. Art gives palpable form to the imagination. The spectator is given the great privilege of being allowed into the secret garden of dreams. Rich veins of darkness and light are discovered through the artist's image streams that run through his or her fingers. These discoveries are made in the safety of the studio or during private time and the sanctuary of the creative worker's abode. Sometimes these discoveries are frightful, persecuting, and monstrous, yet art ventilates them within the sacredness of the studio and the creative process itself, assuring a safe, even if difficult, labor in birth. Painted caves, such as Altamira, or the office of a spiritual counselor or therapist, or the site where ritual dances have gone on for years — and, of course, artists' studios — are all sacred spaces. In such sacred places, art, religion, metaphor, play, and dreams intersect. The analyst's office, the shrine, the child's playhouse, the studio, the theater, the stage, the dance floor are all places separated from and yet bound to reality. We can safely play in these spaces. We can "be" spirit in these places. In these spaces, sacrament and tragedy, rage or ecstasy can all be tolerated. Another term for a sacred place is "playroom." On certain occasions this playroom allows fantasy to take on highly inventive turns and states of revelation; transformation and bliss become available to all of us.

All of us as radiant particles of God, having worked at polishing some aspects of the soul, the genius, a shiny particle of God, sometimes forget about the designated safe houses, the specified sacred places where spirit is sanctioned to play. God treats all places as sacred places. Thus, God's playful behavior may be deemed out of social context at times, which can be inspiring or disturbing to others or just plain comical. God's artistic nature and creative flame often burn light into the world through intruding and

disturbing eyes and a passionate and warm heart. God's heart offers an illumination, an experience of the joy and pain of being human. Sometimes God's brilliance burns others with the chaos of transformation and its sharp cutting sight of mind, and other times with the gentle warmth of love.

The creative power is a blessing and a curse. To support it, to hold its power, we must develop our resiliency and, most of all, our humor. Anyone having traversed life on the edge and having been kissed by the muse must constantly remind themselves that the oscillations between struggle and reward are a passing event; that it comes and goes with the breath of God.

God gave us burdens,
 also shoulders …
— An old Yiddish proverb

The creative mystics speak to a temporal world from a world eternal. Not living by their watch but by infinity, they sometimes say the wrong things at the right time. Sometimes these *wrong* things are created by their simple but piercing presence, pictures, objects, or words that cut to the very heart of issues, freeing the burdens in others that have been carried for years. Things that have been avoided or hidden from view are sometimes exposed by the artist and split asunder, sometimes in chaos and sometimes with compassion. Usually, if it is chaos, the storm quiets after a time and an even greater harmony, creative expansion, and awareness comes. In any event, when a person or persons are touched by the fire of an artist or his or her art, they may become larger, more creative, more willing to risk and develop their own skills, to be more themselves. Mysteriously, even in its seemingly irrational acts, impractical creations, and wild notions, the creativity of genius does its magic, healing and transforming those around one. Something that was not here before, has arrived, delivered from spirit, and it will transform others.

The process of transformation has to reassert itself in order to digest and assimilate the utterly unpractical things that the genius has produced from the storehouse of eternity. Yet the genius is the healer for his time, because anything he betrays of eternal truth is healing.
— Carl Jung[13]

This storehouse is never far away from the irony-filled borderland between madness and genius. As Ken Wilber once said to me when I was in a "troubled" state, "Sometimes the boundary between genius and madness temporarily erases." In order to understand this paradoxical boundary, one must understand the workings of the ego and the refining links between immature and mature defenses. We can say that the psychotic denies or destroys reality around himself; the artist, recognizing reality, attempts to reshape, transform, and uplift it, whether it is painful or pleasurable in the process, knowing that love will prevail.

The creative worker moves through life with the body of the imagination, touching others with a spark of something eternal, reminding us that we are all made of the same substance. Sam Keen offers these words:

In the end, the strangest thing about humankind is not that we are pragmatic creatures made of the same whirling atoms and unstable compounds as stones and stars. It is that we are constructed of the stuff of poetry and dreams. As Norman O. Brown says in his great paean, Love's Body, *"The reality of the body is not given ... the body is ... to be built not with hands but by the spirit; Man makes Himself, his own body, in the symbolic freedom of the imagination. The Eternal Body of Man is the Imagination." Nowhere do we experience this intoxicating freedom, this divine power to create, so certainly as in the loving imagination. In trusting the images and echoes that arise out of our deepest experiences of belonging and communion, we discover, even as we fail again and again, that the way of love sustains the faith and hope that gives abiding meaning to human life.*[14]

ESSENCE

We are made of this essence, the eternal body. It is our divine birthright. Wandering as homeless persons, we just have to come back home to our true nature. We make that simple or difficult for ourselves, we make it challenging, dramatic or boring, joyful or painful. We want to stay at the masquerade ball, we do not want to go home yet. We want to play dress-up, wear different masks and costumes, experience ourselves as different forms and faces, try out various roles and in different places. We want to play at Maya's party, the "Masquerade Ball." We are detaining ourselves by means of our selves: not yet fully experiencing the One looking out through the eyes of the many. It is always our own choice — can we be late in being who we are?

We can use artistic expression to employ our creative power in moving through the barriers and removing the masks of psyche. Art used in this manner bridges both psychological investigation and spiritual practice. When art is employed as a sacred practice, the personal and the transpersonal, the psychological and the spiritual become inseparable. When art is employed as a tool for psychological inquiry, our false identifications are shattered in the release of aesthetic forms that float to the surface. These forms bring into focus the spiritual realizations that unveil essence. The false identifications that had replaced our essence (and this can include shades of beauty) are released and become objects of art. Over time, art used as a spiritual practice will express a truer reflection of our divine nature, as the forms that clouded the soul are spent. Using art in this way is not necessarily about rising above or transcending things but more about moving through what is there, dissolving false identifications, and connecting to and expressing essence. It's not always easy, and we must constantly remember that if we cannot feel pain, we surely cannot feel joy. This transpersonal palette holds all the colors of our past and the forms of our future. It allows us to become free of the chains of our past that bind us and tie up our present. Art can liberate the living images that imprison

us and give to us the true vision and experience of what we are now and what we may become. If we combine art with psychological inquiry, and that with spiritual practice, we can be rewarded with the full realization of our being.

While learning from the incidents in my life, from my past and present, my art, my practice, and from others, I measure where I am by throwing out the following question for myself. The honest response speaks of one's rhythm, one's direction and goal, one's connection and harmony between one's essence and others, the world, and the eternal:

If the whole world followed you,
 would you be pleased with where you took it?

FIG. 39A Ernst Fuchs, *The Anti-Laokoon (Laokoon Victor)*, c. 1965, (detail), mixed media on canvas, approx. 79 x 59 in. The Ernst Fuchs Private Museum, Vienna

Chapter 7

Drinking Lightning: The Lava of Psyche Runs Hot and Healing

THE CREATIVE PROCESS

Stars form, sustain whole solar systems, burn up ... and die. The creative process is a microcosmic reflection of macrocosmic principles in action. Just as the *universe is constantly creating, sustaining, and destroying,* so it is with the mind, a mirror of universal process. The *mind brings* an infinite variety of *thought-forms* into play; it *creates, sustains, and destroys them.* The cycle is endless, unless mastery over the mental-metaphoric seventh day of creation and rest is achieved by learning to still the mind through some chosen contemplative practice.

The creative process exists within everyone because we exist within the grand creative process. Our minds, held up like little mirrors to the immensity of this universal creativity, act as a perfect reflection of that: *as above–so below, macrocosm–microcosm.* Everyone has had the experience at one time or another of having an unusually bright idea. Some people have them more often than others; some seem to be continually inspired. Such moments of insight are called hunches, inspirations, intuitions, strokes of genius, and other similar terms. This is a mysterious eruption of the lava of psyche. In any case, something new has come into mind. And with this new seed in mind, something that never has been in the world before may be born that is true, good, and beautiful.

Developing a relationship with the worlds of art helps us to become acquainted with our own sensitivities to the media we respond to. Art is a dynamic power. In perceiving the artistic object, the responder not only understands its intrinsic value but also experiences his or her own heightened awareness of being. These experiences are a central aspect of human life and act as an agent to integrate the splits within the person, between persons, within the world, and between the person and the world. From increasing experiences of art, self-actualization becomes possible. Higher or subtler needs emerge as the lower needs are fulfilled. In this light, it is easily seen why the creative experience can assist humankind in actualizing and realizing its essential inner core, its being. These intimate moments can effect changes within. Robert Henri explains:

The object of painting a picture is not to make a picture, however unreasonable this may sound. The picture, if a picture results, is a by-product and may be useful, valuable, interesting as a sign of what has passed. The object, which is back of every true work of art, is the attainment of a state of being, a state of high functioning, a more than ordinary moment of existence. In such moments activity is inevitable, and whether this activity is with brush, pen, chisel, or tongue, its result is but a by-product of the state, a trace, the footprint of the state.

These results, however crude, become dear to the artist who made them because they are records of states of being which he has enjoyed and which he would regain. They are likewise interesting to others because they are to some extent readable and reveal the possibilities of greater existence.[1]

The creative act is laden with the human meaning of self-actualization, and each mode of expression reveals some effort, some part of the whole, and is at the very root of true education. Art can be a personal act of beginning, an act of bringing into being that which did not exist before. Art can be an act of remembrance of spirit in the present. It is not only an act of mere recreation, in the Platonic sense or literally, symbolically, or metaphorically. What is created has never existed before — it cannot be recreated. It is the creation of a new form of something derived from another realm.

Each time art lovers encounter the same work of art, their response is likely to differ in some qualitative way, since their own development has continued during the interim. The response to the artwork is not a mere one-time experience, and individuals can respond anew each time they encounter the work. With each new perception of art come new possibilities in beholders' responses. Responders think about their thoughts, are aware of their own awareness, feel their feelings, and in general are conscious of their being. This is due to their special experience with the art, form, medium, and state of being at the moment. Responders can focus their attention more completely on the idea, feeling, or state of mind (human condition) created by the artist and thereby release their own powers of perception, cognition, and imagination. The responder's personal activity can thus become essentially creative and self-actualizing since, at any given moment, he or she creates a gestalt of responses that never have existed before nor will again. With the new awareness from each encounter with art arises a new experiential and conceptual foundation upon which all subsequent growth will be based. Realization of these psychological states helps us to comprehend how each contact with art affects our awareness of ourselves, our concepts, our humanity, and others and their humanity.

In this sense, the human creations loosely designated as arts and humanities have no one meaning. There will be as many meanings as there are responses or responders. We are influenced by reality, and we would like to have some influence on it in return, if only in a spirit of grateful reciprocity. The arts are humankind's way of subjectively interacting with objective nature. Interaction is not a monologue. Whatever unique and individual human meaning each person may realize from an encounter with art cannot be entirely explained discursively; there is nothing that can be said to recreate the qualities of the ontological or existential realities experienced by each feeling and thinking individual. Thus we become familiar with the process of invention, creation, and the effects of inspiration.

The entire history of humanity has been highlighted by the sudden appearance of ideas that seem to have sprung from nowhere and at times have such impact as to cause worldwide change. Galileo's approach to observation and his discoveries, the invention of the steam engine and the electric light bulb are just a few examples in science. In some cases there appears to have been a slight foundation or background for the new idea, and at other times it has been completely unique. Many people who are creative most of their lives find that there are times when something literally seems to possess them and they are driven into a period of continuous, creative endeavor that will not let them go. Lack of sleep or food seems not to matter; the work must go on until completed or they collapse from exhaustion.

These people have tapped into a source of creativity that insists on being expressed. Others have but a momentary contact with this source or just a sudden flash. But such a source is always there, available all the time.

In Emerson's statement, "There is one mind common to all individual men," we can see how we can have access to a tremendous source of ideas. Our mind is an aspect or individualization of the *one mind* and, as such, can avail itself of *its* creative energy. We may not become a genius and experience our mind as a continuous fountainhead of new and brilliant ideas, but there is no question that we can have more new and constructive ideas than we are now experiencing.

All of us are thrilled when we experience the exhilaration of a new idea. It stimulates our mind to greater activity, increases our confidence and self-esteem. It acts like a tonic to our body, and we have a happier, more joyous outlook on life in general. Although we may not be able to tap into this source continually, there is every indication that we can develop an attitude and cultivate a way of thinking that will enable us to connect to *its* resources more frequently.

I have found that we can develop the ability to receive new ideas, inspiration, and vision. In any creative endeavor, I have discovered that focusing all the knowledge I have, then letting it go and remembering that my mind is not *my* mind but an individualization of infinite intelligence, will bear fruit. In this approach we can surrender the thought that we are the prime source of our every idea and thereby become a more perfect instrument of *its* action. The concept is not new; rather, it is attested to by the outstanding accomplishments of many of the greatest men and women of the arts and sciences, of business and human relations. Many have recognized one source to which to turn, and we may turn there too.

One of the best things we can do for the cultivation of creativity, of new ideas, inspiration, and transformative forces is to *expect* that we will have it. We do not need to be specific about the influx of inspiration or determine beforehand what the nature of it should be. What is fruitful is to establish an expectant attitude, a conscious effort to keep our mind open to such an influx. We can meet the day with the conviction that many wonderful new ideas are going to come to us, that we are going to encounter new situations that will provide us with unusual opportunities. Our consciousness is what we really are, so we can let it manifest more of what it already is. We shouldn't keep our mind in chains. We can let it be free to soar, to discover more of the wonder of its own nature.

The following may offer some simple insights into the creative nature and conditions of invention, expression, and manifestation, and they may reveal some of the elements involved.

1. The ability to play is essential to creative work as it is to experiment scientifically without anxiety over the results. The kind of play I am talking about is not art therapy or a way to resolve psychopathology, although healing can occur as a result of creative play. Play (in the child) and creativity and invention (in adults) are proactive. Creativity hones skills and forces of resilience. Playing and dreaming are about developing the new, whereas maturity or

"being adult" has much to do with maintaining the status quo. If the task of youth is to innovate, the work of middle life is to commit and persevere, and the goal of elders is to pass on what has been learned; then perhaps, through mastery of creative process, these three stages can occur simultaneously in the inventive worker. The wisdom of the elder and the playfulness of the child occur in the same person, the creative mystic.

2. The power of ritual is another important element in creative expression. Ritual serves to create environmental peace, thereby allowing the reception and the release of other worlds. Discipline, commingled with the liberation of spirit, sacred space, and ritual, is important to creative manifestation. The bridge of ritual activity serves as a link between the inner and outer worlds, facilitating the transfer of emotional and spiritual energies from one world to another. The order of ritual opens the door to universal play. The form of this order can be "open ritual" (self-designed) or ancient in origin, established in a wisdom tradition. The mysterious affinity between play and order is behind every work of art.

3. Creativity and play involves an appreciation of paradox and the unexpected. This requires the creative worker to move through and liberate fears and a willingness to turn agreed-upon notions and normalities onto their heads. In other words, in order to bring into the world that which has not been here before, one has to be able to see that which others have overlooked. Children enjoy being surprised. Most adults do not. The capacity to find laughter in chaos, spin straw into gold, and see silver linings, is creativity as adaptation.

4. Harnessing feeling as well as thinking is required in creative work and expression, as is emptiness and the state of not thinking. By linking idea and emotion, creativity can serve as a means of achieving intimacy and passion. Harnessing passion often requires mentorship and some sort of identification, association, or intimate relationship with another person and persons, national or world consciousness, or collective empathetic consciousness.

5. The artist's creativity is contained by a certain shyness. The artist wishes to communicate but is often very indirect about it. He is like a lover who is speechless standing before his beloved and then sends a lucid love letter that melts her heart. In the same way, works of art mark the footsteps where the artist has trekked. Creativity touches our heart but usually after the artist has left the room. His presence is no longer required. In many instances, this is nature's way of ensuring humility and purity of experience, allowing intimacy and understanding to take place between works of art and responders.

6. In order for creative expression to manifest discovery for self and others, the study of a medium is necessary for its communication. Mastering a medium or media is essential, and the desire to share and communicate is central to the creative worker's integrity and purpose.

Although there are certain stages involved in the discernible development of *techne* and *psyche,* it should also be understood that creativity may never be explained by reason alone. Creativity compels us not to explain but directly experience the wonder and awe of life. Creativity in all its phases, forms, passages, and transformations is humanity's greatest marvel. It is a spark filched from creation consciousness, bestowing powers upon those who are receptive and self-denied by others. That power leads us to a greater unity and to a broader and more inclusive vision.

Examining the human capacity for adding to the world what has not been here before, from the points of view of the psychologist and the mystic, may be informative. The modern psychoanalytic use of the term *ego* encompasses the adaptive and executive aspects of the human being. The ego is found in our ability to integrate, master, and make sense of inner and outer reality. A psychoanalyst familiar with the studies of the creative would tell us that the capacity for creativity seems closely interwoven with the alchemy of the ego to bring order and meaning out of chaos and distress. A mystic would recognize that this creative capacity can also allow grief to be comforted by an esoteric energy, and it can allow self-deception, once transformed into self-awareness, to be viewed as part of human nature and not as a sickness or sin.

Piaget suggested that creativity reflects how we *assimilate* life, take life in, make it our own, and share it with others. In Freudian terms the ego serves to coherently organize mental processes and address the capacity of the integrated mind to accommodate and assimilate the world. Other researchers on creativity may suggest that it is the artists' ego that also compels them to create and invest their substance into forms and work that will outlive them.

Some mystics would say that the creative process is more shaman-like. It enables one to pass through darkness, a series of deaths and rebirths, and enter the realm of the eternal, the timeless. After moving through darkness, one stands free and untied, unafraid, ferocious, and gentle. Nothing to keep, nothing to lose. No hidden forces, no rules, no undercurrents of constraint. No concern for form or nonform in creative expression and whether or not it is ridiculed by others. The challenge is to carry over this chosen discipline, aesthetic experience, and creative power into everyday life and contact with the world.

I have also been asked by students if going through darkness is necessary for great artistic achievement or self-realization. My response is always no. However, we must all rid ourselves of ignorance and fear, which are forms of darkness, and we are all trying, in one way or another, to liberate ourselves of suffering, and that is another kind of darkness. We all come into life with a fresh piece of work (we codesigned, self-assigned, and are responsible for) which includes a darkness clouding the soul and an illumination lying just behind it. There are many ways to move through darkness and connect to illumination. A creative practice is one of them.

As a creative practice unleashes the power within the individual, he or she becomes a greater force in the world. And with that creative power comes a great responsibility,

and to that we may add a skill in the discrimination and dissemination of that energy. If one is unable to stay in the flow of the creative process, and most of us will go off course at one time or another, then all havoc can break loose, and that creative energy goes haywire. Even staying balanced within the process, a person can undergo mystical encounters, dark nights, illuminations, or ecstatic episodes on various levels, and a person can experience profound emotional and psychological transformations. Such encounters can create turmoil for a while — like a tornado that has passed through — and it can, and often does, leave havoc in its wake. The cleanup may take time, wounds may occur, and healing must follow.

I have discussed the shamanic-artistic wound in creative practice. The healer archetype of the creative worker can have different degrees and stages of this. In certain phases, the once-wounded but almost-healed healer is still a *wounded healer*. In Greek mythology, the healer Cheiron suffers from an incurable wound so unremittingly painful that he comes to regret an immortality from which he cannot escape. It is as a still-wounded healer that artists may affect their environment negatively, until they become *once-wounded*. Artists' wounds are often the source of their gifts and sometimes of their limitations. This yin-yang/positive-negative force in the artist reminds all of us about how closely allied the powers to heal or to wound are.

When creative workers can manage to use invention energy in a positive and healing manner in the world, there is a great synchronization, without warping it, with any situation they are in. Their behavior is inwardly guided, not by cerebral or discursive thought, but by a flow from the inner core of being, and they are simply free. In their fiery presence others feel inspired, safe, accepted, and free in being just who they are. Others can even feel protected by them. I immediately envision the astounding *Anti-Laokoon (Laokoon Victor)*, c. 1965 (see Fig. 40), by my mentor, Ernst Fuchs. In this mixed-media work of art, I see the preparedness and the battling of creative power, at once both poised and at work in spirit — not unlike the great sculpture *David* by Michelangelo. In this work by Fuchs, I see life mastered through art, divine surrender, and intuition. All obstacles are conquered; the serpent power and duality of mind — evil and good — is overcome, and the surrounding figures are protected by the powerful central presence and commanding action of a mystic warrior. Fuchs would say that this piece represents the great battle against "the monster," or death, by the power of prophecy and through the power of art — in this case, a neo-Mannerism, an aesthetic magic revitalizing and synthesizing the art forms of Europe and Asia Minor.

Creative workers could synchronize their inventive energies in a collective manner, and the result could be a renaissance, an aesthetic revolution in action, uplifting the standard awareness of the community at large. Are we moving, can we move in such a direction together? When the lava of psyche runs hot, her creativity and heart is open, her healing powers are flowing. The molten, creative heat clears a space of welcoming within, and we can leap from a place of feeling safe to the unabandoned flight of inspiration. There are no longer any blocks as they are melted away.

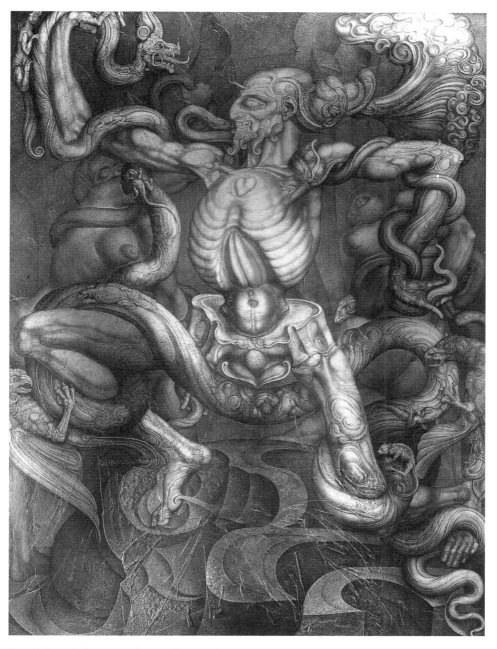

Fig. 40 Ernst Fuchs, *Anti-Laokoon (Laokoon Victor)*, c. 1965, mixed media on canvas, approx. 79 x 59 in. The Ernst Fuchs Private Museum, Vienna

CREATIVE MIND

The ancient philosophy of Kashmir Shaivism tells us that the mind is the body of the self, that the mind is but a throb of consciousness; when universal consciousness, which created this entire universe, descends from that state of pure consciousness and assumes limitations, it becomes the mind. When that mind which created the universe in all its diversity assumes limitation, it begins to create endless mental universes inside (our "mind"). The mind is then a *contraction* of consciousness.

We think all kinds of thoughts and allow all kinds of things to pass through our minds — including thoughts of inferiority, insecurity, and self-degradation. If instead of all this contracted activity we were to think expansively, highly of ourselves, if we were to think of our self as divine, we would be closer to experiencing the joy and wisdom of our true nature. It is the nature of the mind to think, so let it think whatever it likes. At the same time, we need to be aware that we are not the mind, we are the witness of the mind; we are the observer, the spectator, who is watching the mind move. When our mind becomes agitated or turbulent, we do not have to think *we* have become agitated or turbulent. We can just watch our turbulence or our agitation from a distance and see the endless creations of mind. In this way, our state of agitation in the mind is not "supported" and not charged into "action."

Thus, adding a contemplative practice to one's life and working with our mind enables us to experience peace of mind. To attain emptiness and the state of "not thinking" becomes a tremendous asset to creative activity and spiritual growth. My former Hindu teacher would say that the universe is nothing but a sport, a play of consciousness, and that the world is a product of thought. It is a creation of mind. We create our own world by our own thoughts. Thus our life, our relationships to everything, to each other, our artwork, can be numerous heavens or hells and everything in between. From a Hindu point of view, we do not paint, sculpt, or write to attain the self or God. The self is already attained. The Buddhist teacher and master of *Dzogchen* meditation, Chogyal Namkhai Norbu, also affirms this:

Everything has already been accomplished, and so, having overcome the sickness of effort, one finds oneself in the self-perfected state; this is contemplation.

If one has really understood that our real condition is the self-perfected state, then there is a base on which one can develop. If one hasn't understood this, however, even if one studies all the different systems of teachings, one remains in a state of ignorance. From this point of view, even a very learned person could be considered ignorant, while a person without the slightest scholarly education could perfectly well have real knowledge. Study, analysis, philosophic inquiry, and so on, can be useful if one knows how to benefit from them, but often they are an obstacle to true understanding.[2]

It is pure consciousness that makes the mind move, the body work, the paintings flow, the sculptures form, the cake to bake, the flower arrangement to form. We learn and relearn, through art and contemplative practice, that the thoughtless state of pure consciousness

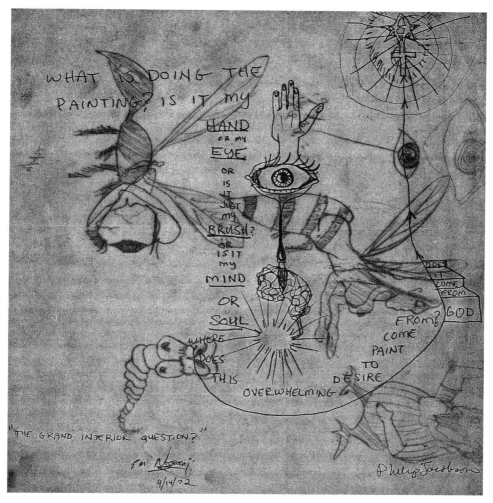

WHAT IS DOING THE PAINTING? IS IT MY HAND OR MY EYE OR IS IT JUST MY BRUSH? OR IS IT MY MIND OR SOUL WHERE DOES THIS OVERWHELMING DESIRE TO PAINT COME FROM? DOES IT COME FROM GOD

"THE GRAND INTERIOR QUESTION?"

4/14/72

Philip Jacobson

FIG. 40A Philip Rubinov-Jacobson, *The Grand Interior Question*, mixed media

which is beyond all thoughts has become all thoughts. Inner visions are seen as waves rising and falling in the ocean of consciousness. The self remains the same, whether there are visions, sounds, thoughts, or non-thought in the activity, or whether there is absence of mind. The self is all forms and without form. In a way, art is a friend of the restless mind, and by its inspirational vehicle, it leads the mind's restlessness to stillness, to Godhead, Christ, the Great Spirit, or Buddha nature — all the same.

When I was nineteen years old, I sat down and playfully created a funny drawing that questioned the process of creativity as a way to self-realization. Yet that silly and simple drawing which I called *The Grand Interior Question* also signaled a profound realization within me, a gestalt, a spiritual affirmation. Shortly after, the drawing slowly evolved into the form or map of *consciousness in creative action*. Here we see the involution and evolution of consciousness as working through the creative process, grand and small.

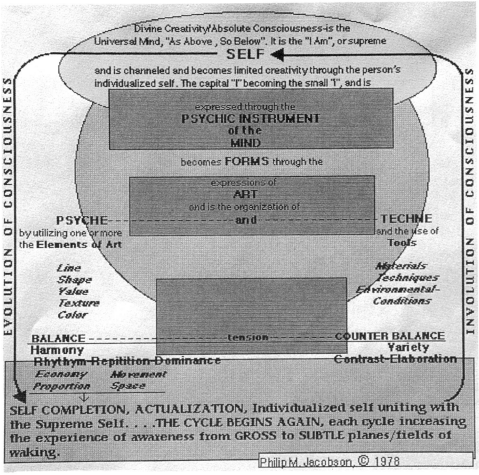

The following text is part of the diagram image:

Divine Creativity/Absolute Consciousness—is the Universal Mind, "As Above , So Below". It is the "I Am", or supreme

SELF ◄

and is channeled and becomes limited creativity through the person's individualized self. The capital "I" becoming the small "i", and is

expressed through the
PSYCHIC INSTRUMENT
of the
MIND

becomes **FORMS** through the

expressions of
ART
and is the organization of

PSYCHE — — — — — — — — — — and — — — — — — — — TECHNE
by utilizing one or more and the use of
the **Elements of Art** **Tools**

Line *Materials*
Shape *Techniques*
Value *Environmental-*
Texture *Conditions*
Color

BALANCE — — — — — — — — — —tension— — — — — **COUNTER BALANCE**
Harmony **Variety**
Rhythym-Repitition-Dominance **Contrast-Elaboration**
Economy Movement
Proportion Space

EVOLUTION OF CONSCIOUSNESS (left vertical)
INVOLUTION OF CONSCIOUSNESS (right vertical)

SELF COMPLETION, ACTUALIZATION, Individualized self uniting with the Supreme Self. . . .THE CYCLE BEGINS AGAIN, each cycle increasing the experience of awareness from GROSS to SUBTLE planes/fields of waking.

Philip M. Jacobson, © 1978

FIG. 40B Philip Rubinov-Jacobson, *Chart B*, 1978

The two major directions in *Chart B*, at the edges, show the flow of consciousness, involution–evolution. *Involution* is the process in which things fall away or separate themselves from union with the divine. This *descent* is a forgetting of spirit. This imaginary journey of separation involves states of alienation from spirit, isolation. It is Maya, and the "grand illusion" — what I earlier described as the "masquerade ball." In the cycle of transmigration, in the metempsychosis (reincarnation) of the soul's awakening, or remembrance, there is an *ascent*, and the soul becomes involved in the *evolutionary return to Godhead*, to self-realization, to spirit. In each round in the spiral of consciousness the soul becomes more aware of its journey home, to where it always was, and is now. Spirit returning to SPIRIT, God becoming GOD. It is a cycle of *remembrance* of our divine nature, what we were, what we are, what we will always be. Involution and evolution is the apparent homelessness that we experience not yet fully realizing that we never left home. It is the illusion, or involution, of feeling away from home and the evolution toward the feeling we are coming home.

From the Buddhist point of view, as long as our life, our point of reference, is based on self-grasping (an illusion of lacking something, of not being whole), we wander endlessly (away from home) in samsara, suffering. To realize one's true nature as "no self," "a Buddha," is the fruit of *zazen* and the goal of practice. The important thing (because only it is truly satisfying) is to follow the path, unveiling the already attained goal while being present in each moment along the way. Truth can be seen from a variety of positions or through different colored lenses. Whether one looks through Native American eyes, Celtic contact lenses, a Christian monocle, a Jewish microscope, a Muslim telescope, Hindu sunglasses, or Zen spectacles, the question of our true nature as a self or a "no self" is not immediately central. Ultimately we all just want *to see*. When engaged in a creative or contemplative practice, the whole basis of our life changes. Our whole feeling, our whole purpose, our whole orientation to life will be transformed by adequately engaging ourselves.

Does the universe, looking back at us, care what we think or do or what our art or creative outcomes should look like? Is the Buddhist perspective of emptiness or of a "no self" the correct one, or is the path of soul the right way? This confusion between "no self" and soul is partly the limitation of words, but it also comes from our efforts to blend eastern philosophy and western traditions. Western psychology encourages us to build up a self as a personality and maintains that religious moral teachings reinforce character. Most eastern traditions tell us to break ourselves down or even to achieve an emptiness. When involved with Hindu and Buddhist practices, if we hear the word "self" we hear "ego." Coming from a Judeo-Christian-based practice, if we hear the term "no self," we hear an escape, an avoidance, or even a loss of our actual being. As we enter the next millennium, we are rapidly becoming beings of both East and West and must come to the center in this apparent theo-psychological dichotomy. In truth, both goals are appropriate: that is, to build a self and to break it down is the way of the journey. Something has to be built and constructed before it can be broken down. We have to be *somebody* before we can be *nobody*. There are many seekers out there who are working to dissolve their ego and a healthy sense of self before they have worked through their own personal psychological material. Before going off into some mystical search for oneness, we need a strong ego to function and master our world around us, otherwise we are trying to learn self-trust by denying our self. It works for a little while, and then the false spiritual identity or mask we wore no longer fits, the old fears surface again, the old dysfunctions bubble up. Trying to achieve an expansion of consciousness by skipping stages of development does not work.

What I am talking about, in essence, is the achievement of, or rather the connection to, our "wholeness." A vision of unity in apparent diversity is common to those of clear insight, connecting us to the whole. It is a vision toward which one can grow without the dramatic forces of a dark night or a lightning-fast illumination but by gradual degrees of genuine inner refinement. In either case, such connections to fundamental unity usually do not proceed from any mere shift in opinion or in one's intellectual philosophy. A vision from a clear insight is always expansive, and the perceptions always hint at broader realities. The tendency toward expansiveness can be cultivated and nurtured through the arts. Great art is

always a living embodiment of this principle, for the simple reason that expansiveness is fundamental to the consciousness of every human being, and greatness is everyone's birthright. Greatness, indeed, means a greater-than-normal vision of reality, an awareness of the whole even while concentrating on the part. One of the most striking characteristics of an expansive and creative nature is readiness for, and openness to, unlimited experiences. A creative person may be interested in the most seemingly insignificant manifestations and will absorb impressions differently from others. Creative mystics realize that the more inclusive consciousness is, the more extended is their field of possibilities. They can give only what they have. If they wish to experience and give more, they will have to become more — by experiencing their true nature.

Wholeness is won by an "inclusive" attitude. Inclusiveness is won by a "creative service," a cultivation of creativity. One of the most important things in understanding the nature of creativity is in looking at the relationship between the will and the imagination, which is not to mean between the ego and desire — there's a great difference. The will and the imagination are equally important. Without the direction of the will, the imagination becomes mere daydreaming. It should be understood, though, that the will is not a creative but a directive force, an instrument of the intellect, not the imagination. Or as my friend, Alan Sparks, a computer engineer, simply puts it, "The imagination creates possibilities; the will can bring them to manifestation." When the imagination and the will are in conflict, the imagination invariably wins. This is because emotion strikes deeper in the wellsprings of being than does the intellect. Things do not happen from will alone, yet a man without will would be like a log adrift on a current. If we use our will in making decisions, and our feeling and imagination are backing them up, things seem to go better. The imaging faculty of the mind is creative: it builds, it molds, it makes mental forms. Imagination conceives and can purify desire, consciously or unconsciously. The secret wisdom of the creative power is veiled, but its expression becomes a force of love, compelling us to court psyche, which slowly unveils its naked beauty and the secrets of soul.

I have addressed the oppression many of us have experienced in educational systems and other events that have brought about wounds and, in many cases, annihilation of creative power. Industrial-corporate education and government still harbor an unspoken attitude that the cultivation of individualized creative courage could challenge certain efforts under their control. Each one of us has the power residing within us to reclaim and realign with our creative potentials and experience a more intuitive approach to life. Intuitive intelligence is at the center of each of us and consciously may be called into immediate use. If one asks for this guidance, one will probably experience an impression, even a definite decision, in a manner that will make itself felt within oneself. Or in some cases one may actually hear words spoken from an inner guidance, see an image or vision, or experience a feeling to go in a certain direction. The intuitive way also opens up skills and reception to healing others and ourselves.

COABSOLUTE HEALING

The recent hospitalization I spoke of in chapter four was one episode in a series of dramatic events in my life. The account provides a small but, I hope, significant glimpse into healing forces that are available to all of us. I return to that event to relate the deeper process that had occurred:

... As I lay in the emergency room of the hospital, fully paralyzed, I felt imprisoned in a cage of flesh and was in the total care of others, something I had always dreaded, an "issue box" of my own. Questions arose: What was all my spiritual practice for? What was all of my work with the creative power about? How can I use it now? Has it all been real and tangible, right here in this very body?

Climbing out of hopelessness, I moved into a space of natural expectation and direction. That is, in conversation with the visitors, God, my own Buddha nature, my self, I naturally expected to walk and move again by the next day, after the operation. This became an unquestionable inner directive that was inspired and blessed by the visitation from the two beings from another order of existence. In this situation, various fields came together for mutual benefit and effectiveness. One field does not interfere with the other, and the good work of my surgeon joined with the prayers and hearts of loved ones. This support added to my own contemplative and creative practice. The surgery, prayers, my inner guidance, my convictions, and the visitation that was beyond my own feeble understanding produced an apparent miracle.

For years I had witnessed the therapeutic effect that art had on others and me. I saw that the creative power can be used consciously and gently but can also be vigorously applied with the certainty of a definite result. I refer to this as "coabsolute healing." In my understanding there is no such thing as a *healer* any more than there is someone who *creates* a garden or *makes* a rose. We plant the seed; nature creates the rose. No one person has more potential to heal than another.

The creative healing I experienced resulted from one mind acknowledged in, through, and as the body and environment. I saw that we can change a situation because we can change our thinking within it, not in some cases but in *absolutely* any circumstance. We can, at the very least, change the context, even if we believe the content is unalterable. What I am talking about is not "mind over matter," it is that *mind and matter are not unrelated.* In essence I am talking about the healing power of love. All the philosophy in the world can offer this and that. You can study scriptures and sutras until your face turns as blue as Krishna's, but you will not know the meanings until you have lived them, tested them, become them. We experience our greatest spurts of growth from the pain of situations, from our failings and mistakes. When everything is fine and dandy, it's great, but usually not a lot of growing is going on. Rather, we are on a spiritual vacation (which is equally needed and certainly enjoyable), and no one who knows me would ever say I do not know how to "celebrate"— my God, no.

To become restored to health also means fully connecting with the outer experience

and inner teacher, that part of us that can see the "tree" in the "seed" *all at once*. The spirit of the action is revealed in the thought. This was the key to becoming whole again, to returning to wholeness when falling into fragmentation. There is an old saying from the Jewish Torah: "Who is Wise? He who sees what is born." This means, as soon as you look at something, you perceive what will be born and all that will proceed from it. You see the future consequences of the thing observed, to the very last one. For example, when one says that a doctor is a great healer, that he or she is very wise, what this really means is that whatever disease the doctor looks upon, he or she is able to see all of the possible results to which it may lead, to the very last one. Similarly, when the doctor looks at any medicine, he or she grasps completely all of the results this particular medicine might have in the body of this patient, and so on. This active wisdom is taken a step further in coabsolute healing to an intuitive level of "seeing."

This experience of "seeing what is born," from each detail of existence, right to the last result, was an integral part of my healing experience. It was a state of creative hyper-visualization. I knew that this situation held a great deal of opportunity for me equal to the potential for devastation. Every truth has its opposite. One aspect of mind is intangible matter, and the other is tangible form. This is already like the art of painting visions, dreams, and spontaneous markings that arise from within. Spontaneous healing is both a subtle and a gross act, an energetic phenomenon of creation and manifestation. What I discovered was that I could use this basic creative principle on yet another level to assist and cooperate with a higher power in the restoration of my body to health. The surgeon did all he could do and wished me well but did not expect much of a recovery.

I was discovering the principle that there is no difference between the essence of form and the essence in form. In other words, we understand that mind in essence and mind in form are one and the same thing, and that matter is an expression of energy. More than this, we are not trying to reach a known fact with an unknown or unknowable principle. We are that. In the moments that I fully moved out of depression, out of the shock of my condition, and accepted and "realized" my paralysis, I equally accepted the opposite of that and realized that my thoughts could be an agent of the creative power in becoming "whole" again. In that moment of realization I knew and felt that there was no difference (between paralysis and wholeness), that they were only different thoughts. I did not spiritualize matter to heal my ruptured disk and pinched spinal cord. Manipulating matter, biologically, physically, was the task of the surgeon's hands. My task was to deal with the inner reality of the pre- and post-operative situation, the invisible behind the visible, which in truth is more potent. The invisible is always greater than the visible. The invisible is the birthing source of what will become visible. There is no such thing as a spiritual control of a material universe as though spirit were separate from it, for such a perspective involves suppositional opposites and would annihilate fundamental unity.

Through this crisis, what I had experienced as a constant "knowing" became at once a "feeling." That is, I *felt* what I *knew*, and when feeling and knowing merge, a flash of true

wisdom and an extremely potent force arises within you. Trapped in my body, my mind and heart fixed onto the assumption that there is no difference between thought and what it is going to do. What it is going to do is announced by the thought, but its ability to do it is not entirely injected by the thinker, for it is a co-creative act with divine blessings, and that basically is a kind of prayer.

In the emergency room, prior to the operation, I slowly toned down my mind's oscillation from despair to hope, and a feeling of calmness arose. I physically experienced it at first as a warmth in my chest and face. I didn't have to figure anything out. I followed an energy moving within me. It was warm and intelligent. While changing the context in which I was holding the *feeling* itself, I followed this energy, which was like a warm wind inside me. I did not need to have a cognitive understanding of what the feeling was about. It was all understood on an intuitive level.

I did not "check out," and I became fully and intensely present. Shifting from a negative to a positive way of relating to the circumstances, I floated through my own personal history, a door that revealed experiences of integration that had occurred in my past. I saw immediately how some negative experiences had positive outcomes. Everyone has had integrating experiences. We can all remember a time when something we experienced seemed bad or wrong but somehow eventually wound up being all right or even beneficial and pleasurable. Many experiences of growing up or coming into adulthood, taking responsibility for one's actions, and taking charge of one's life, are like this. Contexts in such situations change for us and afford us a better perspective. Happiness and power result from appreciating the good to be found and capitalizing on it for our benefit and the benefit of others: the *deep* working in absolute harmony with the *deeper*. This is how and why I came to believe that there are no natural healers in the same sense that we do not say that a physicist is a natural energizer because he deals with energy. I saw that the individual does not do the healing, but if one did not meditate or treat, the healing might not be accomplished. In this sense the individual is a practitioner, one who uses the healing power of love, creativity, and mind.

This also involves an instinctive knowledge that we are spiritual entities right now. We are not evolving into one; we are not going to become something that we are not already. In this inner dialogue we experience self with God. There is no separation. There is great simplicity in this, as when you have really connected with a painting, a poem, or any piece of work well done. Or like those times when two lovers experience each other as one. There is that familiar excitement and joy, but it is also internal and quiet, a timeless hug with the infinite. A principle of mind and creativity in action is that thought directs action, therefore any thought in a spiritual healing action will have only as much power as we recognize that it has. I experienced this as absolutely true. Anybody can stand in front of a paralyzed man and say, "Get up and walk!" The words are simple, but would we not be surprised if he got up? So what must be added to the words is a mental-emotional marriage, a merging and identification that provides the flow of creative power. There must be an unwavering conviction that the thought and words are effective. At the very center of this is the direct

realization of the divine inherent within us, a pure will with a directive whose source is spiritually whole and powerful.

In retrospect, I see that this connection to a power of healing is also a learned emotional skill of reducing resistance to life and increasing power through entering the realm of faith. I would define power in this situation as the skill of using available resources to create results, all of which are supported on the ground of faith. Faith in this case does not mean wishing or wishful thinking. Faith is knowledge by means of fervent sentiment. This awareness can become stronger in critical moments or traumatic events and otherwise escapes us completely in our day-to-day lives.

Although the doctors, nurses, and my relatives all agreed that I probably wouldn't move or paint again, I had to question, is that really going to be true, and should I believe that because they do? I saw that we do have control over the *effect* that our past and present have on us. We have control over the context in which we hold everything, past, present, and future. *Context* is what determines the effect the *content* of an experience has on you. We probably cannot change the content of our situations, but we can surely change the context in which we hold it and work with it. Your happiness, your creativity, and your ability to serve are all functions of context, not content. The shift in awareness, whether in crisis or in dealing with everyday phenomena, can reward one in becoming whole again.

THE CREATIVE WORKER AND SHAMAN

Traditional shamans, as a rule, are unusually strong and healthy in body and mind. They also possess an admirable self-control and strength of will and character and are extremely intelligent individuals. Their intellectual powers often are far beyond those of the people with whom they dwell. These traditional shamans, these guardians, are the transmitters of a secret knowledge and of the heroic traditions of their people. I am speaking of shamans who dwell in a preindustrial world, and interestingly, these particular beings are always masters of poetic vocabularies going way beyond those of their fellow tribesmen and even exceed the average educated individual in literate societies. An outstanding example of this can be found in Siberia, in the Yakut shaman, whose poetic language has been documented as having no fewer than twelve thousand words, as compared to the four thousand in the ordinary language of their community. Other investigations of traditional shamans relative to their communities show this phenomenon to be quite common. John Muir discovered this when he traveled around southeast Alaska in the late 1800s, and Peter Furs documented the same phenomenon in Siberia.

In almost all the arts the call of the shaman beckons those artists who have ventured into virgin territory. They attempt to break free of rational encasement, the obsession and blindness of a material progress, and instead turn toward the echoes of ancient-future sounds and sights of the marvelous. In my opinion, twentieth-century art is remarkable chiefly for what it reveals about the loss of meaning and spirituality in the modern world. The business of the art world has worked hard to keep spirit out of the marketplace and

has done a fine job. However, there has been and continues to be an art imbued with the ancient spirit of shamanism which throbs in the veins of many artists, and will not "go away." These artists answer to the call of the soul, to a deep spiritual longing that is a transformation in consciousness. They bring to light the vital links between the innovative and often provocative world of twentieth-century art and the dreams and visions of the shamans of old. The post-Romantic pursuit of the shamanic power certainly is still accessible in language — through poetry and prose. The developments in twentieth-century literature and theater are evidence, and a number of works — from the novels of D. H. Lawrence, Dostoyevski, and Hermann Hesse to the works of Joanna Macy, Gary Snyder, and Ezra Pound — attest to this. Another example is Jean Arp, whose poetry was a force equal to that of his painting and sculpture. We find the artist-shaman in most all the media. The jazz musicians have long been and continue to be some of the greatest shamans of the twentieth century. John Coltrane, Albert Eiler — the raw impact that their music had and still has cannot be denied, and many more transcend the realm of musical cliché. Singers put us in touch with the music of the spirit that I define as the shape and sound of the invisible. Like my own lineage in painting that I have described, so it is with writers, with musicians, and in the other arts. These creative mystics deal with the themes of the hero/heroine, the wound, healing, and the wounded healer.

One will find the mystic lineage if one looks for it. Following the line of Bach, Mozart, and Bartting that I have described, so it is with musicians, with writers, and in the other arts. These creative mystics deal with the themes of the hero/heroine, theration and ecstasy. In the film industry we find Kurasowa, Bergman, and Tarkovsky, and time will tell if Lucas and Spielberg will stay true to the mystic blood that has thus far pulsated in their veins. In sculpture, the grandfather of all western "solid" shaman-artists is Michelangelo. In this century we can still see the sculptor's activity radiate in Rodin, Henry Moore, Barbara Hepworth, and Noguchi. In other schools and movements in painting we can find trace elements of shamanic energy. In the school of Surrealism we see rather a mixed bag of the artist as shaman and beauty hunter. The unhealthy aspects of the Surrealist movement were an overdependence on Freud and a kind of marriage to an idealistic Marxism. Some exceptions to this agenda are embodied in the works of male artists Max Ernst, René Magritte, and Paul Delvaux and female artists Hilma af Klint, Leanora Carrington, and Romedios Varo. In fact, these women are esoteric jewels expressing the shamanic nature of spirit in matter. In particular, Romedios Varo's work is stunning, inviting us into the lunar realms of the feminine, where reside night-time inventions of song and elegant machinery, delicate intricacies of invention operated by sensitive and smooth-faced women made of moonbeam flesh. These paintings emerge into our surface world, born of the unconscious wonder of autumn's brown leaves. Visions, precious illuminations, rise up through the decaying, leafy blanket of deep, dark, moist soil. Transposed, I look at Varo's work through the leaves of my own childhood, buried and comforted in the scent of smoky memories. A mystery glows softly; her paintings are not frightening, they are risky but welcoming, as in her *Capillary Movement*.

They are intellectual, calculated, and yet full of heart and moon deep. She has the soul of a shaman.

In today's world, the call and beacon of the shaman's way is as necessary as it was twenty thousand years ago, for the shaman and transpersonal artist helps one to develop one's sense of the miracle of life rather than acquiescing to the obsessive nature of the masses to escape the reflection of life, its ultimate dimensions, and death. The great Transformative artists, like shamans, have been through life-threatening initiations or actual near-death experiences. Death is a very wise advisor, and we drop a great deal of pettiness in life when we catch a glimpse of it. When we have a brush with it, we aren't likely to become morbid or depressed by knowing our death is near, or waiting. On the contrary, we become energized, fearless, full of life and creative power. The desire of the creative worker to become an agent of transformation manifests itself in the beginning in the shaman-like symptom of homesickness. That is, homesickness as a kind of debilitating condition that leads to a healthier transpersonal nostalgia can turn the psyche in upon itself. In a sense we miss ourselves, we long to experience our true nature, which is our true home. For a time, our only guide is this feeling of homesickness. Homesickness is the impulse that brings us back to the center of our internal mansion, our inner temple, our very essential nature in which the inner teacher resides, and it also returns us to the material present. Creative shamans take people from death to life, from life to death. They ritualistically bridge the cycles of life.

Picasso, in many ways, has been overrated, overplayed, but despite his complex nature and brutality, he was also a great magician of the arts, a great shaman capable of transforming the familiar world of appearances with the merest flick of a pencil or brush. When we look at Picasso, we should not ignore his bullish nature, his terrible abuse of women, his domination and damnation; we must also see Picasso as the twentieth-century artist exploring a fresh means of expression in numerous media. He worked to find an artistic language worthy of his monumental and metamorphosing energy, rather than the surface delights of nature, and his acute sensitivity to danger. His growing belief was that the function of art was to give spirits a form in order to build up the psychic strengths needed to survive and develop in life. He once said to François Gilot, "There should be darkness everywhere in the painter's studio except on the canvas so the painter may become hypnotized by his own work." For Picasso it was essential that the painter stay as close as possible to his own inner world, to escape the limitations that reason would always try to impose on him: to paint as though in a trance.

For me, another great shaman-artist was Paul Klee, who I believe had the soul of a true seer. I admire how Klee cut away the superficial dross of everyday existence and was able to use the simplest of lines to create a desertlike terrain devoid of superfluous and extraneous materials. His work embodied a timeless, poetic import from another realm. The wild man, the shaman in Klee, had the courage and the imagination to find the journey home. This destination is expressed in paintings presenting a childlike realm that Klee dwelled in, the home he had returned to. On Paul Klee's tomb, in his own words

reads, "In this world I am not understood. So I am better with the dead or with those unborn. Closer than usual to the center of creation. But not yet close enough."

The Swedish poet August Strindberg and the Norwegian painter Edvard Munch both reveal the alchemy of transformation, of individualism developing into individuation through great suffering and pain, by moving through the wound of the shaman. Their paths crossed several times, particularly in the 1890s, and Munch did a striking portrait of Strindberg in 1896, a lithograph in black and white. Strindberg saw his personal mission as "to bring back to life an inanimate nature," a nature which had died "in the hands of the scientists." Strindberg had been aware of the theosophical pursuit of an esoteric synthesis of eastern and western mystical traditions. Both Munch and Strindberg, painter and poet, knew something of the Upanishads and Buddhism. They identified with those aspects of these traditions that wrestled with the feeling that life here on earth is literally an ordeal of suffering.

Both artists saw art as a means of getting in touch with primordial and metaphysical forces, powers that might give back to art something of its ancient shamanic power. Strindberg's magical literary work, the three-part *To Damascus* (1898–1901), cuts through a dramatic veil to reveal the alchemy and arduous task of individualism's developing into individuation. Strindberg also painted on occasion, and at least one of his paintings, *The Lonely Poisonous Mushroom*, 1893, more than suggests the naturalist-occultist's attraction to hallucinogenic plants. In addition, for both of these artists, their beliefs were reinforced by the writings of the Swedish scientist and mystic Emanuel Swedenborg. Munch and Strindberg used their artistic energies and expressions to address the condition of what traditional shamans often diagnosed in individuals as the condition of *soul loss*, which seems very common in the modern world.

Few painters have contributed against soul loss as much as Edvard Munch. As a painter, Munch's work is probably some of the most moving examples in modern art exemplifying the suffering that the great individual may have to go through in order to exhibit to humanity a deeper sense of itself. In Jungian terms, Munch's life was indeed an extended struggle to achieve individuation.

That anguish-racked face had to be painted the way I saw it then against the green walls of the hospital. And the inquiring, suffering eyes of the child I had to paint just as I saw them staring out of the tiny, pallid yellow body as white as the white sheet on which it lay. I had to ignore a lot of other things such as the effect of truth to light, which is relative. Large areas of the picture were like a poster — wide expanses of nothingness. But I hoped to make the best parts, the ones meant to convey the picture's message of pain, something even more sublime.
— Edvard Munch[3]

Munch's sensitivity and deep human expression is a result of his mettle forged in a fire of solitude and suffering. His cosmic sense of self grew from a painful honesty with which he faced the contradictions and complexities of his psyche. From painting to

painting, Munch's urge to return home, to integrate the light and shadow of his own soul, is distinctly demonstrated. The Nordic summer twilight in the hands of Munch becomes a hallucinatory archetypal dimension far beyond the imaginative scope of mental invention. Munch's life, a series of tragic events, cuts, and wounds, shaped the shaman power within him. His tremendous inner strength and openness to the fullness of every experience, whether in the realm of the senses or in archetypal dimensions and transpersonal realms, led him with open eyes to create a healing imagery for himself and others. For Munch, everything was alive with a scintillating tantric sexual power that was human and divine, animistic and transcendental. His diary reveals an ecstatic vision: "A drop of blood is a whole world, with a sun at its center and planets — and stars — and the sea is a drop of blood, a tiny part of a body — God is within us and we are within God — primitive and original light is everywhere, shining out wherever life is found — and everything is movement and light — Crystals are born and grow like a child in the mother's womb — and the flame of life burns even in the hardest stone ..."

The creative wound, the spiritual wound, will probably involve, at times, the feelings of homelessness that I discussed. For the creative worker to cope with this state of homelessness he must call on such reserves of strength that mobilize and martial together all his creative and formal resources. Both art and humor reconcile homelessness. Creative art and humor can move us through pain and heal us. Both the artist and humorist are, in a real sense, contemporary versions of the shaman, as they possess the capacity to simultaneously feel part of and separate from events and also deliver a force that is healing to others.

My brother David uses humor like a stand-up shaman. As the head social worker at the University Medical Center in Tucson, his humor heals others in his daily contact with patients. The laughter he inspires brings the fragmented views, grief, and fears in others into an integrated form of understanding. Laughter leads to a healing and settlement in the soul. Incisive humor can also cut through confusion, offering an instant clarity. Like art, laughter and humor can inspire insight and transformation and allow us to look at situations and ourselves from the state of the witness. Whether David is leading humor workshops for professionals, consoling a family whose teenage son was just shot in the face in a drive-by shooting, organizing two hundred hospital volunteers, doing a stand-up routine at a local night club, or coping with his own debilitating and advanced arthritic condition, his artful skill as a humorist has a considerable healing power.

At the height of laughter the universe is flung into a kaleidoscope of new possibilities. High comedy, and the laughter that ensues, is an evolutionary event. Together they evoke a biological response that drives the organism to higher levels of organization and integration. Laughter is the loaded latency given us by nature as part of our native equipment to break up the stalemates of our lives and urge us on to deeper and more complex forms of knowing.
— Jean Houston[4]

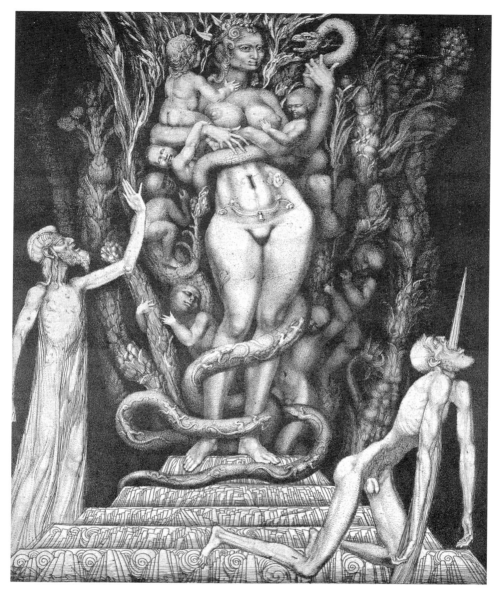

Fig. 41 Ernst Fuchs, *Queen Esther and Dead Haman*, c. 1965–69, etching, as it appeared in *Avant-Garde* magazine, November 1969, p. 19

The humorist and artist are active descendants of the court jester, the fool, in which the functions of wit, wisdom, witnessing, and wonder come together to offer the unexpected gift. The fool can risk speaking the truth in front of the most powerful and will not lose his head. Today, the artist also has the capacity to bring about the unknown, the unexpected. This is usually accomplished by artists working in modes very far from the trends that dominate the international art market. Surely one of the greatest mistakes in the business of

art is its insensitivity to and dismissal of the visual artist's role as shaman and visionary, for these artists are connected to a language of light; it can be what the painter hears that becomes visual poetry, and what the poet sees that becomes spoken paintings.

LIGHTHOUSES

Vincent van Gogh wrote his brother Theo many letters. Some of these letters, written before he began to paint, described a sense of imprisonment, an inability to find an expression that would satisfy him. Van Gogh's letters described a feeling of being caged. Like all creatures of fire, of passion, he felt instinctively: I am good for something, I have come here for a reason, for a mission. How can I serve? Van Gogh's uncertainty as to what he might be or do is typical. The creator, whether artist, scientist, or thinker, creates the structure of his psychic life through the means of his works. Van Gogh struggled to find his "true" work, until the work found him. As Carl Jung remarked:

The work in process becomes the poet's fate and determines his psychic development. It is not Goethe who creates Faust, but Faust who creates Goethe.[5]

This insight of Jung's proved to be a living example for me in my own artwork as I followed the unfolding of consciousness through the evolution of my paintings that emerged. In a subtle reward, it is as the work is done that the meaning of the creative effort appears. Recently Ken Wilber invited me over to celebrate the completion of yet another of his marvelous books. This "grand weaver" of humanity's best efforts is one very prolific man. (I believe it was his fourth book in a year.) Sharing some wine I mentioned this insight of Jung's. In my own words I suggested to Ken that "when one creates something beyond one's immediate comprehension, then that certain something eventually becomes the actual form one was growing toward." Ken, very excited, leaping out of his chair with the grace of a panther, said in an energetic voice, "Stay right there, don't move! I recently wrote something that also says the same thing." Ken returned, very inspired about the synergy of these perceptions, and read from a yellow piece of paper he had written on: "The purpose of truly transcendental art is to express something you are not yet, but that you can become." I believe Ken had written that as part of a letter to our friend, Alex Grey. These mutual insights can be applied to everyone, as we have no future except for what we envision, and what we envision will draw us toward itself. Our soul seeds the future with lighthouses of vision that serve as beacons to our self, beckoning and guiding us out of our own darkness, by means of our very own house of light.

This intuitive force Ken and I discussed can arise within each one of us, its expression guiding us, pulling us toward revelatory states that have a life of their own. As creativity within an individual evolves, it becomes increasingly more automatic, spontaneous, and joyful.

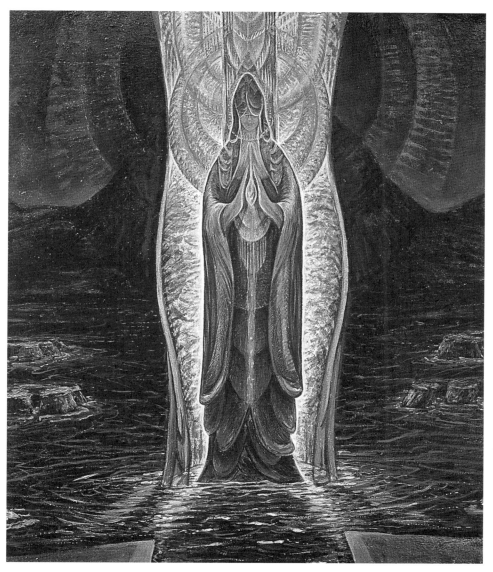

FIG. 42 Sandra Reamer, *Universal Mother*, 1981, (detail), egg tempera and oil on canvas, 30 x 24 in. Private collection

MA

Today in the West there is a great movement and much talk of the return of the goddess, the mother, the feminine. What I have seen, what I have felt, is that this presence never really left and was always right here with us. While in India I spent a good deal of time in a determined state to be totally present, but I also devoted energy to reviewing my life, and, as part of that, my relationship with the feminine. I understand the creative energy to be a

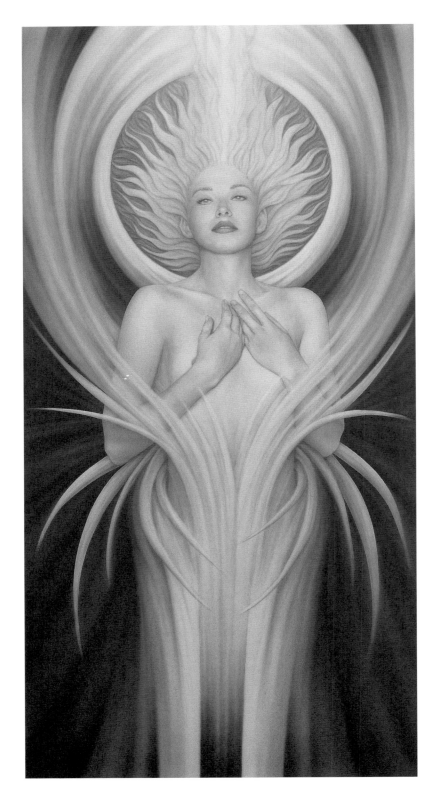

FIG. 43
A. Andrew
Gonzalez,
*The Breath
of Dakini*,
1998, acrylic,
48 x 24 in.

feminine force: *Chiti* or *Chitshakti*.[6] I believe my joy in the company of women is born of the kinship that arises and resonates with my own creative energy and forces. The creative forces in me resonate, radiate, and become inspired when with certain women and men who have a highly developed creative power. The goddess power radiates through some of the women and also men I have been graced to know, inspiring and stirring the creative forces in me. My creative power expands with such contact that my awareness and sensitivity becomes even more vulnerable and alive, passionate and expressive. The great men in my life, masters of body, mind, spirit, and an artful courage, opened my eyes, helping me to see forever. Women, beautiful souls, showed me a mystery, the essence of love, and the understanding that the most beautiful things cannot be seen or touched — they must be felt with the heart.

Although I speak of the goddess as "she," I am not at all implying that the goddess aspect is an actual female being. This is as absurd as the western notion that God is male. Formless consciousness is as genderless as it is bodiless and thoughtless. Yet from ages immemorial the great masters have observed that that which is the creative power of the universe behaves like a mother and manifests worlds out of its own womb-like essence. It fosters life. It creates. The Indian sages refer to this action of "actionless being" in one of the most beautiful, primal, and maternal of Sanskrit words, *Ma*. Defining God as beauty supersedes definitions of the divine as either purely masculine without feminine traits or as a goddess stripped of any masculine attributes. Yet these two definitions are mistakenly and categorically encouraged by various factions. Both perspectives are imbalanced and rather silly, fear-based, and sometimes held out of a defensive energy. God is spirit. God has no gender traits any more than clouds have sex organs.

Raising up the lingam (phallus) and yoni (vulva) as a renewed-ancient idol, seeking God through the sacred path of the divine rod or jade gate, worshiping a universal vagina or cosmic penis, is, again, limiting God to a category and consequently restricts one's self and one's own potential connection to the ultimate. Although men have put the goddess into a historical closet and for many centuries have restricted and persecuted women, and have been brutal (of which I am very sad, regretful, and affected by), I am not a historical figure, I am not those men. I am here now among many other good men, and I realize the goddess through the women in my life. I resonate to the feminine birthing rhythm, women's contemporary issues, all hearts, the one heart, equally alongside the masculine power I honor within me and in all men. In the recent past there has been a tendency to emphasize the qualities and differences between male and female. I believe that it is time for men and women to come together in a manner of spiritual healing. It is also time that men and women enter into creative endeavors together, for creative collaboration inspires love and love inspires healing.

Many mystical religions see the ultimate power as bisexual ("God created man in his own image … male and female created he them." Genesis I, 27); it is explicitly stated in the *Corpus Hermeticum*. In Chinese Taoism and in Indian Tantrism the ultimate is often portrayed as a pair of lovers, and all over the world bisexual gods of fertility are found. In many Gnostic

theosophies, human perfection (gender, sexuality, and creative forms) is described as an unbroken unity. In *The Gospel According to Thomas*, Jesus says, "When you make the two become one, you will become the Son of Man, and if you say, 'Mountain, remove yourself,' it will remove itself." In the second *Letter* of Clement, the Kingdom will come, according to Jesus, "when the two shall be one, the outside like the inside, the male with the female neither male nor female." Certainly many of us have pondered that all love of man for woman and woman for man is really a mystical yearning for the lost part of ourselves, the wholeness of divine wisdom.

Enlightenment transcends gender, but our spiritual path will take different turns and unfold in different ways depending on whether we come into life in a male or female form. Although our soul is not flesh, it is colored by all of our experiences, and the vehicle of those experiences is our body. Our body colors the soul's experience like a green forest colors the shadows of an orange placed in the middle of it. The fruit, although orange in color, takes on green tones in the shadows. In the same way, inhabiting a female or male body will give to our soul a particular tone, a variation in tint, even the experience of a different color. When our spirit has experienced all the colors of the spectrum, through all forms, we attain the total of the pure, white light of enlightenment. Although men and women will experience awakening from the "grand play" in the undifferentiated enlightened state, their dreams will be different. They will have traveled different paths. Along the way, we will probably "dress up" in bodies male and female and perhaps even other marvelous forms; after all, what fun is it going to the dreamy grand masquerade ball in the same costume, life after life?

In expressing the feminine creative power, I often come back to painting the female form. I have the experience, in looking at my model, of understanding something personally and cosmically. I identify with her enigma and appreciate the energetic differences that magnetically polarize us yet come together in the painting, evoking the feminine as God the beautiful. As an adolescent, in my art, feminine forms emerged from the unconscious, despite my identification with masculine values at the expense of feminine ones, which seemed weak to me. Nonetheless, the feminine broke through my dreams with enormous power as a goddess, huntress, great mother, warrior, enchantress, priestess, or Wicca. My artwork led me from a limited view of genders, a rather narrow perception, and into the broad vistas. Initial paintings in my adolescence sometimes depicted a male lion with a humanlike face and a ruby-studded third eye, gazing at a beautiful and wild woman from afar, observing her, mystified by her presence.

Like the rains in spring, the feminine began to wash away my encrusted skin of armor. The more I explored masculine and feminine energies within me, the more I understood multiplicity of being. As it was, the messages in the paintings I did as an adolescent involving the female form were not immediately clear. In my case, it was never the artist creating the paintings but the paintings creating the artist. I was led through the dark, initiated with light, and passed through a labyrinth of half-forgotten lives, places, faces, and feelings. Accepting these images, even without fully understanding, then freeing them to the canvas's surface

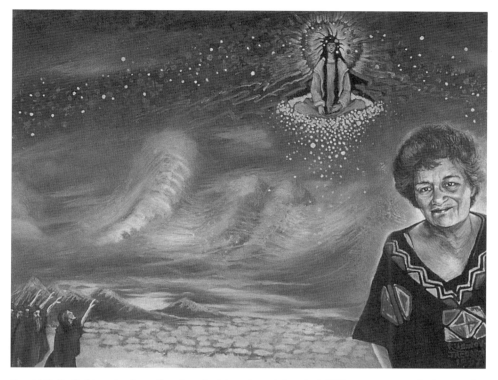

FIG. 44 Philip Rubinov-Jacobson, *Rose (portrait of the author-artist's mother)*, 1997, egg tempera and oil on panel, 14 x 22 in. Collection of Rose Jacobson

and locking them in paint unveiled their secrets. My dreams became a fiery, hallucinogenic place. A giant, naked, cerulean blue goddess emerged from the dark sea at the banks of a great city. In the slowest sensual motion, her gigantic form arose from the black waters. Her beautiful wet body moved before me, leaving me breathless. She represented vulnerability, *Chitshakti*, and an all-encompassing creative power and love within me — indeed, within everyone. Her compassion radiated through me, through all of us. This gigantic part of my soul that emerged from the waters of my adolescent unconscious demanded my attention.

When close to a woman experiencing fear or pain of any kind, I learned to go even deeper. I absorbed their fear at the deepest levels in me and comforted them. Fear of physical pain was nearly absent in me, and the empathetic sensation I felt around a woman experiencing physical, emotional, or spiritual pain, illness, or injury evoked enormous sympathy in me. These situations generated such intense curiosity and absolute attention in me that I became arrested and absorbed (not frozen — actually more attentive and caring) by the foreignness of the experience.

As mentioned, as a boy, I had an uncanny ability to absorb, ignore, even shut off any physical pain. Many fathers have taught their sons this "be a man" numbness, as have their fathers before them, each through subtle suggestion, unspoken behavior, body language. Times are changing now. But in any event, I did not experience much fear around

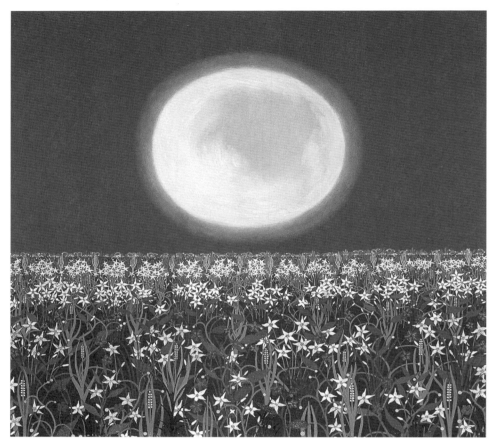

Fig. 45 Eva Fuchs, *Spring Meadow*, 1977, oil on canvas, 26 x 28 in.

physical injury. I had an absolute confidence in my agility and physical power. Although a kind of battling samurai skill seemed to resurface from some ancient past, it was accompanied by a kind of ignorance, a rejection of sensation, a rejection of a source of wisdom. This intrinsic experience is reinforced by a culture that frowns on, disdains, and even discourages vulnerability and sensitivity in males and expects them to submit and surrender their lives by the age of eighteen to an at-ready military. Every boy goes through a quiet wounding deep in his soul when he discovers that his life is not really his own, that it belongs to the government; that he is a mere organic weapon in nationalistic defense or aggression for his country, right or wrong, to protect in margins, boundaries, the imaginary lines imposed on people.

Pain, illness, and injury provide opportunities for a shift in awareness, yielding wisdom, compassion, and sympathy for others. They offer us an experiential knowledge that otherwise we may have lost or ignored. Feeling pain and moving through it in the body allows us to awaken in clarity instead of adopting a mental-emotional denial or numbing ourselves with painkillers. Focusing, contemplating, and moving through the pain, having

the experience rather than running from it, is often a better path than avoidance and pain relief, for it can be a spiritual opportunity for transformation, one of the many teachings *Ma* and all the mamas had given me.

DRINKING LIGHTNING

My journey to India further crystallized for me the Great Mother, the goddess. While in India I met two wandering female "nameless" saints who offered further teachings and helped me develop my ability to discern the presence of a true saint. The saint understands that the devotees bowing before her or him are, in fact, offering homage to the cosmic matrix. Over the past few decades, we in the West have had the pathetic experience of spiritual teachers who have appropriated that reverence for themselves. In India, it is more difficult for egotistical speakers to pass themselves off as gurus or saints. With thousands of years of experience, Indians can tell when it is the divine radiance shining through a human face or the clever, shape-shifting act of limited ego desire.

With all our worldly wisdom and sophistication in the West, many of us do not have the ability to distinguish a saint from a con man. It seems to me that many Westerners have lost contact with the divine. When Westerners accepted that God embodied himself on earth only once rather than continuously in every age and in every culture, when we agreed that we are basically sinful rather than essentially divine, when we handed the key of heaven to a priesthood that seems to have lost it, we gave away our spiritual authority. We locked ourselves out of our own divine birthright. So when any snake charmer or charlatan comes along to tell us he or she can give us the key back, unlocking and freeing us, we run to their feet. To look into the face of God we need to look no further than the person sitting next to us, male or female, or directly in the mirror or at anything around us or in us.

The saints I have read about and the few I have had the privilege of meeting did not tell people what to believe but showed others how to love. They did not prescribe certain texts and forbid the reading of others. They did not forbid one to see family or friends. They did not tell others where, when, how, or who to make love to. They did not ask for money or for people to turn over their businesses or homes or any other earthly goods to them. They did not insist that their way of knowledge has exclusive claim on the divine while everyone else is eternally condemned. They gently suggested that a divine light radiates in every heart, and that we have only to remove the veils covering that illumination. It's as though they drank lightning and electrified the world around them, just being who they are.

Both the female and male teachers I met in India seemed egoless but not colorless; they were a spectrum of many hues, a coat of many colors in divine refraction. They had distinctive personalities and great personal strength. Yet the "real" thing about them was not their personalities but the wisdom and love emanating from them. The true teacher inspires and instructs us on the need to invest in our inner witness: the watcher within us who never sleeps. Ken Wilber writes from this witness state, the state of watchful restfulness, the searchless eye observing the searcher:

When I rest as the timeless Witness, the great Search is undone. The Great Search is the enemy of the ever-present Spirit, a brutal lie in the face of a gentle infinity. The Great Search is the search for an ultimate experience, a fabulous vision, a paradise of pleasure, an unendingly good time, a powerful insight — a search for God, a search for Goddess, a search for Spirit — but Spirit is not an object. Spirit cannot be grasped or reached or sought or seen; it is the ever-present Seer. To search for the Seer is to miss the point. To search forever is to miss the point forever. How could you possibly search for that which is right now aware of this page? YOU ARE THAT! You cannot go out looking for that which is the Looker.

When I am not an object, I am God. When I seek an object, I cease to be God, and that catastrophe can never be corrected by more searching for more objects.

Rather, I can only rest as the Witness, which is already free of objects, free of time, and free of searching. When I am not an object, I am Spirit. When I rest as the free and formless Witness, I am with God right now, in this timeless and endless moment. I taste infinity and am drenched with fullness, precisely because I no longer seek, but simply rest as what I am.

Before Abraham was, I am. Before the Big Bang was, I am. After the universe dissolves, I am. In all things great and small, I am. And yet I can never be heard, felt, known, or seen; I AM is the ever-present Seer.

He adds:

Every time I recognize or acknowledge the ever-present Witness, I have broken the Great Search and undone the separate-self. And that is the ultimate, secret, non-dual practice, the practice of no-practice, the practice of simple acknowledgement, the practice of remembrance and recognition, founded timelessly and eternally on the fact that there is only Spirit, a Spirit that is not hard to find but impossible to avoid.[7]

When I began painting the stuff of my dreams thirty years ago, I also began to see the myths I was living. The paintings served as amulets, talismans that I wore on my third eye and over my heart to cut through the stories of my life, the scripts I had unconsciously written and acted out. We all have this story, this epic poem, and it may take a great deal of time to see its source, truth, and origin. Yet I also saw that each of our stories is sacred, as it can lead us to the truth, to self-realization. If we move too quickly to understand, we can become lost in the "mad theater." When we try to go faster than God, we create chaos for others and ourselves. Eventually, we learn not to rush or push, that this is precious practice, our life unfolding. We need to notice and enjoy the process even through difficult times. See the images, hear the words, feel all of our feelings, know our mind, be in our body, understand, and move on. Do all that is necessary to take care of ourselves and help others as we engage in the great work.

I have spoken of the creative mystic and the dark night, the abyss, and the illumination, and now we turn to ecstasy. We can describe this divine or transpersonal state of ecstasy as a temporary mental alienation, associated with a feeling of timelessness. Ecstasy comes from

a Greek word meaning "displacement" or "standing apart." The experience, though it may linger, is transient and infrequent (except to some rare saints or seers). It has been described by artists, poets, and philosophers in terms of sudden light (though sometimes the distinction between light and dark disappears). It has been likened to the sensation of elevation of the heart like a rising stream or ocean within, or a heightened inner consciousness, or an increased intensity of the senses, or stillness and peace. There is a sense of release, freedom from self and sorrow and desire, knowledge of a totally new kind, identification with the universe or with all living things or with God, a sense of timelessness or eternity, of glory, of joy and happiness and utter satisfaction. Ecstasy is also, of course, spoken of as indescribable or ineffable.

There can be a healing power that arises out of the ecstasy, which prepares the creative worker to become whole enough, brave enough to witness pillars of fire and listen to the gentle and "still, small voice" within. Thus we become ever more inspired, and we enter more deeply into the dazzling spirit of creative fire, the spirit of life. I think it is important to remember that all experiences, small ones or larger ones, can lead us to a greater oneness but only when we are not hung up, stuck, and overly identified with the event itself. Visions, states of ecstasy, and other phenomena associated with altered states are wonderful only because they serve to chart or inspire a spiritual course and give us direct awareness, a direct experience of divine love and wisdom that can never be forgotten, dissolving our feelings of separateness from all things.

I experience wisdom as the marriage between the feeling and knowing within us becoming "no thing" or as an emanation of the divine that serves as a bridge between God and self, between uncreated and created. When spirit marries all of our splintered parts together, then even "feeling" and "knowing" disappear as we return from ecstasy — wisdom is bestowed. A kind of insight pours into the vessel of our being and drinks its enlightening flash of wisdom; we can ground it and be fruitful. For me, wisdom is best defined by one of my boyhood heroes, King Solomon, and portrayed in a poetic and feminine form in *The Wisdom of Solomon* (7, 25-8, I):

Like a fine mist she rises from the power of God, a pure effluence from the glory of the Almighty.

… She is the reflection of everlasting light, the flawless mirror of the active power of God and the image of goodness. She is but one, yet can do everything; herself unchanging, she makes all things new; age after age she enters into holy souls, and makes them God's friends and prophets. She is more radiant than the sun, and surpasses every constellation; compared with the light of day, she is found to excel; for day gives place to night, but against wisdom no evil can prevail. She spans the world in power from end to end, and orders all things benignly.

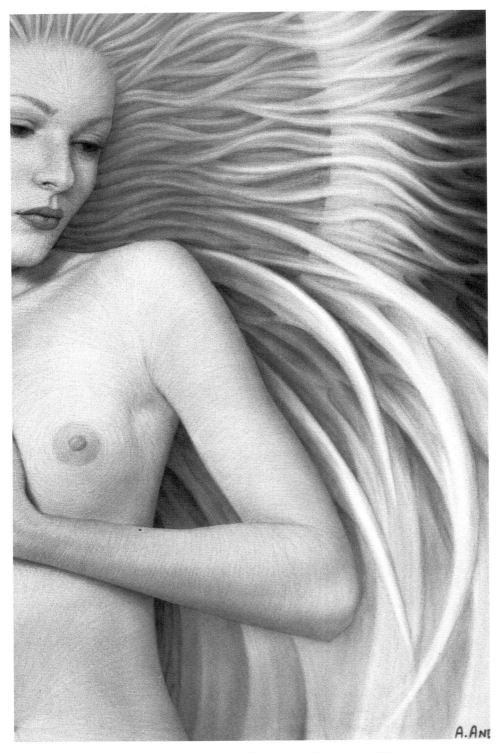

FIG. 45A A. Andrew Gonzalez, *Aura Gloriae*, 1997, (detail), acrylic and air brush, 16 x 20 in.

Chapter 8

The Muse — A Kiss of Creativity and Transformation

"Would you tell me, please, which way I ought to go from here?"
"That depends on, a good deal, where you want to get to," said the Cat.
"I don't much care where — " said Alice.
"Then it doesn't matter which way you go," said the Cat.
" — so long as I get somewhere," Alice added as an explanation.
"Oh, you're sure to do that," said the Cat, "if you only walk long enough."
— Alice's Adventures in Wonderland *by Lewis Carroll*[1]

ALICE

I can identify with Alice and her childlike confusion, the confusion of pure hope. I think of another scene: a condemned prisoner's despair on entering a death chamber. The prisoner's desperation is an anxiety-ridden anticipation of entering nothingness. They are different responses to a similar situation. Alice and the prisoner both find themselves enveloped by some mystifying process that seems to have nothing to do with their own wills. In such a situation, if you regard the process as relatively benign, not identifying with the twists and turns, you ask directions from within and become more alive; if you regard it as less hopeful, you become resigned to a more apocalyptic view, and your courage to create is impaired, weakened, condemned to death. In identifying with Alice, we are rewarded and learn to become more comfortable and even rest with the uncertainty of things, which is, perhaps, our greatest creative challenge. Uncertainty can also be an unexpected joy, a source of inspiration and creativity. We are elated when our work springs forth with a force and life of its own. The dancer Mary Wigman said:

In working out a dance I do not follow the models of any other art, nor have I evolved a general routine for my own. Each dance is unique and free, a separate organism whose form is self-determined.[2]

There are many times when something is new or unknown to us, and we can respond with fear or we can look within. Alice, in another part of her adventure, was confronted by a caterpillar who sat upon a mushroom smoking opium or the like. The caterpillar tried to fit Alice into its dream world, and in so doing, Alice, uneasy, questioned her own identity; that is, what she identified her "self" with. If we come to our own aid, we learn to free ourselves of our false identifications, and our fears begin to dissolve. Many fears have some *commonsense* value beneath them and act as a built-in mechanism to alert us to true danger, but often fear is merely an activity of the mind, a cerebral illusion that produces vibratory

convulsions, waves of various intensities that are dissolved by meeting them with the qualities of the heart. Fear arises when we face the unknown and is often created by memories of hurt and pain. We are even capable of being scared to death. To develop the courage of a lion we need to be able to discern between the need for true protection and when we are just amplifying an illusion out of proportion. Fear is an unpleasant, often strong emotion caused by anticipation or awareness of danger and the false identification and belief that we are simply, and only, our physical body (thus death is our ending, our utter annihilation).

Courage can come from a mental, moral, or spiritual strength to venture into, persevere through, and withstand danger, difficulty, and tremendous hardship. That does not mean martyrdom, or what I call "victim technology." A martial artist's best defense is his openness, his flow, awareness, and embrace of everything around him. To be vulnerable is to be open to attack or damage, to whatever happens, to be able to see everything around you and in you. That may sound foolish or scary, but it is where real and true strength is born. When you can stay in your heart, not succumb to fear, you have arrived at the threshold of courage. The creative path, in essence, is a journey of courage, of having a spirit that uproots one's deepest fears, expressing them, understanding them, and allowing one to pass through them.

To fear change simply because it brings something new is to fear the world. When we are faced with change, we can react as the prisoner or as Alice. Courage becomes an essential tool for creative endeavors. You realize that the joy and pain of change is not only unavoidable but is necessary, that it is life itself, that it is you. If changes did not come into our lives or were created only by our own hands, then we would stagnate, crystallize, resemble a statue. Change is the very essence of creativity and transformation.

BEAUTY AND THE DEEP

Joining our inner life to the outer world is a challenge that rewards us with courage and spontaneity. With the growth and refinement of our emotional nature, a higher sensitivity steadily increases. Our sense of beauty becomes more acute as well as natural. Long before the mind can explain why an object is beautiful, our aesthetic sense *feels* the beauty of it. My friend Alan Sparks, who I've mentioned, is an unusually sensitive man, and recognizes that beyond attempts to analyze symmetry, balance, and the other elements that beauty may contain, language can fall short in describing the *experience* of beauty. Alan has said, "Indeed, how does one *define* beauty? *Only* in terms of *feeling*."

Aspects of truth that we cannot penetrate with our reason we may discern by way of our aesthetic sense, which is a mode of perception by feeling. Thus, where we may not unveil the full logic of truth, we may reveal the beauty of it. To see beauty is to disclose the very soul of truth. This is why I say, when discussing the education of children, that it is important for a child to see the beauty of a thing first; the truth inevitably will follow.

Beauty is truth, truth beauty — that is all
Ye know on earth, and all ye need to know.
— John Keats[3]

The sensibilities of most of us are cultivated to only a fraction of their capacity, so that we live out our lives in the myopic delusion that only the commonplace exists, occasionally rising to the rare altitudes of the extraordinary, the wonderful, the beautiful. If we open up to life, to our joy and our pain, then every instant of existence can be unique and revelatory. The commonplace is nonexistent, everything under and beyond the sun is new. The freshness of our vision fills us with an incessant delight, and we become driven by the necessity of communicating our emotion. Once our eyes open to the beautiful, the perpetual miracle of being, we will never look at things the same way again as long as we live.

To understand beauty is to have that sense of goodness which comes when the mind and heart are in communion with splendor — without any hindrance, so that one feels completely at ease, but also in awe. Beauty is everywhere. We have all observed the subdued colors resting beneath the cloak of a night sky, or the morning sun dancing on our lover's sleeping face. Such things are beautiful to behold, but still they are only superficial expressions of something much deeper. It is inward beauty that gives grace, an exquisite gentleness to outward form and movement. Where there is beauty, there is also love. One of the functions of art is to inspire a deep appreciation of beauty as an essential part of our life. When the mind is merely concerned with itself and its own activities, it is a dim reflector of the beautiful. You cannot love if you are thinking only about yourself, which does not mean that you must think about somebody else. At higher levels, love *is*, it simply has no object.

If an individual means to grow in the path of inspiration, then in addition to the *appreciation* of beauty, he or she must begin the second part of the task, which is to *create* beauty. When any unselfish emotion is tense — that is, when it has a dynamic quality in it, like a spring that is coiled — then the emotion can pour itself into some artistic vessel. The unwinding of the spring results in an act, however slight, that can give substance to something beautiful or intensely human. It may be some sequence of sounds, the beginning of a melody, or it may be in some movement in dance or some phrases that contain the root of poetry, beauty, truth, or love.

By a slow and steady interaction between the response to beauty and the creation of beauty, we find in life a new principle of operation in addition to the principles of love, goodness, or holiness: the principle of beauty. When a person's spiritual eyes have opened to God as beauty, then he or she has discovered yet another way by which to live, and that is to be in communion with everything, to be sensitive both to ugliness and to that which is beautiful.

Love is at the center of the mystery of life. Unfolding a glimpse of the supreme mystery also involves a deep movement of love toward a conviction and fusion of soul

that recognizes the *deeper* calling to us, the *deep*. As self-awareness expands, we begin to mirror that conviction and consciously fashion our lives to become the mirror of a larger life, drawing to ourselves the wisdom, compassion, and strength of that larger life. So it is with the hunt for beauty, when we seek closeness with Godhead through the creative power, as we, the "smaller deep," are moved to call upon and align to that other, "larger deep" until there is no longer a separate experience between us and every thing. The lover of the beautiful prepares himself so that he is always ready to greet the hidden beauty of the mystery.

The beauty lover begins to adore the mathematical splendor of creation, the symmetrical beauty of trees, the delicate and blended beauty of line, shape, and color in flowers, leaves, and creatures of the air, the asymmetrical space and sounds among these things — and all of this Nature provides abundantly. Then the beauty lover's washed eyes may look upon a sunrise with a greater clarity, a sunset, the moon and stars, a waterfall. The beauty of a mountain range that no words can describe is absorbed more deeply. For the first time, such beauty speaks a message to the emotions with a quality of penetration that goes beyond the mind to a spiritual intuition. Moving even deeper, we begin to experience the beauty of all creatures, of children, of the magnificent forms of man and woman. Then we experience the beauty of words, of melody, of rhythm in the dance, of mathematics, of symbols, and on to fields of formlessness and essence.

As we become more alive to beauty through the senses, the appreciation of beauty develops beyond the physical senses. The mind begins to sense beauty in another sphere; it finds beauty in ideas, in character, in planning, in playing, and in the pure act of creation. Then the beauty seeker might insist on being surrounded with beautiful things. For once human beings have sensed the deep within themselves, they may be inspired to greet the larger deep in every moment, creating a more beautiful environment that responds to a higher ideal that serves a deeper sense of home.

The beauty seekers then proceed to surround themselves with more life. They start to yearn for more life, from everything of human creation that serves their needs, from furniture to kitchen utensils, from the large and small things their hands touch and eyes see in the home, the studio, the office — they ask for beauty of line and shape and color. Even in the workshop, they admire the practical, simple beauty of tools, their essential lack of ornamentation. If they do not cultivate the path of artistic inspiration, they may wander like hungry ghosts in search of that slight aesthetic refreshment that will add the grace they need for another day; *addictos aestheticus*.

The increasing appreciation of beauty depends, secondly, on the ability or willingness to create beauty. Beauty wears many veils. To see beyond the first veil, the faculty of creation is indispensable. With each act of creating something beautiful, the appreciation of beauty increases as the psyche unveils its true nature. The creation of beauty is an ability we all possess, because beauty is an attribute of the soul. It is not necessary to create a masterpiece to bring forth what is beautiful. We can all see that a child's drawing is always genuine and beautiful.

Creative workers can then awaken to the third role. The first is to appreciate, the second to create, but the third is to *teach others* the art of creation and, if so blessed, offer the spark to the sleeping creative flame. At this stage the creative worker enters the realm of the mystic and has established a personal path of inspiration. The creative worker no longer *needs* to create beauty in his or her life, no longer depends on beautiful surroundings, as he or she has become beauty, one with its essence. At this point, certain things can be learned only by becoming a teacher, because it is in this role of greater responsibility that a different sort of subtle knowledge is revealed and can be received.

Inspiration and love descend upon the one who can abandon himself, forget himself completely and thereby bring about a state of creative beauty. Beauty obviously includes grace of form, but without inward beauty, the mere sensual appreciation of form is a superficial experience. There is inward beauty only when you feel real love for yourself, for people, and for all things, and with that love comes a tremendous sense of consideration, watchfulness, patience. You may have perfect technique as a singer, know how to put words together as a poet, know how to paint, or dance, design a plaza, but without this creative beauty inside, your talent will have little significance. Inner beauty is something that is cultivated and slowly emerges. We watch, we witness, we gradually transform.

Unfortunately, many of us are becoming mere technicians. We pass examinations and acquire this or that technique in order to earn a livelihood; but to acquire technique or develop capacity without paying attention to the inner state brings about ugliness in the world. It is important to understand that technicians are not creators. There are more and more technicians in the world — "techne-crats" — people who know what to do and how to do it, but who are not creators. These technicians in art are not seeking the sacred through art but are more likely seeking profits from generating images, the "art of icon-nomics."

In the climate of the contemporary art scene, we may ask several questions: Where is the truth in art? Where has its inspiration and spirit gone? These are times in which the artist does not need to say much but needs only to be notorious for some small originality and consequently lauded by a group of patrons and connoisseurs, which is mutually beneficial for them. They are not working from the spiritual imagination but are operating within a material cleverness. Spiritual imagination cannot create out of a selfish motive, for it is born of the subtle and matured child mind; it draws satisfaction from service to others. Transpersonal creators are involved in the comprehensible elements of the activity of God through truth, beauty, and goodness. This effort represents the human desire to discern God in mind, matter, and spirit. On the path of beauty, cosmology is waiting in the later stages of that pursuit.

Without interpreting the following as a rigid and linear formula, we could say that the aesthetic mind takes birth and proceeds through three general spiritual stages with a wide range of sub-excursions:

1. The first stage involves a curiosity of the beautiful through elements of harmony. Then this thirst weds a persistent hunger with discovering new levels of relationships and manifestations of the beautiful. This involves healing pain and cutting through fear, dogma, and narrowness of mind, and, most importantly, cultivating an initial courage both to appreciate beauty and to create.

2. The second stage is an advanced appreciation for all phenomena and manifestations, and creating new and unique forms with existing elements. This includes a movement toward embracing all levels of reality and an expression of the diversification of all forms that are not just defined by their differences but are valued by their "sameness."

3. Stage three involves an extremely heightened and directed sensitivity, for the realization of truth through the appreciation of beauty. This stage unfolds in the recognition of divine goodness in cosmological relations with all life forms leading to the direct experience of Godhead as truth, beauty, and goodness. In this stage we experience God the beautiful as our self and as everything, the One without a second.

We begin to see and feel universal beauty through the harmonious relations and rhythms of creation. This may start as a distinctly intellectual appeal and lead toward unified and synchronous comprehension of the material universe, stirring a sense of wonder within us. The experience of the "awe-inspiring" can expand to what I refer to as "shocking stillness," an eternal moment when all doubt of Godhead vanishes. Though years pass, the soul will never forget that it has been in God and God in it.

FAITH AND THE "IMAGE-NATION"

An intimation is more a felt or suspected truth than a completely established fact. Words failing us, we often call it a feeling, and we are as emotionally disposed to add our intuitive tools to the supplementation of our powers of reasoning. After all, the manifest reality of a fact depends upon the evidence of our senses and the logic of our reasoning power. The essential nature of our intelligence does not permit or encourage us readily to accept as factual anything that we cannot or have not either literally perceived or rationally confirmed or experienced "directly" through our physical senses. And yet, intuitively, we recognize that many of our ideas cannot be ruled out of all bounds of possibility simply because they have not traversed the narrow field of our senses. The mystic sometimes directly experiences the existence of myriad entities, forces, and activities far beyond the relatively infinitesimal portion of immediate perception. We all "believe" in radio waves but have never directly seen them. And some of the mightiest experiences of humankind have arisen out of our firm belief in unsubstantiated notions. This elevated category of persuasion is known as faith; it is conviction permeated by feeling, by fervent sentiment. The following verses are from the teachings of the Buddha on faith.

… Faith is the encouragement when one's way is long and wearisome, and it leads one to Enlightenment … But it is difficult to uncover and recover one's Buddha nature; it is difficult to maintain a pure mind in the constant rise and fall of greed, anger and worldly passion; yet faith enables one to do it.[4]

Faith is not knowledge; it hovers above it. It is the sister of wisdom, and she exerts an incalculable influence. The intellect, while constantly extending its empire over the intelligible matter of life, is powerless to operate in those domains of the imperceptible and imponderable that are beyond its reach. And yet this intellect is most unwilling to resign itself to these limitations. That is why we have turned to the practice of the art of aesthetics as a further attempt to join our ineffable feelings into perceptible reality. Faith, probably more than any other factor, has played the central role in my development as an artist and human being, and I am not alone in this.

When speaking of faith and the creative spirit, we must inevitably turn toward its handmaiden, namely, the imagination. Einstein emphasized that the imagination is more important than knowledge, for a number of reasons. Dream power, discovery, and invention were certainly important in his statement, but I believe he understood something even deeper than that. Many human beings believe in luck; a wise, strong, and responsible human being believes in cause and effect. Imagination is part of the law of cause and effect, of life and belief. The man who believes that luck controls his destiny is ever waiting for something good to turn up. He lies in bed hoping that the mailman will bring him news of an inheritance or that he has just won the latest sweepstakes. He is a dreamer, too, but he is different from the man of imagination who molds, shapes, and fashions his future by his attitude of mind, inventive thinking, creative action — and all this is permeated with his faith.

Whatever you accept, feel, or imagine to be true will come to pass. Indeed, our actions first have their seeds sown in the imagination, or at least we could say that all of our actions are first born in the mind. If we learn to believe in the workings of our subconscious mind, we begin to see that whatever we impress on our subconscious will be expressed subsequently in our experience.

Art is a powerful tool as a psychological device, as an instrument of manifestation, and for the transformation of consciousness. We change upon experiencing the artistic mirror of the canvas, musical score, creative theory, dance or drama, the fantastic idea, a poem, or even in athletic endeavors when the genius of the body astounds spectators through feats of physical art, grace, and accomplishment. As consciousness widens, the "drop" of ego merges with the "ocean" of the self. The small "i" unites with the capital "I." Issues begin to be perceived differently and, thus, behavior is different. If consciousness expands still further, it really does align with our own true nature and becomes something no longer able to be exclusively identified with ego. This is usually expressed by creative workers who leave footprints of higher states of consciousness that they have mapped in music, paint, poetry, philosophical discourse, or other means.

Whether we are dreaming with eyes open or closed, the power to dream is the imagination, which is cultivated by an openness of mind. Our ability to awaken is equal to our power to dream of it. *Imagination* is the ability to cross all boundaries, to be able to "image-a-nation," to invent a nation without boundaries — an "image-nation." In this world of infinite possibilities there are no rules, no laws, no conditions, no filters, no blocks or inhibitors unless we imagine them to be — it is unrestrained creation. The image-nation is a microcosm of the macrocosm. Like creation itself, the mind mirrors the universal process. It is endlessly *creating, sustaining, and destroying* worlds, image-worlds, thoughts, and ideas. Our minds reflect the process of creation. *Imagining* is "imagine-neering," the active or *image-engineering* power structure and delivery system of our creative nature.

The capacity of imagination increases with acts of courage that provide self-perpetuating nourishment. But I probably have more questions about imagination than I have statements or answers. Why does imagination have such a powerful impact on the mind of the experiencer that he or she often becomes intoxicated, prefers solitude to even the most joyous company, or renounces the ordinary pleasures of life to revel in a delight before which all the pleasures on earth seem stale?

When we speak of imagination we are at the same time speaking of creative visualization, the process of invention, the dream power. In the Hindu and Buddhist traditions, *dream-mind* and *sleep-mind* share equally with *waking-mind* in the composition of human consciousness. Thus the mantric seed-syllable "AUM" ("OM") synthesizes the three modes of consciousness: "A," being wakefulness (*jajarat*), "U," being the dream (*svapna*), and "M," being deep sleep (*susupti*). Finally, "OM" as a whole represents the all-encompassing cosmic consciousness (*turiya*) on the fourth plane. How mysterious and beautiful that this primal sound phonetically permeates most wisdom traditions: the Hindu "OM," the Buddhist "AUM," the Jewish "AH-MAIN," the Christian "AMEN" — all spring from the *one voice.*

An in-depth study of the non-dual wisdom traditions as well as certain western esoteric paths reveals an incredibly articulated map of consciousness and the interrelatedness of the body, mind, and spirit, and to the cosmos itself. How tissue-thin our conventional western psychology can seem to be by comparison. Mainstream psychology is largely a mapping of the articulate surface, of the outer cerebral shell.

We should remember that as we become familiar citizens in the image-nation, our bearings become increasingly sharp and clear. In the mystical ecstasy states of imagination, the intellect can remain active, and there is no blunting of the rational faculty. Many have tried to define imagination and explain creativity and its awe-inspiring and puzzling characteristics through analyzing the genius or major talent. There have been wonderful insights into the mechanics of the creative process and into the psyche of artists and inventive minds; however, what many conventional psychologists have to say regarding creativity lacks an acknowledgement of what is potentially infinite. There is no recognition of mystical experiences. They are often dismissed as madness, symptoms of mania or depression.

Just through being sensitive and letting your eyes truly see, your ears truly hear, nature will whisper to you in little ways that begin small acts of creation. When with true sight and true feeling the imagination awakens, then the impulse arises to create a dramatic action, write a poem, narrate an incident, compose a song, infuse your business with an innovative idea, or invent a new product. As creativity and skill evolves we become less hard on ourselves, and we can just play. As Ernst Fuchs once said to Sandra, "Not every painting has to be a masterpiece."

We are what we think all day long, and our character is the totality of our thinking. Cause and effect are as absolute and undeviating in the realm of thought as in the world of visible and material things. Our joy and suffering are the reflections of our habitual thinking and our abundance or lack of imagination. Even the spiritual *path* is but a dream, a spiritual dream that leads us to truly waking up, a thread that pulls us out into the light of wakefulness. Eventually, we move from a thicker dream to a thinner dream, until we finally move out of the dream altogether, awakened. On the way, what can be more real in our dreamy day-to-day lives than the spiritualized imagination, faith, or prayer? Gandhi's powerful influence and life of service in the world drew its strength from exactly that.

When every hope is gone, "when helpers fail and comforts flee," I experience that help arrives somehow, from I know not where. Supposition, worship, prayer are no superstition; they are acts more real than the acts of eating, drinking, sitting, or walking. It is no exaggeration to say that they (thoughts of God) alone are real, all else is unreal.[5]

Empowering our imagination teaches us to master our thoughts, emotions, and responses to life. We are the co-makers and co-shapers of our conditions, experiences, and events. Every thought or imagining felt as true takes root in our subconscious mind, blossoms sooner or later into action, and bears its own fruit of opportunity and experience. When thought or imagination reaches a point of saturation in the subconscious mind, it overflows into the light of day, condensing into external experiences. These worldly experiences are fashioned after the image and likeness of the negative or positive imagine-neering that took place.

If our dream is to awaken fully, acquire tools of awareness, acquire artful skills for creative action, we then will realize and know that *we go where our vision is*. As I stated before: we have no future except for what we envision, and what we envision will draw us toward itself. Cherishing the vision of what we want to be, feeling the pain of situations but letting go of the whining, complaining, and groaning about our current conditions, about "bad luck" and "good luck," will create an entirely new life. By nourishing the imagination and ideals in our hearts, contemplating the indescribable beauty of God and the loveliness that drapes our purest thoughts and deepest longings, the frequent habitations of our minds will grow into more delightful conditions and experiences.

The oak tree sleeps in the acorn, the giant sequoia in its tiny seed, the bird waits in the egg, and God waits to unfold within human nature. We gravitate to what we secretly most

love. We will meet in life the exact reproduction of our own thoughts. There is no chance, no luck (good or bad), no coincidence or accident in a world supported by divine law. We will sink to the level of our lowest concept of our self, and we will rise as high as our dominant aspiration.

It takes us a long time to accept and understand the simple, awesome power of mind, its process, and its responsibility. That acceptance serves to initiate an ongoing contemplative practice. Usually we perceive the results of mind only through our actions or the actions of others, and most people call this "chance," claiming no responsibility for what one thinks, imagines, creates, and commits to action. Even when we do begin to understand the mind, we are still bound to trip over ourselves and be tripped by others. That's okay, for we need to be kind to our selves and to others, to have tolerance and compassion. We can start to influence our future by seeding the present with a greater awareness. Our vision is a definite promise of what we one day shall be; our ideal is the prophecy of what we shall at last become, and what we will unveil. The genius of our soul can guide us to a greater awakening.

THE ALCHEMY OF ART AND SPIRIT

The non-dual wisdom traditions, the esoteric interpretations of the western spiritual paths, certain indigenous belief systems, and most of the ancient and esoteric schools — such as the Eleusinian mysteries, hermetic sciences, earth-based and certain goddess religions, the Rosicrucian order, the mysteries of Xibalba, the extensive metasciences of the theosophical school, and numerous other accounts — attest to the transmigration of consciousness. This time we are living now is not our one and only time. We cultivate the fruits of our actions, sweet and sour, in each incarnation. We cultivate our interests, our awareness, our artistry, and the sharing of that fruit with others. Creativity culminating in genius is not limited to the expression of one lifetime, coincidence, gifts, combinations of genes, or merely environmental conditions. What kind of God would sit up in his bed of clouds and say, "Hey, I've got it! For more fun, I'll make this number of people smart and that number of people not so smart, this many rich and that many poor, so many of this and so many of that — ha, ha, ha!" Where is the honor in that? Genius is the product of many experiential lifetimes, which is developmental and retainable on subconscious to higher levels of awareness, and it is the result of metempsychosis or the transmigration of the soul-consciousness. This is consciousness reembodied, expressing various attainments and refinements accumulated from previous incarnations.

The Talmud, Zohar, the Kabala, and many other mystical and scholarly achievements in Jewish cosmogony affirm that most souls are not new, that they are not here for the first time. Every person bears the legacy of previous existences. Generally, although knowledge and experience may be retained, one does not obtain the previous personality again, for the soul manifests itself in different circumstances and in different situations. Jewish mysticism also tells us that the "great soul" is usually reincarnated not in one single body

but branches out, simultaneously participating in a number of people, each of which has to satisfy different aspects of existence and purpose of soul. Tibetan Buddhism has a strikingly similar explanation. Sometimes, when Sandra and I looked at each other, we felt as though we are one soul that had become two (or maybe we were just co-dependent).

The soul is made of love, love eternal, and there is no material science which can unlock its eternal nature. Supposedly, we stand on the brink of a scientific revolution that promises to have implications as profound as those of the seventeenth century. Apparently it entails a radically innovative understanding of causation which, one would think, for the first time puts humanity fully in the picture. But science cannot give us the knowledge we essentially need, the awareness of "who we are." Man's fear of death motivates science to prolong life. In my view, I think that the one scientific "advancement" that may totally alter life on this planet and everything we might experience is not a new bomb or instrument of destruction but the fruition of research on the *aging process*. This research is highly endowed, and advances are being made. But living hundreds of years will not bring us happiness and peace unless we seek out answers to the essential questions about life and death. Instead, research springs forth from the marriage of *ego* and *material science* and — in the shadows — ego's mistress, *fear*, in a desperate and grasping attempt to extend its loosening hold on physical life. Mystics and transpersonal creators move toward a fearless understanding of death's arrival as a *deathless event*.

Never the spirit is born
The spirit will cease to be never
Never the time when it was not.
End and beginning are dreams
birthless and deathless and
changeless
Remains the spirit forever.
Death has not touched it at all
Dead though the house of it seems.
— Sioux Prayer of Passing

If everyone could live hundreds of years and new births were to become extremely limited, even legislated, how much innovation, creativity, invention, and change would enter into life when the cycle of birth and death had been dramatically altered and controlled? The natural dying of the old to make room for the new on every level would be turned upside down.

Yet it does appear as though the world has already turned upside down, but certain fundamental changes, for better or worse, have been going on in the western world for several decades, and some basic characteristics are becoming more visible:

1. There is an increased awareness of the relationships and connections in all phenomena. Matter and mind, objective and subjective, external and internal are increasingly acknowledged as aspects of the same essential oneness. This is apparent, for example, in a number of ancient mystical texts, new spiritual movements, quantum physics, and in-depth ecology.

2. There is an emerging shift away from dependence on external authority toward an internal authority. In the realms of religion, science, or politics, there is a growing disinterest in external authorities and an increasing reliance on one's own inner, intuitive wisdom and skill.

3. There is a profound change in our perspective about causation that again reflects a movement away from the external toward the internal. The statement "Our thoughts create our reality" has a weak meaning if we perceive only the world around us and ourselves as being affected by the contents of our *unconscious* minds. The stronger meaning of the statement is that we are *co-creators* of our world, and that the ultimate cause of anything is to be found not in the physical world but, rather, in *consciousness* itself.

I believe these basic characteristics underlie changes that will unfold in many areas, including economics. It was in part due to the influence of Newton that science eventually came to understand reality in the form of mechanistic, mathematical, value-free systems where there is no need of ethics or compassion to maintain them. Many scientists still tell us to assume that neither the universe itself nor its component parts are guided by any purpose or moral choice. Modern economics is exactly in this mold and could become an extremely powerful transformative force if it ever embodied the true meaning of *value*. Economics is largely comprised of value equations, but what within that science is considered valuable? How can economics and business serve as a supporting force to a spiritually fulfilled life on a beautiful and healthy planet?

It is true that the wisdom of the world's traditional religions — Buddhism, Judaism, Christianity, Hinduism, Islam, indigenous and earth-centered practices, and others — provide their followers with ethical and spiritual insights. But these traditional faiths have lost their meaning for many people. In this pluralistic, multicultural, one-world (economic) community toward which we are growing, some people are seeking a new worldview that more accurately reflects and integrates the conditions of their real lives and everyday concerns.

I can imagine a new worldview in which ethical purpose and spiritual wisdom are combined with an awareness of spiritual evolution to create a deeper appreciation, love, and respect for all human life. It would embrace individuals and society, planet and universe, as aspects of a greater process, one that recognizes the evolution of ethical purpose. By acting as conscious participants in this process, people's lives would become much more meaningful than is often experienced at present. They would be developing their own potential, helping others to develop theirs, and otherwise contributing in many

ways to the growth and enrichment of their communities and of the human race as a whole, as part of an overall process involving what all may understand as the divine. This could take place in the full knowledge that our understanding of things today can only be provisional and temporary, limited as it is by the stage of evolution in consciousness at which we happen to be.

After the breakdown of the medieval world order, it took almost three hundred years for the modern world order to crystallize. This was the time of the Enlightenment and then the American, French, and Industrial Revolutions. Today, as the modern world order and its associated worldview breaks down, we have a duty to ensure that the new one takes shape. To do this, we must consciously develop its ways of life, its institutions and organizations, and its ideas and values. The responsibility of people living today is to shape the future, not merely to forecast it. Art and creativity can help to provide a stage of exploration, debate, expression, and solutions to our problems and explore potentials for our future.

This emphasis on action is imperative. Action and knowledge are complementary. In our everyday lives, although questions such as "What can we do?" and "What is the nature of reality?" are important, it is equally important that we ask "How shall we live our lives?" None of us can escape the responsibility of our actions. We cannot avoid acting in such a way that will help create one kind of future or another. To attempt to avoid or postpone action is in itself a form of action.

One work of art opens a door to the next. This is the alchemy of fine art. It is not necessarily or usually a linear path but more like a series of gestaltlike events that overlap in images, marking passages of a transformative experience. The spirit of art works as a metaphoric mirror to the process found in alchemy. Art as a transpersonal tool parallels the birth and death of the elemental spirit as captured by the alchemist. As in alchemy, each work of art signals a death in the artist, a form shattered to make way for the next higher and more subtle form of expression embodied in the following piece, yet including the essence of what went before.

In a fascinating and ancient art, alchemists believed that everything, including inert substances, had a spirit within it, that everything was alive. They believed that they could create gold and even a remarkable stone or tincture that could add longevity to human life and could enlighten and expand one's consciousness. Alchemists believed this could be done by replicating the cycle of birth and death in nature; specifically, the process of transmigration of spirit within the mineral kingdom. Generally speaking, their approach was to take the *spirit* of a mineral and transfer it to its next higher "metal" *body*. Repeating the process would eventually bring the isolated spirit into its highest form in the mineral kingdom — gold. Gold is incorruptible; it is pure, unchanging. It is the highest body in the mineral kingdom. The "Christ," or "guru" principle/body in this science is attained in the philosopher's stone or tincture. When this Christlike-guru substance came into contact with any mineral, it would take that mineral to its highest body instantaneously, the shining golden "enlightened" body of the mineral kingdom. If an alchemist were unable to attain

the philosopher's stone, gold could still be made through an arduous and methodical process in which the soul stages of a metal passed through the mineral kingdom's evolution without contact with the philosopher's stone. If the tincture was achieved and ingested by the alchemist, it would induce a level of enlightenment and add longevity to the life of the consumer. This is illustrated in the stories of Saint Germaine and his various identities and devised "incarnations." Whether one views this alchemical art as a valid science that is veiled from the eyes of modern material scientism or as an archetype, purely allegorical, for the transformation of consciousness through metaphorical contemplation, it is interesting to note that enlightened masters throughout our history function in the human kingdom as an alchemical philosopher's stone does in the mineral. They are catalysts in uplifting the body of spirit or consciousness from one level to the next, through states of awareness.

Human beings who have awakened on some level or another represent the inner teacher in outer form. In the same way, the inner guru alchemically guides each work of art and leads the creative worker to ever higher states of true-pure being, gradually revealing the true self. Each painting, sculpture, sheet of music, or page of poetry can potentially reveal the evolving alignment with the self. We may be creating works of beauty for years, but if we remain genuine, we are likely to return, again, as do the seasons, to a winter, a cold and dark night of the soul. But this spiraling return is on a different level now. If we have passed through the depths of our own deepest darkness, these "returns" are more on a shadow level. Shadows suggest a casting by light, and light must already be present to cast shadows. The shadows are now met with the highly tuned skills of the creative aspirant, and the radiance of our light intensifies, even illuminating the shadows. If we do the work, face our demons, the dance with the shadows is almost a joy. That is, we engage the dark side from a stance of creative courage; it is an adventure in awareness that is an exciting challenge. Shadow work is very different from what is dealt with in the dark night of the soul, whereby many mystics, after a great period of illumination, swing back to emptiness, to pain and desolation, to helplessness, in preparation for the total self-surrender to Godhead. Having gone through an intense period of intuition, even oneness with God, the dual nature of Mind may move the aspirant into a period of challenge and testing — a time when this period of darkness also contributes to the recreation of character. It is the sorting house discovered in the abyss. It is the threshold to another higher state.

STILL, SMALL VOICES AND PILLARS OF FIRE

As one experiences this life of creative action, one acquires a sense of bearings in self-development. We may compare the development of consciousness through the creative process to the growth of a child in the womb. This comparison illustrates the important fact that the process is an organic development, and it helps to dispel the notion that creation is simply an act of cold calculation governed by wish, will, and expediency; it is a *natural act* that includes *the whole being*. Most creative workers pick up what they know about this and that by trial and error, by casual observation of others and themselves, and

from such comment as they may chance upon. The consequences of learning so haphazardly are difficult to predict but, in the dedicated creative worker, are obviously not always good.

The life of the creative worker will, of its own force, create constant change, ceaseless movement, construction and destruction, sublimation and transformation, and awakening and greater awakening. The "way of the inner voice and vision" is an aesthetic version of *Laya* yoga (a yoga of the inner sounds and sights), moment to moment, leaving in its wake a map of the journey of consciousness. It is a path of transformation by using the tools of creativity. It is another threshold to the great mysteries, to God. We can return once again to the Mahatma, Mohandas K. Gandhi, who had a steadfast conviction in this regard:

I have no special revelation of God's will. My firm belief is that He reveals Himself daily to every human being, but we shut our ears to the "still, small voice." We shut our eyes to the "pillar of fire" in front of us. I realize His Omnipresence.[6]

The still, small voice and the pillars of fire are doorways that introduce and connect us to the inner teacher, the navigator guiding us through the sea of spiritual imagination and the world outside, day-to-day reality. In both waking and dream states, as this guidance is trusted, intuitive knowledge arises to instruct on practical and technical skills. Much of this depends on the ability of the individual to make experiential the guidance given to him or her. The struggle and pleasure of spiritual growth becomes reflected in the work and expressive media we have chosen for this purpose. As we stay with the process until it has become a practice, whether or not we walk in the sunlight of full communion or in the darkness of arid separation, whether we experience the joy of lofty states or the despair of human limitations, or whether we live an even and steady life, there will always be just a hint of confidence, that beatific knowledge of spiritual triumph. We will be encouraged by the spirit of creative exploration.

I believe it is also important to remember that if you are seeking truth only for yourself, then it is not a fully spiritual pursuit. It must also be for the world that truth is sought. My friend Alex Grey offers this perspective on service and truth, and adds the following:

The correct motivation is not that you are seeking enlightenment just for yourself but rather for the benefit of all beings. It's almost a foreign notion to us that what we are doing could be for the common good. I remember the Dalai Lama did a public talk after he had done a week long teaching on esoteric Buddhism. At the public talk he tried to make everything as simple and straightforward as possible, he said, "I am a human being. You are a human being. Try to be a good human being, not a bad human being."

In the same way, correct motivation is critical for the artist. The type of energy you put into your work has an effect on yourself, your viewers and the collective psyche. Artists must think deeply about what type of energy they want to put into the world. There is an ethical dimension to works of art.[7]

The still, small voices and pillars of fire can unearth and awaken latent and undeveloped powers, and artists, seekers, and traditional practitioners can confuse spiritual and psychic vision. There are many definitions and explanations for our spiritual anatomy. For example, in a perennial theo-philosophy, a threefold field can be described in which people function. They are said to be spirit, mind, and body. The spirit is that which represents the potential and the future of humanity and the human being. The body comes from the past, an inheritance of the animal. The mind and soul are ever subjective, yet they are merged into the great ocean of life we speak of as God. The body, on the other hand, is itself objective and is in touch with a world which is external.

In actuality, subjectivity and objectivity represent two functions or poles of the mind. In the course of evolution these two functions need to be differentiated. In other words, the mind has to learn consciously to look inward in order to perceive spiritual truth, but it also has to learn to look outward in order to master the material aspects of life. For the latter purpose, it has a good starting point in the physical senses it has inherited from the animal kingdom. Ultimately, neither function is complete without the other. Sensory perception is inadequate without spiritual enlightenment, but spiritual vision leaves the individual in the air unless he or she can bring it into practical touch with the sensory levels of life.

In the meta-realms of the psyche or mind, the perceptive function is represented in modern terminology as extrasensory perception, while spiritual illumination is known to the majority of people as an occasional flash of insight or inspiration. There is a difference between *spiritual vision* and *extrasensory perception*, which includes clairvoyance, clairaudience, clairsentience, etc., and is, as the phrase indicates, an extension of physical sensation. It is important to get the distinction clear, otherwise confusion results, and much time and energy can be wasted. I know too many people who go to psychics seeking advice, as though someone who is psychic automatically is endowed with spiritual wisdom.

If we consider clairvoyance as an example, it is evident that though it literally means "clear seeing," it does not follow that the one who sees understands the nature of his or her perceptions. Nor does it mean that his or her mental assessment is accurate. We are always making mistakes about what we perceive at the physical level. Just walk into any courtroom and listen to the testimony of differing witnesses. This is even more true at the level of life at which the subtle material alters in shape, color, design, texture, and many other qualities at every moment.

The good clairvoyant needs to know something about her own psychological makeup in order that she may realize what I call "the personal factor," or, in science, her "margin of error," and allow for it in the vision that she sees and expresses. There is a quality and type of clairvoyance which each possesses. It depends on our training in the past and varies according to the type and temperament of person that we happen to be now.

There are many levels of seeing, and clairvoyant ability is a multidimensional quality with various degrees of attainment. There are those who are reactive clairvoyants, who very largely use the solar plexus and sympathetic nervous system as their mechanism of

perception. These people almost always depend upon conditions that suit their personality. They demand certain things, and unless those things are supplied, they are not able to see. They are often extremely sensitive to any kind of criticism or even objective analysis. Their feelings are very easily hurt. and they are very much the victims of their own sensitivity. They usually cannot control their clairvoyance, and this often makes their lives difficult. Their perceptions, often clouded with personal projections, may result in guidance to others that is imbalanced and incorrect.

"Channeling," a phenomenon claimed by many and probably occurring only in a few, can also be a relevant event in art as well. It could be considered an advanced state of "automatism" as coined by André Breton. This has also been referred to as *automatic writing* in which poets and writers have had a sense of being "inspired" or of receiving material from another reality and feeling compelled to express it. In art, the phenomenon seems more prevalent and authentic in the realm of poetry and lyricism and certainly in musical composition and painting; it is less evident in, say, dance, sculpture, and the crafts. As artistic media moves further away from subtle forms to the gross, from the etheric to the physical, from the mental plane to the body as a means of expression, the likelihood of manifesting heavenly, enlightened experience or higher, vibratory phenomena on earth — right here, right now — simply diminishes. We cannot depict the stuff of a dozen dreams so easily in the solid matter of one sculpture or even one dance. This would be an arduous and perhaps impossible task for even a Michelangelo or a Baryshnikov. So as art becomes more physical in expression, the less it can link itself to and depict the subtle. The more mental-plane arts of poetry, music, and painting serve better in this regard.

The writer and poet Amy Lowell has said,

The truth is that there is a little mystery here, and no one is more conscious of it than the poet himself. Let us admit at once that a poet is something like a radio aerial — he is capable of receiving messages on waves of some sort; but he is more than an aerial, for he possesses the capacity of transmuting these messages into those patterns of words we call poems. It would seem that a scientific definition of a poet might put it something like this: a man of an extraordinarily sensitive and active subconscious personality, fed by, and feeding, a non-resistant consciousness.[8]

In creative endeavors, channeling seems to be more or less the activity of two orders. The first art originates in our relationship with nature and humanity. The second comes from divine inspiration. To receive it, the artist must be in a kind of egoless state, a temporary condition in which the ego is at rest, not interjecting its desire, and therefore consciousness may be imprinted by higher orders of reality, from beyond the sensory world.

The activity and operational anatomy of channels, mediums, clairvoyants, and others using such faculties became clearer to me during my sojourn to India. I saw that one type of clairvoyance depends upon dropping the censorship of the clear, waking mind and falling back into a halfway state which is neither in this world nor out of it. This produces some slight degree of semitrance. But another type uses a different mechanism altogether,

connected with the cerebrospinal system. If the capacity is well under control and integrated into daily life, this type does not rely on or demand special conditions. In this case a great deal of clairvoyant work can be done anywhere, provided there is not too much noise or movement. This work is done in full self-consciousness. In time, creative workers naturally move toward the abilities of the first type as a result of intense focusing in the process of creating art, but they must consciously cultivate the leap toward the second type.

In art, sometimes an artist is unable to express his vision because he gets confused with himself. Psychic people are usually artistic, and good artists are almost always markedly psychic. But they get confused because the clarity of the concept they are trying to embody in their work becomes lost in the mass and maze of mixed psychic perceptions and psychological associations which gather round it. In relating to other artists about these issues, I have seen that exploring with them the difference between their actual vision and their mental and emotional memories and what they perceive extrasensorily helps them to clarify what belongs to their more-than-personal inspiration and what is purely the product of their personal minds. The creative worker with a heightened awareness, because of his or her sensitivity, is usually quick to seize upon these things and is also one of the quickest to make use of them and to change his or her way of working.

True and deep perception is of remarkable value in the ordinary understanding of life. We all know the feuds, the difficulties, and the hatred that religion, politics, and many other topics and situations can produce. If we had the perceptive quality so developed that we could put our consciousness into that of another person and look at his difficulties, ideas, and expressions of them as they really appear to him, we should be able to discover common ground where we could meet and produce a union instead of a clash. Einstein suggested that in trying to communicate with another human being, we should first understand their pain and their suffering, and then we would know a great deal about that individual and be more open and sympathetic.

Again, clairvoyance should never be confused with spiritual vision. No form of clairvoyance gives clear spiritual vision. Spiritual vision changes a person, and she can never be the same afterwards as she was before. But even the higher forms of clairvoyance do not necessarily change the clairvoyant. Many clairvoyants I have met seem to have had little philosophical understanding, true knowledge of metaphysical systems and states, and lacked a simple and deep spiritual devotion. In addition, they can misguide others, even if unintentionally, while adding a fee for this misdirection. I once met an exceptional clairvoyant, but he was also spiritually and psychologically twisted. He set himself up as a guru and claimed to be Jesus, El Morya, a channel for Saint Germaine, and a host of others, a kind of one-man Cosmic Speakers' Bureau. He had a small group of followers and caused them a great deal of suffering through his self-serving activity. Sometimes we need to discover more light by stumbling into darkness. The ability to recognize an authentic teacher is a great skill in today's world. To cultivate a connection to the inner teacher is of immense value in this regard. Many go to a guru to see the embodiment of their own inner teacher. Some seek a guru, an external manifestation of the inner voice, to resonate with

the embodiment of the still, small voice inside themselves. This can be an exceptional step in one's spiritual evolution, unless an unhealthy dependency ensues. The more one turns within to find the truth about oneself, the more one will develop one's own power of inner knowing, guidance, and healing.

IN SPIRIT WE TRUST

One day, Rabbi Zalman Schachter told a story to me and my dear friend and co-worker, Steve Glazer, whose wife Stacey was pregnant. Reb Zalman related an old Jewish tale that says that before we are born we all have absolute knowledge as instructed by the angels. Upon the occasion of our birth, an angel comes and taps us right above our upper lip, creating the indentation there and causing us to forget all of our knowledge — but it is not a complete forgetting. The knowledge sinks down, asleep within us. When we are ready to awaken and seek out spiritual teachings, this event helps us to recognize a true teacher. With a magical twinkle in his eye, the great rabbi continued, "You see, a true teacher would teach us only what we already know, not what we don't know. With each teaching there is a subtle sense of remembering, of already knowing what has been offered. It sounds right and rings true. So if any spiritual teacher tells you something you don't already know, run the other way."

Spiritual vision unifies and does not obscure the differentiations realized through the senses. Even the simplest person can possess a fundamental spiritual vision. The person may understand that the mud underfoot, the stars in the heavens, the relationship to the person he or she loves, to an animal, a flower, even to the ugliness, the dirt, the drudgery of life — are all One.

It behooves the student of life not to try to develop *siddhis* or spiritual powers. They will come in any case when we truly seek the integration of the personality, reunion with the divine, or the Buddha nature. We should not bother about the development of psychic powers, because at some time or another they are inevitable as mere extensions of our physical senses. We can learn to trust that what is needed will arise by cultivating the central disciplines and the heart. Spiritual vision can and does exist without clairvoyance or any other form of psychic perceptivity. But when the latter develops out of the longing for spiritual enlightenment, it then becomes a positive extension to the field of awareness on the subtle and gross planes and hence to the understanding of these various realms. One may connect to intuitive centers through meditation, prayer, or the transpersonal practice of a fine art. Gandhi continually referred to this inner guidance:

For me the Voice of God, the Conscience, of Truth, or the Inner Voice or "the Still, Small Voice" mean one and the same thing.[9]

The greatest need is for each of us to perceive our spiritual stature, so that we realize that we are a life emanating from God and we are, at the same time, the source of that

emanation. Then each one of us can connect to the inner guru, to God dwelling within, as we are. The danger of this world does not lie so much in the *progress* of the outer and material aspects of life. These may have their dangers, but the great danger lies in losing sight of the *dignity of man as a spirit incarnate.* That realization, seeing God in each other, is the only thing that can ultimately deflect war. This is, perhaps, the only thing that can give us the understanding, respect, and compassion for other people, other species and which may bring peace to this troubled world.

On this little blue pearl in the forehead of God, this extraordinarily beautiful planet, man and woman, by virtue of their divine soul, have the potential and the actual capacity of God. This expresses itself initially as the ability to ask the questions: Who am I? and What am I here for? It affords the opportunity to go beyond the limits of a given existence, to move freely and choose other paths. This spiritual capacity enables one to reach the utmost heights or to plumb the deepest hells, to fully awaken from the dream of separation. It is, in other words, the power to will, to awaken, and to create what has never been here before. Our free will thus derives its unique potential from the fact that it is a part of the divine will, without limit and without restriction. Our creative power mirrors the divine power of creation. In this sense, too, we are made in the image of God, and we can see the importance of adding wisdom to the power of creativity — for it is a great responsibility.

Following your intuition is not some dreamy, magical experience; simply, it begins by just learning to trust your gut feelings. We all have this intuitive guidance within us and available to us in every moment. We are born with creativity and intuition, but we are quickly taught to ignore it, distrust it, and dispense with it altogether. We merely need to reclaim what is naturally ours. One begins by just practicing that gut-feeling trust with the small things in life at first. Listening to everything that comes up, moment to moment, to the sense of warnings, to the directions we may go in, to the connections made with others and why, and most of all, trusting our first feelings, first thoughts. We already know what we need now and what we need next. Sometimes, by just relaxing instead of trying to figure everything out, we receive the guidance we need. Connecting to our intuition is a process, an intimate relationship with the still, small voice that gradually unfolds, and it is rewarding. Gradually we become accustomed to recognizing and feeling the difference between this guided state and the "normal" condition of moving and acting from our lower nature, or subordinate powers of creation.

This is a time when a small but continuously growing population finds it difficult to sustain a belief in a God primarily *outside* of themselves, or in laws and dogmas interpreted by officers of the world's great religions who do so in punitive terms and in a language of *fundamentalism.* Yet all that has been said here is that one should adhere to their "faith" and enhance their connection to the *inner truth* within themselves. A path to awaken from the great dream lies at the heart of all the wisdom traditions. There is an age-old story that says when the Buddha first had his enlightenment, he was asked,

"Are you a God?"

"No," he replied.

"Are you a saint?"

"No."

"Then what are you?"

And he answered, "I am awake."

Over the past thirty years, for all its recent popularization, eastern philosophy in America and then elsewhere in the West has only begun to make its influence felt on the mainstream of western thought. This is of little wonder. The western ego, even in its wild version of the Freudian id, is indeed an extremely hard nut to crack. Its psychic genealogy runs back through the Christian notion of soul: the atomic self, final and isolated, stuffed like a Thanksgiving turkey into its bag of corruptible skin, claiming tenacious property rights to personal salvation. When the Vedic-Buddhist critique of selfhood tells us this beleaguered ego is an illusion, we quickly interpret this not as an invitation to free and expand our identity but as a nihilistic assault upon us. Yet the impoverished ego we cling to is nothing less than the root-cause of chaos, ultimately expressing itself in wars. Here we can see the importance in the transformation of ego, the merging of the isolated life with the larger life, awakening from the dream of separation.

The word "personality" comes from the Latin word "persona," which originally referred to an actor's mask. Just as an actor might play Hamlet overzealously onstage, we usually take our own role in society very seriously, forgetting who we really are. As a Buddhist sect, Zen is free of dogmas or creeds whose teachings and disciplines are directed toward self-consummation, demonstrated in the full awakening that Sakyamuni attained (Buddha, c. 563–483 B.C.), in becoming the Buddha and experiencing enlightenment and nirvana under the *Bo* tree after strenuous self-discipline. Zen shuns abstractions, representations, and figures of speech. No real value is attached to such words as God, Buddha, the soul, the infinite, or the One. They are, after all, only words and ideas, and as such are not conducive to the real understanding of Zen. The object of Zen discipline consists in its methodical training of the mind in order to mature it to the state of *Satori*, when all its secrets are revealed. Normally, we assume that our personality is our true self and that we are free, independent, and totally different from everyone else. But the object of Zen and all the sacred paths is to see quite clearly that the personality which we think is our self is actually a masquerade or a put-on, a role that is being played out by the universal self which is the same in each individual.

I traveled to India and went to a teacher to participate with him in that pure dimension of unlimited and complete truthfulness in order to become more familiar and resonate with the God-realized state that the awakened teacher embodies. I went to the teacher to open my mind and heart, to have my assumptions about reality challenged, so that I might be in contact with the truth. I came so that I could love more. I approached the ashram situation by putting all my concepts of reality, beliefs, and convictions into a mental suitcase

and leaving it outside the ashram doors. I could always pick up my suitcase of "beliefs" later, if I wanted them. I then proceeded to study openly, carefully, the total life expression of the teacher for the sake of understanding and imbibing the origin of his reality, the source, and how he united with it.

I came to the teacher and his abode to attain self-realization, or at least, a piece of it. Realization is not simply a function of diet, or of attitude, or of praising God. I am alternately amused and disgusted by certain religious programming on cable television, particularly those that solicit money for praising God, the "praise-a-thons." Are we to imagine that God, with the power of creation and the cosmos itself, needs to hear our constant praises? Such a God must be an underachiever and deeply insecure at best. And what and where does all that money really go to? God always seems to need a lot of money. Apparently, He is all-powerful, omniscient, all-wise but doesn't know how to manage money, so He needs our help.

Retreat programs, ashrams, and monasteries all offer a discipline and practice. These simple environments aid in the dissolving of tensions and help to establish an awareness within our selves and those we relate to in community. It allows our issues to come up as we sit with them. It strikes me that in America and in other countries today there are many students who have no idea what they're doing with a spiritual teacher and do not understand what they really want. As a result, they get totally lost and confused in the whole dynamic around the teacher and the institution. Such people may become involved with an authentic teacher and try hard, but not understanding what they're up to, they look for something outside themselves to solve their problems (the teacher), and they wind up leaving the teacher and the organization feeling ripped off, abused. Or worse, they become fundamentalists, pointing "sinner fingers" at everyone else. Still others follow someone who may be prophesying alien rescues, earth changes, polar shifts, etheric dimensional-vibrational leaps, or apocalyptic diagnostics that culminate in a cosmic battle between Jesus and Satan, a heavyweight bout followed by consequential punishments and rewards for the various peoples of the Earth.

As a child I had recurring, apocalyptic dreams that continued for about twenty years to about the age of twenty-four. I saw cataclysmic events occurring around the world, volcanic eruptions, fires, earthquakes, and tattooed symbols on people's foreheads and arms that looked something like the scanning lines found on supermarket items. I saw marauders, people running and screaming, fighting each other, hysterical and frightened out of their minds. I saw soldiers enforcing martial law. These dreams often ended in the same way: an escalator, like unending keys on a piano, miles long, moving downward, filled to the brim with people falling into a black, bottomless abyss as the escalator met the darkness. I saw ships from the stars picking people up from rooftops. I was introduced to other children from other civilizations by adult beings from another world (they looked human but were not). I was asked to teach the children things about art and spirit. One of the children, I was told, was very special and was named Astar. He was sent to me for very special training. We were both put into a room together. He looked

Hawaiian and wore a large, silver pendant on a heavy necklace. The pendant was shaped something like a bat and boomerang melted together. This dream of Astar occurred many years ago. More than a decade later, a character by the name of Ashtar, of the Ashtar Command, appeared in New Age literature. He began to turn up in New Age publications and in the works of various channelers. Ashtar commanded an off-world fleet of spaceships organized from his mothership. His mission was and is to rescue us and protect us from bad aliens and the forthcoming Earth changes.

What do we make of all this? Did I dream of a cheesy, future New Age-schlock story, experience one of God's jokes or a kind of clairvoyant cosmic humor ("clairhumorance"), just have a strange, repeating dream for many years, or is there some possible thread of reality to this? I really don't know. But what good does it do to dwell on the *possible* cataclysmic events that *might* come? What are we saying to ourselves when we believe that all of this cosmic activity is happening over and above us, totally beyond our control and responsibility, as though we are helpless children being alternately "saved" or "punished" for being bad to our planet and to each other? It seems this is a roundabout way to give away our power and our *responsibility*. In my view, there are *already* cataclysmic events happening all around us — we should turn our eyes, ears, and hearts toward the *present*. For example, we should turn to our children, our babies around the world who are starving: All children are *our* children. I think it is best to live in the moment with an attitude of service to others. That we, through the movement in our lives, may add to the common good, raise consciousness, and uplift the human condition.

There is a strong need for a worldview and cultural shift in which we humans perceive ourselves as spiritual beings in a spiritual universe. This view would recognize that ultimate causation is *not* to be found only in the physical, and that consciousness is not exclusively the product of billions of years of material evolution but was and is *always* present. It is a worldview in which evolution is seen as taking place within consciousness, and in which the physically measurable world is to the universal mind as a dream image is to the dreamer's own mind. It is as difficult to imagine the eventual impact of such a dramatic revolutionary shift as it would have been in the seventeenth century to imagine the characteristics of today's world.

I get very excited over anything invented or created — artistic, scientific, or otherwise — and I often forget that there is a greater shadow to modern science than there is a casting light. In one of my moments of scientific elation, Ken Wilber reminded me, "Phil, science is not your friend." He even repeated the sentence and added, "Quantum physics does not ask you to change your self — art does. Science doesn't change the eye — art does." We cannot forget to recognize that the mere scientific "idea" that the world and the universe are but a lifeless machine — scientific reductionism — has led to the manipulation and exploitation of people and this planet. This "fact" has for the past two hundred years contributed to the consequences of toxic waste, barren wastelands, extinct species, sophisticated weapons of mass destruction, and generally the feeling that we are

separate from nature, disconnected from the source of life, disconnected parts in a random universe. This is science in service of the muse?

Our current human condition seems to have been shaped by two controlling fantasies, one involving self-aggrandizement through spatial extension and the other involving death by strangulation or smothering. Both fantasies can evoke the same content: millions of miles of highways in the process of apparently infinite expansion; nuclear delivery systems and lines of defense being placed and replaced, duplicated and reduplicated, and often hidden from the eyes of the world; cities growing and growing; and the whole process consuming fuel and other resources and leaving in their place a dismal array of pollutants. Our fantasies are compulsive — overpopulation, overcrowding, overkill. This is why it is so essential when embraced by the muse to add spiritual wisdom to our creative powers of invention.

The spiritual life, to which creativity and invention belong, requires responsibility and a sense of service to others. The only real secret to creative power, inspiration, and experience is to fulfill our potential; to responsibly become what we already are, Godlike. William James writes in *The Varieties of Religious Experience*:

This overcoming of all the usual barriers between the individual and the Absolute is the great mystic achievement. In mystic states we both become one with the Absolute and we become aware of our oneness. This is the everlasting and triumphant mystical tradition, hardly altered by difference of clime or creed. In Hinduism, in Neoplatonism, in Sufism, in Christian mysticism, in Whitmanism, we find the same recurring note, so that there is about mystical utterances an eternal unanimity which ought to make a critic stop and think, and which brings it about that the mystical classics have, as has been said, neither birthday nor native land, perpetually telling of the unity of man with God, their speech antedates language, and they do not grow old.[10]

The perennial philosophy as espoused by Aldous Huxley recognizes that a divine reality underlies all phenomena, all of life. This philosophy also suggests that all of the world wisdom traditions point to the same mountain of knowledge, and that each of these traditions is only a different path up the same mountain. One mountain, many paths. Aldous Huxley (1894–1963) was an English writer and thinker, grandson of Thomas Henry Huxley and brother of Julian Huxley, the great biologist. He made his name as a writer of satirical fiction and later turned his attention to nonfiction and philosophy. In *The Perennial Philosophy*, Huxley draws together an anthology and commentary on "the metaphysics that recognizes a divine Reality substantial to the world of things and lives and minds; the psychology that finds in the soul something similar to, or even identical with, divine Reality; the ethic that places man's final end in the knowledge of the immanent and transcendent Ground of all being." Numerous accounts bear similar revelations. Ken Wilber, who adores Huxley's work, adds, in his own words, this stunning description:

I'll tell you what I think. I think the sages are the growing tip of the secret impulse of evolution. I think they are the leading edge of the self-transcending drive that always goes beyond what went

before. I think they embody the very drive of the Kosmos toward greater depth and expanding consciousness. I think they are riding the edge of a light beam racing toward a rendezvous with God. And I think they point to the same depth in you, and in me, and in all of us. I think they plugged into the All, and the Kosmos sings through their voices, and Spirit shines through their eyes. And I think they disclose the face of tomorrow, they open us to the heart of our own destiny, which is already right now in the timelessness of this very moment, and in that startling recognition the voice of the sage becomes your voice, the eyes of the sage become your eyes, you speak with the tongues of angels and are alight with the fire of a realization that never dawns nor ceases, you recognize your own true Face in the mirror of Kosmos itself: your identity is indeed the All, and you are no longer part of that stream, you are that stream, with the All unfolding not around you but in you. The stars no longer shine out there, but in here. Supernovas come into being within your heart, and the sun shines inside your awareness. Because you transcend all, you embrace all. There is no final Whole here, only an endless process, and you are the opening or the clearing or the pure Emptiness in which the entire process unfolds — ceaselessly, miraculously, everlastingly, lightly.[11]

THE MUSE — HER KISS OF GENIUS

Plato in *Phaedrus* wrote of "a kind of madness, which is possession by the Muses; this enters into a delicate and virgin soul, and there inspiring frenzy, awakes lyric and other poetry." We also have de Musset speaking on poetic composition: "It is not work, it is listening; it is as if some unknown person were speaking in your ear." With the mystics this dissociation from the will of the writer seems to be carried further. Catherine of Siena dictated her *Dialogue* in a state of ecstasy. Theresa de Jesus likened her writing to the speech of a parrot repeating without understanding the words of its master. Böhme speaks of himself as compelled to write by a "motion from on high": "Art has not written here. There was no time to consider how to set it down deliberately according to literary understanding. All was ordered according to the direction of the Spirit … The burning fire often forced forward with speed, and the hand and pen had to hasten directly after it; for it comes and goes like a sudden shower." Madame Guyon would have a sudden urge to take up her pen; if she tried to resist, it was agony. Words and sentences, ideas and arguments tumbled from her so that one of her longest books was actually composed in a day and a half: "In writing I saw that I was writing of things I had never seen, and during the time of manifestation, I was given light to perceive that I had in me treasures of knowledge and understanding which I did not know that I possessed." For me, Blake is still the best example of all. He declared that he wrote *Milton* and *Jerusalem* "from immediate dictation … without premeditation and even against my will," and at his death declared that his works were the product of his "celestial friends."

In antiquity, genius carried the connotation of a guardian spirit of an individual, a muse, or of a being possessed by a powerful demon. But more and more, genius has come to mean the visitation of the God-power itself. "Genius is no big deal," proclaims Dr Wilson

Wheatcroft, my dear friend. I believe he is right. Wilson compares the genius to the spiritually accomplished, the self-realized being, the enlightened. In his view, genius is an ordinary faculty that may or may not be accompanied by wisdom. An individual is gradually, over a period of lifetimes, able to embrace truth and existence. This accounts for the fact that just as ordinary beings, talented ones, and those of genius have developed to varying degrees, so too are liberated beings (those who have overcome the cycle of birth and death on the wheel of life) varied in their stages of realization. Each person sets their own limitations in accordance with their own desire.

So, to be realized, genius needs only to be desired, then cultivated. In a real sense, mediocrity is self-inflicted and genius is self-bestowed. Only fear stands in the way of connecting to our greatness, and safety lies in tending toward our highest, and not in resting content with an inferior potentiality. To rest in or follow after an inferior potentiality may seem safe, rational, comfortable, easy, but it ends badly in some futility or in mere circling down into the abyss, ending in the stagnant muck. If we all aimed our spirits low, we would become a race of defeated muckers. Our right and natural road is toward the summits.

Any creative person possesses talent, but the genius is sometimes "possessed" by talent, by the muse, which occasionally owns him or her. Genius is the ability to reorganize existing elements into an entirely new and unique form. On the next level, genius goes new ways. Finally, genius often dares without being afraid of finding itself alone. Genius is master of humankind. Genius should be put into service to benefit others. One becomes endowed in accordance with one's aspirations to serve. Perhaps what is most important to remember is that genius is but a flag, a signpost pointing to something greater for the individual and those who witness, relate, and are touched by its creative life and fire. The signpost declares an awakening to the fact that there is a divinity lying asleep within us all. This awakening develops and then appears as genius. Yet genius is only a drop in the ocean of our potential.

As Wilson says, "Genius is ordinary" and begins by merely opening up, being receptive, vulnerable, and sensitive to everything. That's it. You allow your total being — body, mind, and spirit — to be sensitive to beauty and to ugliness, to the poverty and filth, to laughter and tears, to everything around you and in you. From this sensitivity for the whole of existence can spring genius, goodness, love, beauty, and truth. Many theorists on the subject of creativity maintain that the spirit of genius cannot remain hidden and must of necessity assert itself. Although it is difficult to prove the contrary, it is obvious that certain defects in our mental makeup — inertia for one thing, dissipation for another — may easily prevent development. There is sometimes more than a grain of truth in well-worn sayings, and one of them is that character defeats genius.

More often than not, products of genius carry the lamp of the unusual with them, and they are sometimes frightening to the ordinary eye. These raw angels of mysterious ecstasies are often outsiders on the edge of life peering in, yet their touch of creative fire is an enormously influential one. There is an intense but disciplined exuberance of spirit

and flesh in the genius that can appear to others as completely undisciplined and frightening, particularly to those unfamiliar with such energies.

There is no great genius without a tincture of madness.
— Seneca[12]

Plato also defined inspiration as "the divine release from the ordinary ways of man." Then perhaps I am right when I say that to explain the creative process exclusively in psychological terms is a contradiction in itself, for genius rises out of the measure of all being, the wholeness of spirit. A spiritual explanation is needed and should be added. Yet without a definition of what is psychological and what is spiritual, we are left hanging in the air, without ground below us. For now, let us define the spiritual as a path of love.

Artistry that exists without love is almost always an expression of evil or wrong action. Creating without love can bring only one variation of an original phenomenon into being and then it can only repeat itself in a negative pattern. Thus the Hitlers, serial killers, serial artists of darkness who worship and serve evil can only repeat their actions and "creative destructions" in a remarkable form of duplication. There is no depth, no texture, no subtlety, no variation, and no love.

The spirit of art showers us with a transformative energy when the ego is quiet. The simple thought, "*I* am painting a tree," as opposed to, "I am painting a *tree*," is enough to hinder the clear flow of inspiration. Inventive artists are more apt than many people to be egotistical, not because their egos are naturally bigger or stronger, but simply because there is a greater energy flow through the ego due to a connection to the current of creative forces. I am not assigning a superior station to the artist; the artist is demonstrating a connection to a potential source available to everyone, and due to that connection to creative forces, there is an increase in energy flow. It is important for creative workers, therefore, to let go of the ego as much as possible during their creative work. It is interesting to note that the great yogi, Paramahansa Yogananda, wrote that the seat of the ego is the medulla oblongata at the base of the brain. Those working with body psychology may have noticed that any increase in the thought "I" seems to produce a greater focus of energy at that point. Try it for yourself. When ego-centered experience creates a creative block, the way to remove this block is to divert one's concentration from this area at the base of the brain, and to focus on the "seat of concentration," on the forehead between the eyebrows, and then project it outward toward the project you are engaged in. For people who have little experience of the energy flow in their bodies or of creative blockages, it should be easy all the same to understand that the ego can be more of an obstruction than an aid to artistic expression. Yet the ego should not be despised as the "enemy of art" but befriended, subjectively and playfully tricked into service while being bathed in spirit. The word "ego" causes much confusion, as it is a term describing a subjective function and has been defined in numerous ways by different people. We can say that the ego, although at the center of our feelings of

separation and at the service of illusion, is also a mechanism to be transformed as a vehicle, not fundamentally annihilated or dispensed with, at least not in any of the beginning stages of consciousness development. In the initial and even matured (but not yet liberated) stages, the ego cannot be dispensed with — that is an illusion within itself, a kind of spiritual denial. So initially we set about bathing the ego, washing it in purified waters, leading it toward a vaporous state, less solid than it was.

Many aspects of life may arise as sources of inspiration on many different levels. An intimate muse, nature, the lover, the human form, the accidental, the spontaneous moment, the vision, and ordinary objects can all inspire a creative experience and expression. For some painters it's an old barn on a side of a hill (Wyeth), the music of a particular composer (Kandinsky), the face of a lover (Knopff), or a color field evoking an emotional experience (Rothko). For others it may be scenes from the imagination or aesthetic heat rising off sexual currents. Inspiration cuts through the cultural trance — suspending the prescribed goals and expectations of this conditioned cultural mindscape — so that alternative realities and solutions may be perceived.

Relying on a particular paper, trick technique, drug, political stand, habitual emotion, addiction, or historical reference will not only limit our potential but can replace openness and skill with limiting crutches. Every crutch we lean on, like an addiction, diminishes our creative power. Sometimes divine inspiration comes only after ordinary imagination is completely and absolutely exhausted or simply ignored. The mind must be transcended in order for inspiration to come, and yet consciousness must remain. When we surrender to our intuitive faculties we then open the doors to creative power. I have found that creative power and inspiration descends most often on the still mind. The time just prior to sleep can be an active period of inspiration and reception, as is the time when we are just awakening. Between sleep and awakening the mind is surrendering. We are folding in toward the place where all things are born, where we are rejuvenated — the place where we finally relinquish all control.

Art is a sacred path and inspiration is its gateway that takes form through energetic forces: *prana*, *chiti-kundalini-shakti*, a pillar of flames that consumes the creative worker. When inspired, the artist is no longer a person with free will or personal aim but becomes the instrument of the creative power. Creative workers' and mystics' conversations are peppered with uncanny observations that come from people who have remained in awe of their world and often have unique, fundamental, and childlike perceptions. With this matured child mind, the aspirant always searches, is optimistic, and remains convinced that anything is possible. Children can will themselves to do anything or surrender and be open to receive anything — artists retain this quality.

When inspiration descends or arises in its fullness, it is sometimes like being in the throes of passion. I cannot help but associate inspiration and the creative process to love, a movement of love, making love. The force of life pounds through our veins. When making love, each of us disappears in climax. We transcend the limited illusory state of ego identification. At the moment of sexual climax we no longer remember our name

or our profession. We do not count our debts or our successes. We have merged into the ocean at that climactic moment. The individualized soul has been swallowed by the supreme soul. The little "i" has immersed itself into the capital "I." This is why the majority of people find their highest experience of bliss in the act of creation — making love. It is God's built-in mechanism for the assurance of the fun, ecstasy, and bliss of creation and procreation.

One must learn to evolve in a relationship with inspiration as one does with a lover. In love we must learn to surrender at times, which is an act of vulnerability, of bravery, and it is the same way with inspiration and art. We dance between asserting and allowing — we are co-creators. The creative process is a form of unconditional love. It is the heart's nature to want to circulate love freely back and forth without putting limiting conditions on that exchange. Love, in its deepest essence, knows nothing of conditions and is quite unreasonable. Unconditional love has its own reasons that our rational nature cannot know, and so it is with inspiration: It is larger than the person it inhabits. It is a mysterious, attractive lover we learn to surrender to and eventually become seduced by. Through this process, we give to ourselves the unconditional love we most desire, which is followed by an inevitable fire of inspiration that continually increases our creative powers.

Inspiration is like a radiant fire-eye of God, a sharp sword made from silver moon metal, its edge sharp and pure, hot and flashing like a beam of sunlight that cuts through our frozen identities. It is a spiritually radical journey that is not copyrighted as only Buddhist, pagan, Native American, Muslim, Hindu, Christian, Shinto, or Jewish, earth-based, female or male, or any other category of being or becoming. Where there is truth there must also be love, and where there is love there must also be beauty. This is the way of art. True beauty uproots the heart of whoever sees it and snaps all the fibers that fixed it to its ancient soil and carries it away to leave us in a state of awe, breathless and fully alive. This breaking through to the heart is the transmuting force in the alchemy of art awakening us from a spiritual amnesia. We are then moved, compelled really, to spend our lives serving a mission inspired by a kiss of the muse, to express the human spirit. We must do it. We must continue until we are done even though we never can see an end to our work.

An artist spends himself like the crayon in his hand, till he is all gone.
— Ralph Waldo Emerson[13]

At times, the forces of the muse can become so strong as to literally consume us — at that point, our life is no longer our own and we are moved by something greater, something more powerful. The inspiring ideals one experiences and expresses inevitably become outgrown and are discovered to be the seeds for a truer vision. Visions give way to greater visions and dreams will be dreamed, realized, and left behind. Because of this, the early part of the search can entail ceaseless change and suffering, not to mention frequent mistakes, difficult

mutations of consciousness, and struggles with circumstances. But as the years pass, and as we abandon ourselves to trusting the inner-guided process of listening and seeing, we begin to leave behind the many shattered forms and images that clouded the vision of the soul.

Kisses from the muse swell with forms from cracked stone
reckless nymphs drag the images out of night
Each one screaming, stop dreaming!
Stop dreaming!
another muse screaming
She folds me in her wings
the night disarmed, the curve of sky
Windswept dream of angels creep through
In madness, I marvel
shivering in innocence like love in flesh
My new eyes up, I give their image to my soul
spirited in hunks of color and lion's roar
Soul astounded
blessed yawns, arising, waking love, in a moment see
what I and the world have dreamt
with dancing eyes
Charged by drinking lightning with long kisses
heart rises, peopled with spirits and fire
tenderness and garlands of stars
And my new vision
shatters like a jar
and love took me in
where believing was seeing farther than everything
and everything
fell into me
and I into it

At the very summit of creative action is found the exquisite apex of human endeavor, when the individual and solitary mind strikes a momentary accord with the rhythm of the great unknown, when we have an intuitive flash, a vision of the perfection that we have eternally sensed but never seen, and when we feel the inexpressible thrill of even the most ephemeral fusion of identity with the infinite, a love through which we achieve our fullest gratification.

The spirit of art seizes you ... awakens and changes you ... so as to see forever.

FIG. 46 *Rochester, New York, 1973*. Marta Lee Leone and me at Busch Gardens in Bushnell's Basin, New York.

FIG. 47 *Rochester, New York, 1979*. These are students from my courses on the Old Masters' techniques of painting at AllofUs Art Workshop, Inc. The students are from a special, advanced master class that over a period of several years studied techniques of the van Eyck brothers, Dürer, Caravaggio, and Rembrandt. In the two years I spent teaching there, I had well over several hundred students doing intensive studies in painting and transpersonal art. Some of the artists pictured are (front, left to right) Joe DeVita, Sandra Reamer, Evelyn Cammarano, Marilyn Berwind, Donna Boddery, Barbara Palmer, two unidentified students, and me. In the back are Helen Kent, Louis Mendola, and Shirley Weltzer. Other students who studied with me at the workshop between 1978 and 1980 who are not pictured here include Linda Hokin, Carol Acquilano, David Puls, Debra Stewart, Mark Zane, Carolyn Galligan, Bill Stephens, Ina and Tirza Orr.

FIG. 48 *"The Castle," Webster, New York, August 15, 1981.* My best man, Dr Wilson Wheatcroft, and Janet Wheatcroft, with Sandra and me on our wedding day.

FIG. 49 *The Ernst Fuchs Museum, Vienna, 1994.* On our way to Poland to attend a conference on holistic education, Sandra and I stopped in Vienna to visit Ernst Fuchs and others. Sandra and Ernst caught up; it had been ten years since she had lived at the villa and studied painting with him, long before the villa's incarnation as a museum.

FIG. 50 *Boulder, Colorado, 1998.* Visionary artist neighbors and dear friends, Robert Venosa and Martina Hoffmann.

FIG. 51 *Boulder, Colorado, Summer 1997.* Rabbi Zalman Schachter, my younger brother David, and me. After attending a service together, we sat by a creek and discussed life.

FIG. 52 *Vienna, Fall 1996*. While on a visit to Austria with my assistant to investigate potential programs in the arts, we had a nice dinner with Joseph Askew and Ernst Fuchs. We dined near a small and beautiful lake, not far from the villa-museum where Ernst played in the woods as a child. Dinner conversation ranged from my desire to re-establish the "castle art seminars" in Payerbach-Reichenau and enlisting the support of Ernst to discussing theology and metaphysics on the relativity of time. Then we bade farewell.

FIG. 53 *Boulder, Colorado 1999*. Celebrating Ken's birthday at the Boulderado Hotel. *From left to right:* Alex Grey, Ken Wilber, and myself.

CHAPTER ONE

1 Julia Cameron, *The Vein of Gold: A journey to your creative heart* (New York: G. P. Putnam's Sons, 1996), 19.

2 In oil painting, the usual frustrating approach taught in most art schools involves achieving form, light, shade, and color all at once, which is a very difficult task, even for the talented. The genius of this "mixed technique" is not only the availability of both water and oil media at the artist's service but in the division of labor as it is employed. In other words, the artist does not have to achieve form, light, shade, and color all at once but is able to achieve them in successive layers and stages in which these elements are broken down. A monochrome underpainting in egg-tempera white on a dark, earthy ground allows for a meticulously rendered form with light being pronounced by the addition of an egg-tempera white, while shadow is achieved by merely allowing the earthy ground color to remain in various intensities. Color is added by layers in varying degrees of transparent oil resin over the underpainting. The effects can be incredibly luminous, like stained-glass sheets over an underlying light bulb. For an artist with mystical subject matter this is ideal, as she or he can paint the most impossible image with relative ease; for example, one can paint even numerous, transparent beings standing in front of each other and be able to see through each one of them.

3 Astrid Fitzgerald, *An Artist's Book of Inspiration: A collection of thoughts on art, artists, and creativity* (New York: Lindisfarne Press, 1996), 88.

4 ibid., 84.

5 Veristic Surrealism: *veritos*, or a "positive" style of Surrealism — a term coined by Michael Bell, a former curator at the San Francisco Museum of Modern Art. Bell has cataloged numerous painters of this new generation and, in particular, many of the offspring on Fuchs's tree of vision, in the permanent slide library of that museum.

6 R. Fields, P. Taylor, R. Weyler, R. Ingrasci, *Chop Wood, Carry Water: A guide to finding spiritual fulfillment in everyday life* (Los Angeles: Jeremy P. Tarcher, Inc, 1984), 20.

7 In this century, a significant way of thinking that triggered rejection of the mystic painter was prompted and reinforced by Gotthold Lessing, an art critic who introduced an absolute distinction between painting and poetry. According to him, the realm of the former is space; of the latter, time. Lessing posited that the painter, unlike the poet, could deal with the visible only. By implication, this denies him or her access to the spiritual (that is, "the invisible, the spirit") and thus dismisses all narrators, all dramatists, all painters, and all prophets in the visual arts whom I refer to either as mystical precisionists or devotional abstractionists. The echoes of this unfortunate hypothesis have reverberated through modern times. In this criticism, Lessing is reinforced by Roger Fry's exclusive relations of forms and colors, the preoccupation with paint media, the emphasis on the surface of things and their

texture. None of this is a strong case to exclude the spiritual journey as traveled and expressed by the mark of the mystic artist.

8 Fitzgerald, op. cit., 197.

9 ibid., 175.

10 ibid., 161.

11 Joan Bennett (ed.), *Four Metaphysical Poets: Donne, Herbert, Vaughn, Crashaw* (New York: Vintage Books, 1953).

12 Ernst Fuchs, *Exhibition Catalog: Arbeiten der Teil aus den Jahren 1972–1973–1974* (Sommerakademie Reichenau/Schloß Wartholz, June 1974), foreword.

13 Fitzgerald, op. cit., 94.

14 Fields, Taylor, Weyler, Ingrasci, op. cit., 131.

15 ibid., 26.

CHAPTER TWO

1 R. Fields, P. Taylor, R. Weyler, R. Ingrasci, *Chop Wood, Carry Water: A guide to finding spiritual fulfillment in everyday life* (Los Angeles: Jeremy P. Tarcher, Inc, 1984), 79.

2 A *Paramahansa* is a great Sanskrit scholar who has transcended all doctrinal differences. He dwells in a non-dual state of awareness. A period of twelve years must pass before he can achieve this status and title.

3 *Japa* is the repetition of a mantra or divine name. It is a sacred vibration of the divine name. It is the undifferentiated awareness of the nature of the inner self. In fact, the mind is the same as the mantra. It quivers within itself as mantra. *Japa* (repetition of mantra) is an easy technique, a yoga that brings immediate results. The *japa* first mixes with the *prana* (the vital force; specifically, the vital air in the breathing process) and then travels along the *prana* to the heart. From there it merges with each of the seven constituents (*chakras*, seven major energy centers or nerve plexes) of the body. The mantra creates an electric current in the *prana*, which purifies the body and the mind. *So'ham*, the science of *prana*, is at the root of respiration and is the very life of man. *Prana* flows in, *apana* flows out. The breath is inhaled with the sound *sah* and exhaled with the sound *aham*. One full breath is accompanied by one repetition of mantra. *So'ham* is a means to identify the mind (our identity) with the self. We become exactly what our mind dwells on. *Japa* yoga is an ancient spiritual practice that ends duality; the world and mind dissolve, and the mantra reciter is lifted to a higher consciousness seeing equality in all things, the undifferentiated One in all.

4 Astrid Fitzgerald, *An Artist's Book of Inspiration: A collection of thoughts on art, artists, and creativity* (New York: Lindisfarne Press, 1996), 75.

5 Fields, Taylor, Weyler, Ingrasci, op. cit., 272.

6 *Shakti* means "divine energy" and in Hinduism is conceived of as female. Since *shakti* is the divine energy, and since the guru is concerned with the transference of divine power, the use of that energy in such a transfer produces an immediate impact. *Shaktipat* is the stirring, awakening, and expansion of consciousness.

7 Regarding spiritual names: Spiritual names given by an adept to the seeker are an interesting and curious phenomenon, often describing "who you are" at that moment or what you may become; perhaps they are just one of the many names of God distributed by spiritual teachers and have no relevance other than that. "Umesh" was the spiritual name Muktananda gave me when we first met in 1975, which he said I should think of as meaning "Lord of Creative Energy." My mother, sister, brother-in-law, several friends, and Sandra also studied with Muktananda and in 1978–79 received initiation and a spiritual name from him as well. Fifteen years later, in 1993, my mother, Sandra, my friend Mary Jane, and I took refuge with the Buddhist teacher and Treasure Revealer, H.H. Khenpo Jigmey Phuntsok Jungney. Through this Buddhist initiation, I was given the name "Rang rig Lhundrub," which means "Spontaneous Presence of Self-originating Intrinsic Awareness."

8 Fields, Taylor, Weyler, Ingrasci, op. cit., 19.

9 According to most of the metaphysical systems I am familiar with, it is said that it is in the human form that the evolving consciousness of spirit attains its full development as a "soul." The process of evolution of consciousness has its terminus in the human form. Here consciousness can become full and complete. Although there is no difference in the souls of all things, there is a difference in the consciousness of souls; there is a difference in the experience of souls and thus there is a difference in the state of souls. There is a reason that the bodies and forms of life are different, and the forms themselves dictate limitation to creative abilities and production. The hand of the human being is an exquisite tool of creativity, allowing for the most stunning works of art. And, without the Mental and Subtle bodies working in connection with the Gross Body, creativity would be found only within the Print Out of Divine Mind in Nature, its extraordinary patterns, rhythms, and harmonies. The art and inventive powers of humankind not only mimic nature but create its own forms, even if from existing elements arranged into entirely new and unique expressions. There are numerous metaphysical systems addressing soul evolution. Perhaps one of the most intriguing is the one laid out by Meher Baba, God Speaks (Dodd, Mead and Company, second revision, 1973).

10 Fields, Taylor, Weyler, Ingrasci, op. cit., 40.

11 Fitzgerald, op. cit., 56.

12 Ken Wilber, *Eye of Spirit, An Integral Vision for a World Gone Slightly Mad* (Boston and London: Shambhala Publications, 1997), 61.

13 Fields, Taylor, Weyler, Ingrasci, op. cit., 143.

14 In India, the term *mast* is used for a God-intoxicated person on the Path. Many *masts* came under the care of the great saint and avatar, Meher Baba. See Meher Baba's *Discourses* and *God Speaks*.

15 Jainism is a religion in India that rejected the Hindu system involving caste and sacrifice and sought liberation through asceticism. The great teachers in this tradition were called *Tirthankaras*, who crossed the stream of reincarnation. The last of these,

Mahavira, was a contemporary of Buddha. At the age of twenty-eight, he renounced his family and spent twelve years in silent meditation and stern asceticism, not even wearing a loincloth. In the thirteenth year, after a long fast, he achieved perfect knowledge and liberation. There are fewer than two million Jains today, but, like the Quakers, they have had an influence out of proportion to their numbers. The Jains's practice includes right faith (studying the nature of soul) and right conduct (nonviolence, truthfulness, chastity, non-attachment, fasting, charitable aid to others, and spiritual meditation on the true nature of self). There is no belief in a saving deity — there are temples without gods. The *Tirthankaras* open doors to liberation for others to follow.

16 Fields, Taylor, Weyler, Ingrasci, op. cit., 215.

17 José and Miriam Argüelles, *Mandala* (Boulder: Shambhala, 1972).

CHAPTER THREE

1 John Canady, *Metropolitan Seminars in Art, The Artist* (Metropolitan Museum of Art, 1959), 8.

2 Pablo Neruda, *100 Love Sonnets*, translated by Stephen Tapscott, second edition (Austin: University of Texas Press, 1986), 37, sonnet XVI.

3 The Theosophical Society was founded by Madame Helena Petrovana Blavatsky, a Russian aristocrat, and Col. H. S. Olcott in 1875 in New York. The adherence of the well-known secularist and orator, Annie Besant, and the clairvoyant, C. W. Leadbeater, gave the movement a considerable force. Theosophy literally means "divine wisdom." In 1875, knowledge of Indian religion began to permeate through to Britain and America. From this emerged a new synthesis or syncretism, drawing together aspects of Hindu, Buddhist, Christian, and Jewish wisdom, together with other strands. Theosophy is not a religion, per se, but more of a science and an ongoing investigation into the unexplained laws of nature and the latent powers in human beings. Today, the Theosophical Society still encourages a universal brother/sisterhood, the study of comparative religion, philosophy, the sciences, and the arts. When theosophy mixed with and verified my own perceptions and experience, I became very clear on a number of basic spiritual issues, which continue to become more refined. Theosophy proposes that a human is essentially a spiritual being, and the human spirit is an emanation from the Universal Spirit God. To know oneself is to know God. Out of this experience come the two central tenets of theosophy: the immanence and transcendence of God and the unity in God of all living beings. These can be expanded into four: the unity of God who is One without a second, the superlife and superconsciousness in whom all lives and consciousnesses inhere; the manifestation of God in the Trinity of Will, Wisdom, and Mind; the hierarchy of beings, including a vast army of superhuman intelligences and another of subhuman intelligences; and universal brotherhood. The spirit is eternal; the individual climbs the ladder of being through a series of reincarnations until he or she reaches the stature of the perfect human, "beyond birth and death, 'fitted for immortality,'

ready for work in the larger life." Exponents of the theosophical also tell us that the individual exists on three planes: he or she acts through his or her physical body, desires or receives sensation with his or her astral body, thinks with his or her mental body. In death the consciousness passes from the physical plane to the astral plane or immediate world, and so to the mental plane or "heaven" until ready for incarnation. People who are called "psychic," visionaries, endowed with a second sight, are living on the astral plane. A spirit that, through noble and virtuous living and through guidance of a higher power, has reached the goal of human perfection, becomes a master or mahatma. Such a one may pass into other worlds or remain as a guardian of this world, offering spiritual support to others on their way; or, in exceptional circumstances, put himself or herself into a human body and become one of the founders of the world religions. Those familiar with the ground of the world wisdom traditions can see pieces of each represented in theosophical literature. Philosophers can also detect the substance of Gnosticism, the Teutonic theosopher Jakob Böhme, and Swedenborg in the mix as well. I found this school of philosophy and metaphysics very informative but quickly understood that for me, personally, it lacked the heart, the aliveness of a sacred path.

4 Robert Goldwater, *Artists on Art, from the XIV to the XX Century*, Michelangelo's sonnet to Vasari in 1554 (New York: Pantheon Books, Random House, 1972), 60-61.

5 Stephen Breslow, *Arts Magazine* (September 1982), Volume 57, Number 1.

6 Kay Redfield Jamison, *Touched with Fire — Manic-Depressive Illness and the Artistic Temperament* (Free Press Paperbacks of Simon and Schuster, 1993), 258-60.

7 Julia Cameron, *The Vein of Gold: A journey to your creative heart* (New York: G.P. Putnam's Sons, 1996), 298.

8 R. Fields, P. Taylor, R. Weyler, R. Ingrasci, *Chop Wood, Carry Water: A guide to finding spiritual fulfillment in everyday life* (Los Angeles: Jeremy P. Tarcher, Inc, 1984), 114.

CHAPTER FOUR

1 Astrid Fitzgerald, *An Artist's Book of Inspiration: A collection of thoughts on art, artists, and creativity* (New York: Lindisfarne Press, 1996), 209.

2 These beings appeared to be genderless, but the energy felt more masculine than feminine.

3 Fitzgerald, op. cit., 161.

4 Stephen Mitchell (ed.), *The Enlightened Mind* (New York: Harper Collins, 1991), 165.

5 Fitzgerald, op. cit., 189.

6 ibid., 210.

CHAPTER FIVE

1 Julia Cameron, *The Vein of Gold: A journey to your creative heart* (New York: G. P. Putnam's Sons, 1996), 30.

2 R. Fields, P. Taylor, R. Weyler, R. Ingrasci, *Chop Wood, Carry Water: A guide to finding spiritual fulfillment in everyday life* (Los Angeles: Jeremy P. Tarcher, Inc, 1984), 237.

3 Albert Einstein, *Ideas and Opinions*, edited by Carl Seeling (New York: Crown Publishers, Inc./Bonanza Books, 1954), 66-67.

4 ibid., 66-67.

5 We can transcend the masculine connotations associated with the term "God": My friend Mary Jane Fenex refers to the divine as "Mother God," combining both male and female attributes. The Unity Church uses the term "Father/Mother God." Others use "God" and "Goddess" in unison.

6 Astrid Fitzgerald, *An Artist's Book of Inspiration: A collection of thoughts on art, artists, and creativity* (New York: Lindisfarne Press, 1996), 104.

7 Chogyam Trungpa Rinpoche, *Visual Dharma Sourcebook, Volume I*, Nalanada Foundation transcripts, July 9-13, 1978 (Vajracarya, the Venerable Chogyam Trungpa Rinpoche, 1978), 53.

8 For a thorough understanding of the Chinese aesthetic, one may study the Ku Hua P'in Lu ("Record of the Classification of Painting") by the portrait painter Hisieh Ho, c.A.D. 500. I find the Six Canons of Painting more interesting and revealing of the Oriental mind, and although the canons are presented by Hisieh Ho, they are thought to come down to him from an even earlier time. In these studies it is also important to note the difference in aesthetics as applied to the arts of calligraphy versus painting.

9 T. P. Kasulis, *Zen Action — Zen Person* (Honolulu: University of Hawaii Press, 1981), 140.

10 Fitzgerald, op. cit., 203.

11 Reproduced in Harold Osborne, *Aesthetics and Art Theory: An historical introduction* (New York: E. P. Dutton & Co. Inc, 1970), 266.

12 Fitzgerald, op. cit., 105.

13 Kay Redfield Jamison, *Touched with Fire — Manic-Depressive Illness and the Artistic Temperament* (Free Press Paperbacks of Simon and Schuster, 1993), 104.

14 Fitzgerald, op. cit., 130.

CHAPTER SIX

1 Astrid Fitzgerald, *An Artist's Book of Inspiration: A collection of thoughts on art, artists, and creativity* (New York: Lindisfarne Press, 1996), 30.

2 Sam Keen, *To Love and Be Loved* (Bantam Books, 1997), 187-89.

3 Robert Goldwater, *Artists on Art, from the XIV to the XX Century*, from a conversation with Vittoria Callahan as recorded by Francisco de Hollanda, c. 1550, on Michelangelo (New York: Pantheon Books, Random House, 1972), 57, 67-68.

4 Irving and Jean Stone, *My Life and Love Are One, Quotations form the van Gogh Letters* (Boulder: Blue Mountain Press, 1978).

5 Fitzgerald, op. cit., 95.

6 ibid., 29.

7 ibid., 69.

8 Unpublished poem.

9 Brewster Ghiselin, *The Creative Process*, from C. G. Jung (University of California at Berkeley: Mentor Books, 1952), 221.

10 Chogyal Namkhai Norbu, *Dzogchen — The Self-Perfected State*, edited by Adriano Clemente, translated from Italian by John Sloane (Ithaca: Snow Lion Publications, 1996), 127.

11 Fitzgerald, op. cit., 22.

12 ibid., 2.

13 ibid., 4.

14 Keen, op. cit., 240.

CHAPTER SEVEN

1 Robert Goldwater, *Artists on Art, from the XIV to the XX Century* (New York: Pantheon Books, Random House, 1972), 401. Robert Henri, the oldest member of the famous "eight," lived from 1865 to 1929 and wrote these words while he was an influential teacher. Among his students was George Bellows.

2 Chogyal Namkhai Norbu, *Dzogchen — The Self-Perfected State*, edited by Adriano Clemente, translated from Italian by John Sloane (Ithaca: Snow Lion Publications, 1996), 119.

3 Astrid Fitzgerald, *An Artist's Book of Inspiration: A collection of thoughts on art, artists, and creativity* (New York: Lindisfarne Press, 1996), 154.

4 R. Fields, P. Taylor, R. Weyler, R. Ingrasci, *Chop Wood, Carry Water: A guide to finding spiritual fulfillment in everyday life* (Los Angeles: Jeremy P. Tarcher, Inc, 1984), 146.

5 Jolandi Jacobi, *Complex, Archetype, Symbol in the Psychology of C. G. Jung*, second edition, translated by Ralph Manheim (Princeton: Princeton University Press, 1972), 123.

6 *Chiti* or *Chitshakti*, in Hinduism and particularly in the school of Kashmir Shaivism, is *kundalini, mahamaya, parashakti, shakti*, divine conscious energy, dynamic aspect of Godhead referred to as a goddess. It is the dynamic power of the absolute which manifests the world process.

7 Ken Wilber, *Eye of Spirit, An Integral Vision for a World Gone Slightly Mad* (Boston and London: Shambhala Publications, 1997), 295-96.

CHAPTER EIGHT

1 Lewis Carroll, *The Annotated Alice: Alice's Adventures in Wonderland and Through the Looking Glass*, introduction and notes by Martin Gardner (Meridian, 1960).

2 Brewster Ghiselin, *The Creative Process,* Mary Wigman's *Composition in Pure Movement* (Los Angeles: University of California, The New American Library, 1952), 78.

3 John Bartlett, *Familiar Quotations: A Collection of passages, phrases, and proverbs traced to their sources in ancient and modern literature,* 10th edn, revised and enlarged by Nathan Haskell Dole (New York: Blue Ribbon Books, Inc, 1919).

4 Bukkyo Kyokai Dendo, *The Teaching of Buddha* (Japan: Kosaido Printing Company, Buddist Promotion Foundation, 1966), 179-80, vs. 118, 127.

5 M.K. Krishnan, *Gandhi Speaks … Selections from His Writings* (Coimbatore, India: reprinted courtesy of Navajivan Press, 1978), 11.

6 ibid., 11.

7 Alex Grey, *Free Spirit*, interview, New York, 1995, 83.

8 Ghiselin, op. cit.

9 Krishnan, op. cit., 9.

10 William James, *The Varieties of Religious Experience: A study in human nature* (New York: Random House, 1902), 410.

11 Ken Wilber, *A Brief History of Everything* (Boston and London: Shambhala Publications, 1996), 43.

12 Julia Cameron, *The Vein of Gold: A journey to your creative heart* (New York: G. P. Putnam's Sons, 1996).

13 Astrid Fitzgerald, *An Artist's Book of Inspiration: A collection of thoughts on art, artists, and creativity* (New York: Lindisfarne Press, 1996), 220.

List of Color Plates

List of Black and White Figures

The author wishes to express his gratitude to all the publishers, artists, and writers who have kindly granted permission to quote from their works. DeEs Schwertberger's work appears in this book as a courtesy of Morpheus International, <www.morpheusint.com>. Every effort has been made to locate the copyright holders of quotations and artwork presented in this book. The author apologizes to anyone whose rights may appear to be overlooked or whose spirit was lowered as a result of omission of credit due to publication deadlines and welcomes information regarding anyone who has not been consulted.

Excerpts from the writings of Nancy E. Levin, used in the painting *Gods Not Home*, 1997, Fig. 32.

Special thanks to Sam Keen for gettin' tough with a tough guy, to Rabbi Zalman Schachter for getting gentle with a soft guy, and to both for their honesty, friendship, and wisdom. My thanks to the entire staff I hired to give birth to the new School of Continuing Education at Naropa University, including Nancy, Sue Hammond, Kristin Demko, Jan, Summer, Joanna, Deborah, Michelle, Mark, Barry, Christine, Bryan Mahanes, Mark Beaver, Shnoid, and the many others who worked so hard alongside me for six years. My thanks to John Whitehouse Cobb III, Michael Fuchs, Liz Rolick-Hughes, Gigi Hopple, Sandy Goldman, and Saul Kotzubei. To Julie Girl, Lena, Jade, Israel, Shira, Sam, Yosie, Joshua, Kayla, and Mari for the joy they bring me, and to Stacey Glazer, Melanie, Leonardo Laudisio, the Amoeba-Fenex family, Lynn Tidd, Mark Soot, Hans Pater, and Gigi Maria-Antonia Stein, for all their love and support over the years.

INFORMATION FROM THE AUTHOR

For current information visit the author's website at: **www.Rubinovs-Lightning.com** (website designed by A. Andrew Gonzalez). Regarding upcoming publications, seminars, workshops, original art, reproductions, and exhibitions, contact the following agents.

For inquiries about publications, reproduction rights, notecards, posters, original artwork, and commissions, contact:

Dana Cain, Agent
Visionary Arts Cooperative
5061 S. Stuart Court
Littleton, Colorado 80123
USA
Telephone (303) 347-8252
e-mail: dana.cain@worldnet.att.net

Regarding upcoming lectures, workshops, and seminars, or for booking engagements, contact:

Mary Jane Fenex, Agent
Jay&EM Creations
229 Seventh Street West
Kalispel, Montana 59901
USA
Telephone (406) 257-6586
e-mail: mjfenex@montana.com

The publisher is not responsible for the delivery or content of any information or materials provided by the author. The reader should address any questions or inquiries to the author at one of the addresses shown above.

Index

Page numbers in italics refer to images

A

Aaron, 97

Abrams, Isaac, 44, 104, 106, 113, 114

Abrams Publications, 52

Access, 1978 (Schwertberger), *102*

Acquilano, Carol, 271

al-Arabi (died 1240), 145

Alice's Adventures in Wonderland (Carroll), 12, 241

Alien (film), 45

AllofUs Art Workshop, Inc., Rochester, New York, 62, 63, 271

Alpert, Richard (Ram Das), 70

Anagone, Pietro, 36

Anderson, Clay, 42

Angel of Death Above the Entrance to Purgatory is Transfixed by the Angel of Light, The, c. 1953–56 (Fuchs, Ernst), 108

Angela of Foligno (1248–1309), 144

Anti-Laokoon (Laokoon Victor), The, c. 1965 (Fuchs, Ernst), *208, 214, 215*

Aphrodite, 194

Arachne, 195

Architectura Caelestis (book) (Fuchs, Ernst), 194

Ares, 194

Argüelles, José, 91, 107

Arizona Visionary Alternative, 42

Arp, Jean, 225

Art and the Spirit of Man, 1962 (book) (Huyghe), 179

Art as Healing (book) (Kubicek), 42

Art Critic, 1972 (Klarwein), *155*

"Art Institute of the New Age," 110

Arts Magazine (magazine), 113, 114

Askew, Joseph Frederick, 45–6, 274

Atomus Spiritus Christi (Venosa), 79

Augustine, 144

Aura Gloriae, 1997 (Gonzalez), pl. 32, *240*

Avant-Garde (magazine), 31

B

Bach, Johann Sebastian, 225

Bartting, 225

Baryshnikov, 257

Battle of the Metamorphosed Gods, 1951–58 (Fuchs, Ernst), pl. 11, 108

Bayer, Franz, 20, 45

Bell, Michael, 35, 42, 113

Bergman, Ingmar, 53, 225

Berwind, Marilyn, 271

Besant, Annie, 38

Bhagawan Nityananda, 68, 69, 82, 88

Bissier, Julius, 52

Blake, Robert, 130

Blake, William, 101, 115–18, 127–31, 137, 141, 189, 265

Jerusalem (poem), 265

Milton (poem), 265

Blavatsky, Madame Helena Petrovana, 38

Boddery, Donna, 271

Böhme, Jakob, 130, 265

Book of the Flowering Light of the Godhead, The (book) (Mechtilde), 189

Bosch, 37, 189

Boucher, Catherine ("Kate"), 129, 130, 131

Boulder, Colorado, Summer, 1997 (photograph), *273*

Boulder, Colorado, 1998 (photograph), *273*

Boulder, Colorado, 1999 (photograph), *275*

Boulder Community Hospital, 123

Boulder Museum of Contemporary Art, 38

Brauer, Arik, 35, 36, 50, 52, 59

Breath of Dakini, The, 1998 (Gonzalez), *232*

Breslow, Stephen P., 114, 115

Breton, André, 257

Brown, Norman O.

Love's Body, 206

Brueghel the Elder, 37

Buddha, 12, 70, 97, 145, 246, 247, 260, 261

Bussie, Max, 36

C

Californian movement of Visionary Art, 42

Cammarano, Evelyn, 271

Campbell, Clayton, 45

Campbell, Joseph, 181

Capillary Movement (Varo), 225

Caravaggio, 271

Carmel, c. 1963 (Fuchs, Ernst), *186, 191*

Carrington, Leanora, 225

Carroll, Lewis

Alice's Adventures in Wonderland, 12, 241

Castaneda, Carlos

Tales of Power (book), 124

Castle Kuenburg, Austria, 42

Castle Wartholz, 1973 (photograph), *34*

Catherine of Genoa (1447–1510), 189

Catherine of Siena

Dialogue, 265

Cayce, Edgar, 99

Celestial Arch, 1986 (Reamer), *76*

Cezanne, 196

Chagall, Marc, 59

Chains, 1968 (Rubinov-Jacobson, Philip), *26*

Chart A, 1996 (Rubinov-Jacobson, Philip), *100*

Chart B, 1978 (Rubinov-Jacobson, Philip), *218*

Cheiron, 214

Cherub Like a Rhinoceros, 1962 (Fuchs, Ernst), *30*

Cherub Seemingly Resting on Blue Wings, 1963 (Fuchs, Ernst), pl. 12, *80*

Chogyal Namkhai Norbu, 202, 216

Christ *see* Jesus Christ

Church, Frederick, 35

Clemente, Francesco, 37, 38

Cohen, Emma (maternal grandmother), 21

Cohen, Samuel "Poppy" (maternal grandfather), 21

Collective Power, 1978 (Schwertberger), *103*

Coltrane, John, 225

Confucius, 36

Corpus Hermeticum, 233

Cosmic Art (book) (Swann), 112

Cranach, Lucas, 20

Crucifixion, 1996 (Madrid), *40*

Crucifixion, 1968 (Rubinov-Jacobson, Philip), *26*

D

da Vinci, Leonardo, 37, 97, 130, 181

Dali, Salvador, 46, 52, 53, 55, 97